3 1994 01242 6786

SANTA ANA PUBLIC LIBRARY

P9-DUU-625

# TIME STANDS STILL
# TIME STANDS STILL
# TIME STANDS STILL
# TIME STANDS STILL
# TIME STANDS STILL
# TIME STANDS STILL
# TIME STANDS STILL
# TIME STANDS STILL
# TIME STANDS STILL
# TIME STANDS STILL
# TIME STANDS STILL
# TIME STANDS STILL
# TIME STANDS STILL
# TIME STANDS STILL
# TIME STANDS STILL
# TIME STANDS STILL
# TIME STANDS STILL
# TIME STANDS STILL

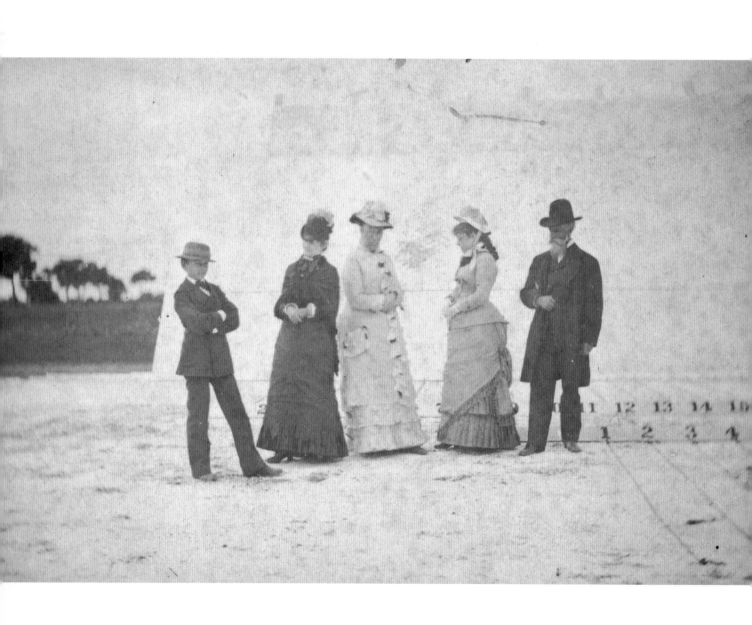

TIME STANDS STILL
TIME STANDS STILL
TIME STANDS STILL
TIME STANDS STILL
TIME STANDS STILL
TIME STANDS STILL

# Muybridge
# and the
# Instantaneous
# Photography
# Movement

TIME STANDS STILL
TIME STANDS STILL

**Phillip Prodger**
**with an essay by Tom Gunning**

TIME STANDS STILL

TIME STANDS STILL

TIME STANDS STILL

THE IRIS & B. GERALD CANTOR CENTER FOR VISUAL ARTS AT STANFORD UNIVERSITY
IN ASSOCIATION WITH OXFORD UNIVERSITY PRESS          2003

778.3 PRO
Prodger, Phillip.
Time stands still
31994012426786

# OXFORD
## UNIVERSITY PRESS

Auckland   Bangkok   Buenos Aires   Cape Town
Chennai   Dar es Salaam   Delhi   Hong Kong   Istanbul   Karachi
Kolkata   Kuala Lumpur   Madrid   Melbourne   Mexico City   Mumbai
Nairobi   São Paulo   Shanghai   Singapore   Taipei   Tokyo   Toronto

Copyright © 2003 by Oxford University Press with The Board of Trustees of the Leland Stanford University

Oxford is a registered trademark of Oxford University Press
All rights reserved. No part of this publication may be reproduced, stored in a retrieval system, or transmitted
in any form or by any means, electronic, mechanical, photocopying, recording, or otherwise, without the
prior permission of Oxford University Press.

Intinerary
Cantor Arts Center: February 6 - May 11, 2003
Cleveland Museum of Art: February 15 - May 16, 2004

The exhibition and catalogue have been made possible through the generosity of Carmen Christensen, with
additional support from The Bernard Osher Foundation and the Cantor Arts Center Members.

*Front cover*:
Eadweard Muybridge
*Gallop, Bay Horse "Daisy,"* 1864–86
Cyanotype print, mounted on card, printed c. 1887 (full-plate proof of plate 628, *Animal Locomotion*)
31.8 x 48.4 cm
Photographic History Section, National Museum of American History, Smithsonian Institution

First published in 2003 by Oxford University Press
198 Madison Ave.
New York, NY 10016-6443
in association with the Iris & B. Gerald Cantor Center for Visual Arts at Stanford University
Stanford, CA 94305-5060

Library of Congress Cataloging-in-Publication Data is available
ISBN 0-19-514963-7 (cloth)
ISBN 0-19-514964-5 (paper)

Exhibition coordinated at Cantor Arts Center by Bernard Barryte
Edited by Karen Jacobson, Bernard Barryte
Index: Kathleen Preciado
Principal photography, Cantor Arts Center: Lee Fatherree
Rights and Reproductions, Cantor Arts Center: Alicja Egbert
Text design by Adam B. Bohannon

9 8 7 6 5 4 3 2 1

Printed in Hong Kong on acid-free paper

# CONTENTS

FOREWORD

**P**hotographic imagery (and its descendants—film, video, and computer simulation) is the most prevalent of all fabricated visual forms in the industrialized world. It is generally understood today that photographic images do not necessarily render or portray truth or fact. Not only are the images selectively made by a photographer, but after the film is exposed, the image is subject to manipulation during printing. To complicate matters further, in the digital environment of the early twenty-first century, simulacra of photographs may be completely fabricated without an original image (in the conventional sense) ever having been made.

But it was not always thus. Technological innovations aside, it may not be a coincidence that photography emerged when fidelity to nature was a dominant artistic goal. The names that Nicéphore Niépce suggested in 1832 for his invention—for example, "painting by nature herself," "real nature," "true copy of nature"—are coincident with the aesthetic ideals summarized by Gustave Courbet in 1861, when he declared that "the art of painting should consist solely of the representation of objects visible and tangible to the artist." Sharing the desire of other artists to achieve verisimilitude, most early photographers were interested in *how* to depict reality, or to accurately portray a particular place or individual at a particular moment.

This exhibition focuses on those innovative photographers who became especially interested in the reality that we might not be able to see clearly or accurately with our own eyes. As photography effectively freezes its subject, it was hypothesized that if the medium could work fast enough, it could stop motion—that is to say, capture the animate reality of nature. Photography's perceived ability to arrest motion was the impetus for many of the technological developments in cameras and film that culminated in Eadweard Muybridge's remarkable accomplishment, the production of so-called instantaneous photographs in which the "reality" of nature in motion could be seen.

Leland Stanford became a major force in the effort to stop motion because he wanted to better understand how his race-horses' legs moved when trotting. At his stock farm in Palo Alto (now the site of Leland Stanford Junior University), he sponsored Muybridge and a team of engineers with the goal of developing a technique of photographically documenting a horse's motion through sequential images. This effort in many ways laid the foundation for the future development of motion pictures.

Because of the Stanford/Muybridge association, Stanford University is the repository of a uniquely important collection of original works by Muybridge. This precious material was first catalogued and seriously studied by the museum's former registrar and curator of photography, Anita Mozley. In 1972 she organized the landmark exhibition *Eadweard Muybridge: The Stanford Years, 1872–1882* and published the accompanying catalogue, which has long been out of print. Since that time the study of photography has matured; in particular, much exciting material has become available regarding the earliest history of the medium. After a period of institutional transition and revival following the 1989 earthquake, and spurred by the enthusiasm of a young scholar who had immersed himself in these materials at Stanford, we decided that it would be appropriate and valuable for the Iris & B. Gerald Cantor Center for Visual Arts at Stanford University to undertake another exhibition drawn in part from this exceptional collection. This exhibition attempts to place Muybridge within a historical context, focusing on many of the photographers who were his forebears and contemporaries, examining the impulse that inspired them to try to make time stand still.

*Time Stands Still: Muybridge and the Instantaneous Photography Movement* is the vision of Dr. Phillip Prodger, recently appointed assistant curator at the Saint Louis Art Museum. Ably assisted by the talented staff at the Cantor Arts Center and other colleagues, notably Professor Tom Gunning of the University of Chicago, Phillip has crafted this intriguing exhibition and cata-

logue. Its realization would not have been possible without the generosity of our lenders, many of whom parted with some of their rarest and most fragile images. We are grateful to them for their understanding and support of this significant project.

We are delighted to be sharing the exhibition with the Cleveland Museum of Art. We are grateful to its trustees, its director Katherine Lee Reid, and staff for their partnership. The exhibition's development has been generously supported by Carmen Christensen with additional support from The Bernard Osher Foundation, and the Cantor Arts Center Membership. This handsome catalogue has been produced by Oxford University Press, working with our chief curator and managing editor Bernard Barryte.

Organizing this international loan exhibition was a very ambitious undertaking for our relatively small institution. Virtually all members of the staff contributed to its success, but we want to especially acknowledge exhibition coordinator Sarah Miller, Alicja Egbert, who coordinated photography, and two registrars, Noreen Ong and Donna Mauro, who efficiently addressed the logistics of international loans during a difficult time. It is a pleasure to acknowledge the staff's efforts and to thank them, along with our partners and supporters, for helping us to bring this fascinating material before a larger public.

*Thomas K. Seligman*
JOHN AND JILL FRIEDENRICH DIRECTOR

ACKNOWLEDGMENTS

Eadweard Muybridge was one of Stanford University's first academic heroes. Although his career neither began nor ended there—and indeed the university was not formally founded until some years after he had left—the effects of his work in Palo Alto were far-reaching. The international importance of the experiments he performed under the patronage of Jane and Leland Stanford is widely recognized. Unfortunately the local significance of his work is sometimes overlooked. Without his novel experiments in the 1870s, the history of photography would undoubtedly be different. And the history of the university would be as well.

Muybridge helped to establish a pattern that has been repeated often at Stanford. Guests are welcomed, provocative thoughts are entertained, and the force of the university's intellectual muscle is marshaled to test the limits of possibility. It is one of the things that makes the university special. In its own small way, this exhibition builds on this strong tradition.

Teamwork has always been an essential element of work at Stanford. *Time Stands Still* has been no exception, and I am deeply indebted to all my colleagues at the Iris & B. Gerald Cantor Center for Visual Arts at Stanford for their efforts. I am especially grateful to Bernard Barryte, chief curator at the Center, for his unflagging support. His skill, insight, enthusiasm, and experience were the engines that drove the project. He has been deeply involved in every stage of this project, serving as coordinator at Stanford, and at times acting as its curator. This catalogue is largely the result of his efforts. Thomas Seligman, director of the Cantor Arts Center, also guided the project, combining his ambitious vision for the collections with an astonishing ability to surmount all obstacles. Both made me more welcome than I could reasonably have hoped.

Exhibitions coordinator Sarah Miller has been my close associate and the main conduit for all problems great and small. Her peerless efficiency and good humor have made working from a

distance of many hundreds of miles not only possible but enjoyable as well.

Each of the members of the Muybridge project team also made vital contributions. They are Mona Duggan, external relations; Alicja Egbert, rights and reproductions; Anna Koster, publicity; Noreen Ong and Donna Mauro, registration; Susan Roberts-Manganelli, conservation and technical management; and Patience Young, education. My thanks also to other members of the Cantor Arts Center staff, who provided invaluable help. Among them are Julie Bond, Katie Clifford, Laura Janku, Dolores Kincaid, and Alison Roth.

Preparation and installation of the exhibition at Stanford was skillfully organized by Chief Preparator Don Larsen and implemented by Jeff Fairbairn, Holly Gore, Frank Kommer, Ray Madarang, Danny Meltsner, and Chandra Nicola. Conservation was provided by Tracy Power, Thornton Rockwell, and Heida Shoemaker. Lee Fatherree was the photographer for the large number of items from Cantor Arts Center collections. John Blazejewski provided photography in Princeton. John Weight and Eric Johnsen prepared the Stanford zoopraxiscope for exhibition.

The Muybridge collection at Stanford University owes much of its strength to Anita Mozley, former registrar and curator of photography. Her exhibition *Eadweard Muybridge: The Stanford Years, 1872–1882* and its catalogue are the foundation on which *Time Stands Still* was built.

I would also like to thank Maggie Kimbell in the Department of Special Collections at Green Library. Thanks are due as well to Cantor Arts Center curators who have lent advice over the years, including Hilarie Faberman, Betsy Fryberger, and Joel Leivick.

The contributions of colleagues at the Cleveland Museum of Art have been invaluable; Tom Hinson has been especially helpful. Special thanks are also due Clare Hennessy, who very kindly assisted with research in London.

Michelle Delaney, collections manager of the Photographic

History Collections at the National Museum of American History, Smithsonian Institution, has been one of *Time Stands Still*'s most important boosters. She not only opened doors for us at the Museum of American History, making the museum's colossal Muybridge collections available, but she arranged financial support as well. The symposium associated with *Time Stands Still* is made possible with support of the museum's Rudolf Eickemeyer Jr. Fund. Shannon Perich, John Hiller, and Lynne Gilliland also helped enormously.

Joyce Berry, Ruth Mannes, and their colleagues at Oxford University Press are to be thanked both for designing and producing this very handsome catalogue and for the speed and efficiency with which they did so. Claudia Sorsby provided invaluable comments on early drafts of the manuscript. Dan Hillman provided technical advice. The texts throughout have benefited from the astute editorial scrutiny of Karen Jacobson; the index is the work of Kathleen Preciado.

The exhibition was greatly enriched by a number of experts who graciously shared their knowledge of various subjects. Deac Rossell, Rebecca Solnit, and Roger Taylor were especially generous, making suggestions that fundamentally changed the exhibition. Michael and Jane Wilson not only lent works to the exhibition but shared their enthusiasm for the subject and provided valuable insights as well. Ken and Jenny Jacobson, whose private collection has always gravitated toward instantaneous photography subjects, also lent critical works. They too provided information available nowhere else.

There were many others who offered crucial help, including John Alviti, Sylvie Aubenas, Gordon Baldwin, Martin Barnes, Peter Bunnell, Katia Busch, Mikka Gee Conway, Charlotte Cotton, Julian Cox, Daniella Dangoor, Bodo von Dewitz, Maurice Dorikens, Roy Flukinger, Duncan Forbes, Philip Glass, Paul Goodman, Michael Gray, André Gunthert, Todd Gustavson, Violet Hamilton, Colin Harding, Mark Haworth-Booth, Françoise Heilbrun, Ydessa Hendeles, Stephen Herbert, Paul

Hill, Charles Isaacs, Toby Jurovics, Brian Liddy, Anne Lyden, Magdolna Kolta, Jiri Krohn, Charl Lucassen, Carol McCusker, Karen Moran, Richard Morris, Therese Mulligan, Werner Nekes, Alex Novak, Michel Poivert, Pam Roberts, Russell Roberts, Phyllis Rosenzweig, Cheryl Smith, Robert Sobieszek, Katie Solender, Annamária Szoke, Anelia Tuu, Tran Vo, and Jessica White.

I also thank our friends at the Musée Marey in Beaune: Joyce Delimata, Marion Leuba, and Daniel Rouvier. Although the fragility of the materials in their care prevented them from lending to the exhibition, we are nevertheless grateful for their encouragement.

It has been a pleasure to work with each of the lenders to the exhibition, who are identified in the checklist at the end of this volume. We appreciate all of their efforts on our behalf, from assisting with initial access to their collections to the complexities of arranging loans.

Research support was provided by the staff at the Bancroft Library, the Bibliothèque Nationale de France, the Bodleian Library, the British Library; Cambridge University Library, the Marquand Library, and the Witt Library.

I am deeply indebted to Dawn Brooks, whose advice, encouragement, and companionship sustained me at every step. I am also grateful to Brian and Yvonne Prodger for their continuing support.

Finally, I want to echo Thomas Seligman's acknowledgment and personally thank the sponsors and lenders whose generous support enabled us make this exhibition a reality.

*Phillip Prodger*

Eadweard Muybridge born Edward Muggeridge, 9 April 1830, Kingston-on-Thames, England

Immigrates to the United States, 1852

Settles in San Francisco, 1855

Takes up landscape photography, c. 1866

Marries Flora Stone, 1871

MUYB

HISTORY OF

←— 1830   1835   1840   1845   1850   1855   1860   1865   1870

Announcement of invention of photography by William Henry Fox Talbot and Louis-Jacques-Mandé Daguerre, 1839

David Octavius Hill and Robert Adamson, Newhaven photographs, 1843-48

Talbot, first instantaneous picture with flash; wet-plate collodion invented, 1851

John Dillwyn Llewelyn exhibits "motion" photographs, Exposition Universelle, Paris, 1855

Gustave Le Gray, *Breaking Wave*, c. 1857

George Washington Wilson, *Princes Street, Edinburgh*; Edward Anthony, *Broadway* (New York), 1859

Louis-Jean Delton, photographs of clowns, 1863

Gelatin dry plate invented, 1871

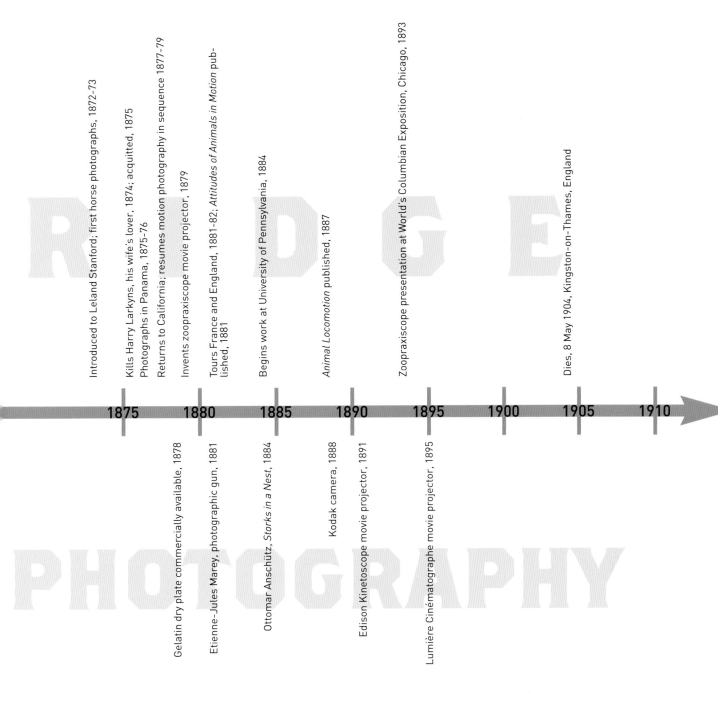

Introduced to Leland Stanford; first horse photographs, 1872-73

Kills Harry Larkyns, his wife's lover, 1874; acquitted, 1875
Photographs in Panama, 1875-76

Returns to California; resumes motion photography in sequence 1877-79

Invents zoopraxiscope movie projector, 1879

Tours France and England, 1881-82; *Attitudes of Animals in Motion* published, 1881

Begins work at University of Pennsylvania, 1884

*Animal Locomotion* published, 1887

Zoopraxiscope presentation at World's Columbian Exposition, Chicago, 1893

Dies, 8 May 1904, Kingston-on-Thames, England

1875    1880    1885    1890    1895    1900    1905    1910

Gelatin dry plate commercially available, 1878

Etienne-Jules Marey, photographic gun, 1881

Ottomar Anschütz, *Storks in a Nest*, 1884

Kodak camera, 1888

Edison Kinetoscope movie projector, 1891

Lumière Cinématographe movie projector, 1895

RIDGE

PHOTOGRAPHY

TIME STANDS STILL
TIME STANDS STILL
TIME STANDS STILL
TIME STANDS STILL
TIME STANDS STILL
TIME STANDS STILL
TIME STANDS STILL
TIME STANDS STILL
TIME STANDS STILL
TIME STANDS STILL
TIME STANDS STILL
TIME STANDS STILL
TIME STANDS STILL
TIME STANDS STILL
TIME STANDS STILL
TIME STANDS STILL
TIME STANDS STILL
TIME STANDS STILL

# A Time and Place
## Eadweard Muybridge
## and His Legacy

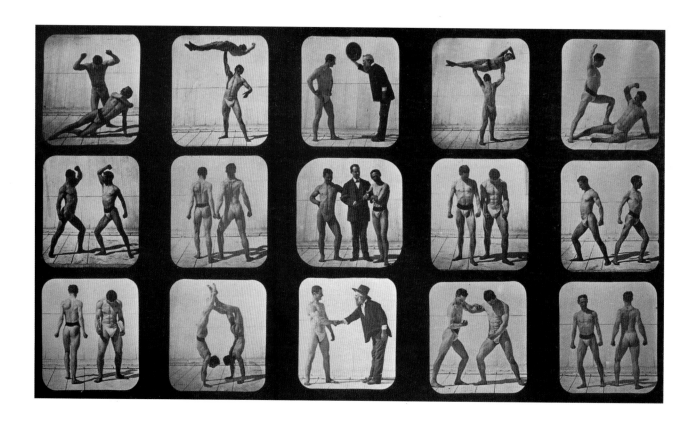

**M**uybridge, Muygridge, Muggeridge, Maybridge—the man known variously as Edward, Eadweard, and even Eduardo Santiago adopted as many guises as he did names. A gifted landscape photographer, an inventor, the putative "father" of motion pictures, and the creator of a revolutionary group of instantaneous photographs, Muybridge (the name he would finally settle on) was a figure of influence and importance, yet he never quite fit in. An Englishman who lived in the United States, he was sometimes celebrated by those around him but never fully embraced. He was the quintessential outsider, working for long periods in partial isolation far from the technological centers of London, Paris, and New York, yet he quickly emerged as a formidable figure in photography.

Muybridge entered the field at about age thirty-six and soon achieved distinction as one of California's best landscape photographers. Six years later he embarked on his renowned project of photographing horses and other animals in motion. With the publication of these images came immediate international fame, and the extension and interpretation of these motion study experiments occupied him for the rest of his career. Eventually he would tour the United States and Europe as a sort of photographic ringmaster, captivating audiences with shows of his astounding animated pictures (see fig. 4-1.).

By then Muybridge was already well known. Many who went to see his presentations knew him not so much as a photographer, but as a gold rush–era pioneer who had killed his wife's lover after learning that he had fathered Muybridge's only child. It was a story of hot-blooded Wild West justice, made even more sensational when, despite admitting to the crime, he was acquitted on grounds of justifiable homicide. Eccentric and unpredictable, Muybridge had a volatile temper that was sometimes attributed to a brutal stagecoach accident suffered on one of his transcontinental journeys.

Scholars have long debated what motivated him and how to account for his extraordinary success. Was it the result of a brain

Fig. 1-1
Eadweard Muybridge
*Posturing*, 1879, plate 115 from the series
  *Attitudes of Animals in Motion*
Printing-out paper print
16 x 22.4 cm

3

injury suffered on that fateful crossing? Or was it the intervention of California governor Leland Stanford? Muybridge was such a colorful figure, and his photographs so unprecedented, that his work seems to defy simple explanations.

The purpose of this exhibition and catalogue, *Time Stands Still*, is to push beyond the melodramatic stories of Muybridge's persona and to focus instead on his achievements as a photographic artist. To do so, we concentrate on a single phase of his career: the motion studies he began in California in the 1870s and continued at the University of Pennsylvania from 1884 to 1886. We explore the role of Muybridge as an "instantaneous" photographer, as a climactic figure in the struggle to record rapid action using camera and lens. In a short burst, he became one of the most prolific photographers in history, producing tens of thousands of images and publishing two prodigious photographic atlases. This intense period deserves attention and is the particular focus of this exhibition.

Muybridge worked at a formative time in photographic history, as the medium was beginning to assert its identity as an enterprise distinct from its cousins, drawing and printmaking. His works redefined traditional notions of what could be displayed pictorially, as he used the mechanical properties of photography to probe the world in ways the eye cannot. He never dispensed completely with painterly notions of composition, however, and sometimes altered his results to achieve artistic effects. The nature of these effects is a subject of considerable interest, which has not yet been adequately addressed.

In the new world Muybridge created, the depiction of moving things was freed from the limitations of memory or preconception. The story of instantaneous photography is the story of this shift in visual possibilities. Consequently, the ideas embodied in his work of this period are fundamental not only to understanding Muybridge and his repertoire but also to the aesthetics of photography itself.

*OPPOSITE PAGE*
**Fig. 1-2**
Colonel Stuart Wortley
*A Wave Rolling In*, 1863–65
Albumen print
23.2 x 27.9 cm

**Fig 1-3**
Eadweard Muybridge
*"Occident" Trotting at a 2:20 Gait*, 20 June 1878, from the series *The Horse in Motion*
Albumen print (cabinet card)
10.2 x 20.9 cm

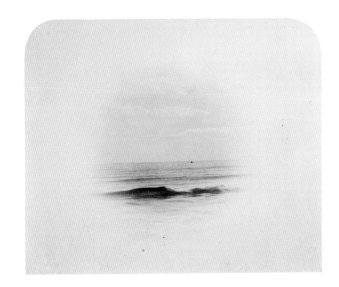

Muybridge is not the only photographer represented in this exhibition. He is, however, its centerpiece. He serves as a touchstone for understanding those who worked in motion photography before him, and for the sizable school of photographers who followed his example. The exhibition begins with a survey of instantaneous photography in the 1850s and 1860s (fig. 1-2), continues with an examination of Muybridge's motion experiments of the 1870s (fig. 1-3), and concludes with his late works, including the celebrated portfolio *Animal Locomotion* (fig. 1-4), published in 1887. Muybridge's contributions to motion picture history are also discussed, as are works by the so-called chronophotographers, with whom he frequently interacted and who used related techniques to photograph similar subjects (fig. 1-5).

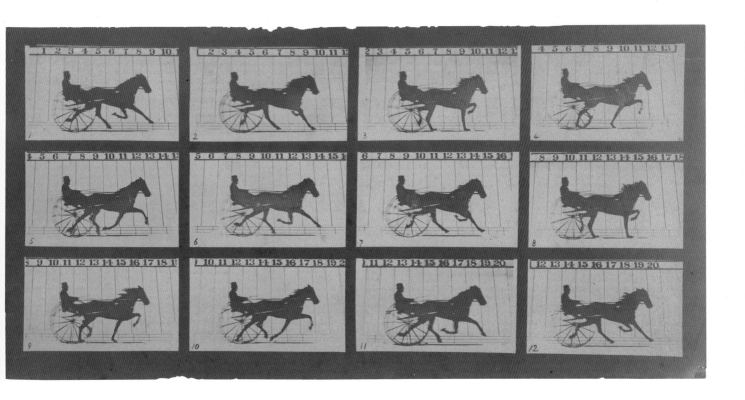

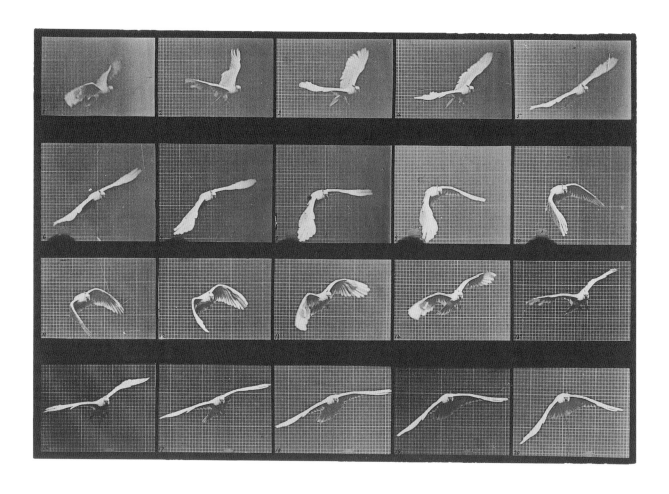
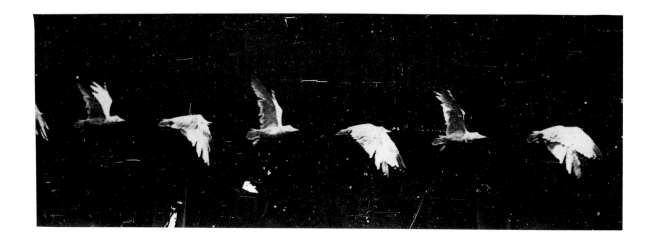

*OPPOSITE PAGE*

**Fig. 1-4**
Eadweard Muybridge
*Cockatiel in Flight*, August 1885, plate 760
    from the series *Animal Locomotion*
Collotype
22 x 31.9 cm

**Fig. 1-5**
Etienne-Jules Marey
*Gull in Flight*, c. 1883
Albumen print
5.8 x 16.6 cm

The intention is to place Muybridge's work in context and to explore what was unique and original about his art.

Muybridge would undoubtedly be a subject of interest even if he had not embarked on this project. His photographs of the Pacific Coast of the United States; his survey of its railroads; his landscape expeditions in the Yosemite Valley, Guatemala, and Panama; and his documents of the Modoc Indian War are themselves subjects of great interest. They display little of the preoccupation with instantaneity that would later engulf him, however, and are consequently beyond the scope of this exhibition. Although his studies of human and animal motion are occasionally foreshadowed in these earlier projects, the connection is tenuous. There is little evidence that Muybridge was concerned with using photography to freeze subjects in motion until he turned his attention to galloping horses in the early 1870s. As a result, the early phase of his work is not represented in *Time Stands Still.*

Although he remained a presence in instantaneous photography until his death in 1904, by 1887 Muybridge had effectively ceased work as a professional photographer. After this time, he presented motion pictures using his zoopraxiscope projector, compiled almost entirely of images made in the Philadelphia period. Although he continued to show this work until the end of his life, public interest in these efforts quickly faded. At the same time, rapidly improving technology in motion picture recording and projection—based on the inventions of the Lumière brothers (active 1887–1920s), Thomas Edison (1847–1931), and others—soon rendered zoopraxography (as Muybridge called his motion picture process) obsolete. Eventually he abandoned it and spent his late years preparing facsimile editions of his Philadelphia experiments.

In short, there was little new in Muybridge's work after the publication of his *Animal Locomotion* portfolio in 1887. As a result, this body of work provides a convenient cutoff for the consideration of his motion photography. Although colleagues such as Etienne-Jules Marey (1830–1904), Albert Londe

(1858–1917), and Ottomar Anschütz (1846–1907) had fruitful careers extending beyond this date, only works made in or before 1887 are considered here. Moreover, some familiar figures who worked in motion photography after Muybridge completed his work—such as Georges Demenÿ (1850–1917), Lucien Bull (1876–1972), and Albert Lugardon (1827–1909)—are not included at all.

*Time Stands Still* is not a biography. Although this volume does contain a number of fresh revelations about Muybridge's career, its aim is to present them in the context of his artistic achievements. Fortunately, several excellent biographies already exist. Any new study of Muybridge necessarily builds on the efforts of three scholars in particular, whose books remain excellent sources of information about Muybridge, his life, and his work. All wrote in the 1970s, the centennial of Muybridge's first successful experiments in California. Anita Mozley's *Eadweard Muybridge: The Stanford Years, 1872–1882* (1972) remains a seminal treatment and is the best resource on the collections at Stanford University. Her extremely informative but sometimes overlooked introduction to the Dover reissue of *Animal Locomotion* (1979) is another important source. Robert Bartlett Haas, with whom Mozley collaborated, produced his own insightful study, *Muybridge: Man in Motion* (1976). And the closely researched *Eadweard Muybridge: The Father of the Motion Picture* (1975), written by the historian Gordon Hendricks, is another invaluable biographical source.

In *Time Stands Still*, the focus is rather different. Instead of looking at the circumstances of Muybridge's admittedly dramatic life, we examine what was new and original in his thinking. By concentrating on a single, crucial element of his work, his motion studies, and on a narrow period in his career, we feature just one of the many "names" by which Muybridge is now known. And by including the works of his peers, we highlight the development of technology and ideas that culminated in his work. Muybridge was, and remains, a distinctive and elu-

sive figure. Eadweard, Edward, and even Eduardo Santiago continue to command attention.

## Muybridge and Stanford

*Time Stands Still* is inspired by the collection of Muybridge photographs and related materials held by the Iris & B. Gerald Cantor Center for Visual Arts and the Department of Special Collections at Stanford University. Stanford University and Muybridge have an intimate historical association. Although the first experiments were conducted elsewhere, it was on what would later become the university's grounds, in 1878, that Muybridge began his comprehensive program of motion study photography. He worked under the patronage of the university's founders, Jane and Leland Stanford (1828–1905 and 1824–93, respectively). Jane Stanford was an important figure in the growth of the university and its collections and was at times an active participant in Muybridge's motion experiments (see frontispiece). It is her husband, Leland, however, who is credited with initiating the project.

In addition to serving as California's governor during the Civil War, Leland Stanford (fig. 1-6) was a United States senator and president of the Central Pacific Railroad. The Central Pacific was the line that helped make transcontinental rail travel possible when it joined the Union Pacific at Promontory, Utah, in 1869. The Golden Spike, which Stanford tapped into a railroad tie in a ceremonial joining of the lines, is among the Cantor Arts Center's prized possessions.

In addition to his political and business dealings, Stanford was a breeder of racehorses, and it was his desire to better understand the gait of his horses that occasioned the project. By understanding the mechanics of equine movement, he hoped to improve the performance of his animals at the track. Physiological information of this type was doubly useful. Theoretically it could enable trainers to adjust training and rehabilitation regimens to strengthen critical motions or correct perceived weak-

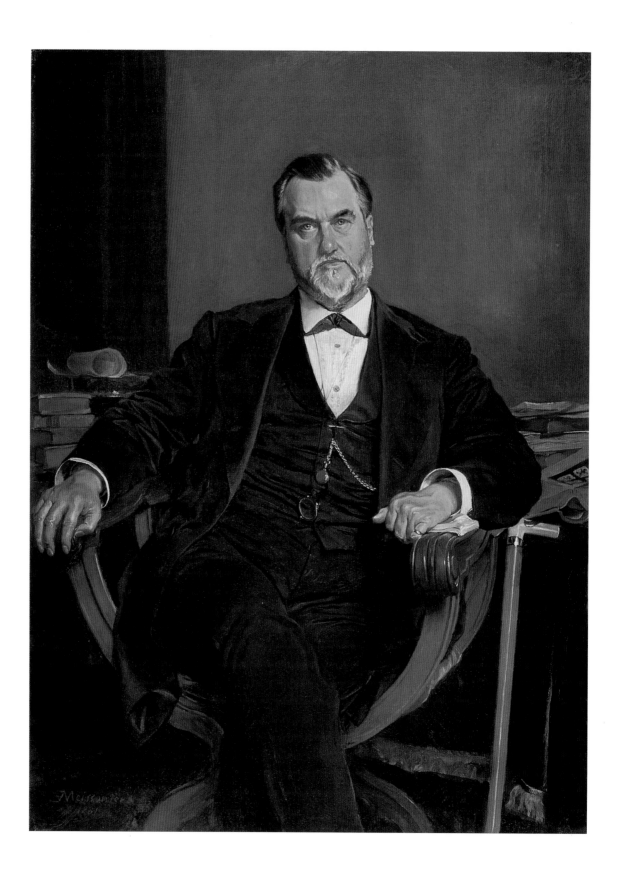

OPPOSITE PAGE
**Fig. 1-6**
Ernest Meissonier
*Portrait of Leland Stanford with Muybridge's*
*Book "Attitudes of Animals in Motion,"*
1881
Oil on canvas
41.9 x 31.7 cm

nesses. In addition, it could be used to assist breeders in identifying promising foals early in their development and to select parents for breeding. The extent to which photographic evidence was actually used for these purposes is not known.

In or around 1872 Stanford asked Muybridge to photograph a horse in motion. Such a photograph had never been made before, and there was little in Muybridge's resume to suggest that he was a suitable candidate for the job. Nevertheless, at Stanford's urging, he set about trying to make the sought-after photograph. Limited early successes encouraged more trials, and the technique was perfected several years later.

It is often asserted that Stanford bet money on the outcome of Muybridge's experiments, believing that they would prove that at a particular moment in the gait of a galloping horse, all four hooves leave the ground simultaneously. This was indeed Stanford's position and appears to have been the hypothesis that Muybridge was hired to test, but reports that a wager was made seem to have been invented later. The question of unsupported transit, as it was known, was a source of considerable debate among horse aficionados. Haas, for instance, noted that talk of a bet was in the air among the "horsey crowd" but contended that Stanford himself was not a protagonist.[1] Scholars opposed to the betting story have traditionally argued that gambling of this sort was not in keeping with Stanford's character. The conspicuous lack of evidence to support the claim is sufficient to cast doubt on it. Stanford himself never mentioned the existence of a bet, nor has the identity of another participant been reliably established. Several individuals have been nominated for the role, but none ever acknowledged taking part. Moreover, the amount of the supposed bet has been variously reported as ten, twenty-five, or fifty thousand dollars. This too suggests that the story is apocryphal.

Although the details of their introduction are lost to history, Stanford and Muybridge would have been familiar with each other's work prior to their collaboration in Palo Alto. In 1869

1. Haas 1976, 46.

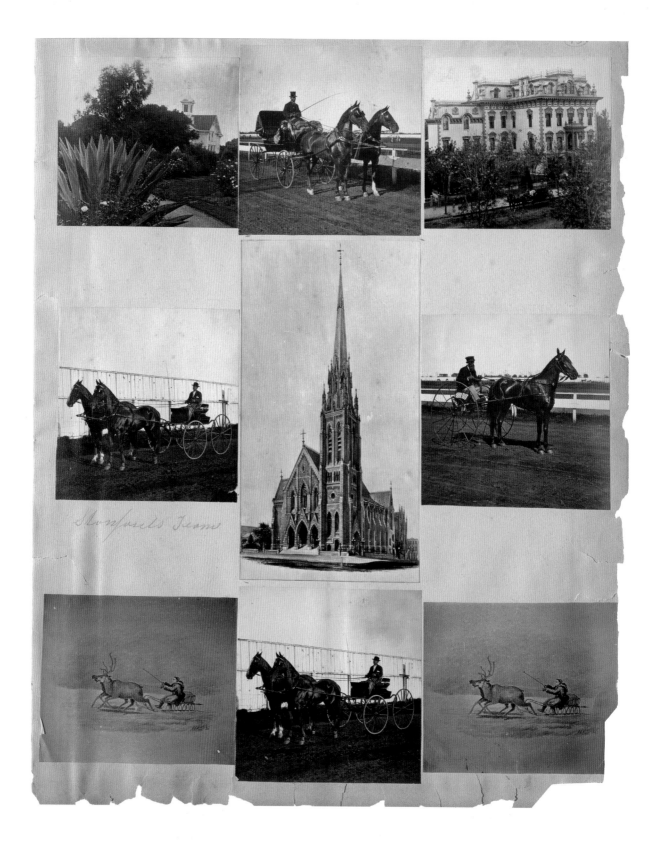

*Stanford's Team*

*OPPOSITE PAGE*
**Fig. 1-7**
Eadweard Muybridge
*Horse Studies, Drawings of Reindeer, and
  Views of Sacramento*, 1872-73
Albumen prints
33 x 26.3 cm

Muybridge published a series of photographs of the Central Pacific Railroad. He also produced a group of photographs of the Stanford family home at Eighth and N Streets in Sacramento, some 140 kilometers north of San Francisco. These photographs are not dated, but it has been inferred that they were produced in 1872 based on the apparent age of certain sitters and other details. This was at about the same time that Muybridge began to photograph Leland Stanford's horses in Sacramento. Some accounts also place these early experiments in San Francisco.

The first photographs Muybridge made of horses in motion have not been preserved. Although both he and Stanford claimed that it was in the early 1870s that they first managed to record the paces of a galloping horse photographically, the quality of these experiments is thought to have been poor, and they were never published. The earliest known photographs of Stanford's horses by Muybridge appear in the Brandenburg Album (fig. 1-7), a photographic scrapbook probably assembled by Muybridge's wife, Flora, and now in the collection of the Cantor Arts Center. The photographs themselves are undated, but they depict horses at the racetrack in Sacramento, most likely in 1872. The horses themselves are stationary. Interestingly, in assembling the page, Flora paired these photographs with prints of a team of reindeer pulling a sleigh. The reason behind the juxtaposition is not known, but it hints at the interest in animal locomotion with which Muybridge would soon be consumed.

In 1874, however, fate intervened. Muybridge became embroiled in the infamous Larkyns affair (see pp. 258–262), in which he killed his wife's lover, Major Harry Larkyns. Muybridge learned that Larkyns had fathered Floredo, the son Muybridge believed to be his own. In a calculated rage, he traveled nearly 130 kilometers to the town of Calistoga, where Larkyns was enjoying festivities at the Yellow Jacket Mine. He called on Larkyns and, when he appeared, greeted him coldly. "Good evening, Major," he is said to have told him. "My name is Muy-

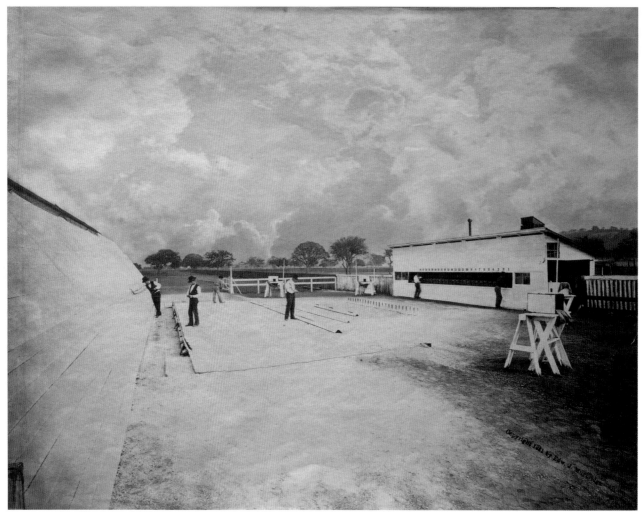

**Fig. 1-8**
Eadweard Muybridge
*General View of Experimental Track*, plate F
   from the series *Attitudes of Animals in
   Motion*, 1881
Collodion printing-out paper print from
   bound album published by Eadweard
   Muybridge, with photographs made
   1878–79
17.7 x 24.5 x 3.5 cm

2. Haas 1976, 68.

bridge. Here is the answer to the message you sent my wife."[2]
He then shot him in cold blood and surrendered himself to
Larkyns's friends. Following a highly publicized trial, he was
acquitted. Afterward, a photographic trip to Central America
was considered advisable. Muybridge sailed to Panama and
Guatemala in 1875, producing some of the most expressive and
romantic landscapes of his career.

These events caused Stanford and Muybridge to suspend
their investigations for some three years. When Muybridge
returned in 1876, he quickly resumed his association with the
Stanfords. In 1877 he returned to photograph Occident in

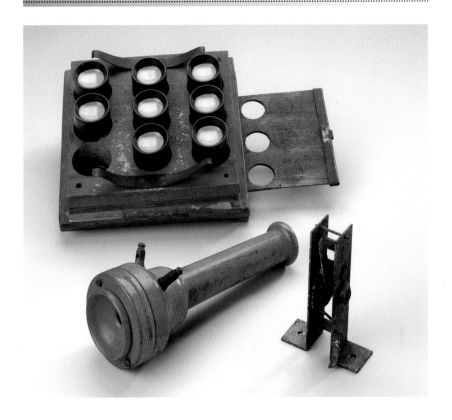

**Fig. 1-9**

*Top*
Kerbs & Speiss Co. (for Eadweard
    Muybridge)
*Nine objective lens board*, c. 1879
Photographic equipment
8 x 17.5 x 19.6 (diam.) cm

*Lower left*
Maker unknown, possibly John D. Isaacs
    (for Eadweard Muybridge)
*Trigger mechanism*, c. 1878
Photographic equipment, brass
10.5 x 7 x 3.8 cm

*Lower right*
Maker unknown, possibly John D. Isaacs
    (for Eadweard Muybridge)
*Piece of an electric shutter mechanism*,
    c. 1878
Photographic equipment
20 x 9 x 9 cm

Sacramento, and the following year moved to the new horse farm Stanford had been building south of San Francisco, in Palo Alto. There he recommenced his investigations of animal motion. Stanford provided generous funding for equipment and chemicals, also putting the services of his company's technicians at Muybridge's disposal. With Stanford's support, his work blossomed, and he perfected his system of instantaneous photography. In Palo Alto, Muybridge built the track and bank of cameras that enabled him to make sequences of imagery (fig. 1-8); previously he had been largely confined to single pictures. The work continued with varying intensity until 1881, when Stanford and Muybridge parted company.

The association with Stanford resulted in the archive that forms the heart of *Time Stands Still*. The material is of three types. It includes presentation copies, proofs, and maquettes of photographs given by Muybridge to Jane and Leland Stanford in the course of his employment. Also included are materials Muy-

bridge left behind when he departed, perhaps unintentionally, and which were absorbed into the collections (fig. 1-9). And finally there are items that were subsequently purchased or donated to the university to augment the collections. Together, these form one of the most extensive and revealing groups of Muybridge photographs and related drawings, paintings, equipment, correspondence, and ephemera. They provide a unique and invaluable resource for the study of Muybridge's motion photographs.

### Tempest in a Teacup?

To begin to appraise Muybridge and his influence, it is important to know something of the historiography—that is, the history of histories written about him. Muybridge has always been a polarizing figure. Even in his lifetime, his work went in and out of vogue. So it was that in the 1880s he packed houses in Europe and America as a sought-after lecturer, but when his legendary zoopraxiscope theater debuted at the World's Columbian Exhibition in Chicago in 1893, it closed with a whimper due to lack of interest. By the late 1890s, however, his reputation had revived enough that he was able to make a living by publishing books drawn largely from his Pennsylvania experiments. The London publishers Chapman and Hall published his *Animals in Motion* in 1898 to near-universal praise. It was followed in 1901 by *The Human Figure in Motion*, his last great statement on his photographic studies of motion.

After his death there were those who championed Muybridge as a major figure in the history of photography. And, as the cinema industry was then booming, they pointedly attached his name to its invention. Another camp was less charitable, dismissing him as a peripheral figure in its development. This antagonistic view reached its height in 1926, when the historian Terry Ramsaye published his monumental two-volume work, *A Million and One Nights: A History of the Motion Picture*. At the time, Ramsaye's book was the most comprehensive treatment of the

early years of motion pictures, and it was here that many of the pioneers of cinema were acknowledged for the first time. Muybridge, however, received scathing treatment. According to Ramsaye, he contributed little of consequence to the field. Moreover, Ramsaye contended, the attention Muybridge has received is due more to his colorful life story than to real intellectual contributions. In other words, he viewed him as a splendid publicist and, at best, an interesting figure. But Muybridge was not, Ramsaye stressed, of much historical importance.

In a twenty-eight-page treatment tellingly called *Muybridge in Myth and Murder*, Ramsaye provided a caustic assessment of Muybridge, his life, and his work. He dismissed the story of Muybridge's contributions to the invention of motion pictures, describing it as "the screen's first accepted chapter of Genesis, growing in authority and weight down the years." It is, he claimed, "a tale of a tale . . . the supreme classic reference of all motion picture history." But, he declared, "the supreme classic is supremely wrong. Muybridge, in a word, had nothing to do with the motion picture at all; and, in truth, but a very small part, if any, in the creative work of the hallowed race horse incident."[3]

Ramsaye attempted to thoroughly dismantle Muybridge's legacy, proceeding point by point through his association with Stanford and his experiments in human and animal locomotion. At each step he challenged conventional accounts of Muybridge's contributions, while accentuating those parts of the story he considered attractive. For example, Ramsaye claimed that Stanford definitely did wager twenty-five thousand dollars on determining the gait of a galloping horse, even though this claim had already been questioned by the time of his writing. It was to be paid in "good California gold," he added with a flourish, though this seems to have been a detail of his own devising.[4] Although he provided no evidence for the claim, he listed two of Leland Stanford's associates, James R. Keene and Frederick MacCrellish, as partners in the wager.

3. Ramsaye 1926, 1:21.
4. Ramsaye 1926, 1:23.

In a particularly repellent passage revealing his shoddy scholarship and personal bigotry, Ramsaye argued that the burgeoning reputation of Stanford University as a place of higher learning prompted a revisionist history of Muybridge and his work:

> Since the name of Stanford has become immortalized by a university and laureled by time, one or two distinguished chroniclers writing for local consumption have sought to cast over the race horse matter a Puritan aura by firmly asserting in limpid accents that Governor Stanford never at any time or place engaged in betting. Let us observe that the worthy Governor owned many race horses with great pride in their speed and that this was the California of 1872, when and where men were men, etc. The circumstantial evidence is as definite as that surrounding a darky in a melon patch.[5]

*A Million and One Nights* is full of bombastic accusations of this type, designed to impugn the reputation of Muybridge and those who acknowledged his accomplishments. Whether or not one believes that a bet was made, it is clear that Ramsaye was poorly informed and his approach biased. As a scholar he is scarcely credible, and it is difficult to take his arguments seriously today. Yet in 1926 his arguments enjoyed considerable currency. This, in turn, prompted a strong and impassioned backlash, which lasted for thirty years or more. Indeed, Ramsaye's academic crusade has partly framed the discussion of Muybridge ever since.

Ramsaye was right, in a very limited way, about the effect of Stanford University on the Muybridge legacy. The collaboration that began so promisingly in 1872, and that achieved so much during Muybridge's tenure at Stanford, ultimately disintegrated in a series of legal wrangles. The problems began when Stanford published a lithographic compendium of Muybridge's photographs in 1877, under the title *The Horse in Motion*. Upset that

5. Ramsaye 1926, 1:23.

Stanford's friend Jacob Davis Babcock Stillman (1819–88) was listed as the book's author, and that he himself received only a technical acknowledgment, Muybridge demanded to be properly credited for his work. Stanford considered his claims overreaching and asserted his proprietary rights as financial sponsor of the project. Discussions quickly broke down, and the collaboration soured.

Since that time, writers have tended to take sides in the dispute between Stanford and Muybridge. This too has colored the debate over Muybridge's historical importance. Those sympathetic to Leland Stanford's perspective point to his role as the originator of the project and emphasize the contributions of the unheralded technicians who helped develop the scheme and built the necessary machinery. By contrast, those who support Muybridge's claims note that Stanford's involvement in the day-to-day operation of the photographic studio was minimal. They also argue that the artistic and technical achievements embodied in the motion study work, though facilitated by others, are properly the product of Muybridge's imagination and should be credited to him alone. Early in the debate, scholars affiliated with Stanford University were inclined to take the side of Stanford, presumably out of allegiance to the university's founder. Later, as it became clear that Muybridge could fairly be described as one of the university's first intellectual heroes, support swung back in his favor.

Although they were not identified by name, the "limpid accents" to which Ramsaye referred were most probably those of two early historians of Muybridge at Stanford: George Clark and Walter R. Miles. Clark, former director of the Stanford University Library, belongs to the category of scholars loyal to the reputation of Leland Stanford. Clark was one of Stanford's first biographers and an enthusiastic devotee of his life and work. Though his appraisal of Muybridge was influential, he did not write about Muybridge per se, but about Stanford's relationship with him. Clark's account of their association spans two chapters in his

biography *Leland Stanford: War Governor of California, Railroad Builder, and Founder of Stanford University*, published in 1931. In keeping with his pro-Stanford bent, he considered Muybridge primarily in the context of Stanford's penchant for racehorses. He also discussed the lawsuits that finally divided them, weighing in firmly on the side of Stanford's version of events.

Working at nearly the same time, Miles, former professor of experimental psychology at Stanford, was among the first biographers to return to primary sources in order to separate fact from fiction in Muybridge's career. In addition to examining the archives at the university, he conducted an extensive letter-writing campaign, corresponding with those who had firsthand knowledge of Muybridge's time at Stanford. Miles's letters remain among the most valuable resources for Muybridge scholarship, as they contain some of the best descriptions of Muybridge by those who worked with him but were otherwise unheard in the debate over his legacy. Bolstered by his research, Miles published several influential papers on Muybridge, adopting a more circumspect tone than Ramsaye. And in 1929 he helped to restore Muybridge's reputation in the motion picture community with spectacular aplomb. On May 8 he organized a semicentennial celebration of Muybridge at Stanford under the patronage of the Academy of Motion Picture Arts and Sciences. Among those in attendance were movie moguls Louis B. Mayer and William C. DeMille.

Perhaps the most vociferous critic of Ramsaye and his book was one of the unsung figures of Muybridge scholarship, Janet Leigh. Leigh is not well known, as she never published her research, instead working behind the scenes to combat Ramsaye for the benefit of Muybridge. She was in some ways an unlikely champion. Leigh was the daughter of Wirt Pendegast, the lawyer who defended Muybridge in his murder trial. Working in the 1940s and 1950s, she became Muybridge's chief advocate, treating his reputation as though it were part of her own family history. Leigh collected copies of countless original documents from various institutions in California and corre-

sponded with people who knew or might have known Muybridge. She made copious notes on the details of Pendegast's speeches during the murder trial. She also tried to get a motion picture studio to produce a film about Muybridge and prodded *Life* magazine, among others, to write a feature about him. These efforts appear to have been unsuccessful.

Leigh did contact a number of published scholars, however, notably George Nitzsche of the University of Pennsylvania, offering advice and encouragement. Nitzsche was an emeritus recorder of the university, who claimed to have known Muybridge personally. He was instrumental in preserving many of the artifacts of Muybridge's Pennsylvania period and may have arranged for the donation of the glass interpositives and collotype prints from the series *Animal Locomotion* that are now in the Cantor Arts Center's collections.[6] The two exchanged lengthy correspondence and commiserated over Ramsaye's harsh treatment. Leigh even helped Nitzsche write a thirteen-page manuscript called "Notes from Ramsaye." The theme of the work, which does not appear to have been published, was the "prejudiced" treatment Ramsaye afforded Muybridge.[7]

Leigh picked up the gauntlet Ramsaye had thrown down, praising Muybridge to anyone who would listen. And she made sure to contact everyone she could think of to press her views. She bequeathed her papers to the Bancroft Library at the University of California, Berkeley, where they are currently archived.[8] There her work has continued to influence scholars, although she is seldom credited for her contributions.

## A New Appraisal

Two general conclusions may be drawn from the historical debate about Muybridge's life and work. First, many of the scholars who have engaged in this debate have done so with vested interests, often guided by personal preference, inclination, or loyalty. Typically they have elevated one figure at the expense of another. In this sense, Muybridge may be regarded

6. The circumstances of the arrival of these materials at Stanford is not documented, although they were accessioned in 1941. This is precisely the period during which Nitzsche was active in distributing similar works.

7. George Nitzsche, "Notes from Ramsaye," Bancroft Library, University of California, Berkeley, C-B 715, part 1, folder 3.

8. The Leigh papers are contained in Bancroft Library volume C-B 715.

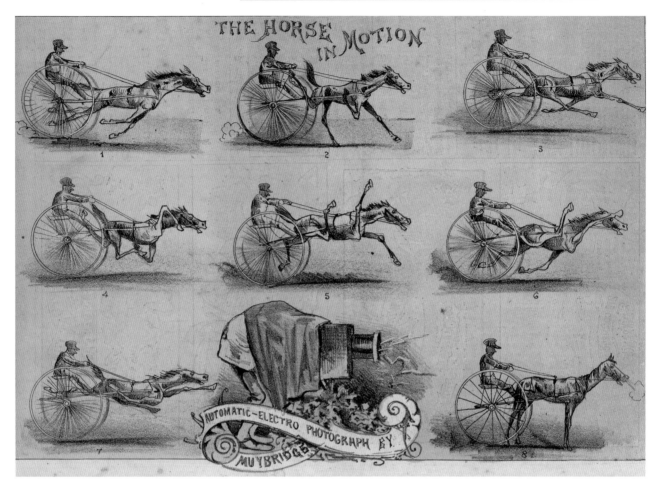

**Fig. 1-10**
Maker unknown
*The Horse in Motion—Automatic Electro Photograph by Muybridge*, 27 July 1878
Page from the *San Francisco Illustrated Wasp*
37.4 x 26 cm

as a political figure whose standing has been influenced by personal affiliations and historical agendas.

Scholars have often weighed Muybridge's accomplishments based on their assessment of his participation in key events. Those who see the role of other figures, such as Leland Stanford, as decisive in the development of Muybridge's photography have tended to downplay the significance of his involvement. Similarly, those who consider rival photographers more important, either for nationalistic or philosophical reasons, tend to de-emphasize his role relative to others.

More importantly, these treatments have historically centered on the claim that Muybridge created a new technology, such as motion picture projection or sequential photography.

The role of Muybridge as an inventor has long been a preoccupation among scholars. This debate is largely technical, revolving around his role in the development of certain types of machinery (fig. 1-10). This is a curious position to assign a photographer, particularly one so original as Muybridge. Unlike most photographers, he is remembered principally for his role in the industrial progress of the medium, as a bridge between one mechanical device and another. But he is seldom remembered for his imagery, for the way in which he used the tools he helped to develop to communicate ideas. In other words, lost in this debate has been appreciation for what Muybridge accomplished artistically.

In *Time Stands Still*, we take an alternative approach, attempting to explore Muybridge's unique artistic vision. By comparing and contrasting his photographs with those of his colleagues, we try to examine what made his work his own, but we also consider it as the product of a particular time and place.

# In the Blink of an Eye
## The Rise of the Instantaneous Photography Movement, 1839–78

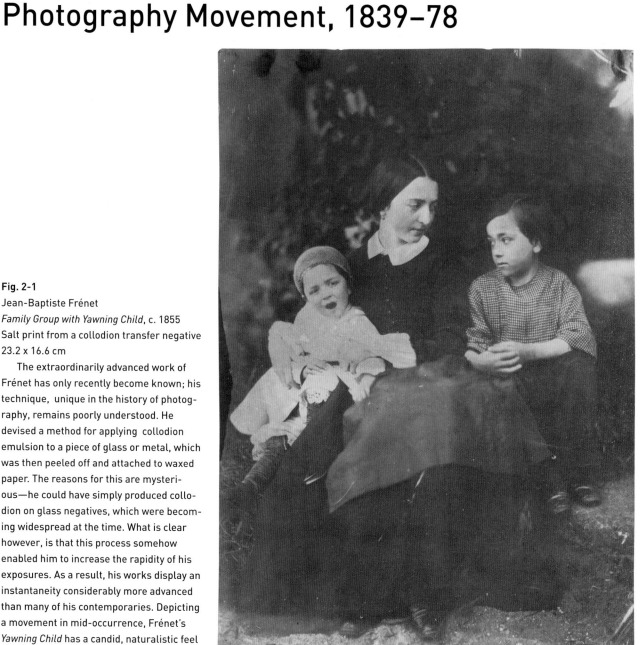

**Fig. 2-1**
Jean-Baptiste Frénet
*Family Group with Yawning Child*, c. 1855
Salt print from a collodion transfer negative
23.2 x 16.6 cm

The extraordinarily advanced work of Frénet has only recently become known; his technique, unique in the history of photography, remains poorly understood. He devised a method for applying collodion emulsion to a piece of glass or metal, which was then peeled off and attached to waxed paper. The reasons for this are mysterious—he could have simply produced collodion on glass negatives, which were becoming widespread at the time. What is clear however, is that this process somehow enabled him to increase the rapidity of his exposures. As a result, his works display an instantaneity considerably more advanced than many of his contemporaries. Depicting a movement in mid-occurrence, Frénet's *Yawning Child* has a candid, naturalistic feel unusual for the period.

Instantaneous photography was a movement. But it was not a movement in the classic art historical sense. It is impossible to identify all of the individuals who participated; there are simply too many of them. The people who made up the movement never gathered in a single place. There were no manifestos or journals devoted to instantaneous photography, though its questions, ideas, and achievements were regularly discussed in the publications of the day. Those who worked to produce instantaneous photographs had no unifying political or social agenda. They had no catchy name, like Fauvism, Futurism, or Impressionism; nor were they featured in exhibitions as a group. Rather, the instantaneous photography movement was founded and orchestrated by a loosely affiliated community of like-minded people. It was what might be described as a *vernacular* movement—a grassroots upheaval, organized around a singular wish: to freeze motion in time.

That wish originated in photography's seemingly limitless potential to record visual information and was also born of its failings. The first photographers tried to use the medium to record action. Often they were unable to do so because early photographic materials were slow and awkward. The ability to capture motion, to arrest time photographically, required an exacting combination of technology, vision, and skill. Unlike traditional artistic movements, propelled by personalities and circumstance, instantaneous photography was driven by this single, distinct enterprise. It began even with the announcement of the invention of photography in 1839 and is evident in the experimentation that preceded it, for example, in the proto-photographs made in the late 1820s by the pioneering French inventor Nicéphore Niépce (1765–1833). It climaxed with the first successful photographs of motion occurring too rapidly to be seen with the naked eye. These were the celebrated photographs of galloping horses made by Eadweard Muybridge in 1872.

But what is an "instantaneous photograph"? And, just as important, what did nineteenth-century photographers and

OPPOSITE PAGE
**Fig. 2-2**
Gustave Le Gray
*The Broken Wave, Sète (La grande vague, brisée, Sète)*, c. 1857
Albumen print
41.4 x 33.5 cm

critics mean by the term? The phrase became common in nine-teenth-century writings, though there was surprisingly little discussion regarding precisely what it meant or how it should be applied. Most nineteenth-century practitioners agreed that instantaneity was desirable and tried to give their pictures this nebulous quality whenever they could. The understanding of exactly what constituted instantaneity in photography remained fluid and subjective, however. The success or failure of a would-be instantaneous photograph was evaluated on a case-by-case basis. Judgments about instantaneity shifted over time and frequently varied from one viewer to the next. Nevertheless, most photographers, if asked to define instantaneity, might have responded much as Supreme Court Justice Potter Stewart did when asked to define obscenity: "I know it when I see it." Though few agreed on the details, opinions about what constituted a proper instantaneous photograph abounded.

This uneasy situation accounts for the sometimes contradictory assessments of photographs made by critics and pundits of the time. There are many instances in which photographs were accepted by some as instantaneous wonders but criticized by others as false or unconvincing. The seascapes of the French photographer Gustave Le Gray (1820–84), for example—in which the artist appeared to have captured waves, clouds, and boats in motion—were considered revolutionary by many when they were first exhibited in 1857 (fig. 2-2). Yet, as the writer and collector Ken Jacobson has pointed out, not everyone was impressed. One critic, for example, writing in the *Liverpool and Manchester Photographic Journal*, admitted that the way in which Le Gray's photographs appeared to capture the motion of the sea and sky was remarkably successful. He complained that the lighting needed to accomplish the task, however, which usually required shooting directly into the sun, made the pictures look artificial. "It is a difficult matter," he noted wryly, "to condemn as utterly untrue pictures to which universal praise is given for truthfulness."[1] But condemn them he did.

1. *Liverpool and Manchester Photographic Journal*, n.s., 1 (15 March 1857): 57–58; cited in Jacobson 2001, 10.

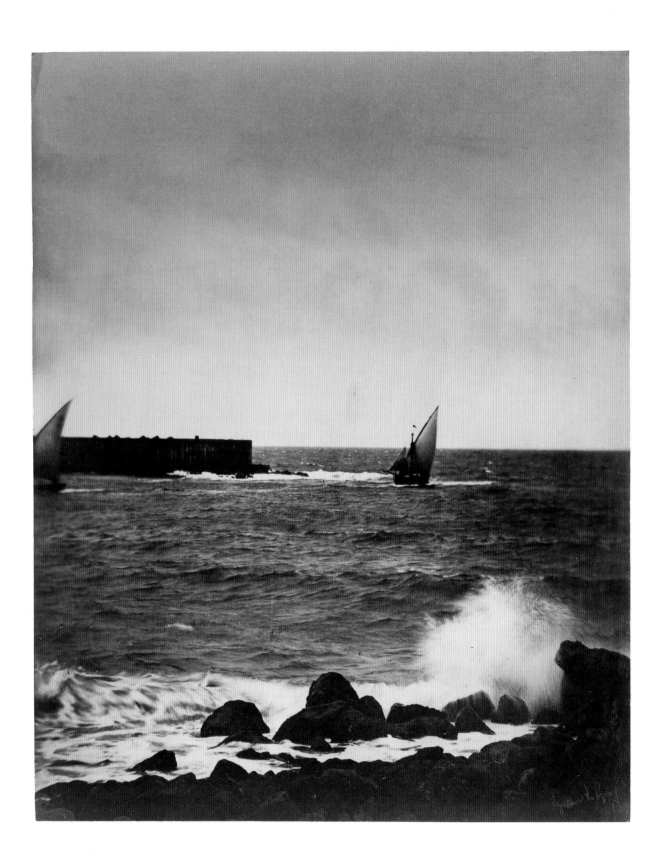

*OPPOSITE PAGE*
**Fig. 2-3 (top)**
Maker unknown (Britain?)
*Breaking Wave, with Boat Passing at the
  Shore*, c. 1855
Stereo albumen print
6.7 x 13.6 cm

**Fig. 2-4 (bottom)**
C. A. D. Halford
*Beach and Pier at Ventnor, Isle of Wight*, 1864
Stereo albumen print
8.0 x 15.5 cm
  This photograph won the British Amateur Photographic Association prize for instantaneous photography in 1864.

The history of instantaneous photography is rife with conflicting appraisals of this sort. Photographs that were considered to have broken new ground in the medium by some were dismissed as abject failures by others. In part, this is due to the strangeness of what instantaneous photography revealed. As technology progressed, photography became increasingly capable of depicting things beyond the limits of natural perception. What it revealed was sometimes unfamiliar and even unsettling.

People had long been accustomed to seeing motion portrayed using certain conventions. The traditional art forms of painting, drawing, printmaking, and even sculpture had developed an intricate visual language to convey motion. Running horses, for example, were frequently portrayed with all four legs in the air at the same time, spread in an elongated leap known by its French name, *ventre à terre* (belly to the ground). According to this convention, running horses were shown with their front legs stretched in front of their heads and their hind legs extending backward. Artists and equestrian experts in particular had long suspected that this was not the way horses actually moved. Running horses move too quickly, however, for their gait to be reliably analyzed by the naked eye. So artists used the *ventre à terre* position as a kind of symbol to communicate the idea of a running horse, rather than trying to show how the horse actually runs. In other words, they used a semiotic approach rather than a mimetic one.

Much of the debate surrounding the success of instantaneous photography in the nineteenth century can be reduced to this theoretical opposition. As more and more people began to accept photographic evidence as definitive, gradually the old conventions were vanquished. But they did not go without a fight. In the case of the galloping horse, for example, the *ventre à terre* convention persisted for several years after Muybridge published his celebrated photographs of galloping horses in the 1870s. Eventually, however, the new standard of photographic evidence was accepted as correct. A new visual language formed,

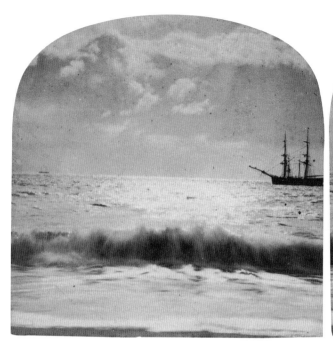
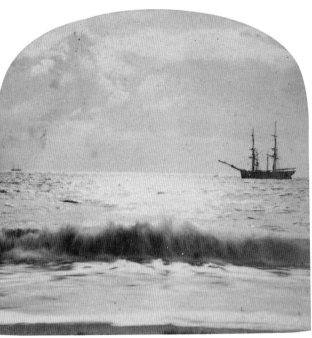
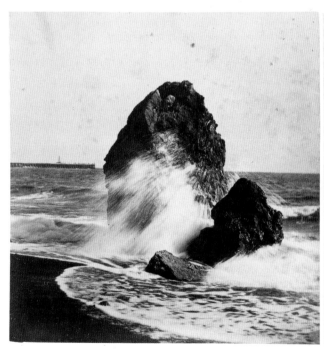
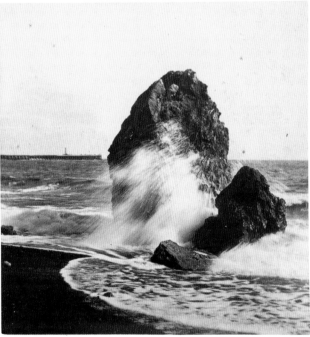

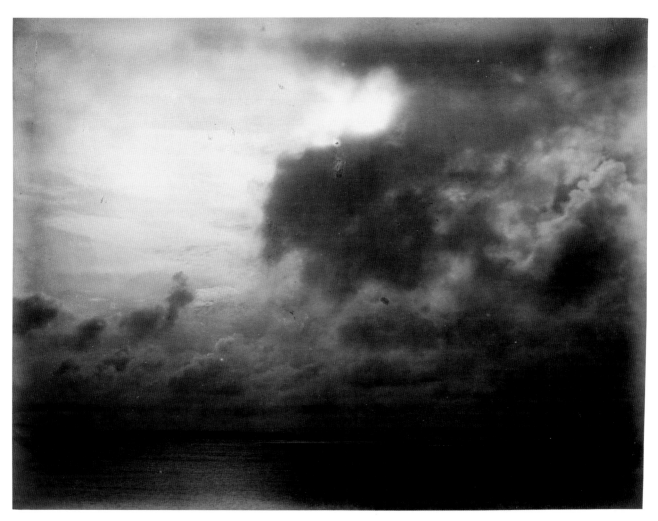

**Fig. 2-5**
Colonel Stuart Wortley
*Rolling Clouds*, c. 1863
Albumen print
26.5 x 35.2 cm

based not on what was customary and agreed upon, but on what photography showed to be true.

Despite the enormous importance of these developments, there has never been a rigorous assessment of the instantaneous photography movement. In fact, the idea that instantaneous photography constituted a "movement" is a new one. In the history of scholarship, instantaneous photography has received only occasional mention. The German photo-historian Josef Maria Eder (1855–1944) was among the first to write about it. His *La photographie instantanée: Son application aux arts et aux sciences* (Instantaneous photography: Its application to arts and sciences) was published in 1888.[2] The book contains many valuable observations, but it is as much a how-to manual as a historical study. Moreover, Eder was particularly interested in developments contemporaneous with his writing. He focused largely on the works of the chronophotographers of the 1880s, with little reference to the pioneering photographers of the preceding three decades. It was precisely one hundred years before instantaneous photography was raised again as a distinct subject, this time by the formidable British historian Helmut Gernsheim (1913–95). His encyclopedic survey *The Rise of Photography, 1850–1880: The Age of Collodion* includes a short but provocative chapter devoted to instantaneous photography.[3] In it, he identified several of the protagonists of the movement but omitted a number of important figures. Moreover, the normally thorough Gernsheim made the mistake of many of his nineteenth-century predecessors, breezing through a list of successful instantaneous photographs without identifying what made them distinctive.

The reasons underlying historians' long neglect of instantaneity are complex, and they relate to the struggle for photography to be appreciated as an art form. Instantaneous photography, as I have noted, was a vernacular movement. It was driven by the technical aspirations of a loosely affiliated group of individuals, for whom philosophical concerns were secondary. As

2.  Eder 1888.
3.  Gernsheim 1988, 73–83.

such, the subject has never fit comfortably into histories dedicated to photography as a fine art. Until recently, many photohistorians have adopted a somewhat defensive posture in championing the artistic merits of the medium. Purposely avoiding discussion of technical issues, they have focused instead on photography's artistic credentials and matters of connoisseurship, such as artistic pedigree, style, and conceptual content. Ironically this has caused scholars to overlook one of the things that make photography special. Though the movement to create instantaneous photographs in the nineteenth century was not "artistic" in a conventional sense, it is of considerable importance in the history of art. In the history of photography, it is fundamental.

### Defining Instantaneity

Whether an exposure is long or short, a photograph records the elements of a scene as they appeared in a particular period of time. This is one of the basic characteristics of photography, and one that separates it from other visual media. A painter or sculptor may elect to represent a particular episode or moment, but a photographer has little choice but to do so. All ordinary photographs have a single starting point and endpoint. Consequently they describe not just an area in space but also a length of time. Just as a photographer must decide how to compose a scene in the camera, he or she must also select the moment to begin and end exposure. An instantaneous photograph is one in which the beginning and end of the exposure are close enough together that any action depicted is rendered without blur or indistinctness.

One prominent writer, Captain William de Wiveleslie Abney (1843–1912), argued that the term *instantaneity* in its purest sense could never be applied correctly to a photograph, no matter how quickly it is made. In his 1895 manual *Instantaneous Photography*, he argued that the word *instantaneous* implies an exposure of infinite quickness. "A photograph taken by a flash

**Fig. 2-6**
Henry Peach Robinson and Nelson King
    Cherrill
*The Beached Margent of the Sea*, 31 May
    1870
Albumen print
28.5 x 37.8 cm
    The gulls seen flying in this photograph
are fake; nevertheless, the turbulent sea
was itself a highly challenging subject.

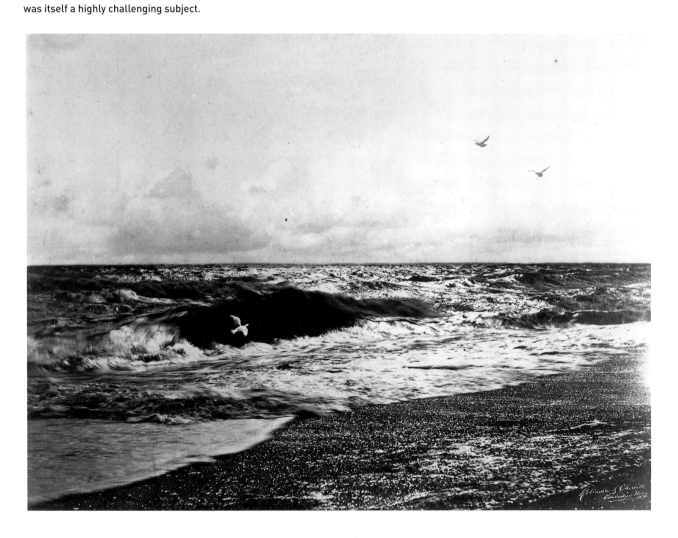

**Fig. 2-7**
Balch's Art Views
*Devil's Hole, Fish Swimming (Instantaneous)*,
  c. 1868
Albumen print
8.2 x 15.9 cm

of lightning," he explained, "is not instantaneous, for the exposure takes a time which is not beyond the limits of measurement."[4] Abney argued that theoretically an instantaneous photograph should depict a mere point in time. No conventional photograph could ever achieve this, he wrote, because the beginning and endpoint of a photographic exposure cannot be eliminated. At best, he claimed, instantaneous photographs are ones made in an extremely short period.

Despite Abney's caveats, the idea of instantaneous photography is as old as photography itself. William Henry Fox Talbot (1800–1877), the inventor of the first practical photographic process in Britain, seems to have been the first to introduce the word *instant* into a description of the medium. In one of the more poetic passages in his famous paper of 1839, "Some Account of the Art of Photogenic Drawing," he wrote evocatively about his vision of a future in which small fractions of time could be recorded for posterity: "The phaenomenon which I have now briefly mentioned appears to me to partake of the character of the *marvellous*, almost as much as any fact which physical investigation has yet brought to our knowledge. The most transitory of things, a shadow, the proverbial emblem of all that is fleeting and momentary, may be fettered by the spells of our 'natural magic,' and may be fixed for ever in the position which it seemed only destined for a single instant to occupy."[5] The word *instantaneous* (or *instantanée*) was first applied to a photograph the following year, in an official report on the daguerreotype process offered to the French senate in 1840. With hindsight, the definition offered in this report by the scientist and senator Jean-Baptiste Dumas (1800–1844) seems surprisingly unassuming. A photograph may be considered

4. Abney 1895, 3.
5. William Henry Fox Talbot, "Some Account of the Art of Photographic Drawing," *London and Edinburgh Philosophical Magazine and Journal of Science* 14 (March 1839); reprinted in Vicki Goldberg, ed., *Photography in Print* (Albuquerque: University of New Mexico Press, 1981), 41.

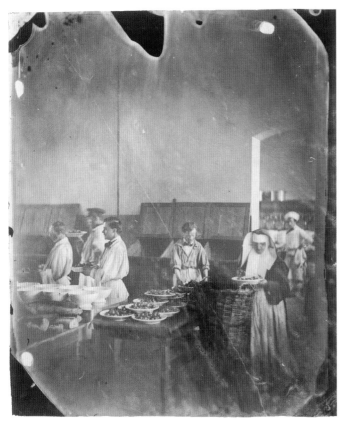

**Fig. 2-8**
Charles Nègre
*The Kitchen at Vincennes Imperial Asylum,*
   1858–59
Albumen print
16.8 x 17.2 cm

6. Jean-Baptiste Dumas, "Obser-
   vations sur le procédé de M.
   Daguerre," in Macédoine Mel-
   loni, *Rapport sur le daguerréo-
   type* (Paris: Normant, 1840),
   67; cited in Gunthert 1999, 81.
7. Blanchere 1865, 275.
8. "On Instantaneous Exposures,
   and Improved Means for
   Effecting Them," *British Jour-
   nal of Photography* 13 (12 Janu-
   ary 1866): 13.
9. Londe 1886, 1. The translation
   is my own.

"nearly instantaneous," he wrote, if it is
made with a "twelve- to fifteen-minute
exposure."[6]

Attempts were occasionally made to
define instantaneous photography for-
mally, but these were usually vague and
halfhearted. The French photographer
Henri de la Blanchere (active 1859–c.
1865), for example, writing in an article
entitled "Instantaneous Photography" in
the *British Journal of Photography* in 1865,
felt it necessary to remark only that he used
the word "in its conventional sense," with-
out elaboration.[7] A year later, in another
article in the same journal, called "On
Instantaneous Exposures, and Improved
Means for Effecting Them" (a provocative
title, because the word "effect" implies a
certain amount of artifice in their cre-
ation), the editors clarified the definition slightly, noting: "We
use here the word [instantaneous] in its conventional sense—
i.e., very rapid."[8] The photographer Albert Londe, who would
become a leading figure in the so-called chronophotography
movement ushered in by Muybridge's experiments, offered an
equally unclear definition. "The designation 'instantaneous
photography'," he wrote, "is reserved for all those shots taken in
a very brief period of time."[9]

Perhaps the most prophetic statement regarding instanta-
neous photography, its aims, and its attributes was offered in
1860 by the noted British scientist, photographer, draftsman,
and inventor, Sir John Herschel (1792–1871). "What I have to
propose may appear a dream," he wrote, "but it has at least the
merit of being a possible, and, perhaps, a realistic one—realis-
able that is to say, by an adequate sacrifice of time, trouble,
mechanism and outlay." It was no less than the "representation

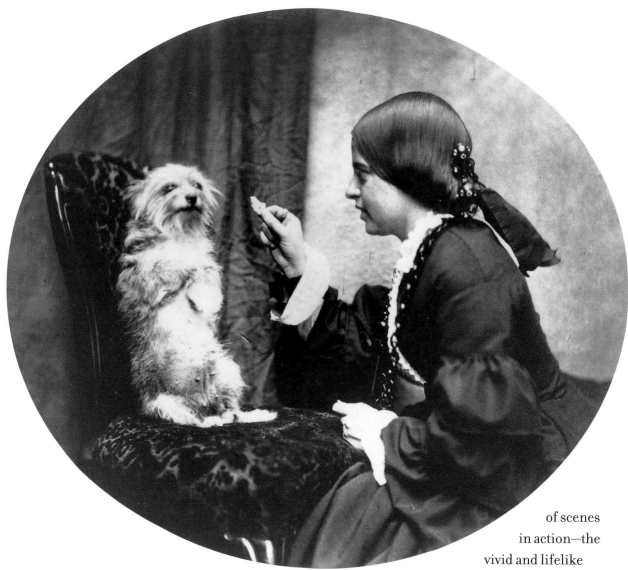

of scenes in action—the vivid and lifelike reproduction and handing down to the latest posterity of any transaction of real life—a battle, a debate, a public solemnity, a pugilistic conflict, a harvest home, a launch—anything, in short, where any matter of interest is enacted within a reasonably short time, which may be seen from a single point of view."[10]

Herschel went on to describe such photographs as "snapshots," the first recorded use of this term. To Herschel, "snapshot" photographs could be achieved only when two conditions were met. First, he believed they would require exposures of at least a tenth of a second. And, second, a mechanism would have

10. Herschel 1860, 1.

*OPPOSITE PAGE*
**Fig. 2-9**
W. G. Campbell
*The Lesson*, c. 1856
Albumen print
14.8 x 17.6 cm

to be devised, "no matter how complex and costly," he warned, "by which a prepared plate may be presented, focussed, impressed, displaced, numbered, secured in the dark, and replaced by another within two or three-tenths of a second."[11] Herschel was writing at a time when most photographic negatives were prepared individually by hand, using glass plates. Unwittingly, in this article he anticipated the development of flexible roll film, a material that would not be widely available for another thirty years or so.

Notwithstanding the attempts of Herschel and others to characterize instantaneous photography and outline its objectives, the precise meaning of the term remained ambiguous throughout the nineteenth century. Did it mean merely spontaneity and freshness in appearance, a naturalism that conveyed a genuine impression of subjects captured in real time? Or did it mean pushing the very boundaries of human vision, recording information the eye could not see without assistance? In practice, it meant both of these things.

In the nineteenth century the term *instantaneous* could be applied to a photograph of any subject so long as it contained an element of movement. In his invaluable study of the rise of instantaneous photography in France, the photo-historian André Gunthert traced the various types of instantaneous subjects that were listed in nineteenth-century French publications.[12] The first, which appeared in an account presented to the French Academy of Science by the mathematician François Arago (1786–1853) in 1841, identified "trees blowing in the wind, flowing water, the sea, storms, sailing ships, clouds and the jostling of crowds."[13] From 1851 to 1869, as Gunthert noted, numerous other instantaneous subjects were named. Among these were waterfalls, moving carriages, speeding trains, people walking, rising smoke, flying birds, the flapping of cloth (such as flags or clothes), crashing waves, street scenes, and groups of people in city squares.[14] One unnamed commentator, writing in the *British Journal of Photography* in 1866, made a particularly eloquent inventory of instantaneous subjects:

11. Herschel 1860, 1.
12. Gunthert 1999, 120.
13. François Arago, "Rapport sur le Daguerreotype," *Comptes rendus de l'Académie des Sciences* 12 (4 January 1841): 23; cited in Gunthert 1999, 120. Translation is my own.
14. Gunthert 1999, 120.

*OPPOSITE PAGE*
**Fig.2-10 (top)**
Maker unknown, possibly Achille Quinet
*Ice-Skaters on the Seine*, c. 1855
Lightly albumenized salt print
20.5 x 27.8 cm

**Fig. 2-11 (bottom)**
Edward Anthony
*Ice-Skating, Central Park*, 1866
Stereo albumen print
7.6 x 15.1 cm

If it be a sea-side view, we see the breaking waves—caught, it may be, in the very act of showering their spray over the rocks—or the thousands who may be congregated on the beach whiling away the time, taking "a plunge before dinner," or otherwise hygienically employed. If it be a street view, we are enabled from a "loop-hole of retreat" and without feeling annoyance from the crowd, to inspect at our leisure the hurrying throng arrested on the paper before us. Silver-tipped clouds—the setting sun—ships sailing—gondolas gliding—babies careening and crowing in their guardians' arms—these and many other associations are called up by the idea of instantaneous photography.[15]

The intriguing idea of a "loophole of retreat" is a recurring one in nineteenth-century discussions of instantaneous photography. The phrase is borrowed from the poetry of the English Romantic poet William Cowper (1731–1800). In the fourth book of his epic poem *The Task*, he wrote, "'Tis pleasant, through the loopholes of retreat / to peep at such a world; to see the stir / Of the great Babel, and not feel the crowd."

In 1851, commenting on the potential of Talbot's new amphitype process, one Dr. Clavel inexplicably added "a horse in full gallop" to the list of instantaneous subjects.[16] The amphitype process was a progenitor of flash photography, designed to make rapid exposures using an electric spark as a source of illumination. It was not suitable for photographing large subjects such as horses, and there is no evidence that Talbot ever attempted to do so. Nevertheless, this early reference seems to have been absorbed and repeated in numerous French publications, including the Larousse encyclopedia of 1874. As Gunthert has noted, photographs of horses "running," "leaping," "springing," "trotting," and "galloping" are mentioned in at least eight articles published between 1851 and 1874. The idea that moving horses could be photographed became so thoroughly entrenched in France that eventually it was asserted that such photographs had been made, although no example was ever given, nor was any

15. "On Instantaneous Exposures," 13.
16. Dr. Clavel, "Académie des Sciences," *Lumière*, no. 22 (6 July 1851): 85; cited in Gunthert 1999, 114.

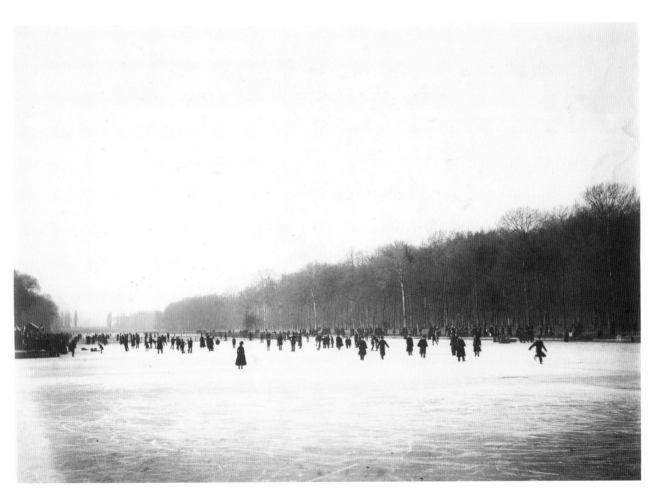

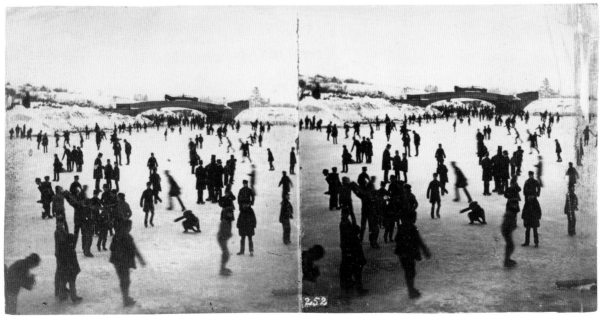

252

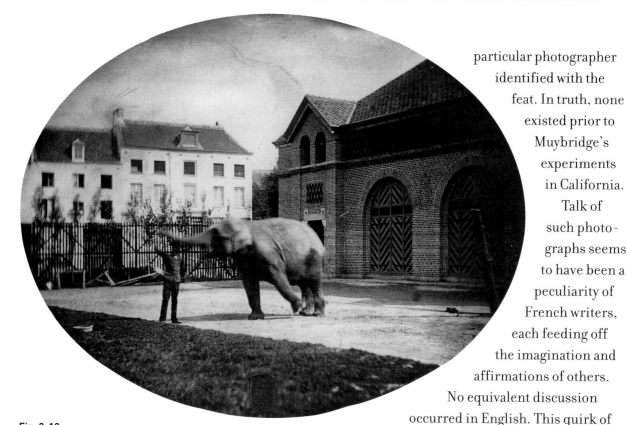

**Fig. 2-12**
Louis-Pierre-Théophile Dubois de Nehaut
*Another Impossible Task ("Miss Betsy," the
    Elephant)*, 1854
Salt print from a glass negative
16.3 x 21.2 cm

particular photographer identified with the feat. In truth, none existed prior to Muybridge's experiments in California. Talk of such photographs seems to have been a peculiarity of French writers, each feeding off the imagination and affirmations of others. No equivalent discussion occurred in English. This quirk of history, Gunthert has argued, accounts for the unique reception Muybridge's photographs received when they were first shown in France.[17] In other countries, such as the United States and Britain, they were considered sensational when first shown. They commanded attention almost as soon as they were published and were eagerly received by the public. In France, however, the reaction was more muted, at least at first. No French citizen had ever seen photographs like them, but presumably many believed that they had.

Although the term *instantaneous* was associated with rapid action in the nineteenth century, the speed at which those actions occurred and their prominence in the picture frequently look modest to a modern viewer. In part, this is due to enormous improvements in technology since the nineteenth century, which have made such pictures commonplace. In the twenty-first century photographs of action are common, and expectations about what can be successfully depicted have changed accordingly.

17.   Gunthert 1999, 130.

Instantaneity in a photographic context is a relative term. The length of exposure necessary to produce a successful photograph of motion depends not just on the rapidity of the camera and film but also on the speed at which a subject is moving. For this reason, there is no clear numerical threshold by which instantaneous photography can be defined. Modern cameras are usually notched or colored at the one-sixtieth of a second exposure mark, an indication of the minimum speed needed to eliminate camera shake in handheld views and to obtain photographs of most ordinary motion subjects without worrying about blurriness. Yet photographing at this speed is no guarantee of success. An unsteady photographer would not obtain sharp photographs even at one-sixtieth, nor would this be sufficiently fast to photograph a sporting event or a speeding train. John Herschel, as we have seen, considered one-tenth of a second to be a crucial rate of exposure. Writing more than twenty years later, Londe, in his treatise on instantaneous photography, argued that photographs should not be considered instantaneous unless they were made in no more than one-quarter of a second.[18]

In the nineteenth century instantaneity was not always identified with activities that are obvious or occur very quickly. Instead, it was often used to mean simply that the nuances of a scene had been captured without looking blurry or stilted. Gunthert has labeled this type of instantaneity "promptitude," after the term used extensively in the correspondence of one of photography's inventors, Louis-Jacques-Mandé Daguerre (1789–1851).[19]

The term *instantaneous* was frequently applied in studio portraiture, for example, even though formal portraits rarely show a sitter engaged in activity. A portrait was considered instantaneous if the subject looked natural and unaffected. In the 1840s and 1850s it was not unusual for people in portraits to be held in a pose with an arrangement of clamps and wires and to be asked to hold their face and limbs absolutely still for the duration of an exposure. The results could look stiff and rigid. An instanta-

18. Londe 1886, 8.
19. Gunthert 1999, 54.

**Fig. 2-13**
Attributed to David E. James & Co.
*Two Women, Looking Down from a Window in Boston(?)*, c. 1855
Daguerreotype
1/9 plate; 5.4 x 4.1 cm (unopened)

This extraordinary image has been described as the first known "snapshot" photograph. The photographer looks down at two figures who gaze at an unseen event, apparently unaware of the presence of the camera that records the act. With the announcements of the invention of photography in 1839, two rival processes were released nearly simultaneously. Improved versions of William Henry Fox Talbot's calotype process, which required the creation of a negative to make the final print, would become dominant, but in the first decade, photographs made using Louis Daguerre's dagauerreotype process were more common. No negative is used to make daguerreotypes, which are produced by direct exposure of a silvered metal plate. Because no negative is used in their production, initially daguerreotypes were sharper than works made with alternative methods. Also, daguerreotype chemistry was the fastest known. As a result, some of the most successful early instantaneous photographs were made using this technique.

neous portrait was one in which such contrivances had been eliminated and the sitter could relax (see fig. 2-13). This enabled more lifelike portrayals, in which posture and facial expression were rendered convincingly. The daguerreotypist Antoine Claudet (1797–1867) was among those famed for his ability to capture natural-looking expressions despite inherently slow materials. In 1842, just three years after the invention of photography had been announced nearly simultaneously in England and France, the *London Spectator* described the pleasure of sitting for one of Claudet's portraits: "The momentary quickness with which the likeness is taken prevents the necessity for retaining a fixed look and posture for a certain time; this is not only more agreeable to the sitter, but gives a more life-like ease and vivacity to the photographic portraits: thus, the objections made to their stern and gloomy expression are obviated in a great degree, the most transient smile being reflected in the polished surface of the plate as in a mirror."[20] Claudet applied his technical facility with great effect. In a move foreshadowing Muybridge's experiments in California, he was even reputed to have made the first sequential photographs, of a man smoking a cigarette. Composed of two daguerreotype portraits, it showed the man with the cigarette close to his lips in one image and recoiled after a puff in the other.

Photographic studios often found it useful to advertise that they made portraits by the "instantaneous process," and many went so far as to print this claim in letterpress on the back of their carte-de-visite and cabinet-card mounts. Not only did this suggest that the photographer produced naturalistic pictures, it also indicated to the potential customer that the procedure of being photographed would be relatively effortless. It is a

**Fig. 2-14 (top)**
Frédéric Viret
*Bathers, Sologne*, 1857–64
Stereo albumen print
7.2 x 13.4 cm

**Fig. 2-15 (bottom)**
A. Taupin
*Milking a Cow (from Nature)*, c. 1860
Albumen print
16.7 x 21.2 cm

20.  *London Spectator*, 16 April 1842;
cited in "Instantaneous Pho-
tography a Quarter Century
Ago," *Photographic News*, 22
May 1868, 249.

measure of the success of this marketing strategy that it persisted well into the 1880s, disappearing only with the launch of the Kodak camera in 1888, which rendered the term largely obsolete.

Importantly, photographers also came to use the word *instantaneous* as shorthand for authenticity and trustworthiness in their pictures. Instantaneity implies spontaneous execution, capturing things as they actually looked at a particular moment in time. This suggested an element of objectivity. To be genuinely instantaneous, it was believed, a photograph must be made using mechanical contrivances alone. There was little room in this scheme for intervention by the photographer. Particularly in the 1860s, the word *instantaneous* and the phrases "from life" and "from nature" were used almost interchangeably (fig. 2-14). The French photographer A. Taupin (active 1860–70s), for example, labeled his charming picture of a maid milking a cow (fig. 2-15) not as "instantaneous," but "d'après nature" (after nature), though it appears to freeze the woman's action.

The English portraitist Julia Margaret Cameron (1815–79) made similar claims about the famous portraits she made of friends and family in the 1860s and 1870s. The phrase "from life" invariably appears in her photographs, written indelibly

**Fig. 2-16**
Guillaume-Benjamin Duchenne
de Boulogne with Adrien
Tournachon
*Synoptic Plate*, c. 1856
Albumen print
13.3 x 13.3 cm

Scientists were at the forefront of those seeking instantaneity in photography. Instantaneous photographs, they reasoned, could provide a means to examine the world beyond the limits of human perception. In addition, they offered the tantalizing possibility of using the camera to generate objective evidence, eliminating the need to rely on skilled artists to record behaviors for analysis and study. In effect, properly controlled instantaneous photographs could be used as data, enabling researchers to analyze ephemeral events and easily share observations with colleagues.

Duchenne, a neurologist at the Salpêtrière hospital outside Paris, devised an innovative method of simulating facial expressions using electrical current. Using electrodes, he stimulated facial muscles to contract artificially and held them in position long enough to photograph clearly. As a result, though his pictures of facial expressions required considerable skill, they are not entirely instantaneous. They are hybrids, combining speedy execution with the artificial poses made possible by his electrical technique.

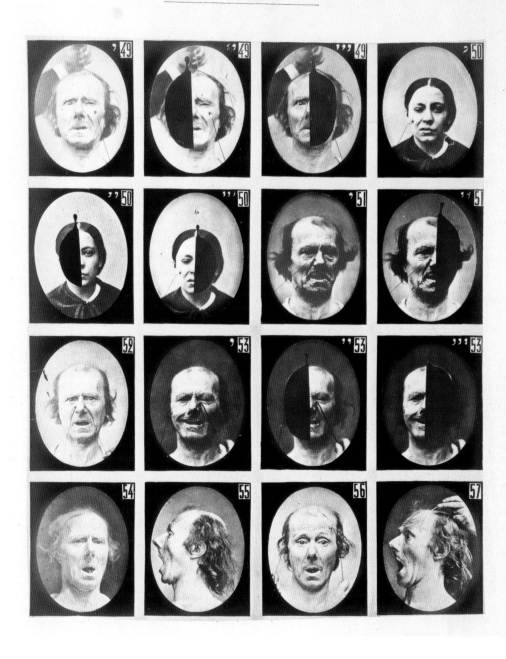

ICONO-PHOTOGRAPHIQUE

MÉCANISME DE LA PHYSIONOMIE HUMAINE

Pl. 6.

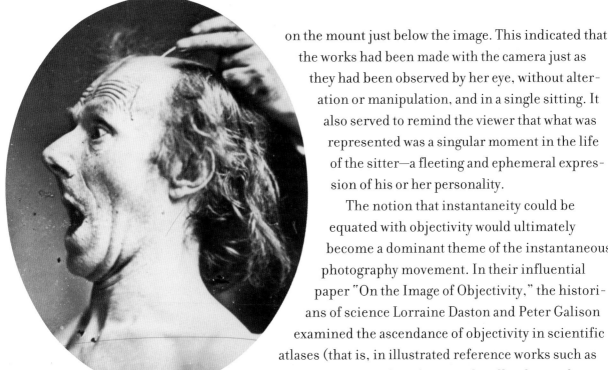

**Fig. 2-17**
Guillaume-Benjamin Duchenne de
    Boulogne with Adrien Tournachon
*Horror (profile)*, 1862
Albumen print
11.6 x 8.8 cm

21.  Daston and Galison 1992.

on the mount just below the image. This indicated that
the works had been made with the camera just as
they had been observed by her eye, without alter-
ation or manipulation, and in a single sitting. It
also served to remind the viewer that what was
represented was a singular moment in the life
of the sitter—a fleeting and ephemeral expres-
sion of his or her personality.

The notion that instantaneity could be
equated with objectivity would ultimately
become a dominant theme of the instantaneous
photography movement. In their influential
paper "On the Image of Objectivity," the histori-
ans of science Lorraine Daston and Peter Galison
examined the ascendance of objectivity in scientific
atlases (that is, in illustrated reference works such as
guides to anatomy and medicine or handbooks on plants,
animals, or geology).[21] As they have noted, the desire for trust-
worthy information gradually came to shape the methods of
illustration used in these books. Over time, scholars increas-
ingly came to expect that they should contain not just illustra-
tions but data: actual specimens recorded for analysis and
study. Whereas early scientific illustrations were drawn or
painted, in the nineteenth century the role of traditional artists
was diminished. The movement of information from eye to
hand to paper was too subjective to be relied on for impartial-
ity. Photography, by contrast, was increasingly thought of as an
objective medium because it did not depend as much on the
talents of an artist. Mechanical detachment replaced human
judgment.

These developments are intimately bound up with the rise of
instantaneous photography. As the capabilities of photo-
graphic materials expanded, the photographer increasingly
assumed the role of experimenter, setting up an empirical sit-
uation to see what would result (figs. 2-16, 2-17). Muybridge,

for one, came increasingly to view his photographic work as a scientific undertaking, though his qualifications in this regard were minimal.

### An Instantaneous Aesthetic

The association of instantaneity with objectivity arises from the belief that at a certain point a photographer must stand back and let the equipment do the work. The photographer selects the subject, chooses suitable materials, aims the camera, and decides when to take the picture, but what happens when the negative is actually exposed is largely beyond control. With moving subjects, actions may happen so fast that the photographer cannot foresee the precise appearance of the finished picture. There is an element of surprise and even of randomness in an instantaneous photograph. Such unpredictability is the main reason that instantaneous photographs can sometimes look strange to a viewer.

Charles Nègre's (1820–80) *Fall or Death of a Horse, Quai Bourbon* (fig. 2-18) is an excellent example of this phenomenon. This picture, actually a pair of uncut (and apparently unpublished) stereo views, shows a street scene in which a horse has collapsed on the Quai Bourbon in Paris and a crowd has assembled to attend to it. It is hard to make out what is happening in the picture. It breaks many rules of conventional composition, with various figures overlapping and obstructing one another. The horse itself is partially obscured, and many figures have their backs to the camera. The carriage that the horse had been pulling is visible, but it is difficult to separate visually from the jumble of rubbish and construction materials strewn across the street. The overall effect is of something happening the way an ordinary person might see it.

*Fall or Death of a Horse* is an early example of what some commentators have described as the "snapshot aesthetic." Embedded in this phrase is the idea that there is something unique about the way the world looks through an instantaneous lens.

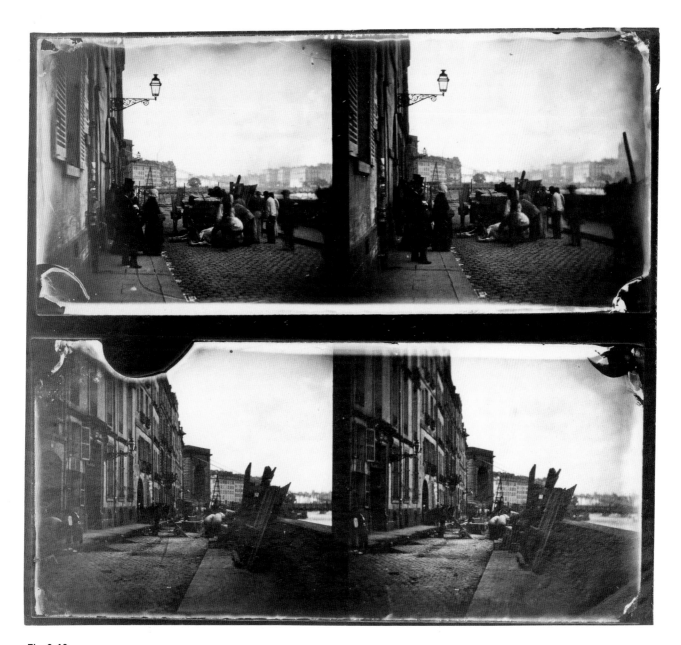

**Fig. 2-18**
Charles Nègre
*Fall or Death of a Horse, Quai Bourbon,* and
    *Works on Pont Louis Philippe, Quai*
    *Bourbon,* 1855–60
Two uncut and untrimmed stereo albu-
    men prints mounted together
18.3 x 20.1 cm

Unlike paintings, drawings, or prints, in which the artist must decide how to organize the picture and then execute it, in an instantaneous photograph the pieces arrange themselves.

Of course, the photographer still has a vital role to play in the process. He or she must create the conditions to make such a photograph effective, and an experienced photographer can even anticipate the appearance of things to a limited degree. Nevertheless, the fine details of how each ingredient of an instantaneous photograph appears are governed not as much by traditional rules of artistic composition as by happenstance. A photographer taking a picture of a beach, for example, cannot control the placement of individual waves and ripples at the shore, nor can he or she arrange the placement of each grain of sand. Yet the camera will record the precise location of all of these things at the moment the picture is taken (figs. 2-19, 2-20).

In the case of *Fall or Death of a Horse*, which was made around 1855–60, the way in which Nègre used photography to capture chance events was virtually unprecedented. The curator Françoise Heilbrun has likened the picture to quasi-documentary photographs made around the same time, such as the Crimean War photographs of Roger Fenton (1819–69) and Le Gray's pictures of soldiers at the Camp de Chalons. But there is no exact parallel. "In a scene such as this one, in which an unforeseeable incident is captured, Charles Nègre shows himself a true pioneer of reportage," she has written.[22] Crucial to this assessment is the idea that *Fall or Death of a Horse* conveys something that was "unforeseeable"—that is, that the photographer could not have anticipated. As we shall see, this kind of picture provoked debate about the relative merits of photographic pictures, causing some to question whether or not instantaneous photography could be considered an art form in its own right.

Heilbrun hinted at this dilemma in her discussion of the picture: "Without doubt the scene is static. It is not the moment

22. Françoise Heilbrun, *Charles Nègre: Photographe*, exh. cat. (Arles: Musée Reattu; Paris: Éditions des Musées Nationaux, 1980), 90. Translation is my own.

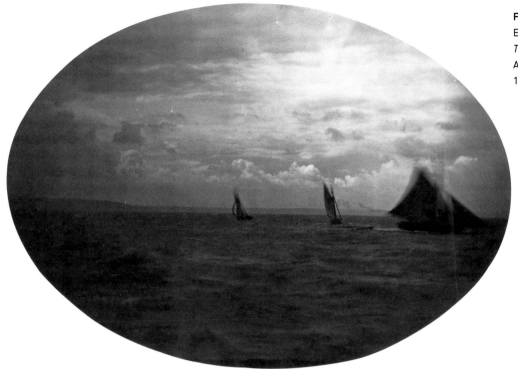

Fig. 2-19
Eugène Colliau
*The Coast*, c. 1861
Albumen print
17.2 x 24.2 cm

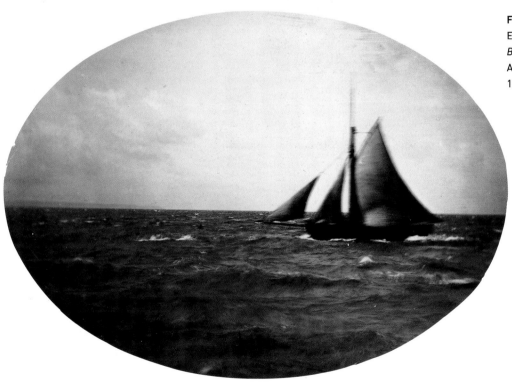

Fig. 2-20
Eugène Colliau
*Boat under Full Sail*, c. 1861
Albumen print
17.2 x 24.2 cm

that the horse fell that the artist represented, but the instant after, in which onlookers have gathered. It certainly comes across as a real instant and not as a composed scene, but Nègre knew to 'frame the subject' with his sense of inner harmony."[23] The extent to which photographers could use chance events to create artistic compositions became a source of contention among photographers and critics.

As Gunthert has noted, the word *instantaneous* has an aesthetic dimension. Although the term supposedly applies to the speed with which an exposure is made, it was not considered appropriate in reference to rapid photographs taken of still or inanimate objects. A still life taken with an extremely rapid exposure was not said to be instantaneous. Nor would any nineteenth-century photographer have dreamt of applying the notion of instantaneous photography in such a case, Gunthert has argued, noting that the term "does not only describe a brief pose, *but its application to a certain type of subject, and to certain photographic conditions*." The idea, he contended, is equivalent to Leonardo da Vinci's (1452–1519) definition of studies from life: the capacity to immediately register a chance subject.[24]

As the curator Alexander Sturgis pointed out in his excellent exhibition catalogue *Telling Time*, a painter attempting to portray an instantaneous subject will generally stick to easily recognizable moments. "Without the aid of photography, every stage of a movement may be visible," he noted. "But some phases are more memorably perceived than others, and it is these that a painter usually depicts. These are usually when the direction of movement changes: a pendulum, for example, will be most visible at the top of its swing."[25] Thus, Sturgis explains, the traditional "walking pose" in paintings shows legs between strides, just before the back leg swings forward, because this is when they are most clearly seen. In the case of leaping or falling figures, paintings look more natural when rendered with minimal detail. The reasons for this are psychological. A person cannot actually see rapidly moving subjects clearly. By replicating the

23. Ibid.
24. Gunthert 1999, 28; translation from the French is my own.
25. Sturgis 2000, 36.

indistinctness associated with seeing figures in motion, an artist may evoke in the mind of the viewer the sensation of witnessing such a subject.

Indeed, the depiction of action subjects has a long and rich history in the arts and is not confined to photography alone. Leonardo was just one of many artists who prized the ability to depict the ephemeral in their pictures. The great Renaissance art historian and painter Giorgio Vasari (1511–74), for example, lavished praise on those artists who managed to invest their works with spontaneity and freshness of appearance. The medium of fresco, which thrived in Italy in the fourteenth through sixteenth centuries, was particularly well suited to this sensibility. Artists working in fresco have to work with speed and precision, as the plaster with which they mix their paints dries shortly after it is applied. Fresco does not allow for extensive reworking and correction, as oil painting does, for example. In his *Lives of the Artists*, Vasari identified Giotto (c. 1267–1337) as the first Italian painter to return to drawing compositions based on sketches of living models, an approach he believed had been lost since classical times. Describing the altar he attributed to Giotto at the Badia monastery in Florence, Vasari praised the *Annunciation* (fig. 2-21) for just the sort of vivacity that would later become the instantaneous photographer's stock in trade. "In this work he vividly expressed the fright and dread with which Gabriel's greeting filled the Virgin Mary. Full of the greatest fear, She seems as if She wishes to run away."[26] In other words, the painter appeared to have captured Mary in a state of transition, as though she were about to act.

Concern with the fleeting and momentary in art would later become a principal theme of the Romantic movement. It is difficult to generalize about Romanticism because it encompassed many different artists working over a broad geographical area and an extended period of time. In this regard, it is not unlike the instantaneous photography movement. Nevertheless, depicting that which is transitory in nature was a common

26. Giorgio Vasari, *The Lives of the Artists*, trans. J. Bondanella and P. Bondanella (Oxford: Oxford University Press, 1991), 16. The alterpiece is now attributed to Lorenzo Monaco (Marvin Eisenberg, *Lorenzo Monaco* [Princeton, N.J.: Princeton University Press, 1989], 103–04.)

*OPPOSITE PAGE*
**Fig. 2-21**
Lorenzo Monaco
*Annunciation with Saints*, c. 1409
Tempera on panel
129.5 x 102 cm
Florence, Accademia
Central panel from the Badia altarpiece,
    ascribed to Giotto by Vasari. Photo:
    ©Scala/Art Resource, NY

**Fig. 2-22 (above)**
William Rimmer
*Flight and Pursuit*, 1872
Oil on canvas
46 x 66.7 cm
Boston, Museum of Fine Arts, bequest of
    Miss Edith Nichols, 1956; 56.119. Photo:
    ©Museum of Fine Arts, Boston

27.  Honour 1979, 17.
28.  Albert Boime, *The Academy and French Painting in the Nineteenth Century* (New Haven: Yale University Press, 1971), 35. I am grateful to Bernard Barryte for this reference.

interest of Romantic artists. They assumed the roles of mediator and conduit. Directness of execution, from nature to eye to hand, was highly valued. The concept of artistic genius flourished at this time because it implied an almost supernatural ability to convey what is actually seen. The capacity to seize and convey momentary experience was considered crucial to artistic success.

Similarly, Romantic artists regarded spontaneity as a vital element of picture making. As a result, the ability to sketch received new appreciation. As the art historian Hugh Honour has written, the sketch is the least premeditated form of art, one "in which the painter's or sculptor's feelings may be communicated with spontaneous directness."[27] Romantic sketches were frequently made outdoors, *en plein air*, with the goal of capturing what things really look like. Unlike painting in the studio, which in the nineteenth century was inevitably a ponderous and studied process, sketching enabled the artist to depict the way things appear in action. The ability to capture the essence of a subject in motion was considered a mark of virtuosity. The painter Eugène Delacroix (1798–1863) put it forcefully: "If you are not skilful enough to sketch a man falling out of a window during the time it takes him to get from the fifth story to the ground, you will never be able to produce a monumental work."[28]

In the Victorian era a number of artists worked to produce finished compositions of action scenes. Perhaps the most famous was William Rimmer (1816–79), the Boston artist

whose painting *Flight and Pursuit* (fig. 2-22) was completed in 1872, at nearly the same time that Muybridge was beginning his motion study experiments. *Flight and Pursuit* shows two men running through the halls of a Moorish palace, seemingly frozen in time while engaged in a mysterious chase. Unconventional and enigmatic, the painting represented the figures in a way that instantaneous photography would soon come to master.

Muybridge himself used to preface his public lectures with a review of historical representations of motion. His lecture on quadrupedal walking, for example, began with a slide of a Neolithic reindeer carved in bone. It continued with a discussion of early Assyrian and Egyptian depictions. A substantial portion of his talk was given over to discussion of later examples. To illustrate the ancient Greek ideal, he used a relief by the Neoclassical English sculptor John Flaxman (1755–1826); he also considered statues by the Florentine sculptors Donatello (c. 1386–1466) and Andrea del Verrocchio (1435–88). Albrecht Dürer (1471–1528) also received consideration, as did more contemporary artists such as Paul Delaroche (1797–1856), Sir Edwin Landseer (1802–73), and Rosa Bonheur (1822–99). He defended Elizabeth Thompson's (1846–1933) controversial painting *Calling the Roll after an Engagement, Crimea* of 1874 (British Royal Collection). Likening it to a painting by Ernest Meissonier (1815–91) that was disparaged for its interpretation of a walking horse, he expressed indignation over the reception it received. "Miss Elizabeth Thompson underwent precisely the same ordeal of reckless and ignorant criticism when she exhibited this picture of the *Roll Call*," he said. "The English critics wrote of the absurdity of the Colonel of the Regiment trotting along in front of the line of soldiers while the Roll was being called."[29] In spite of this apparent affront to military protocol, Muybridge admired the picture for its interpretation of the walking horse, which he claimed was ahead of its time and poorly understood.

29. Eadweard Muybridge, "Quadrupedal Walk," Photographic History Collection, National Museum of American History, Smithsonian Institution, sec. 38.

**Imagination and Invention**

Clearly the desire to depict moving subjects has a long heritage in the history of art. This raises interesting questions about the invention of photography itself. It has long been accepted among historians that the medium represented the culmination of years of experimentation that had its intellectual origins in the Renaissance. During this period artists and scholars became increasingly interested in making pictures that were perspectively correct—that is, in which space was defined according to geometric rules and optical principles. Photography has been seen as a natural extension of those efforts. From the pinhole camera to the camera obscura, and from the physionotrace to the camera lucida, there is a continuum of drawing tools that originated in the fifteenth century and continued to the 1830s. These are without doubt the mechanical predecessors of photography. Using light to project an image on paper is a time-honored practice. Only the chemical registration of that image was new in photography.

The photo-historian Beaumont Newhall famously outlined this position in his standard reference, *The History of Photography*, which was first published by New York's Museum of Modern Art in 1949 and has remained in print ever since. Newhall linked photography to the writings of Florentine architect Leon Battista Alberti (1406–72), who appears to have been the first to establish the mathematical rules that govern the perception of pictures. In his essay *On Painting* (1435), Alberti described the human eye as the apex of a cone to which light comes in rays. This conception enabled artists to think of the world around them in linear terms; a picture, according to this scheme, is little more than a plane in which the rays have been recorded. Since then, Newhall argued, inventors have repeatedly tried to systematize the rules of perspective with mechanical aids. By the nineteenth century, he claimed, the desire had reached a fever pitch: "The physical aid of camera obscura and camera lucida had drawn men so near to exact copying of nature and to satisfying the current craving for reality, that they could not

**Fig. 2-23**
Attributed to Lady Clementina Eliphinstone
    Hawarden
*A Kiss*, c. 1860
Albumen print
19.1 x 11.4 cm

30. Newhall 1949, 9, 11.

abide the intrusion of the pencil of man to close the gap. Only the pencil of nature would do."[30]

But, what kind of "pencil of nature" did artists aspire to? Was it a pencil like the old ones, bound by the limits of human vision? Or was it a new pencil, capable of drawing things people could only imagine? Newhall suggested that it was the wish to make improved conventional imagery that drove the inventors of photography. By this line of reasoning, the invention of photography was basically a technological advance. It enabled its practitioners to work more efficiently in a mode with which they were already comfortable.

Talbot, for example, an amateur artist at best, was said to have been frustrated by his inability to draw landscapes during a holiday in Lake Como in 1833. Essentially it was artistic ineptitude that motivated him to invent his process. Working nearly simultaneously in France, Daguerre, a scene painter and impresario of the diorama, perfected a rival process with the aid of the printmaker Niépce. They too were driven by a desire to make pictures more efficiently. Daguerre—who, in contrast to Talbot, was a skilled painter—wished to automate the production of the highly detailed paintings he made. And Niépce, who had been experimenting with lithographic reproduction processes, hoped to perfect an improved method of printmaking. In his own way, each of these inventors was trying to make pictures like those he was already accustomed to, but more quickly and easily, and with absolutely correct perspective.

And yet there are signs that each of these inventors was wrestling with the question of instantaneity. Talbot, writing

later about his fateful experience at Lake Como, cited his inability to draw well as the impetus for his invention. In the same passage, however, he described the images he wished to record as "fairy pictures, creations of a moment, and destined as rapidly to fade away." He continued, "It was during these moments that it occurred to me—how charming it would be if it were possible to cause these natural images to imprint themselves durably, and remain fixed upon the paper."[31]

Daguerre too expressed concern about instantaneity in his early writings. As Gunthert has pointed out, his correspondence with Niépce in the 1830s is littered with references to the speed of the process they were working together to develop. For example, in February of 1830 Daguerre wrote: "Up until now we have done nothing concerning rapidity [*promptitude*], and it is impossible to be able to operate without this." In October he wrote again with similar concerns: "I am delighted to learn that you are succeeding in augmenting rapidity, because we can do nothing without it." The sentiment was repeated, with a touch of frustration, in February 1831: "I regret, my dear M. Niépce, to have nothing to say to you about rapidity, but I very much hope that we will make some progress in this respect."[32]

Of course, Daguerre's references to rapidity must be considered in context. In the 1830s, while still using highly insensitive bitumen of Judea as an emulsion, the Niépce-Daguerre partnership labored with extremely long exposure times. Niépce's celebrated 1826 photograph of rooftops taken from his window at Le Gras (Gernsheim Collection, Harry Ransom Humanities Research Center, Austin, Texas), for example, was made in approximately eight hours. Under such conditions even slow and subtle movements, such as the progress of shadows in the course of a day, fail to register. Consequently, the dialogue Daguerre and Niépce shared about rapidity was concerned with the simple practicality of making a photograph, not just the type of subject that could be depicted. Nevertheless, the inability to record even modest changes in a scene must have been an enor-

31. William Henry Fox Talbot, *The Pencil of Nature* (London, 1844); cited in Newhall 1949, 9.
32. Gunthert 1999, 54.

mous frustration, particularly for Daguerre. The diorama he
managed was all about visual transitions. Audiences flocked to
see shifting scenes such as fluctuations in the weather or the
change from night to day. Photography, in its earliest form,
offered little hope of making such scenes.

The point here is not to challenge Newhall, whose work is
unquestionably rigorous. He never claimed that perspective was
the *only* concern that propelled the invention of photography.
The wish to capture the ephemeral in pictures is, however, con-
spicuously missing from his analysis. Perhaps Newhall, writing
at a time of high modernism, was particularly drawn to ques-
tions of structure and composition. By focusing on the treat-
ment of perspective in the techniques that preceded photogra-
phy, he emphasized the formal qualities of the medium. Yet it is
curious that the ability to render scenes with perspectival cor-
rectness should be regarded as the driving force behind the
invention of photography. As Newhall teaches us, the ability to
represent things in geometric perspective is nothing new. Since
the Renaissance, skilled artists have been able to draw faithfully
according to mathematical rules. Capturing movement, how-
ever, is something photography would become uniquely good at.

In his recent book *Burning with Desire,* the photo-historian
Geoffrey Batchen explores some of the historically neglected
factors that may have contributed to the invention of photogra-
phy. Batchen notes that the act of making a photograph is inher-
ently temporal in nature. As a result, he argues, photography
offers an experience unlike other media. In a painting, for
example, the surface itself, composed of an elaborate structure
of marks and brush strokes, reminds the viewer of the time
needed to make it. In other words, the painting is an artifact of
an artist's efforts to convey meaning. By contrast, Batchen
argues, photographs direct attention to the temporal qualities of
the subject. Almost always, they represent a set of objects in
fixed spatial relations at a given moment in real time. Accord-
ingly, a photograph may be thought of as an artifact not of the act

**Fig. 2-24**
Charles Furne and Henri Tournier
*Pumping Water*, c. 1861
Stereo albumen print
7.6 x 13.5 cm

Stereo views conventionally make a sub-
ject look three dimensional. Using both
eyes, a viewer focuses on two prints simul-
taneously, one on each frame. This creates
the illusion of perspective in real space.
However, a small number of photographers
used stereo viewers for a different purpose.
As in this example, they photographed the
same subject twice at slightly different
times. The viewer was meant to close each
eye in turn, seeing two phases of activity in
rapid succession. This startlingly creative
adaptation of the stereo camera directly
foreshadowed Muybridge's system of
sequential photography.

33. Geoffrey Batchen, *Burning with
Desire: The Conception of Photog-
raphy* (Cambridge: MIT Press,
1997), 92–93.

of creating a picture, but of time passing in the scene depicted. From painting to photography there is a subtle but important shift in meaning. As Batchen notes, this led Talbot to conclude that the subject of every photograph is time itself.[33]

This intriguing proposition suggests that the circumstances that resulted in the invention of photography were far more complex than previously believed. If, as Batchen has claimed, there is something inherently different about the handling of time in photography, and if its inventors recognized this difference, then perhaps time itself was one of the things they were hoping to record. This does not necessarily mean that perspective was unimportant, nor does it detract from the technological progression that can clearly be traced from the Renaissance to the present. It does suggest, however, that ephemerality, transience, and flux were among the subjects photography's inventors hoped to conquer. If one accepts this view, Muybridge, who ultimately perfected the ability to make pictures that could not be obtained by traditional means, becomes an extremely important figure. His successful photographs of actions that could not be seen with the naked eye mark a climactic parting of the ways between photography and the traditional arts. Yet the seeds of instantaneity were sown in photography's initial stages.

### A New Art

Significantly, in the nineteenth century there was a small but vocal school of thought that held that instantaneity offered the key to photography's acceptance as a fine art. At the time, a debate raged over the proper place of photography in the pan-

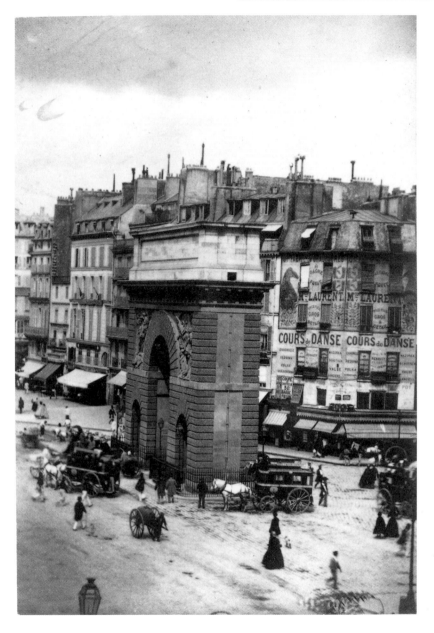

theon of arts. Some believed
that it was little more than a
mechanical reproduction
process, with no claim to fine
art status. Others felt that it
was basically a printmaking
process and might belong
among such "lesser" arts as
engraving or lithography. A
more radical group main-
tained that it should be
embraced as a new art form.

Among those who argued
for this position was the
Swedish émigré photographer
Oscar Gustave Rejlander (c.
1813–75), although he later
retreated from this stance.
Rejlander was admired for his
ability to mimic fine art con-
ventions in photography. One
reviewer, for example, praised
his works in the *Art Journal* in
1868: "Later years have shown
that more can be done than we
thought at one time possible,
and that results are obtainable
from lens and camera, which
are not merely imitations and copies from still nature, but pro-
ductions of mind and thoughtful study, and which, when gazed
on, raise emotions and feelings similar to those awakened at the
sight of some noble sepia sketch, the handiwork of a good
draughtsman."[34] At the time this was the most common view of
photography's claim to fine art status. A skilled photographer
could invest a picture with expressive content and meaning by

34. "The Photographs of Rejlan-
der," *Art Journal*, n.s., 7 (Janu-
ary 1868): 15. Note the refer-
ence to inartistic "still"
photography.

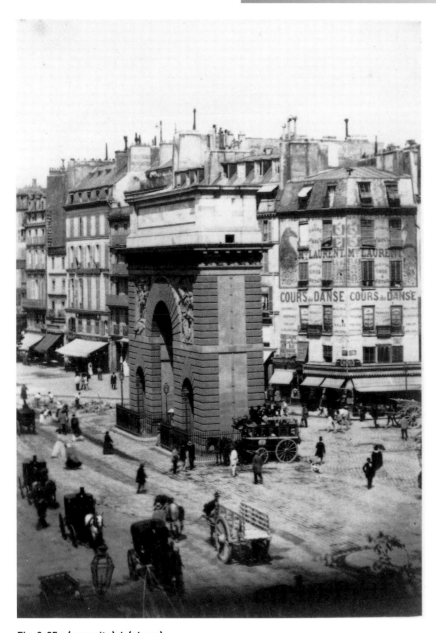

**Fig. 2-25 a (opposite), b (above)**
Gustave Laverdet
*Porte St. Martin*, 1862
Two albumen prints
10 x 7 cm each

emulating the conventions of drawing and painting. In other words, a photograph can be used just like a canvas, and a photographer can compete with a painter on painterly terms. With conscious composition and planning, it was believed that photographers could fill their pictures with artistic content.

But there were those who took the opposite view. There was no good reason, they would argue, for photography to be constrained by standards borrowed from other media. Instead, it should delve into that which it does well, even if that means departing from usual expectations about art. Photography, they would say, should be valued on its own terms.

Some believed that the capacity to record movement instantaneously was itself grounds for its admission to fine art status. This idea surfaced in the 1870s, just before Muybridge began his motion study experiments in California. Writing in 1871, the British photographer Stephen Thompson (c. 1830–93) sounded an especially provocative call to arms:

There is a latent desire running through the minds of most photographers—unshaped and unembodied, it may be, but

**Fig. 2-26**
Carleton Watkins
*Montgomery from Market Street*, 4 July 1864
Stereo albumen print
7.8 x 15.3 cm

*OPPOSITE PAGE*
**Fig. 2-27 (top)**
Edward Anthony
*Broadway from Barnum's Museum, Looking
  North*, c. 1860
Stereo albumen print
7.5 x 15.1 cm

**Fig. 2-28 (bottom)**
Giorgio Sommer
*Via Toledo, Naples*, 1865–67
Stereo albumen print
7.3 x 14.1 cm

still felt in some dim way, that has not yet found means of expression—to enlarge the somewhat restricted domain or sphere in which photography lives, and moves, and has its being; in short, the peaceable extension of our frontier line in the region of art; which, happily, in this case, does not involve any annexation of the territory of our neighbors.

. . . We earnestly scan the horizon on every side, seeking to find some avenue, some outlet, where we may breathe a freer air, and attain a nobler, fuller life. In what direction may we hope to find it? Colour? No, not yet, if ever may we hope to clutch such an intangible beauty as colour! Why sigh for the unattainable? As well bay the moon, or spend our days and nights in seeking the elixir vitae or the philosopher's stone. That is not the path for the transmutation of our labours into precious metals. But there is one direction, within the bounds of possibility, in which it may be sought, and it would enlarge our sphere of operations in an immeasurable degree; and that is, absolute instantaneity on large plates, say plates 18 by 16, a size sufficiently large to make pictures for hanging.

At present we are confined, in great measure, to one aspect of nature only—nature in repose. The peaceful landscape, the stately ruin, on which time feeds like slow fire upon a hoary brand, are ours; but life, motion, and all its poetry; nature—living, warm, breathing, pulsating nature, with her April face and her April eyes, her stormy passions and sudden calms; the power and mystery of nature, not only her outward form, but her beating heart—lies just beyond our domain.[35]

35. Thompson 1871, 102–3.

Thompson went on to criticize works hung in the annual exhibitions of the Royal Academy, noting the staid and placid

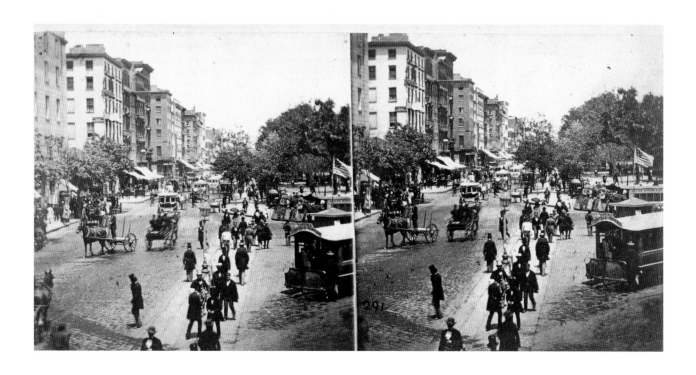

GIORGIO SOMMER

NAPOLI { Atelier Monte di Dio No. 4. { Magazzino S. Caterina No. 5.

appearance of many entries. People hungered for pictures that were more dynamic, he believed, and photography could give it to them. Thompson was among the few who argued that the state of the arts could be improved, if only photographers could achieve absolute instantaneity.

Writing in his book *Instantaneous Photography* some years later, Abney took this argument one step further, asserting that the peculiarities of instantaneous photography could form the basis for a new type of beauty:

> The practical making of instantaneous photography cannot be the low form of photography which some believe it to be. For our own part we believe its results give greater pleasure to more people than do the most carefully planned photographs. It must not be considered for a moment that an instantaneous photograph gives of necessity the idea of motion. As a matter of fact, it is often grotesque, and conveys the idea that figures are posed in attitudes in which they are never seen, and it is their very grotesqueness that often makes them the most interesting, and it might often be added, comical. The attitude of a man who is caught whilst walking, just touching the ground with the heel of a preceding leg, for instance, is never associated in the mind with progression; nor do the sharply defined spokes of its wheels give the idea of the rapid bowling of a hansom cab; and yet both of these are seen in instantaneous photographs. They open out to view what would be seen if the eye were differently constituted, and could distinguish between two attitudes taken up for, say, a 1-100th of a second.[36]

Blanchere phrased this point differently: "Photographs taken instantaneously . . . possess certain advantages peculiarly to themselves. By such picture the crowded streets and other 'busy haunts of men' are brought home to our minds with a force which enables us to realize the original in a way we could not otherwise do."[37]

36. Abney 1895, 2.
37. Blanchere 1865, 275.

# HOW TO MAKE AN INSTANTANEOUS PHOTOGRAPH

IN THE NINETEENTH CENTURY a would-be instantaneous photographer had to consider many factors when composing a picture. Each required careful thought and planning.

**Chemistry.** The insensitivity of early photographic chemicals was the main obstacle to producing effective instantaneous pictures. Most materials were slow by modern standards, requiring long exposure times. This made photography difficult, because moving subjects can appear blurry, and in some cases even invisible, in long exposures. The precise length of time required varied widely, depending on the subject and the equipment used. Exposures of a second or more were not unusual, however, and tens of seconds were sometimes required for studio portraits.

Some of the first successful instantaneous photographs were made using the daguerreotype process (a direct positive image on a silvered plate), because it enabled faster exposures than contemporaneous alternatives such as waxed-paper negatives.

Throughout much of the 1860s and 1870s however, the wet-plate collodion process was the medium of choice for instantaneous photography. Though faster than prior methods, wet-plate collodion negatives must be handmade and exposed while still slightly wet. Suggestions for additives and refinements of the standard formulas were published regularly in professional magazines, and chemical accelerants and intensifiers were available from commercial sources, but many of the most successful instantaneous photographers closely guarded the secrets of the chemistry they used.

The exact materials used by Eadweard Muybridge are not known. His earliest experiments in California were made using the wet-plate collodion process. Later, as faster gelatin dry plates became available, he used them instead.

**Light.** The more light illuminating a subject, the less time is needed to record an image in the negative.[1] Early photographers used this principle to make instantaneous photographs. Some, such as William Henry Fox Talbot, even experimented with flash and other sources of artificial light. But most contented themselves with maximizing natural light in their pictures.

Nineteenth-century portraitists designed their studios carefully, with large windows, skylights, and reflectors to make the most of available light. Outdoor subjects too were chosen with particular attention to season, time of day, and the amount of light they reflected. Depending on conditions, waves and clouds can be particularly bright subjects; this is one reason why many of the first successful

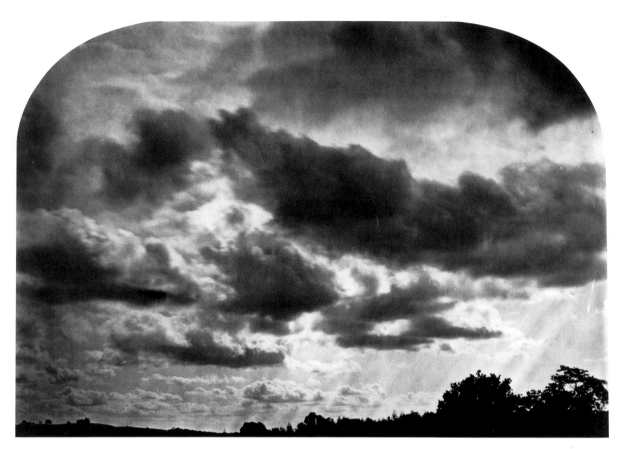

**Fig. 2-29**
Roger Fenton
*September Clouds*, 1859
Albumen print
20.6 x 28.7 cm

instantaneous photographs depict them (fig. 2-29).

When he began his work in Palo Alto, Muybridge benefited from the clear, brilliant sunshine typical of inland California. To make the light brighter still, he erected large white painted light baffles to reflect light onto his subjects; he also sprinkled the ground with lime.

**Conditions.** The photographer had to be extremely sensitive to the time of day, season, and weather conditions in which a photograph was made. According to one writer, the best exposures were usually made between nine in the morning and three in the afternoon. Photographs were also generally easier to make in the summer than in the winter, although the acute angle of light characteristic of winter

months could be advantageous for certain subjects.

**Optical quality.** A good lens is essential to making successful instantaneous photographs. Lenses transmit light from the subject to the negative. A thick, optically impure lens reduces the amount of light transmitted, whereas a thin, optically clean lens allows light to pass relatively undiminished.

The best instantaneous lenses were made by skilled manufacturers using high-quality glass. Among the best was the English firm of J. H. Dallmeyer Ltd. Shortly after he began his experiments, Muybridge ordered a set of Dallmeyer lenses from London. He used these to make nearly all of his published motion studies.

**Focal length.** The photographer had to be careful to choose a lens of appropriate focal length. The best lenses for instantaneous photography are ones that are relatively "short"—in other words, in which the objectives are mounted close together. Such lenses are typically made with less glass and so do not impede the transmission of light to the degree that longer lenses do. Stereo cameras were usually equipped with very short lenses, so many early instantaneous photographs are stereo views.

The use of short lenses also affected the length of bellows extension on plate cameras.

In early cameras, focus was controlled by changing the distance between the lens and the plate. Joining the two was an accordioned leather cover called a bellows. With short lenses, general views could be taken with the lens and plate close together and the bellows contracted. This made it easier for the photographer to reach around from the back of the camera to control the lens.

Lens length restricts the types of picture a photographer may take. Long lenses, like modern "telephotos," magnify the subject. Short lenses, by contrast, produce wide-angle views. Consequently, many early instantaneous photographs are of activity taking place within large, sweeping vistas. Photographers did not necessarily want to make such wide views but were forced to as a result of using a quick but short lens.

Because short lenses are best suited to wide-angle pictures taken from a distance, instantaneous photographs in which action filled the frame were highly unusual. Close-up photographs of motion were seldom made that way in the camera but were altered to look like close-ups later through cropping and enlargement.

This is how Muybridge made his close-up views of birds and other small animals in *Animal Locomotion* (fig. 2-30). The original negatives were made with short lenses that made the animals too small to see. For publication, the images were edited and enlarged.

**Aperture.** Another important factor photographers had to consider was lens aperture. The aperture of a lens is the diameter of its opening. A wide aperture admits more light than a small one. As with focal length, this quality of a lens can be used to help a photographer obtain rapid exposures.

The ratio of focal length to diameter is known as an ƒ-number. Lens speed is often described in terms of this figure. For any given focal length, the smaller an ƒ-number is, the wider its aperture opens. This system helps a photographer to judge the speed of lenses. A small ƒ-number lens (ƒ1, ƒ1.4, etc.) opens wide and is said to be fast. A large ƒ-number (ƒ32, ƒ64, etc.) of the same focal length opens only narrowly, and is said to be comparatively slow.

But using wide apertures too comes at a cost. Photographs taken with a wide aperture are generally not as sharp as those made with smaller ones. In 1932, for example, a group of photographers including Ansel Adams, Imogen Cunningham, Edward Weston, and others famously founded what they called the ƒ64 school, advocating the use of tiny apertures to make extremely sharp pictures.

Nineteenth-century photographers, however, had less freedom to choose narrow apertures. Because the chemistry they used was slow, they would frequently select wide apertures to speed up exposure. The unintended result, however, was a loss in clarity.

Also, large apertures reduce the amount of depth of field a photographer can achieve.

Depth of field is the range of focus in a photograph. Lenses used at wide apertures typically have poor depth of field; that is, they can focus only on a narrow range of objects. For example, a photographer working with a wide-aperture lens may find that he or she is able to focus the midpoint of a scene clearly but cannot register the foreground and background without blurriness.

To make his motion studies, Muybridge used a medium-short lens with a semi-wide aperture. The precise model used is not known but was probably Dallmeyer's "Quick-Acting Portrait" type, which was sold with an ƒ3 aperture.

**Shutter.** Although mechanical shutters existed early in the 1850s, they were seldom used, even for instantaneous photography. Initially they were considered more of a convenience than a necessity. Given the slowness of early chemistry, there was no need to start and stop exposure mechanically. Most photographers operated by simply uncapping and capping their lenses. Some substituted arrangements of cloth or card. The Scottish photographer George Washington Wilson, for example, was said to have used his hat to control exposure. Stuart Wortley used his bare hand.

Many photographers claimed that working in this way gave them the ability to "feel" the correct exposure. Skill in uncapping and capping a lens or other contrivance quickly and

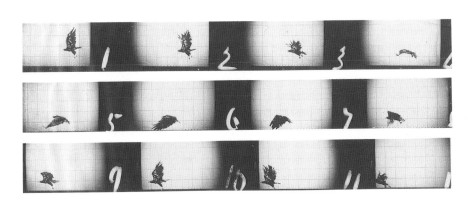

**Fig. 2-30**
Eadweard Muybridge
*American Eagle, Flying*, August 1885,
    unpublished proof from the series
      *Animal Locomotion*
Six cyanotype prints, mounted on card
29 x 41.8 cm

smoothly, without knocking or shaking the camera, was considered essential to the instantaneous photographer's craft.

The use of a mechanical shutter to control exposure was one of the innovations employed by Muybridge shortly after he began his motion study experiments in California. Contrary to popular belief, however, he did not invent the mechanical shutter; there were many different designs in existence prior to his work.

Muybridge's initial design involved a slotted piece of wood, spring-loaded with rubber bands. It was fired using an electromagnetic switch fashioned from a telegraph key.

**Distance.** Action occurring far away from a camera is easier to record than action occurring close up. This is because the size of a subject appears relatively small in a distant shot and so for any given activity moves less distance in the plane of the negative. For example, a pedestrian photographed from a hundred yards away might register as a figure just a fraction of an inch tall on a five-by-seven-inch negative. The same person, taken from fifty yards, might register as a full inch tall. If the figure is moving, the distance traveled in the negative will be proportionally bigger. Consequently it will look blurrier.

For this reason, many early instantaneous views were made from distant vantages. Although this did help to minimize blurring, it also involved a trade-off. From far away some

sharpness is lost, and the details of a subject can be difficult to see. In fact, this is why instantaneous photography seems to work well from a distance. The blurring of motion is still recorded, but since its size is sufficiently reduced, it is less obvious and distracting.

Another reason to shoot instantaneous subjects from a distance is the unpredictability of certain action subjects. When photographing birds, for example, Muybridge took pictures from a remove, ensuring that his cameras would not lose them as they flew. He then went back and cropped the images in printing to make it look as though the birds had been closely tracked.

**Perspective.** Subjects proceeding toward or away from a camera look less blurry than ones moving back and forth across the frame. So, depending on the direction in which a subject is traveling, a photographer may be able to reduce blur by photographing from an oblique perspective.

Most instantaneous street scenes of the 1860s and 1870s make use of this phenomenon. Not only are they usually taken from a high vantage point, typically the upper stories of a building or similar structure, but they also show the road receding into the distance.

In addition, because sunlight shines down from the sky and reflects back upward, photographers found that they had more light to work with when working from above. The light reflected back from a street scene is usually

**Fig. 2-31**
Ernest Lamy
*Porte and Boulevard St. Denis, Paris, in the Snow*, c. 1863
Stereo albumen print
8.1 x 14.8 cm

It is difficult to photograph steet scenes in the snow because it is hard to balance the exposure of relatively dark figures with the bright reflected light of whitened ground. A skilful photographer like Lamy was able to use these conditions advantageously because landscapes covered in snow are also among the brightest subjects possible in natural light. This enabled the photographer to make unusually rapid exposures. Muybridge would later simulate this effect by coating the ground of his motion studio with lime.

more intense from a slight elevation than it would be at ground level.

The photographer Samuel Fry also recommended taking photographs from a slight elevation in order to make more picturesque marine compositions. From a raised vantage point, he reasoned, the reflections of clouds and boats are more visible on the water.

Muybridge included a series of foreshort-enings—angled views—in the motion studies he made in California and Pennsylvania. Most of the pictures he made were taken laterally, however, perpendicular to the motion of the subject. This is the hardest type of instantaneous photograph to make.

**Panning.** Another way to reduce blurriness in action photographs is to track the subject with

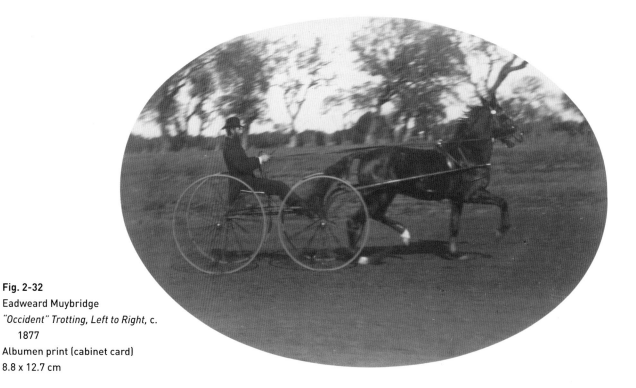

**Fig. 2-32**
Eadweard Muybridge
*"Occident" Trotting, Left to Right*, c.
   1877
Albumen print (cabinet card)
8.8 x 12.7 cm

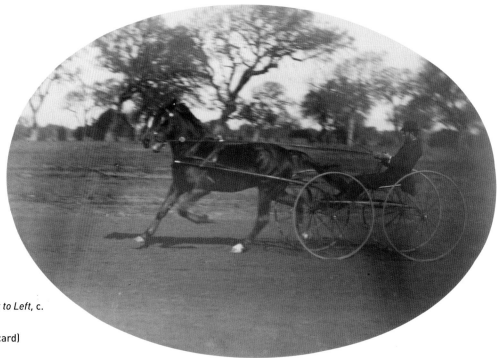

**Fig. 2-33**
Eadweard Muybridge
*"Occident" Trotting, Right to Left*, c.
   1877
Albumen print (cabinet card)
8.8 x 12.7 cm

the camera, thus adjusting the picture plane to accommodate the movement of the subject. This can reduce blurring in the moving figure but will make any stationary objects, such as the foreground or background of a landscape, indistinct.

Panning to track motion is tricky and was not often done. There is evidence that Muybridge used this technique early on, however, before he had mastered sequential photography. In his single-frame pictures *"Occident" Trotting, Left to Right* and *"Occident" Trotting, Right to Left* (figs. 2-32, 2-33), he seems to have done so.

**Fake It.** The history of instantaneous photography is full of examples in which motion was not actually captured, but rather simulated. There were many ways of doing this, from composite printing (that is, using two or more negatives to create a scene artificially) to posing or slowing down figures so that they appear to have been captured in motion. Even genuine achievements in instantaneous photography frequently profited from a little creative tweaking. The Scottish photographers David Octavius Hill and Robert Adamson, for example, managed remarkably rapid exposures using primitive paper negative chemistry. Nevertheless, they often relied on artful posing to accentuate the effect of motion.

Another way in which instantaneity could be simulated was by direct intervention in the negative. "Retouching," as it was euphemistically known, ranged from the subtle reworking of a subject's eyes or hands to correct blur to the wholesale redrawing of large sections of an image. Oscar Rejlander's *Ginx's Baby* (figs. 2-34 – 2-37) provides an excellent example of the latter approach. To make this image, the photographer completely copied a small faded photograph by hand. He then rephotographed the copy to give the illusion of an original photograph.

Muybridge himself did much the same thing. His celebrated early image *Occident Trotting at a 2:30 Gait* is almost completely redrawn from a lost original photograph. Only the head of the driver is truly photographic; it was glued to the drawing before it was re-photographed (figs. 3-20, 3-21).

Later in his career this tendency to alter and manipulate imagery would make some scholars suspicious of Muybridge's photographs. As the art historian Marta Braun and others have pointed out,[2] numerous alterations and omissions can be found in his final work, the 781 motion sequences he published under the title *Animal Locomotion* in 1887.

NOTES

1. Not all photographic processes, then as now, involve the use of a negative. In some, such as daguerreotypes, exposure results in a direct positive. For the sake of simplicity, however, I refer throughout this article to exposing "the negative," as this was the approach most commonly used.
2. See Braun 1992.

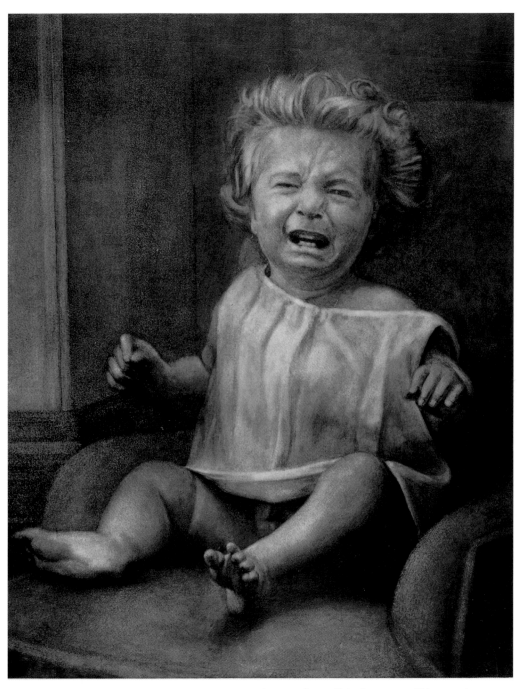

**Fig. 2-34**
Oscar Gustave Rejlander
*Ginx's Baby*, 1871–72
Polychrome drawing;
　enlargement of the
　original photograph
54 x 43.9 cm

This image, published as Plate 1, Figure 1 of Charles Darwin's book *The Expression of the Emotion in Man and Animals*, was among the most sensational instantaneous photographs of the Victorian Era. Press reports claim that some 250,000 copies of it were sold across Britain; it was said to have "scattered to the winds" all previous attempts at instantaneous photography.

Darwin intended it to illustrate the muscle contractions of a child's mouth in a fit of rage. Those who bought it in photographic form, however, identified it with a popular novel by Edward Jenkins, *Ginx's Baby: His Birth and Other Misfortunes* (1870). In the book, the hapless baby Ginx is the thirteenth child born into a poor family. Abandoned by his parents because they cannot afford to keep him, he is shuttled between various self-serving charities before eventually killing himself by throwing himself off a London bridge.

The book was a huge popular success, and Rejlander's photograph, detached from Darwin's book, seemed to illustrate the luckless child perfectly. Ironically, though hailed as an instantaneous wonder, most of the "photographs" sold of *Ginx's Baby* were not true photographs at all. In the course of his commission, Rejlander did produce a small, indistinct photograph of a crying baby (fig. 2-25). However, because it was too small and the quality too poor to reproduce, Rejlander redrew it by hand. The result was this large colored drawing. The drawing was then rephotographed, giving it the appearance of a photographic original as in Figure 2-36. Such "retouching," as it was known, was not uncommon.

**Fig. 2-35 (left)**
Oscar Gustave Rejlander
*Ginx's Baby*, 1871–72
Original carte-de-visite
   albumen print
9.1 x 5.7 cm

**Fig. 2-36 (right)**
Oscar Gustave Rejlander
*Ginx's Baby*, 1871–72
Carte-de-visite albumen
   print, copy after a
   drawn enlargement
7.9 x 5.5 cm

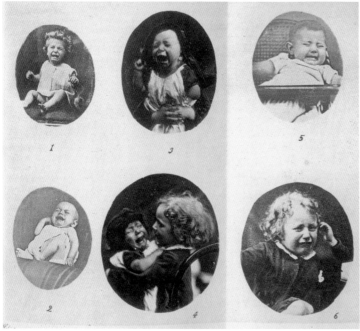

**Fig. 2-37**
Charles Darwin
*The Expression of the Emotions in Man and Animals: Plate
   1, Expressions of Suffering*, 1872
Heliotype plate
Octavo

    The scientist Charles Darwin was fascinated with
instantaneous photographs and collected dozens of
examples. He also commissioned the photographer
Oscar Rejlander, among others, to make instantaneous
pictures for him. Several were included in this volume,
his last great book on evolution. In it, Darwin compared
the facial expressions of humans with their animal
cousins, believing that even the most complex human
emotions can be seen in rudimentary form in animals.
Because expressions are fleeting, Darwin used instan-
taneous photographs to help him analyze the contrac-
tions of various muscles. The publication of these pho-
tographs enabled him to share his observations and
provided an important precedent for the use of photo-
graphic evidence as scientific data.

OPPOSITE PAGE

OPPOSITE PAGE
**Fig. 2-38 (top)**
Twyman Brothers
*Beach and Pier at Margate*, c. 1865
Stereo albumen print
7.8 x 13.5 cm

**Fig. 2-39 (bottom)**
Henry Sampson
*Landing from a Pleasure Trip,*
   *Southport*, c. 1860
Stereo albumen print
7.2 x 13.8 cm

### Sea and Sky

Instantaneous photography arose from the medium's demo-
cratic nature. With few exceptions, those who led the movement
were not aspiring fine artists. Rather, they were mass-produc-
ers of imagery catering to an avid buying public. In general, it
was the tastes of consumers that ushered the movement along.
Consequently, many of its best examples are in small, portable
formats such as cabinet cards or stereo views, although exam-
ples exist in many different sizes. In addition, the subjects of
instantaneous photographs often echo popular leisure pursuits.

In England, as in France, one of the most common of these
pursuits was visiting the seashore. Many of the photographers
who worked in this area are obscure, while some remain anony-
mous. They were local operators, catering to visitors at resorts
along the coast. The Twyman Brothers firm (active 1860s and
1870s), for example, is not well known. Nevertheless, the broth-
ers captured, in instantaneous form, vacationers waiting to be
ferried back to their homes in London on the pier at Margate
(fig. 2-38). Similarly, Henry Sampson's (active 1858–70) instan-
taneous photograph of a boat excursion in Southport shows a
group of tourists returning from a pleasure trip (fig. 2-39).

Most instantaneous photographs of the seaside are not of visi-
tors, however, but of the sea itself. The Welsh photographer John
Dillwyn Llewelyn (1810–82) was among the first to exhibit pho-
tographs labeled instantaneous. These were made near his home
on the south coast of Wales near Swansea in the early 1850s. An
associate of Talbot, Llewelyn used Talbot's calotype (or Talbo-
type) and the wet-plate collodion process to make his pictures.
He exhibited two photographs of waves at the Photographic Soci-
ety of London in 1854 (fig. 2-40), one of which a reviewer
described as "a wonderful specimen of the instantaneous
process."[38] In 1855 he submitted four more instantaneous pic-
tures of the coast to the Exposition Universelle in Paris. They
were reviewed by an English critic prior to their submission:

38.  Morris 1980, 8.

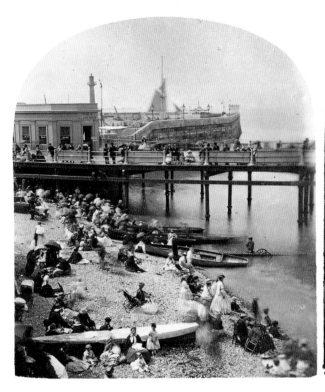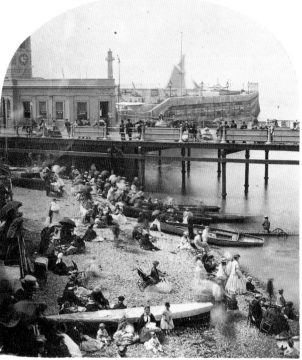

Mr. Llewelyn . . . has sent four instantaneous pictures, in one of which the seashore has been taken, with carts and persons moving upon it. Waves are caught and fixed with foam on them, and fixed while they are rolling; and the feintist trace of indecision in some walking figures shows that they could scarcely have completed one footstep before the picture was complete. Another picture represents the sea beating itself into foam against a rock, with flying clouds. Another represents a steamboat at a pier, and has fixed instantaneously the floating smoke and steam.[39]

The four photographs were entered into the Paris exhibition under the heading "Motion." Even at this early date, Llewelyn may have been using a shutter to help achieve instantaneous results. In a short memoir of his life, his daughter Thereza wrote that he had "contrived a shutter, which by falling rapidly over the lens of the camera, enabled instantaneous pictures to be made."[40] She did not specify, however, when Llewelyn began using the device.

Another extraordinary early picture of crashing waves was submitted by the French photographer Edmond Bacot (active 1850s) to the Société Française de Photographie in 1868. Called *View of the Sea, Boulogne-sur-Mer* (fig. 2-41), it was actually made in May of 1850, according to annotations on the reverse. The process by which it was made, using an albumen emulsion on a glass negative, was experimental. Its submission to the Société in 1868 was probably intended to demonstrate the photographer's early technical prowess to his peers. He may have had difficulty replicating his results, however, and it is unclear whether the image was ever exhibited at the time. Using this obscure process did enable Bacot to record the turbulence of the sea but resulted in a highly contrasty print. Nevertheless, as Sylvie Aubenas and André Gunthert have pointed out, the effect is almost poetic.[41]

The English photographer Robert Howlett (1831–58) was

39. Morris 1980, 9. The source of the review is not known; it was found in a newspaper clipping among Llewelyn's possessions.
40. Morris 1980, 10.
41. Aubenas and Gunthert 1996, 13.

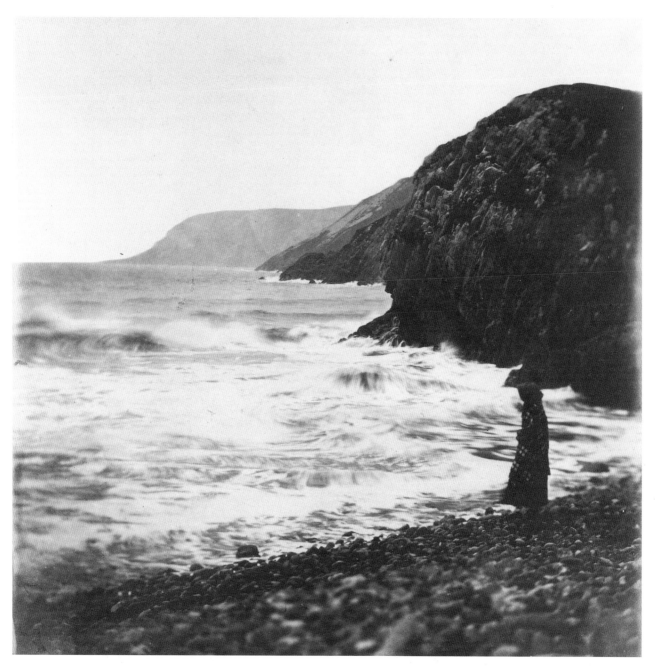

**Fig. 2-40**
John Dillwyn Llewelyn
*Caswell Beach—Breaking Waves*, 1853
Albumen print
15.6 x 15.9
Victoria & Albert Museum © V&A Picture
    Library

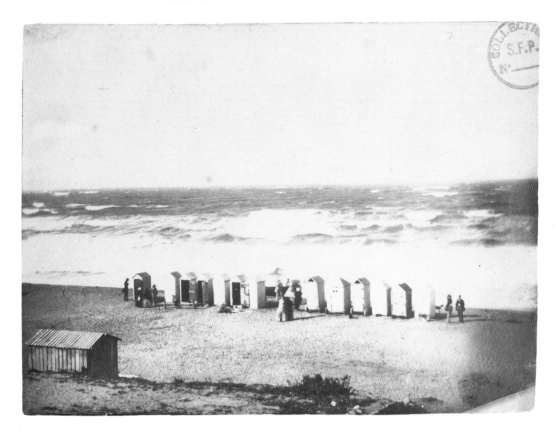

**Fig. 2-41**
Edmond Bacot
*View of the Sea, Boulogne-sur-Mer*, May 1850
Albumen print
13.7 x 18.6 cm

Bacot's view of the sea at Boulogne was presented to the Société Française de Photographie, Paris, in 1868 to demonstrate his novel technique. Bacot had devised a method to make glass negatives using a hand-made emulsion comprised of silver nitrate and albumen (egg white) that enabled him to make dry glass plates at a time when most of his contemporaries were forced to use negatives made of ordinary paper. Although never released commercially, Bacot's process was evidently much faster than others available at the time—the detail with which he captured crashing waves at the shore was unprecedented. Innovative chemistry, however, was not the only reason Bacot succeeded. He also shot from a slight elevation, which provided him with as much reflected light from the ocean as possible.

among the first to write about his own success in producing instantaneous photographs of aquatic scenes. In a letter to the editors of *Photographic Notes* in 1858, he described the lenses and the chemistry with which he was able to photograph the coast of Jersey. The editors replied, praising Howlett's works as delightful:

To see the ripple on the surface of the sea, and the waves running up the sides of rocks and breaking over them, or tumbling in heavy rollers upon the beach, are sights as familiar to us as those of cabs and omnibuses to our London readers. But to see the white blank space that has hitherto stood for the restless sea, in all our photographs of Jersey scenery, replaced by well-defined ripples and breakers . . . has delighted us more than we can express, and it indicates an advance in

sea-scape photography which has put us greatly on the "qui vive."[42]

The article went on to say that improvements in instantaneous photography of the sea were still necessary. The water in Howlett's photographs, though clear, was still not quite crisp, and details were absent in the dark areas of the rocks. The editors also complained that the optics of the lens used had concentrated light unnaturally in the center of the picture. To remedy these problems, they suggested adopting the approach of Rejlander, who, they said, had proved "that this sort of thing might easily be done."[43] They noted that he had managed to create a coherent image from as many as thirty-six different negatives—an oblique reference to his notorious *Two Ways of Life*, shown in the Manchester Art Treasures exhibition the year before.

This was precisely the approach taken by Le Gray in his pictures of the Normandy coast near Cette, made around 1856, and his pictures of the Mediterranean made in 1857. Although there is some controversy regarding the extent of the manipulations he made in producing these pictures, it is widely accepted that many, if not most, of these views were made by combining negatives from two separate exposures. The early view *Sea and Sky* (c. 1856; fig. 2-42) in the Cantor Arts Center collections, however, may have been taken in one shot. Although the horizon line does have a slightly unnatural appearance, it is unclear whether this was caused by underexposure of the negative or by later alteration. One of the main reasons for using two separate negatives was that it enabled the photographer to eliminate the unintended moonlight effect caused by shooting directly into the sun. *Sea and Sky* is dark and brooding, however, as though no correction was ever made.

Photographic technology advanced so rapidly that by 1863 Hugh Welch Diamond (1809–86), writing for the jury of the

42. "On Taking Instantaneous Pictures," *Photographic Notes* (1 January 1858): 11.

43. Ibid.

**Fig. 2-42**
Gustave Le Gray
*Sea and Sky*, c. 1856
Albumen print
31.6 x 40 cm

International Exhibition of 1862 (the so-called second Crystal Palace exhibition), would preface his comments on the marine subjects section by saying that "in the production of marine subjects—sea, shipping, clouds, and atmospheric effect, it seems as if little remains to be accomplished."[44] Among those singled out for praise in this area were George Washington Wilson (1823–93) (figs. 2-43–2-45), Valentine Blanchard (1831–1901), and Charles Breese (1820–75), whose name is amusingly abbreviated as "C. Breese."

Breese was strongly commended (fig. 2-46). "The exquisite transparent photographs contributed by the latter gentleman possess photographic and artistic qualities quite unsurpassed; every drop of foaming water or foaming cataracts is reproduced by an operation perfectly instantaneous and with a transparency beyond comparison." Diamond wrote: "The sea-gull is arrested on the wing, the balloon depicted in its ascent, whilst foreground and distance, sea and cloud, are each at the same time perfectly rendered. The effects of sunlight and moonlight are perfectly given; and to add wonder to beauty images of objects photographed by the light of the moon are amongst his contributions."[45]

Diamond also praised the works of the French photographer Jean-Victor Warnod (1812–c. 1866): "They are of a size larger than the majority of instantaneous productions consisting of sea, cloud and shipping, and possess a delicacy and vigour with perfection of definition in the highest degree satisfactory."[46] Warnod was born Jean-Victor Macaire; he and his brothers Hippolyte-François (1804–52) and Louis-Cyrus (1807–71) had developed an international reputation for the production of instantaneous daguerreotypes of aquatic scenes. After Hippolyte's premature death, Cyrus and Jean-Victor formed a short but tempestuous partnership. For unknown reasons, Jean-Victor took his wife's name, Warnod, and in 1858, after his brother's studio in Le Havre burned down, he immediately announced that he would continue in business on his own.

44. Diamond 1863, 12.
45. Ibid.
46. Ibid., 13.

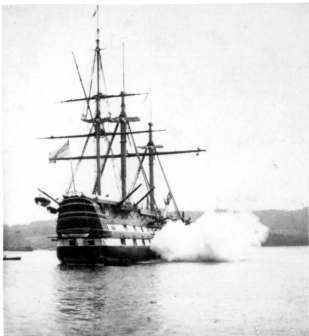

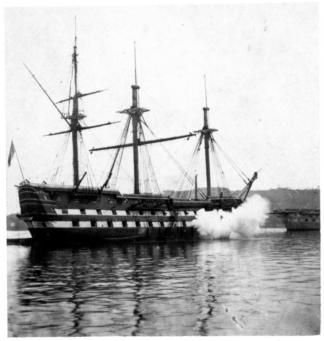
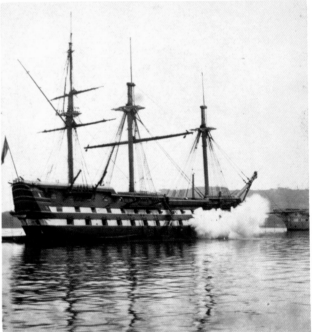

**Fig. 2-43 (top)**
George Washington Wilson
*H.M.S. Cambridge in Hamoaze, Great Gun Practice*, 1857
Stereo albumen print
7.6 x 15.4 cm

**Fig. 2-44 (bottom)**
George Washington Wilson
*H.M.S. Cambridge in Hamoaze, a Broadside*, 1857
Stereo albumen print
7.6 x 15.4 cm

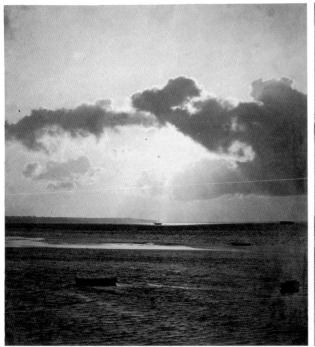
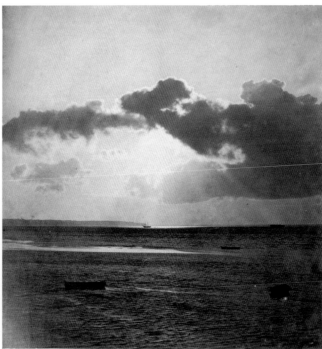

**Fig. 2-45 (top)**
George Washington Wilson
*View from Ryde Pier, Isle of Wight, Evening (Instantaneous)*, c. 1860
Stereo albumen print
7.5 x 14.3 cm

**Fig. 2-46 (bottom)**
Charles Breese (England, 1820–75)
*Moonlit Landscape*, c. 1861
Collodion on glass stereo slides
6.5 x 13.4 cm each
Ex-collection Ken and Jenny Jacobson

**Fig. 2-47**
Jean Victor Warnod
*Ships at Le Havre*
Albumen print
21.5 x 16.9 cm

As Ken Jacobson has pointed out, the Macaires enjoyed near-celebrity status in the French photographic press throughout the early 1850s for their instantaneous marine views, receiving more attention than even Le Gray would later.[47] One reviewer nearly burst with excitement when describing a particular Macaire daguerreotype of the sea. "This is, without contradiction, the most fantastic picture in the world," he wrote. Regrettably, modern viewers are unable to judge this extravagant appraisal for themselves. The Macaire–Warnod partnership seldom exhibited its works and sold them for such high prices that few were able to afford them. As a result, hardly any have been preserved, and those that have are of uncertain provenance. Nevertheless, those that do survive, such as Warnod's *Ships at Le Havre* (fig. 2-47), provide a hint of the photographer's style and subject matter.

Though he would become known for his instantaneous street scenes, the Scottish photographer George Washington Wilson was also an accomplished photographer of marine and atmospheric subjects. The photo-historian Roger Taylor has described his experiments in this field beginning in 1858, which reached an early apogee a year later in his celebrated *Loch of Park* series (fig. 2-48). Although these images are essentially snapshots, recording his family's holiday in a gamekeeper's cottage close to the village of Park, outside Aberdeen, they became landmarks in the history of photography. As Taylor described it, "On a fine summer's evening, Wilson took his camera down to the water's edge to make a series of photographs of various members of his family being rowed by Sandy,

47. Jacobson 2001, 27.

**Fig. 2-48**
George Washington Wilson
*Loch of Park, Aberdeenshire—Sunset*
   *(Instantaneous)*, 1859
Stereo albumen print
7.8 x 14.5 cm

48. Taylor 1981, 71.
49. *Liverpool and Manchester Photo-
     graphic Journal*, n.s., 1 (15
     March 1857): 57–58; cited in
     Jacobson 2001, 10.

the boatman."[48] He managed to take six photographs before the
setting sun disappeared behind the hills that surrounded them.
These photographs are remarkable not only for the action they
record, which was itself a considerable achievement, but also
because they were photographed facing into the sun in the
ebbing light of dusk. This made photography doubly difficult;
not only did Wilson have a very limited amount of light to work
with, but it was also angled in such a way that it was difficult to
make a balanced exposure. An enlargement of one of Wilson's
*Loch of Park* photographs used to hang in the Octagon at the
Royal Photographic Society. Attached to it was a plaque,
describing it as the "world's first instantaneous photograph."

As Taylor has noted, the *Loch of Park* photographs caused
great excitement when they were presented to photographic
journals for review. The editor of the *British Journal of Photogra-
phy*, George Shadbolt, compared them with the work of Le Gray,
echoing the theme raised in the *Liverpool and Manchester Photo-
graphic Journal*, which had condemned Le Gray's photographs as
"utterly untrue."[49] Shadbolt claimed that Wilson's works were

superior, because while Le Gray unintentionally gave the effect of moonlight (as a result of the image being underexposed, then overprinted), Wilson's gave a real effect of sunshine—"glorious, liquid golden sunshine."[50] His colleague the photographer Valentine Blanchard wrote, "I shall not forget my impressions on seeing for the first time his wonderful sunrise and sunset effects. The boldness of the idea which prompted him to turn the daring gaze of his lens at the sun—and coming suddenly too upon our old notion about the necessity of keeping the sun out of the lens, nearly took my breath away."[51] George Dawson also marveled at the depth of field exhibited in Wilson's prints: "He has reproduced with true effect the moving cloud and rippling water by the use of lenses of small aperture."[52]

### Street Life

Although mechanical shutters were not always useful in making instantaneous pictures, their use was explored from the earliest days of photography. By 1861 Samuel Highley was able to categorize instantaneous shutters into four main types: those that open and close the lens "with a motion similar to the opening and closing of a book cover, those in which a plate is slid across the lens, those in which the aperture of the lens is closed by a diagonal sweep, and those that open at the center of the lens." Less structured variants also exist, he noted, including Wilson's use of a "Glengarry cap," and Harwich's use of a piece of black cloth before the aperture.[53] Highley's article was accompanied by eight schematic drawings of shutters. Despite the experimental nature of these devices, many are strikingly sophisticated. Among the designers mentioned by Highley were Samuel Fry, Rouch, Dallmeyer, Murray and Heath, Leake, Sutton, Shadbolt, Ross, Skaife, Hockin, and Salvin.

William England (1815–80), one of the founding photographers of the London Stereoscopic Company, appears to have been among the first to use a mechanical shutter to obtain

50. Taylor 1981, 72.
51. Blanchard 1863, 5.
52. Dawson 1863, 138.
53. Highley 1861, 104–5.

**Fig. 2-49**
William England
*Rue de Rivoli, prise de l'Hotel du Louvre à
　Paris: Vue instantanée*, 1861
Stereo albumen print
7.1 x 14.6 cm

instantaneous street views (fig. 2-49). Writing in 1862, a cor-
respondent for the *British Journal of Photography*, George Daw-
son, described the contraption he used to photograph the
streets of Paris: "It acts along the guillotine principle by means
of a slot falling immediately in front of the sensitive plate; and
by a simple arrangement this slot can be lengthened or short-
ened, so as to vary the time of exposure." He went on: "I con-
sider it the only true method of delineating, with precision,
small objects in motion. . . . I consider Mr. England's plan to
be theoretically the best yet brought before the public for
instantaneous photography, and from the extraordinary speci-
mens we have already seen, we may expect the same con-
trivance, or some modification of it, to be generally
adopted."[54] The jury of the 1862 exhibition apparently agreed,
raving, "the photographs of Mr. England, executed for the Lon-
don Stereoscopic Company, are perfect and beautiful, espe-
cially those of his views of Paris."[55]

In the case of Muybridge, Dawson's words about the use of a
guillotine shutter for instantaneous photography were
prophetic. Although few photographers used the guillotine

54. Dawson 1862, 446.
55. Diamond 1863, 13.

shutter technique he described in the immediate aftermath of his suggestion, a variant of it was employed by Muybridge to make his instantaneous photographs. According to Highley, this type of shutter was first described on page 165 of his work *Photographic Manipulation*. The photographers Murray and Heath (active 1860s) improved the device with the addition of India rubber tubing to dampen the spring. A similar device was also said to be in use by the photographer Arthur Melhuish (active 1854–95). And, in an arrangement directly anticipating Muybridge's approach, the scientific photographer Warren de la Rue (1815–89) was said to have used a similar device for solar photography, activated using a trip wire. Unlike Muybridge's triggers, however, which used an electrical impulse to activate the shutters, de la Rue fired his device by using a "Lucifer match" to burn a retaining thread.[56]

Street scenes became one of the most popular instantaneous subjects. In the earliest days of the medium, photographers struggled to register moving subjects in cityscapes (figs.2-50a, b). Many early city scenes seem curiously deserted because exposure times were too long to register moving people. With exposures lasting many seconds or even minutes, people would either be recorded as ghostly blurs or would fail to register at all. Beginning in the late 1850s, however, photographers began to make photographs fast enough to capture their activities.

One of the most precocious of these photographs was made by the eccentric British photographer Charles Piazzi Smyth (1819–1900) in Novgorod, Russia, around 1857 (fig. 2-51). Smyth is perhaps best known as Scotland's astronomer royal, who resigned over disagreements regarding his research on the Egyptian pyramids. An avowed mystic, he believed they contained mathematical messages from God.[57] He was also an associate of John Herschel and visited him in South Africa at the Cape of Good Hope. Using a portable camera decades before they were commonplace, Smyth was able to photograph soldiers milling around a public square. Smyth made at least two versions

56. Highley 1861, 128.
57. His book *Great Pyramid: Its Secrets and Mysteries Revealed* is still in print.

**Fig. 2-50 a, b**
Auguste-Adolphe Bertsch
*La barrière blanche*, 1855
Two salt prints
22.2 x 19 cm each

This remarkable sequence of early photographs was made by Bertsch to test a new chemical formula. Shooting down on a public square, he recorded activities as they happened, anticipating snapshot photography by several decades. It is impossible to know how carefully Bertsch selected the time to make each photograph. However, the apparent objectivity of each is striking. The effect is not of contrived and composed photographs, but of surveillance. Many changes are visible between the two photographs. For example, in the second image the smoke rising from a distant factory has disappeared.

of the picture. One is in the collections of the Royal Observatory, Edinburgh, and the other is in a private collection. In the observatory version, a small collodion-on-glass slide, the subject is labeled "Unconscious Lookers On." The picture is not only years ahead of its time in instantaneous photography; it also anticipates theoretical developments in the medium by forty years or more. The idea of photographing people unaware prefigures works by twentieth-century photographers, such as Paul Strand's (1890–1976) portraits of people on the streets of New York and Walker Evans's (1903–70) secret photographs of passengers on the city's subway.

Blanchard described an especially ingenious method for making instantaneous photographs (fig. 2-52). Working in wet-plate collodion, as most photographers of the day did, it was necessary to have all the chemicals needed to prepare and process plates nearby when making a photograph. To get around this problem, Blanchard adapted a horse-drawn carriage as a

*OPPOSITE PAGE*
**Fig. 2-51**
Charles Piazzi Smyth
*Unconscious Lookers-on, Novgorod*, c. 1857
Collodion on glass negative
17 x 8.5 cm

darkroom. He would mount his camera and tripod on the roof of the cab and ask his driver take him around London. When he found an interesting view, he had the driver wait while an exposure was made. The plate could then be processed in the cab. At times, traffic was a serious obstacle. On one occasion, Blanchard said, his cabby managed to stop all traffic in and out of the Stock Exchange and Bank of England in the heart of the City of London, just so Blanchard could take an instantaneous photograph from the middle of the road. The cabby conned the local police into thinking that Blanchard was a crown surveyor working on official business, and this deceit enabled him to take one of his best photographs of the busy intersection.[58]

The field of instantaneous street photography was also pioneered by two photographers working simultaneously in the United States and Scotland. Wilson, fresh from the success of his *Loch of Park* photographs, began to photograph pedestrians from the upper stories of a building on Princes Street, Edinburgh, in 1859. These images were considered a great success, having captured passersby and carriages in the roadway in motion.[59] They were criticized at the time, however, for the amount of blurriness they displayed, and for a slight optical aberration caused by the lens used. The following year Wilson returned to Princes Street and took an improved series from the same vantage (fig. 2-53). These were followed by another, nearly identical series taken in 1863 and 1864 from the same position.[60]

Unknown to Wilson, the American photographer Edward Anthony (1819–88) had been making similar photographs of New York City at nearly the same time. As Roger Taylor has noted, Anthony sent samples of his views of Broadway to the British publication *Photographic Notes* in August of 1859, asking if anything comparable had been made in Europe (fig. 2-54). A reviewer for the *Notes* praised them, warning British photographers, tongue-in-cheek, to beware of an impending American onslaught. "We old-world stick-in-the mud fellows must take care or the Yankees will go a-head of us."[61] Anthony, whose

58.  Blanchard 1891, 157.
59.  Taylor 1981, 73.
60.  Taylor 1981, 73.
61.  *Photographic Notes*, 29 August 1859; cited in Taylor 1981, 73.

**Fig. 2-52**
Valentine Blanchard
*The National Gallery and St. Martin's Church,*
  *London, from Pall Mall,* before 1862
Stereo albumen print
7.7 x 15.6 cm

  Blanchard developed an ingenious
method of making instantaneous photo-
graphs. Working in wet-plate collodion, he
had to at hand all the chemicals needed to
prepare and process plates. To achieve this,
he outfitted a horse-drawn carriage as a
travelling darkroom. He would mount his
tripod and camera on its roof and drive
around London. When he found an interest-
ing view, he had the driver wait while an
exposure was made and the plate
processed. At times, fighting with traffic
was an obstacle.

*OPPOSITE PAGE*
**Fig. 2-53 (top)**
George Washington Wilson
*Princes Street, Edinburgh, Looking West,*
  1860 or 1863–64
Stereo albumen print
7.6 x 13.5 cm

**Fig. 2-54 (bottom)**
Edward Anthony
*Broadway—Burst of Sunlight after a Shower,*
  c. 1859
Stereo albumen print
7.4 x 15.4 cm

 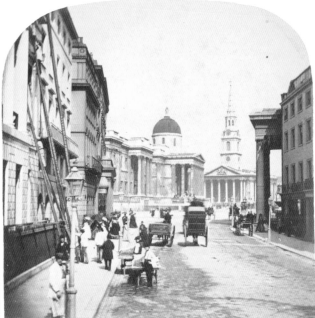

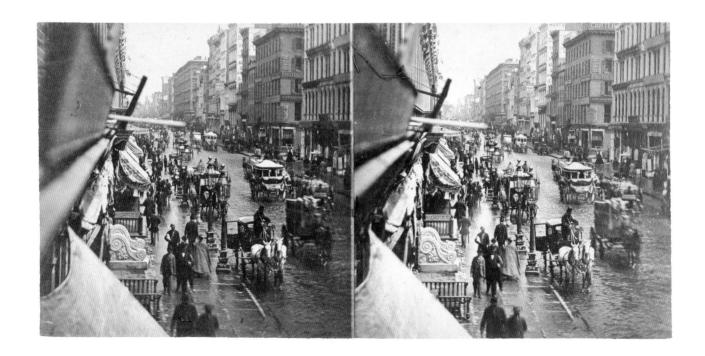

firm published the journal *Anthony's Photographic Bulletin*, went on to have a long and prosperous career in instantaneous photography. The *Bulletin* became an important source of information for the newest developments in chemistry, optics, and other instantaneous paraphernalia. And throughout the 1860s Anthony published hundreds of scenes of New York, from the harbor to Central Park, many with the description "instantaneous" included in the title.

## But Is It Real?

Marine views and street scenes remained the two main categories of instantaneous photography until the beginning of Muybridge's experiments in Palo Alto. There were, however, many other subjects to which instantaneous photographers applied themselves. Portraiture, genre scenes, pictures of animals, work and play, tricks by jugglers and clowns—in short, anything that showed action or movement—were considered the domain of the instantaneous photographer.

The problem with, and also the attraction of, these other types of subject matter is that they were much easier for the photographer to control. In a studio setting, for example, human beings can be told how to act, and their posture can be managed. In many cases it was easier for the photographer to pose sitters to look as though they were in motion than to actually photograph them that way. Maneuvers of this sort were sometimes unavoidable because real instantaneous pictures of rapidly moving subjects simply could not be achieved. Skillfully arranged, posed instantaneous scenes can be convincing. Critics frequently dismissed such pictures as "quasi-instantaneous," however, arguing that they represent an impure form of instantaneous photography. Nevertheless, the proliferation of these quasi-instantaneous pictures played an important role in shaping expectations about what could and should be depicted photographically and thus form an important part of the story of instantaneous photography (figs. 2-55–2-64).

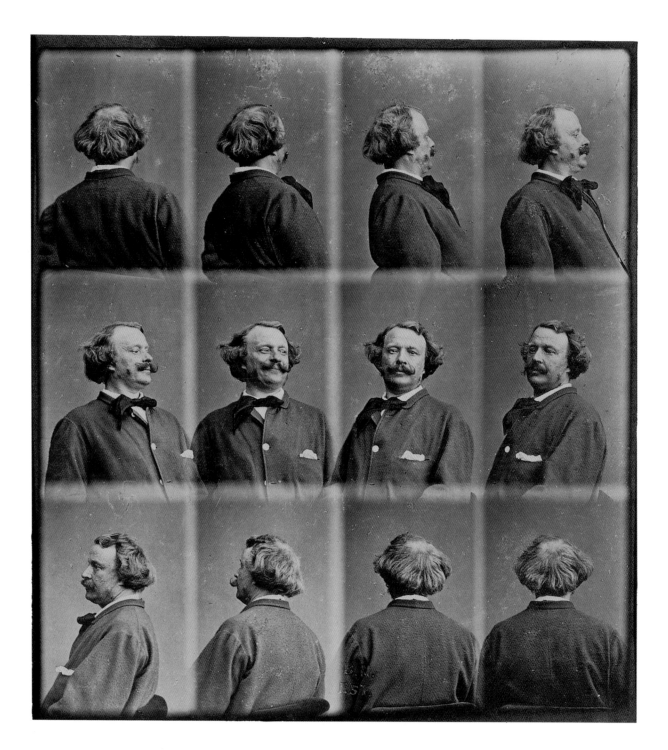

**Fig. 2-55**
Nadar (Gaspard-Félix Tournachon)
*Series Self-Portrait*, c. 1864
Albumen print
14.5 x 13.3 cm

**Fig. 2-56**
Geoffrey Bevington
*Glove Leather Dyers*, 1863
Albumen print
37 x 42 cm

**Fig. 2-57**
Léon Crémière
*Savage Expressions of a Dog and a She-Wolf*,
   October 1867
Woodburytype print
12.7 x 17.5 cm

   Animals were always challenging sub-
jects for instantaneous photography,
because they move unpredictably and don't
always behave according to the photogra-
pher's wishes. In this case, Crèmiere seems
to have found a solution to these problems.
The dog and she-wolf in this picture are
almost certainly stuffed.

**Fig. 2-58**
Louis-Jean Delton
*Riders in the Bois de Boulogne*, 1882, from
the series *Le Tour de Bois*
Albumen print
27 x 35.5 cm

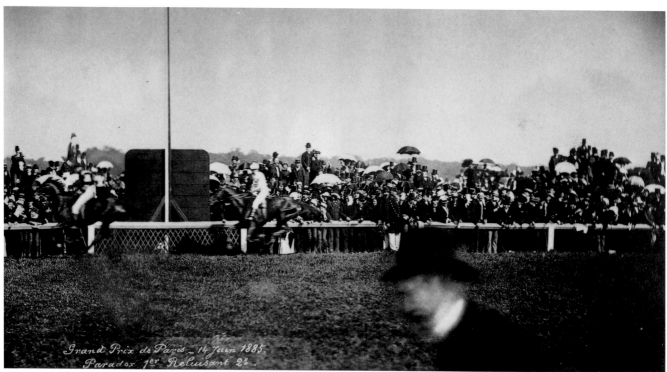

**Fig. 2-59**
Louis-Jean Delton
*Longchamp, Grand Prix de Paris, Paradox
First, Reluisant Second*, 14 June 1885
Albumen print
9.5 x 18.8 cm

**Fig. 2-60**
Louis-Jean Delton
*Bicycle, Acrobatic Maneuvers*, c. 1868
Albumen print
18.1 x 13.5 cm

**Fig. 2-61**
Adrien Tournachon
*Meeting Interrupted by an
 Ape*, 1861
Albumen print
7.4 x 9.9 cm

**Fig. 2-62 (below)**
Adrien Tournachon
*Tug of War*, 1861
Albumen print
7.4 x 9.9 cm

*OVERLEAF*
**Fig. 2-63 (left)**
Louis-Jean Delton
*The Clowns Georges and
 Sarinel*, 21 August 1863
Albumen print
19.4 x 15.4 cm
   Delton wanted viewers to
know that this wonderfully
dynamic image was not
posed, but a genuine instan-
taneous photograph. He
signed his name on the
mount with the words, "Cer-
tified taken in exactly one
shot, 21 August 1863."

**Fig. 2-64 (right)**
Louis-Jean Delton
*The Clowns Georges and
 Sarinel (Violin)*, 21 August
 1863
Albumen print
19.4 x 15.4 cm

Dr. John Adamson (1810–70) is an excellent example of a photographer who employed both genuine and simulated instantaneity in his pictures. His extremely early photograph *An Athlete* (fig. 2-65), for instance, was made around 1842, just three years after the announcement of the invention of photography. It is clearly posed. In a scene reminiscent of Muybridge's studies of athletes made more than thirty-five years later, the subject was seemingly arrested in mid-stride, shown in what Alexander Sturgis has described as the conventional "movement" pose of a drawing or painting, with one foot firmly planted on the ground. In spite of this, the photograph must still be considered a significant accomplishment. Even the awkward balance of the subject and his raised arms would have been difficult to record using available materials.

In another picture by Adamson taken around the same time, real instantaneity is more evident. His *Street Scene with Flags* (fig. 2-66) reveals the subtle movement of a breeze as well as the energetic hubbub of the people below. Using natural light and calotype materials, he somehow managed to create a scene that is utterly photographic, anticipating developments in instantaneous photography by many years.

Similarly, the partnership of David Octavius Hill (1802–70) and Robert Adamson (1821–48) worked to combine modest achievement in instantaneous photography with artfully contrived scenes. (Robert Adamson was John Adamson's brother.) Like John Adamson's *Athlete*, Hill and Adamson's portrait *Mr. Laing as a Tennis Player* (fig. 2-67) shows a figure seemingly engaged in a sporting contest. He recoils slightly, as if ready to receive a shot, and the seriousness of his expression suggests that a ball is whistling in his direction. In reality, Laing is quite still. He was probably dressed in tennis attire specifically for the sitting.

Hill and Adamson's picture of women and children in a market square, *Fishergate, St. Andrews* (fig. 2-68), provides a more complex example. A single woman strides purposefully across

**Fig. 2-65**
John Adamson (Scotland, 1810–70)
*An Athlete*, c. 1842
Calotype
30 x 30 cm
Royal Scottish Museum, Edinburgh,
    1942.1.1.75
Photo: The Trustees of the National
    Museums of Scotland

**Fig. 2-66**
John Adamson (Scotland, 1810–70)
*Street Scene with Flags*, c. 1842
Calotype
30 x 30 cm
Royal Scottish Museum, Edinburgh,
    1942.1.1.200
Photo: The Trustees of the National
    Museums of Scotland

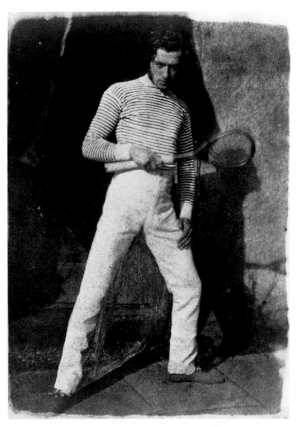

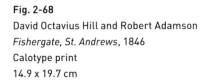

**Fig. 2-68**
David Octavius Hill and Robert Adamson
*Fishergate, St. Andrews*, 1846
Calotype print
14.9 x 19.7 cm

**Fig. 2-67**
David Octavius Hill and
    Robert Adamson
*Mr. Laing as a Tennis Player*,
    c. 1843–47
Calotype print
20.8 x 15.7 cm
Scottish National Portrait
    Gallery, Edinburgh,
    Laing (1)g

the foreground of the picture, while the others, decidedly stationary, look on. Nevertheless, there is a surprisingly unaffected quality to the motionless figures and a naturalness to the moving woman that belie the artificiality of the scene. The ability to render even rigidly constructed compositions with sensitivity and artistic expression is one of the defining characteristics of the Hill and Adamson partnership.

But humans were not the only subjects that could be posed; even animals could be made to comport themselves for the camera. Frank Haes (1832–1916), who photographed at the London Zoological Gardens in the 1860s, used Dallmeyer lenses, as Muybridge would later do, to photograph animal specimens. Haes was unable to take pictures of animals in motion and instead resorted to tiring the animals out before he photographed them. In a lecture on the history of animal photography, he described his technique: "Of course, the only method of working in those days was wet collodion, and younger photographers can have little idea what it meant to run an animal about in its enclosure on a broiling hot day, endeavouring to tire him out; then rush off, shut yourself off in a closed tent to prepare your plate, coming out with eyes watering from the ether vapour, to find your subject refreshed by the interval of rest, and having to commence *de novo*, knowing that your plate was rapidly spoiling."[62] Even when the subject depicted was real, the circumstances behind a picture were not always obvious.

In the same way, the enthusiastic amateur Count de Montizon (active 1853–55) specialized in photographing animals but confined himself to those he could easily work with. Though he was renowned for his animal photographs, the subjects of his pictures are nearly all extremely slow-moving creatures. His *Hippopotamus at the Zoological Gardens, Regent's Park, London* is notable more for the instantaneity of the crowd behind it than for the animal itself (fig. 2-69). The hippo lies splayed out in front of the crowd, showing little sign of motion. It could as easily be stuffed as alive. Montizon's photographs inevitably fea-

62. Haes 1892, 39.

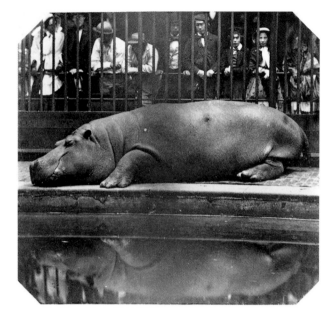

**Fig. 2-69 (top)**
Count de Montizon
*Hippopotamus at the Zoological Gardens,*
  *Regent's Park, London,* 1855
Salt print
11.2 x 12.1 cm

**Fig. 2-70 (bottom)**
John Dillwyn Llewelyn
*Two Birds at a Rustic Cottage,* 1852
Calotype print
17 x 22.9 cm

ture animals of this type—a crane or pike, for example—which remain still for long periods of time.

One of the more surprising entrants to the category of animal photography was John Dillwyn Llewelyn, whose photographs of breaking waves at Caswell Bay had so impressed critics in 1855. Before undertaking that series, he had experimented with elaborate tableaux of birds and other animals, posed to look as though they had been caught in action. His photograph *Two Birds at a Rustic Cottage* (fig. 2-70), for example, almost certainly employed taxidermic specimens and not live animals. Their artful placement outdoors, in a genuine rural environment, gives them a surreal but convincing look. Llewelyn continued to experiment with animal arrangements of this sort even after he achieved success in real instantaneous photography. The Royal Photographic Society collection, for example, contains numerous examples of carefully contrived pictures by Llewelyn of an otter seeming to cross a stream. It wasn't until the 1880s, when Charles Reid (1837–1927) would tackle the same subject using rapid gelatin dry-plate materials, that such a photograph would really be possible.

Two extreme examples of posed, or quasi-instantaneous, photography were provided by Rejlander and the French photographer André-Adolphe-Eugène Disdéri (1819–90). In their respective images of jugglers, each made around 1860–61, the photographers used invisible wires to suspend objects that are supposedly traveling in air. Rejlander's juggler (fig. 2-71) attends to four balls, two of which are shown in his hands, with another two levitating above his head. Disdéri's hero is similarly engaged (fig. 2-72), though in his case a more menacing

**Fig. 2-71**
Oscar Gustave Rejlander
*Juggler*, c. 1860
Platinum print
14.5 x 19.5 cm

The unnaturally even spacing of the flying balls, their sharp focus without a hint of blurriness, and the relaxed, even blasé expression of the juggler combine to convince the viewer that it is not real action that is depicted in this picture, but a facsimile. This image is probably a composite print, made artificially in the studio by combining a negative of the figure with one or more separate negatives of balls printed into the area above him.

**Fig. 2-72**
André-Adolphe-Eugène Disdéri
*The Juggler Manoel*, 1861
Albumen print
20 x 23.3 cm

**Fig. 2-73**
André-Adolphe-Eugène Disdéri
*A Lesson*, c. 1854
Salt print
11.4 x 16.8 cm

**Fig. 2-74**
André-Adolphe-Eugène Disdéri
*Digo Djanetto with Dog*, c. 1854
Salt print
15.2 x 12.2 cm

group of machete knives seemingly hurtle through space above him. Each image is scarcely believable. The unnaturally even spacing of the flying objects; their sharp focus, without a hint of blurriness; and the relaxed, even blasé look of the jugglers themselves combine to convince the viewer that it is not real action that is depicted, but a facsimile.

In these examples, however, perhaps this is the point. With their jugglers, Rejlander and Disdéri proffer a mischievous jab at the instantaneous photography movement. Both photographers were quite capable of creating truly instantaneous pictures. Rejlander, for example, had made a career out of providing studies of human expressions for artists to use in their compositions. Charles Darwin was so drawn to this facility with fleeting behaviors that in 1872 he commissioned Rejlander to provide illustrations for his photographically illustrated book *The Expression of the Emotions in Man and Animals*. Disdéri too was renowned for his mastery of instantaneous imagery. Around 1854 he produced a landmark group of salt prints in which subtle human interactions were explored. The charming instantaneous pictures *A Lesson* (fig. 2-73) and *Digo Djanetto with Dog* (fig. 2-74) were both made during this period.

Rejlander and Disdéri may have felt that the obsession with instantaneous photography was ripe for satire. Journals were brimming with critiques of instantaneous photographs, debates over the meaning of instantaneity, and advice for taking more and better instantaneous photographs. Exhibitions provided a forum for instantaneous photographs to be shown, and prizes were given to the most successful entries. The public clamored for fresh imagery and pushed photographers to strive for increasingly impressive pictures. Yet, as the juggler photographs remind us, the kind of instantaneity that could freeze rapid action remained elusive throughout this period, much as the balls and knives of the jugglers seemed forever out of reach. It was into this predicament that Muybridge entered in 1872.

# Make It Stop
## Muybridge and the New Frontier in Instantaneous Photography

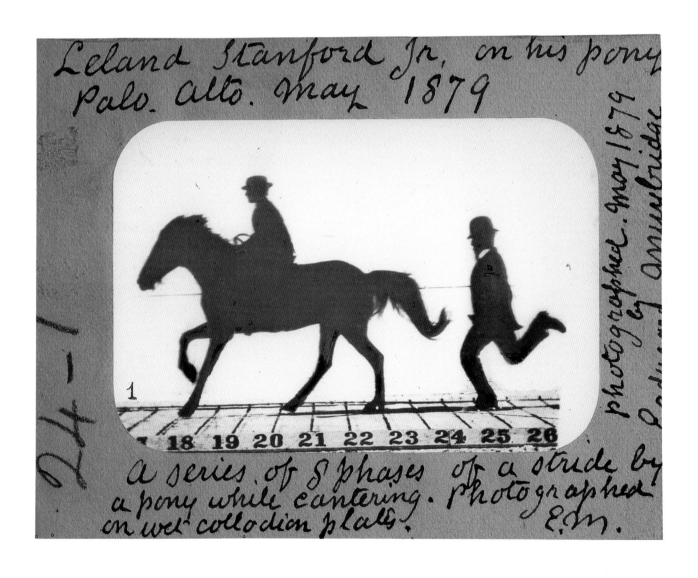

In the 1930s and 1940s several would-be filmmakers hoped to make movies about the life and work of Eadweard Muybridge. It was only natural. Muybridge was at that time widely considered to have been one of the inventors of cinematography, at least in the United States. It was the so-called golden age of Hollywood, and yet within this young upstart industry there was a certain insecurity about the medium. Muybridge and his story offered legitimization in the form of a creation myth. Better still, he had built his first motion picture projector in California, and his life had been sensational in the extreme. Sex, violence, and a touch of brooding inscrutability were more than some could resist. And so partial scripts and treatments began to circulate among the studios. None of these was ever made into a feature film. World War II caused a shift in priorities that made the tale of an eccentric English photographer seem less appealing. Nevertheless, fragments of these early treatments still exist, providing a fascinating window on the shifting understanding of Muybridge and his work.

The most complete of these movie treatments is preserved in the Jane and Michael Wilson collection in London. It was written around 1930 by the former curator of the Stanford Museum, Harry Peterson (1876–1941),[1] who was an early chronicler of Muybridge and who published several notable articles about his work. The treatment was never published; nor was it ever made into a film. Although it contains many factual errors, which is uncharacteristic of the work of the normally thorough Peterson, it does echo some of the positions he took in his publications. Stylistically it also displays a panache typical of his writings.

Peterson called his picture "The Birth of Movies, or From Cave Man to Edison." It was to begin with a flashback through art history. A caveman was to be shown scrawling a picture of a horse across the wall of a cave. This was to be interspersed with reproductions of the famous Neolithic drawings in Altamira and Cogul. A quick fade, and the bisons at Font de Gaume would appear, followed by Assyrian tablets, Egyptian monuments,

OPPOSITE PAGE
Fig. 3-1
Eadweard Muybridge
*Leland Stanford on His Pony "Gypsy"—Phases of a Stride by a Pony While Cantering,* May 1879 (detail of fig. 3-2)
Lantern slide; glass collodion positive
5.4 x 7.6 cm

1.    The manuscript is undated but refers to "Modern Pathe films." The Pathe film company was absorbed into RKO in 1932 and ceased operations under the Pathe name.

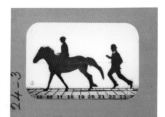
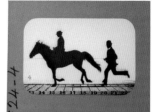
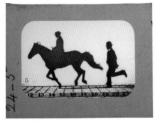
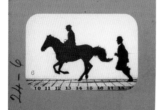
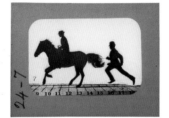
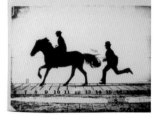

**Fig. 3-2**
Eadweard Muybridge
*Leland Stanford on His Pony "Gypsy"—Phases of a Stride by a Pony While Cantering,* May 1879
Series of eight lantern slides; glass collodion positives
5.4 x 7.6 cm each

This series of glass positives was designed to be shown using a candle-lit slide projector called a Magic Lantern. Before inventing his motion picture projector, the zoopraxiscope, Muybridge used slides like these to give public presentations of his work.

2. Harry C. Peterson, "Muybridge Movie Treatment," c. 1930, Jane and Michael Wilson collection, 1.

Aztec, Greek, Eskimo, and American Indian examples, "all illustrations from authentic sources," he specified, and "all directly tending toward the depiction of one thing—motion."[2]

Then, Peterson planned, the picture would cut to a scene of Muybridge leaving his home in Wales for America "to make good." A tearful good-bye, and he would be shown promising to send for his sweetheart just as soon as he had enough money to support her. Working as a cabinetmaker in New York, he would quickly earn the funds to send for his lover. But he would buy a camera instead, enticed by a meeting with Samuel Morse (1791–1872), the inventor best known for his perfection of the telegraph machine, but himself an important photographic innovator. Muybridge would make his first pictures of New York City. They would be well received by critics, and his photographic career would be launched.

According to the screen version of events, news of Muybridge's prowess would make its way to the halls of power in Washington, D.C. He would be given a lucrative commission to photograph the Pacific Coast for the United States Geologic Survey. The infusion of cash would finally make it possible for him to send for his pining British sweetheart. They would meet in San Francisco. He would travel via Panama, where he would take some impressive pictures. She would go directly to California.

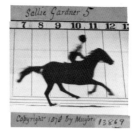
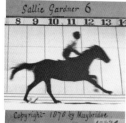
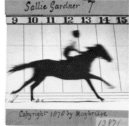
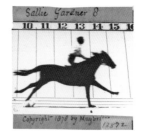
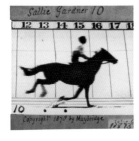
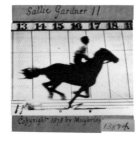

**Fig. 3-3**
Eadweard Muybridge
*"Sallie Gardner" Galloping (Phases 1, 2, 5, 6, 7, 8, 10 and 11)*, 1878
Series of eight lantern slides; glass collo-
dion positives
5.4 x 7.6 cm each

3.   Harry C. Peterson, "Syn-
opsis of 'The Birth of Movies,
or From Cave Man to Edison,'"
Jane and Michael Wilson col-
lection, 1.

The delay would enable Ead-
weard and the future Mrs.
Muybridge to arrive in San
Francisco at the same time.
Reunited, they would marry
and buy a charming cottage.
With Muybridge a successful
and established photogra-
pher, the scene would be set
for his fateful introduction to
Stanford and the start of their
project of photographing
horses in motion.

Most of the biographical informa-
tion Peterson hoped to present in his
film was simply untrue. It is impossi-
ble to know how much of this was mere
poetic license, intended to provide
continuity and entertainment for the
movie-going public. In a separate let-
ter Peterson wrote that it would be "folly" to attempt a film
visualization of all the historical incidents in Muybridge's life
without giving them a logical sequence. The value of the film
would be lost, he wrote, because "no audience would sit
through it."[3] Still, for what he claimed would be an educa-
tional project, he took enormous liberties with the truth. The
version of events related in the movie treatment is based only
very loosely on reality, and contains a number of flagrant
inaccuracies.

Muybridge was not born in Wales; in fact, he does not appear
to have had any connection to the country at all. It may be that
his unusual name struck Peterson as Welsh in origin (it is not),
but the circumstances of his childhood are now well docu-
mented. The birth of Edward James Muggeridge, who would
later take the name Eadweard Muybridge, was recorded in the

parish register in the Church of All Saints in Kingston-on-Thames, just outside London, in 1830.[4] He was born on April 9 at 30 High Street, formerly known as Towns End. His mother, Susannah, was a native of Kingston, who died in April of 1874 at age sixty-six. When and how Muybridge received news of his mother's passing is not known, but it is interesting to note that her death occurred just six months prior to the notorious Larkyns affair, in which Muybridge killed his wife's lover. Historians have never noted this connection, but it may have been critical to Muybridge's mental state that autumn. The news may have taken a month or more to reach him in California and must have been a potent ingredient in the cocktail of emotions percolating through his mind as he set out to find Harry Larkyns that fateful October.

Muybridge's father, John, was a merchant in Kingston. The business seems to have been successful in terms of longevity, though it may not have been particularly prosperous. The tax registers of 1840 list the premises as rented, and based on the entries in the Muggeridge family birth registries, John's occupation seems to have switched from "coal merchant" to "corn merchant" (the British word *corn* means grain in American parlance) shortly after Eadweard was born. Some scholars have described John as a coal and corn merchant, but there is no evidence he ever sold both products simultaneously. John died fairly young, at age forty-six, in 1843, when Muybridge was just thirteen. And though the Muggeridge family business does appear in the 1839 Kingston business directory, by 1864 it had disappeared. Muybridge did have an older brother, also named John, who died in 1847, and two younger brothers, George and Thomas, both of whom immigrated to San Francisco.

According to Peterson's movie script, Eadweard Muybridge left his English girlfriend behind in order to find his fortune in the New World. He went to New York to become a cabinetmaker and raise money to send for her. In fact, the idea that there was a love interest involved in his decision to leave seems to have

4. This information, and much that follows, is extracted from copies of records kept in the archives of the Kingston Museum and Heritage Service.

been a complete fabrication. And there is little to suggest that Muybridge ever made cabinets. He is known to have settled in New York City in or around 1852, but the route he took to get there is a matter of speculation. It has been suggested that he first worked in London. While this is a reasonable proposition, there is nothing to substantiate it. No records of Muybridge's departure have ever been found. Even the date of his leaving, 1852, remains an educated guess.

What is clear is that Muybridge settled in New York in the early to mid-1850s and quickly embarked on a career as a book merchant. He was an agent of the London Printing and Publishing Company, arranging the importation of unbound books from London for their binding and sale in the United States. He also seems to have worked for the firm of Johnson, Fry and Company, an American publishing company with offices in Boston, New York, and Philadelphia. As the historian Robert Bartlett Haas has noted, his work at this point seems to have involved a considerable amount of travel. In his personal scrapbook, now in the collections of the Kingston Museum and Heritage Service, visits to numerous American cities are mentioned, including New Orleans and "other shipping points in the United States."[5] This inclination to travel and explore distant corners of the continent would later find expression in his landscape work.

Muybridge's involvement in the book trade, too, prefigured events in later life. The sale of books in the nineteenth century was closely entwined with the sale of photographs, as book retailers would often sell photographs in their shops. But it is also important to note that Muybridge consistently thought of his photographic works as potential publications. The history of his photographic career is in part a history of his desire to make illustrated books. Beginning with his self-published *Attitudes of Animals in Motion* in 1881, through his encyclopedic *Animal Locomotion* of 1887, and the final compilations *Animals in Motion* (1899) and *The Human Figure in Motion* (1901),

5.   Haas 1976, 5.

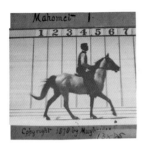
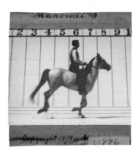
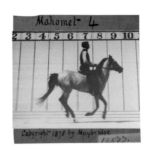

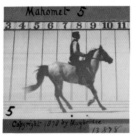
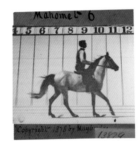

Fig. 3-4
Eadweard Muybridge
*"Mahomet" (Phases 1, 3, 4, 5, and 6)*, 1878
Series of five lantern slides; glass collodion
   positives
5.4 x 7.6 cm each

6.   There is some confusion concerning which member of the Selleck family may have introduced Muybridge to photography. Haas asserted that Muybridge's friend Silas T. Selleck, who testified at his murder trial and with whom he later worked in San Francisco, may have taught him. But it is not entirely clear that Silas T. Selleck was himself a professional photographer in New York. Silas W. Selleck, however, presumably his son or brother, does seem to have been. Silas T. is reported to have been "working in" photography, as Haas (1976, 5) explained, but it is not clear whether that meant commercially, or for his own amusement.

prepared in his retirement, Muybridge often returned to the bound book as the form in which his works would be presented. With few exceptions, his motion studies were never meant to be framed and hung on a gallery wall. Ever sensitive to questions of profit, he did sell his plates individually. It was his preference, however, that they be used as pages in a comprehensive reference book. Their sale and distribution would therefore be conducted according to the rules of the book trade. And, from an artistic standpoint, plates would not be seen in isolation but would play off one another as the viewer turned the pages. Furthermore, the experience of seeing them would be more intimate than a gallery setting might afford.

It is not known how Muybridge became interested in photography or precisely where he received his training. Peterson nominated Samuel Morse for the role, but there is no evidence that he taught Muybridge directly. Morse was an influential figure in American photography who had a hand in the careers of many early photographers. One of them appears to have been the daguerreotypist Silas T. Selleck (active 1850s–70s), whom Haas identified as a friend of the photographer Mathew Brady (1823–96).[6] A rival historian, Gordon Hendricks, described Selleck as an employee in the Brady firm, but without identifying the source of this information.[7]

The relationship between Muybridge and Selleck is poorly understood. It may be surmised, however, that Selleck, like Muybridge, was engaged in bookbinding and printing and appears to have taken up photography as an extension of his

business. He later testified in Muybridge's murder trial that he had known him during his residence in New York.[8] Though it may be supposed that Muybridge would thus have been introduced to photography and the idea of running a photographic business, there are simply too many uncertainties to lend any weight to the claim. And there is little to substantiate the idea that Selleck taught Muybridge how to photograph. Certainly it would be ten years or more before Muybridge would take up photography seriously. Throughout the 1850s and early 1860s he remained a printer, binder, and bookseller.

Equally obscure are the reasons Muybridge left New York for California. Neither Haas nor Hendricks provides a satisfactory explanation, though each suggests that Selleck, who also left for California at about this time, may have been involved. Haas claimed that Selleck left New York before Muybridge in order to become a gold prospector. If his prospecting failed, according to Haas, he planned to fall back on a photographic career. Reports of his success (though it is not known how, or in what) purportedly made their way back to Muybridge, encouraging him to join Selleck in the West. As appealing as this version of events may seem, there is again no evidence that this was the case. Indeed, there is no proof that Selleck even went to California before Muybridge did. It is highly likely, however, as both Haas and Hendricks note, that San Francisco was booming as a result of the 1849 gold rush when Muybridge left New York, although at the end of 1855, when he most likely arrived, the city suffered an economic collapse.

Despite the unhealthy financial climate, Muybridge quickly set up shop as a bookseller at 113 Montgomery Street. The first evidence of his presence there appeared in an advertisement for a salesman "to obtain subscribers for a new illustrated standard work," which appeared in the *San Francisco Daily Evening Bulletin* on April 28, 1856.[9] The title of the publication was not given. Having changed his name from Muggeridge (which he had begun to spell "Muggridge") to Muygridge, he also contin-

Most photographic references do not distinguish between the two presumed relatives, referring only to "Silas Selleck." The essential point, however, is that Muybridge may have learned photography, or may simply have become interested in the medium, from one or both of them.

Nevertheless, Haas's claims about Selleck should be viewed with caution. For example, he describes "an unending round of sitters" visiting the Selleck studio (Haas 1976, 5). He also cites the New York City directory as listing S. T. Selleck as a "printer," though there is no reason to suppose this meant a photographic printer. There is no way of knowing how successful either photographer was or precisely when each began his career. Works by both are rare, and attributions are typically vague.

7.  Hendricks 1975, 5.
8.  Haas 1976, 5.
9.  As cited in Hendricks 1975, 5.

ued as an agent for the London Printing and Publishing Company, effectively running two separate but related businesses. Both prospered, so that by 1858 his brother George (interestingly, also named Muygridge at this point) had joined him. George suffered from tuberculosis and may have died in San Francisco later that year.[10] Soon the youngest brother, Thomas, also arrived. In 1860 Eadweard Muybridge decided to return to New York and London. He advertised that he would travel to "New York, London, Paris, Rome, Berlin, Vienna etc." and would accept "orders or commissions for the purchase of Works of Literature or Art entrusted to me."[11] He put the bookstore in the hands of a music publisher named Matt Gray and left the London Printing and Publishing Company business under the direction of his brother Thomas.[12] On July 2, 1860, he left for New York.

The trip to New York proved fateful. Instead of traveling in the relative comfort of an ocean liner, Muybridge opted for the comparatively grueling method of a stagecoach operated by the Overland Stage Company. It may be that he had missed the boat he had intended to take; Hendricks asserted that he was booked on a boat called the *Golden Age* but missed it as a result of a longer than planned visit to the Yosemite Valley.[13] Haas, by contrast, claimed that Muybridge decided to travel by land in order to see new regions of the United States.[14] Whatever the case, it was an arduous journey, taking about six weeks to travel from San Francisco to Saint Louis, from whence he could travel by train.

About halfway into the trip, in northeastern Texas, the stage crashed, and Muybridge was seriously injured. Reports of the incident appeared in both the *San Francisco Daily Evening Bulletin* and the *Alta California*:

> The Overland Mail Coach, with San Francisco dates to the 2d of July, arrived at half-past 10 o'clock this morning, with some of the passengers who received injuries at

10. See Haas 1976, 8. Family records indicate that George died in 1858, which would place him in San Francisco at the time of his death. But his whereabouts have not been established.
11. *San Francisco Daily Evening Bulletin*, 15 May 1860; cited in Hendricks 1975, 10.
12. Haas 1976, 9.
13. Hendricks 1975, 10.
14. Haas 1976, 10.

**Fig. 3-5**

Jacob Davis Babcock Stillman

Page from *The Horse in Motion, as Shown by Instantaneous Photography with a Study on Animal Mechanics, Founded on Anatomy and the Revelations of the Camera, in Which Is Demonstrated the Theory of Quadrupedal Locomotion*, 1882

Quarto: 31 x 24 x 5.3 cm

This bound book contains five heliotype photographs and ninety-one photo-lithographs of drawings made after photographs by Eadweard Muybridge.

Its publication provoked a fierce disagreement between Muybridge and Leland Stanford, poisoning their partnership. Stanford commissioned Stillman to write the book based on Muybridge's photographs. But rather than credit Muybridge as a co-author or originator of the research, he was identified merely as a technician. This infuriated Muybridge, who learned of the slight during a lecture tour of Europe, because it roused skepticism about his claims among European scholars by suggesting he was only a minor participant in the endeavor. Eventually Muybridge sued Stanford but lost and severed ties with him, launching his career as an independent photographic researcher. In addition to the issue of proper credit, Muybridge was disappointed that the book was made not with original photographs, but with less expensive lithographic reproductions.

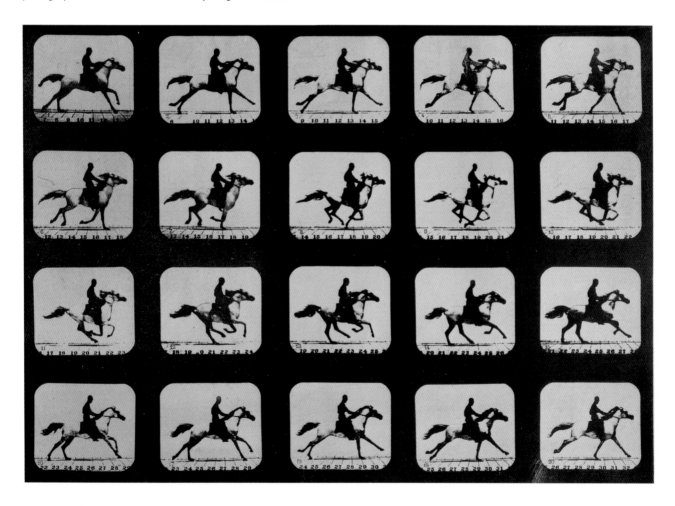

Mountain Station by the running away of a team, the particulars of which are as follows: The stage left Mountain Station with several passengers, besides the driver and Mr Stout, a road-master, in the employ of the Overland Company, who was acting as conductor. On leaving the stable, the driver cracked his whip and the horses immediately started on a run. When they arrived at the brow of the mountain the brakes were applied, but were found to be useless. In his efforts to stop his horses, the driver drove out of the road, and they came in collision with a tree, literally smashing the coach in pieces, killing one man named Mackey, a drover from Casseville, Mo., who was on his return from California, and injuring every other person on the stage to a greater or less extent. Mr Stout was severely cut in the face, and had his nose completely flattened. He also complained of internal injuries. Several of the injured remained here for the rest of the stage.[15]

Muybridge later recalled that he had been alarmed by the ride in the coach and knew that an accident was imminent. He was trying to cut his way out of the back with a knife when it crashed. He was knocked unconscious and had no memory of the impact. He came to about 150 miles away, in Fort Smith. When he awoke, his head was bandaged, he had double vision, and he could not taste, smell, or hear. He continued on to New York, but the deafness and double vision persisted. He stayed there for about two months, under the care of a Dr. Parker. When the worst of the symptoms subsided, he traveled to England, probably in the early winter of 1860–61. In London he was attended by Sir William Gull, who was Queen Victoria's private physician.[16] According to Muybridge, he was under constant care for more than a year after his accident.

Muybridge's stagecoach accident has been a subject of considerable interest among scholars. Recently the psychologist Arthur Shimamura published a persuasive paper assessing its clinical impact. He argues that Muybridge experienced an

15. *San Francisco Evening Bulletin*, 7 August 1860; cited in Hendricks 1975, 11.
16. Hendricks 1975, 13. Muybridge actually wrote that the doctor's name was "Dr. Sir William Garrell." The misspelling suggests that he may not have visited the physician often.

injury to the anterior part of the frontal lobe of the brain, an area known as the orbitofrontal cortex. This area is associated with the control and regulation of emotions, and Shimamura argues that the sometimes erratic behavior Muybridge displayed after his injury may be traced to damage in this area.[17] Frontal lobe injuries can result in unpredictable and even violent behavior, which might help to explain Muybridge's murder of his wife's lover in 1874. Muybridge also notoriously engaged in numerous legal battles, the result of an apparent inability to resolve matters in a less contentious manner. Those who suffer frontal lobe damage may also exhibit obsessive-compulsive disorder, which may have manifested itself in the single-minded determination he applied to his photographic efforts from 1884 to 1886 in Philadelphia, where he produced thousands of photographic negatives.

Muybridge was also said to be eccentric, moody, and cantankerous. This too can result from frontal lobe damage. Many of his colleagues remarked on the change in his personality after he returned to San Francisco from England in 1866. Shimamura has studied accounts of his personality and collected references in which the change in his personality after the accident is discussed. Excerpted from Muybridge's murder trial, they provide fascinating reading:

> Silas Selleck, photographer, called and sworn—Resides in San Francisco; known Muybridge for 26 or 27 years. . . . Muybridge, from 1852 to 1867, was a genial, pleasant and quick business man; after his return from Europe he was very eccentric, and so very unlike his way before going; the change in his appearance was such that I could scarcely recognize him after his return (*Sacramento Union*, 5 February 1875).

Silas Selleck testified that before Muybridge's trip East he was active, energetic, strict in all his dealings, open and candid. When he came back he had changed entirely. He

17. Arthur Shimamura, "Muybridge in Motion: Travels in Art, Emotion, and Neurology," in *History of Photography* (in press).

was eccentric, peculiar, and had the queerest of odd notions, so much so that he seemed like a different man (*San Francisco Chronicle*, 6 February 1875).

M. Gray, called and sworn—Resides in San Francisco; been there twenty years. Knew the defendant for twenty years intimately. Remember his going to Europe in 1859. . . . Was much less irritable than after his return; was much more careless in dress after his return; was not as good a business man. . . . Has not been the same man in any respect since (*Sacramento Union*, 5 February 1875).

J. G. Easland testified that he had been intimately acquainted with Muybridge for a number of years before and after his European trip. Heard of the accident to him on the trip. After his return I noticed certain eccentricities of speech, manner, and action, and my impression formed thereof. I thought the change was such that had I heard of this killing before the accident it would have surprised me, but occurring after it did not (*San Francisco Chronicle*, 6 February 1875).

Shimamura also notes that frontal lobe damage may result in increased risk-taking behavior. Patients may become quixotic and embark on absurd projects, such as Muybridge's seemingly impossible attempt to make instantaneous photographs in 1872. Such an injury might also lead to a career change, such as the switch from bookseller to photographer shortly after his accident.[18]

Shimamura makes a compelling case, and there is no doubt that much of Muybridge's behavior after the accident could be attributed to frontal lobe damage. The extent to which his actions may be ascribed to his injury is impossible to assess, however, and there will likely never be a thoroughly reliable clinical appraisal of his mental health. For each of the behaviors

18. Ibid.

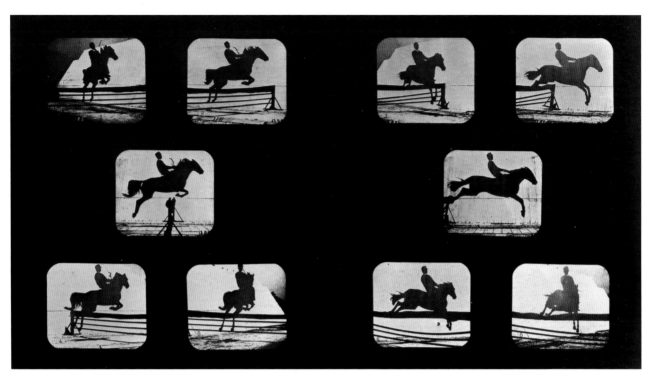

**Fig. 3-6**
Eadweard Muybridge
*"Phryne L" Leaping*, 1879, plates 173–74
    from the series *Attitudes of Animals in
    Motion*
Printing-out paper print
16 x 22.4 cm

noted by Shimamura, alternative explanations can be offered. It may be argued, for example, that the testimony at the murder trial is unreliable. If witnesses felt that establishing a change in Muybridge's mental state would help in his defense, they may have tried to exaggerate or even make up testimony to that effect. It is interesting to note that those who testified about his altered personality were friendly witnesses; perhaps they believed that by helping to establish his insanity they would help to exonerate him. Moreover, there are indications of impetuousness in Muybridge's personality before the accident as well as after. Leaving England for New York, and New York in turn for California, is every bit as dramatic a change as switching from being a bookseller to a photographer. His name change is also sometimes mentioned in this regard. While it is true that Muybridge adopted his final pseudonym after his accident, it was only the latest in a series of name changes spanning his adult life. The name he was born with, Muggeridge, was jettisoned soon after he arrived in America.

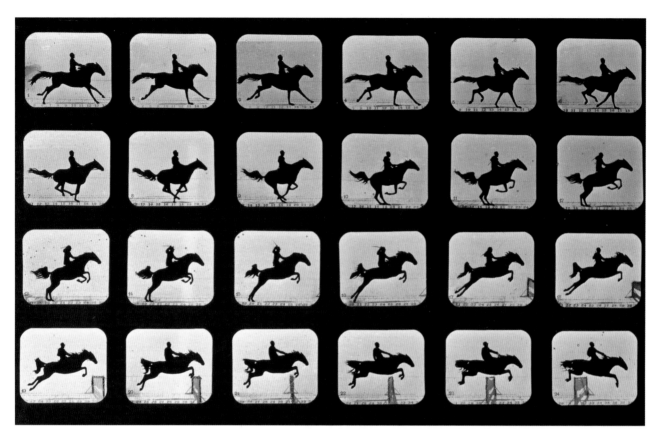

**Fig. 3-7**
Eadweard Muybridge
*"Phryne L" Leaping a 3'6" Hurdle*, 1879, plate
   46 from the series *Attitudes of Animals in*
   *Motion*
Printing-out paper print
16 x 22.4 cm

Perhaps the accident did help to unleash Muybridge's creativity, but it would be difficult to argue that the patents he took out in 1860 and 1861 resulted from the accident. U.S. patent 2352, for an improved method of plate printing, and British patent 1914, for a new type of washing machine, were registered after the accident. These were entered on September 28, 1860, and January 8, 1861, respectively. The incapacity Muybridge suffered during this period, and the close proximity of these patent registrations (which required drawings and specifications) to the date of the accident itself, suggests that they were initiated before the injury.

Muybridge was viewed as eccentric, but this is hardly surprising for an Englishman living in the United States, particularly one who lived in the West. Accounts of his eccentricity may be attributed in part to cultural differences. On his return to England, for example, these eccentricities appear to have gone unremarked.

Finally, one might argue that, in each case of seemingly brash behavior, Muybridge was justified in his actions. The more one learns about him and his circumstances, the more sympathy one develops for his conduct. One certainly cannot condone murder, but taken in context, the killing of Larkyns was not out of keeping with the climate in San Francisco at the time. The legal system in California was new and unproven, and citizens had become accustomed to vigilante justice. Moreover, the way in which Muybridge discovered his wife's adultery and his son's illegitimate parentage was extraordinarily brutal, so much so that a jury acquitted him on grounds that his actions were justifiable. As to his legal wrangles, there is ample evidence that Muybridge was frequently wronged and was warranted in his claims for compensation. None of his claims was frivolous. His confrontation with Leland Stanford, for example, resulted only after Muybridge was publicly embarrassed in London, when copies of the book *The Horse in Motion* by J. D. B. Stillman began to circulate in the city. Although Muybridge had been lecturing

on the subject, and despite the fact that the book had been compiled entirely from his photographs, he was not credited as an author. And few would begrudge him the suit against the Overland Stage Company, which settled his wrongful injury claim for $2,500.

The point here is not to contradict Shimamura, whose work is convincing. Rather, it is to emphasize the intricacy of the question of Muybridge's injury and to discourage overreaching conclusions. It is interesting to consider a possible physiological basis for his behavior, but there is also a danger of reductionism—that is, of creating a general explanation for complex occurrences. Even if one accepts that the accident did alter his personality, the events that followed were hardly inevitable. Nor can one hope to understand Muybridge's photography merely by evaluating the consequences of his injury.

## Muybridge as a Photographer

In Harry Peterson's planned movie, Muybridge would be so enthralled by a visit with the photographer Samuel Morse in New York that he would find immediate inspiration and become a photographer. According to Peterson, his early work would be widely praised, news of his accomplishment would reach the halls of government, and he would be sent out West on a commission. The reality was quite different. As we have seen, it is impossible to know quite when Muybridge took up photography or even when he became interested in the medium. Selleck may have provided an entree during his early years in New York, or the spark may have come from someone else. Alternatively, Muybridge's time in New York may have been immaterial.

Most probably, when Muybridge left for London in early 1861, he was not yet a photographer. He may have entertained thoughts of becoming one, perhaps for some time, and the settlement from the Overland Stage Company may have been the catalyst that made it possible. Alternatively, both Haas and Hendricks have suggested that Muybridge's physicians pre-

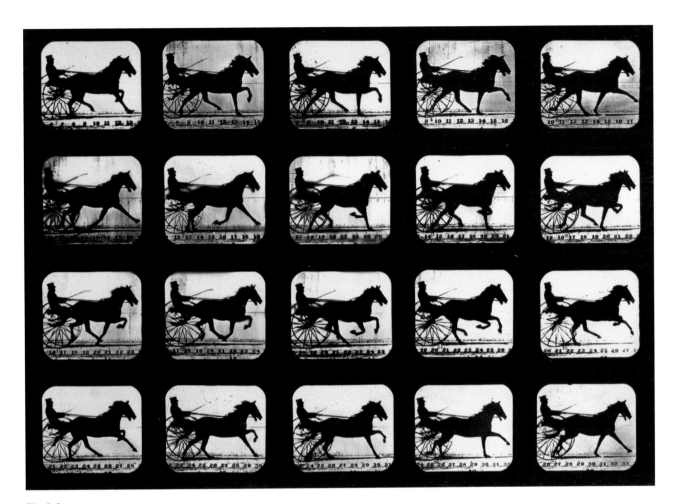

**Fig. 3-8**
Eadweard Muybridge
*"Phryne L" Pacing, Change to Running*, 1879,
   plate 59 from the series *Attitudes of Ani-*
   *mals in Motion*
Printing-out paper print
16 x 22.4 cm

scribed outdoor activity as part of his rehabilitation. This, in turn, could have led to his decision to become a photographer. Returning to work as a bookseller was not considered advisable, as fresh air and exercise were thought to be effective for one recovering from such an injury. So long as he became a landscapist, photography would enable him to obtain the therapy he needed. If this is true, then it is a wonderful coincidence, as Stanford is said to have taken up horse breeding on the advice of doctors. Ultimately the combination of the two prescriptions would prove a potent mix.

After returning to England, Muybridge disappeared from view for some five or six years. Most of the time was probably spent in his native Kingston. His activity during this period and the exact date of his return to the United States remain mysteries. In 1867 his name once again appeared in the San Francisco city directory.[19] His extended stay in England was almost certainly dictated by the Civil War. His departure closely coincided with the attack on Fort Sumter, which occurred on April 12, 1861. And his return probably occurred after the surrender of General Lee on April 9, 1865. Because he does not seem to have engaged in any trade during his stay in England, little is known about his activity during this span. His lack of occupation is not surprising, however, as the settlement from his stagecoach accident would have been more than enough to sustain him. Haas has suggested that some of Muybridge's time in Kingston was spent learning photography from an amateur photographer named Arthur Brown, but there is no definitive evidence linking the two figures.

In late 1867 or early 1868 Muybridge set up shop in San Francisco with his old friend Selleck. At this point Muybridge seems to have been at least a competent photographer, and he soon embarked on a comprehensive project to photograph San Francisco, its environs, and the Pacific Coast. From the start he seems to have identified himself as a landscapist. For approximately six years he threw himself headlong into depicting both

19. Hendricks 1975, 13.

**Fig. 3-9**
Eadweard Muybridge
*"Mohawk," Irregular (Bridled)*, 1879, plate 62
from the series *Attitudes of Animals in
Motion*
Printing-out paper print
16 x 22.4 cm

20. Contrary to popular belief, he
was not one of the first to do so.
Charles L. Weed (1824–1903)
had begun to photograph the
Yosemite Valley as early as
1859.

famous and lesser-known sites in the area. He began with
views of San Francisco, then photographed the Yosemite Valley
(see fig. 4-8).[20] By 1868 he had moved to Vancouver and
Alaska; later he would photograph Pacific Coast lighthouses,
the Farallon Islands, geysers and railroad lines, including
Stanford's Central Pacific. He quickly developed an astonish-
ing virtuosity with the camera. He produced hundreds of
images during this early period, many of extraordinary beauty.
Soon his works challenged those of his principal rival in Cali-
fornia landscape, Carleton Watkins (1829–1916). Many of
Muybridge's images were published under the name Helios, a
reference to the sunlight used to expose them. He also dubbed
his operation "the Flying Studio." And fly he did, as large
swathes of land quickly succumbed to his lens.

Although his landscape photographs are a subject of enor-
mous interest, there is little in them to presage his work as an

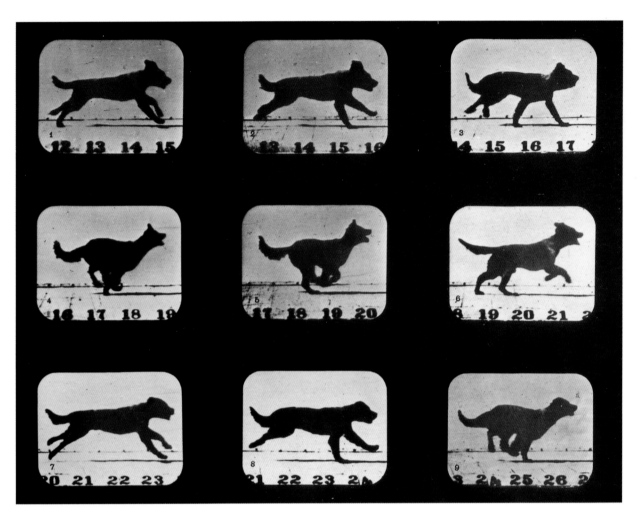

**Fig. 3-10**
Eadweard Muybridge
*Dog Running*, 1879, plate 74 from the series
   *Attitudes of Animals in Motion*
Printing-out paper print
16 x 22.4 cm

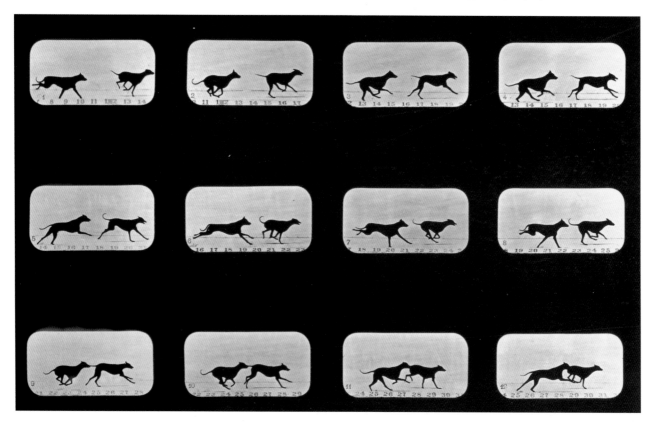

**Fig. 3-11**
Eadweard Muybridge
*Greyhounds Running*, 1879, plate 77 from the
series *Attitudes of Animals in Motion*
Printing-out paper print
16 x 22.4 cm

21. *Philadelphia Photographer*,
November 1868; cited in Haas
1976, 19.

instantaneous photographer. There are occasional hints of what
would follow: glimpses of the momentary, such as rainbows,
clouds, streams, and waterfalls. The editors of the *Philadelphia
Photographer* were sufficiently impressed by a sampling of Muy-
bridge's landscapes in November of 1868 that they likened them
to those of "the great Wilson of Scotland," referring to the noted
instantaneous photographer George Washington Wilson.[21] It is
not clear, however, whether they intended to compare the works
of the two photographers for their instantaneous qualities.
Muybridge appears to have been more interested in pictorial
effect than true instantaneity. One of his favorite motifs during
this period was rushing water, but he seldom managed to arrest
water in motion. Instead, he frequently used long exposures,
which gave the water a blurry but evocative look. Perhaps the
greatest harbinger of his later achievement in instantaneous
photography was his technical mastery of the medium. He rap-

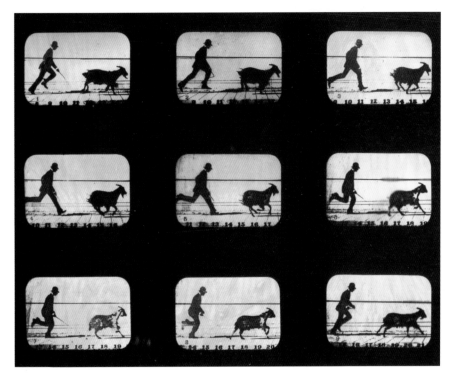

**Fig. 3-12**
Eadweard Muybridge
*Goat Running, Chased by Man Wielding Stick*,
    1879, plate 88 from the series *Attitudes
    of Animals in Motion*
Printing-out paper print
16 x 22.4 cm

idly established himself as a practitioner with a remarkable degree of control over his materials.

In 1872 Muybridge, by this time affiliated with the Studios of Bradley and Rulofson, received a commission that would change his career beyond recognition. Leland Stanford—former governor of California, United States senator, and president of the Central Pacific Railroad—approached him about photographing a horse in motion. Muybridge would later claim to have been amazed at the "boldness and originality" of the proposition. In an anonymous letter to the *San Francisco Examiner*, published on February 6, 1881, Muybridge described the circumstances of their encounter. According to him, in June of 1872 Stanford sought him out for the project due to his "undisputed pre-eminence." Stanford asked him to photograph a horse in motion in order to ascertain whether all four of its hooves ever left the ground at any point in his stride. Muybridge described the scene with characteristic flourish:

> No wonder even the skilled Government photographer [i.e., Muybridge] was startled, for at that date the only attempts that had ever been made to photograph objects in motion had been made only in London and Paris, only by the most conspicuous masters of the art, and only of the most practicable street scenes. And even in these scenes in which the photograph of no objects moving faster than the

ordinary walk of a man had been attempted, and in which the legs had not been essayed at all, the objects were taken as they moved towards the camera, in which action, owing to the laws of perspective, the continuous change of place was less noticeable. [The horse] Occident was then admittedly the fastest trotter in the whole world, having recorded a mile in 2:16 3/4, which was faster than even the skipping Goldsmith Maid had done. And the picture was required to be taken, not as the flyer should bear down on the camera, but as his driver should shoot him at fullest speed past the lens. Mr Muybridge therefore plainly told Mr Stanford that such a thing had never been heard of; that photography had not yet arrived at such wonderful perfection as would enable it to depict a trotting horse at full speed. The firm, quiet man who had, over mountains and deserts and through the malignant jeers of the world, built the railroad declared impossible, simply said: "I think, if you give your attention to the subject, you will be able to do it, and I want you to try." So the photographer had nothing to do but "try." He thought over the matter, skilfully made all the then known combinations of chemistry and optics for taking an instant picture, made the trial, and succeeded in getting the first shadowy and indistinct picture of Occident at a trot.[22]

As Muybridge makes clear in this passage, Stanford's request was for an *instantaneous* photograph, an image of a subject in motion beyond the realm of ordinary human vision. The model for the picture was the instantaneous street scenes made in London, New York, and Paris by photographers such as Edward Anthony, Valentine Blanchard, William England, and George Washington Wilson. Muybridge had little or no experience with this kind of work.

The instantaneous nature of the photograph helps to explain the possibly apocryphal story of a bet surrounding the horse in

22. Muybridge 1881B; reprinted in Mozley 1972, 120–21.

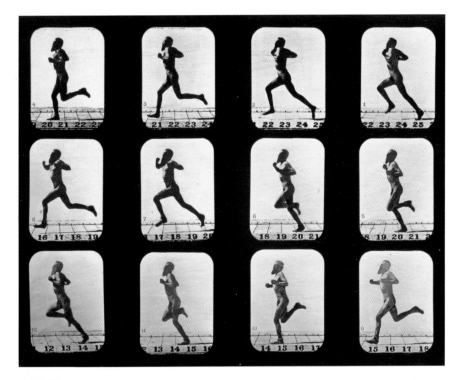

Fig. 3-13
Eadweard Muybridge
*Athlete Running*, 1879, plate 95 from the
series *Attitudes of Animals in Motion*
Printing-out paper print
16 x 22.4 cm

motion. The oft-repeated tale of Stanford's wager over the position of a horse's legs concerns the need for objective, mechanical evidence. A photograph was required to settle a matter upon which two sets of eyes could not agree. One simply cannot see if a horse lifts all its hooves simultaneously at some point in its gait; the action occurs too quickly to be seen well by the unassisted eye. Writing in Stillman's book *The Horse in Motion*, Stanford put the matter succinctly: "I have for a long time entertained the opinion that the accepted theory of the relative positions of the feet of horses in rapid motion was erroneous. I also believed that the camera could be used to demonstrate that fact, and by instantaneous pictures show the actual position of the limbs at each instant of the stride. Under this conviction I employed Mr Muybridge, a very skilful photographer, to institute a series of experiments to that end."[23]

According to A. C. Rulofson, son of the photographer William Rulofson (1849–78), Stanford originally approached not Muybridge, but the Bradley & Rulofson Studio, with which he was affiliated. Muybridge received the commission by default, simply because he was best qualified to photograph outdoors:

At the time Stanford had some photographs of horses drawing a stage and the art critics severely criticised them saying that while it was a pretty photograph it was impossible for a horse to assume those attitudes. Bradley & Rulof-

23.  Leland Stanford, preface to
Stillman 1881, unpaginated

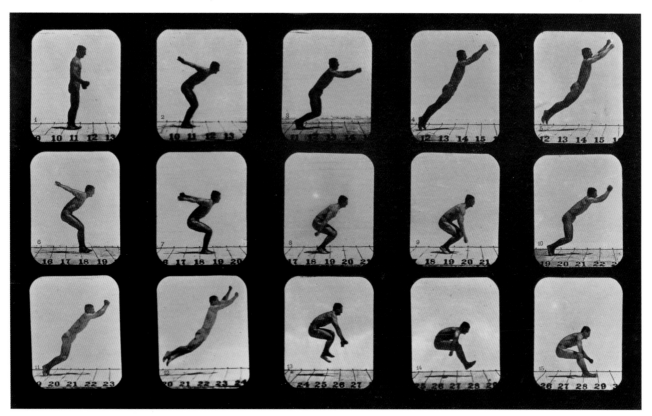

**Fig. 3-14**
Eadweard Muybridge
*Athlete, Standing Leaps*, 1879, plate 100
   from the series *Attitudes of Animals in
   Motion*
Printing-out paper print
16 x 22.4 cm

son were approached by Senator Stanford to see if it were possible to make a picture of a horse in motion. Rulofson said it was a new proposition and did not think it could be done probably. That was the day of iron headrests or clamps and it was necessary to be fastened for several minutes to get a photograph. Stanford explained to them his ideas for a number of cameras and told Rulofson that he wanted a good man as an operator. After he left Rulofson called Taber, Beckhardt and Muybridge for a consultation about it. Muybridge was the outside man who had done all the outside and railroad work. As most of the work was to be outside they finally decided that Muybridge should be sent to do it. When the news was sent to the employees in one of the galleries the next day one of them asked who the damned fool was that thought he could get pictures of an animal in motion. Mr. Rulofson told him that damned fool

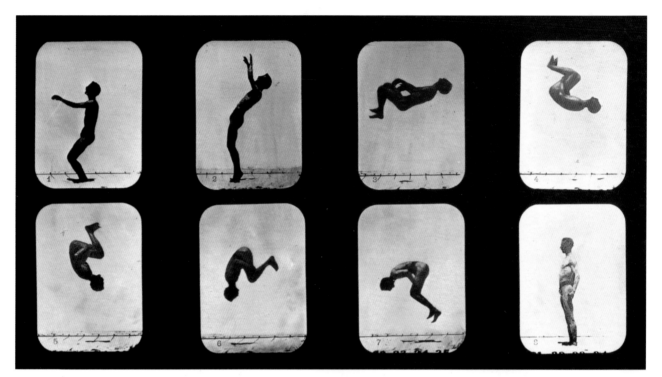

**Fig. 3-15 (above)**
Eadweard Muybridge
*Athlete, Backwards Somersault*, 1879,
    plate 104 from the series *Attitudes
    of Animals in Motion*
Printing-out paper print
16 x 22.4 cm

**Fig. 3-16 (right)**
Eadweard Muybridge
*Athletes Boxing*, 1879, plate 111 from
    the series *Attitudes of Animals in
    Motion*
Printing-out paper print
16 x 22.4 cm

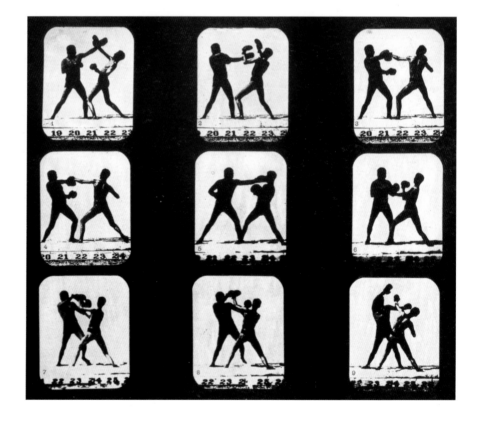

or no damned fool, the man had money and was perfectly willing to pay for the experiments, and that was the prime consideration at the time.[24]

It is hard to know whom to believe regarding the origin of the commission. Certainly Muybridge presented a romanticized version of events, but it is not unreasonable to suppose that Stanford would have sought him out specifically. Muybridge did enjoy some fame in San Francisco, and Stanford may well have recognized his work photographing the Central Pacific Railroad. Moreover, among the first subjects Muybridge would photograph for him was the Stanford family home in Sacramento. Hendricks supposed that Muybridge met the Stanfords during an April visit to Sacramento to sign up subscribers for his new series of Yosemite photographs.[25] Muybridge undoubtedly did photograph the Stanford residence around this time, but it is debatable whether this occurred before or after the horse commission.

The correspondence of the eminent Stanford University psychologist Walter R. Miles (1885–1978) provides one of the more interesting windows into Muybridge's work, though it is often neglected. Miles, who was professor of experimental psychology at Stanford and later became president of the American Psychological Association, is best known for his research on human adaptation to stress. Like Muybridge, Miles was interested in human performance under varying conditions. And, like that of his photographic predecessor, Miles's research had military applications. His work on human vision, for example, is believed to have led to the use of red lighting in World War II pilot night-mission ready rooms. In 1929, however, he focused his attention on Muybridge, particularly his Palo Alto motion experiments. Miles served as chairman of the Muybridge "Semi-Centennial Celebration," held at the university on May 8, 1929.

Less well known is the correspondence Miles engaged in as

24. Unpublished interview, "Testimony of A. C. Rulofson," Jane and Michael Wilson collection, unpaginated. Undated, but probably c. 1916, based on other interviews in this series. This is a packet of detailed interviews with living associates of Muybridge, possibly compiled by Harry Peterson.

25. Hendricks 1975, 45.

**Fig. 3-17**
Eadweard Muybridge
*Skeleton of a Horse, Leaping, Leaving the*
   *Ground*, 1879, plate 201 from the series
   *Attitudes of Animals in Motion*
Printing-out paper print
16 x 22.4 cm

part of his research leading up to the celebration. This material, which is largely unpublished, is archived in the Department of Rare Books and Special Collections at the Stanford University Library. Perhaps most interesting is information Miles obtained after the semicentennial, which consequently never found its way into published accounts of Muybridge's work. Although the experiments had been carried out some fifty years previously, and though Muybridge himself was deceased, Miles tried to contact all those who had been connected with the project—lawyers, assistants, technicians, and administrators—to gather firsthand accounts of Muybridge's life and work.

Miles's correspondence provides valuable information about how and where Muybridge's first motion photographs were made. The results of his earliest experiments have not been preserved. It is widely reported that they were produced at the Union Park racecourse in San Francisco. In a letter to Miles,

however, Sherman Blake, who was Muybridge's assistant at the time, reminisced that some of the first successful photographs were made in San Francisco, at the Old Bay District Track. Stanford had a hand in building the track, which opened on Geary Boulevard in 1873. Blake wrote:

> There were no dry plates or films, as is now used, in Mr Muybridge's time. The process being wet, sensitized plates, which were first dipped in collodion, and then in nitrate of silver bath, and placed in plate holders, and used as quickly as possible in the matter of exposure.
>
> It was necessary to improvise a temporary dark room out at the Bay District Track, and we took along with us an express wagon, a heavy orange and red cloth tent, and an improvised ruby light containing a lit candle.
>
> I carried six buckets of water, (the old fashioned wooden buckets) into the dark room, and when the horse sprang the instantaneous shutter, by means of the thread across the track, Mr Muybridge immediately took the plate holder from the camera, went into the dark room, and developed same.
>
> Being a boy, between 16 and 17 years old (I am now 65 years), I distinctly recall the joy and pleasure when Mr Muybridge called from the dark room, "I've got the picture of the horses jumping from the ground."
>
> To the best of my knowledge, Mr Muybridge was the first photographer in the world to make instantaneous pictures of horses in motion. I am the only living man who recalls Mr Muybridge's attempts in instantaneous photography.[26]

The location of these early experiments may seem inconsequential, but it does help to date the earliest experiments. If all the early experiments were conducted at the Bay District Course, then they could not have occurred before 1873, when the track was built. The photographs Blake describes, however,

26. Sherman T. Blake to Walter R. Miles, 6 May 1929, Walter Miles Papers, Department of Special Collections, Stanford University Libraries.

using threads to trip the camera shutters, marked a second phase of experimentation, which occurred after the first successful photographs. Consequently, the Bay District experiments may represent an intermediate location, between Sacramento and their ultimate home in Palo Alto. This is an aspect of Muybridge's work that has not been explored.

Muybridge claimed that his first photographs of horses in motion were fuzzy and indistinct but sufficiently sharp to demonstrate Stanford's theory of unsupported transit. Unfortunately, none of these experimental pictures has survived. They may have been destroyed in the great earthquake and fire of 1906; Blake suggests this in his memoir. Possibly Muybridge decided not to preserve them, given the superior results he obtained just a few years later. The first published account of Muybridge's initial success appeared in the newspaper *Alta California* in April of 1873:

> All the sheets in the neighborhood of the stable were procured to make a white ground to reflect the object, and "Occident" was after a while trained to go over the white cloth without flinching; then came the question how could an impression be transfixed of a body moving at the rate of thirty-eight feet to the second. The first experiment of opening and closing the camera on the first day left no result; the second day, with increasing velocity on the opening and closing, a shadow was caught. Mr. Muybridge, having studied the matter thoroughly, contrived to have two boards slip past each other by touching a spring, and in so doing leave an eight of an inch opening for the five-hundredth part of a second, as the horse passed, and by an arrangement of double lenses, crossed, secured a negative that shows "Occident" in full motion—a perfect likeness of the celebrated horse. The space in time was so small that the spokes of the wheels of the sulky were caught as if they were not in motion. This was considered a great triumph as

a curiosity in photography—a horse's picture taken while going thirty-eight feet in a second![27]

The writer does not report having seen these photographs, nor did he or she specify when the experiments were conducted. According to Muybridge, they would have been performed some ten months earlier.

The first known examples of horse photographs by Muybridge are in the collections of the Iris & B. Gerald Cantor Center for Visual Arts at Stanford University. They appear in the so-called Brandenburg Album, which contains photographs probably assembled by Muybridge's wife, Flora (see fig. 1-7). There is little in them to suggest movement, but the slight elevation and distance from the subject are typical of instantaneous street photographs of the time. If, as Muybridge wrote, the first models for his instantaneous photographs were street photographs, then the earliest pictures would probably have been made from a similar vantage.

The earliest known representation of a horse in motion made by Muybridge exists in the form of two canvases by Thomas Kirby Van Zandt of the horse Abe Edgington. One, a rough drawing of crayon and ink wash, is presumably a sketch for a more finished composition (fig. 3-18). Dated 16 September 1876, it is probably traced from an original Muybridge lantern slide. It may have been presented to Stanford or Muybridge for approval before being worked up into a finished composition. The existence of a nearly identical finished canvas, also by Van Zandt, is puzzling (fig. 3-19). It is dated five months later, in February 1877. Presumably the date does not refer to the original photograph, but to the execution of the painting. Both of these works reveal the difficulty Muybridge had producing publishable works during this period. Although he was able to obtain results, he struggled to make images suitable for public consumption.

Muybridge would not publish a photograph of a trotting horse until some five years after his experiments began. Produced in

27.  "Quick Work," *Alta California*, 7 April 1873; reprinted in Hendricks 1975, 47.

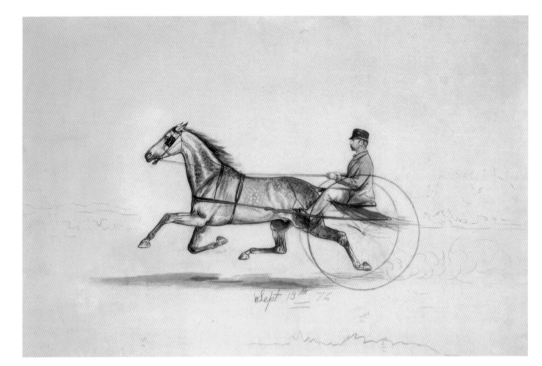

**Fig. 3-18**
Thomas Kirby Van Zandt
*"Abe Edgington" with Sulky
 and Driver, Budd Doble*, 16
 September 1876
Crayon and ink wash under-
 drawing on canvas
53.4 x 81.3 cm

**Fig. 3-19**
Thomas Kirby Van Zandt
*"Abe Edgington" with Sulky
 and Driver, Budd Doble*,
 February 1877
Oil on canvas
53.5 x 81.2 cm

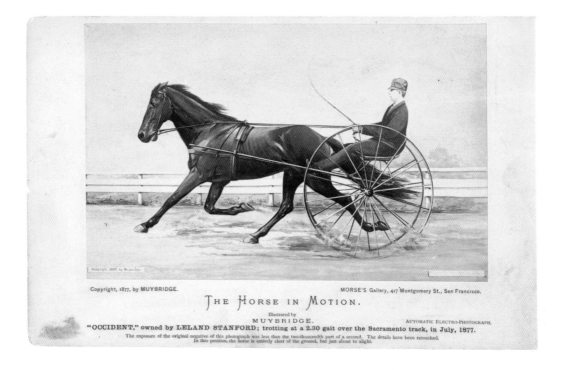

THE HORSE IN MOTION.
Illustrated by
MUYBRIDGE.
Copyright, 1877, by MUYBRIDGE.
MORSE'S Gallery, 417 Montgomery St., San Francisco.
AUTOMATIC ELECTRO-PHOTOGRAPH.
"OCCIDENT," owned by LELAND STANFORD; trotting at a 2.30 gait over the Sacramento track, in July, 1877.
The exposure of the original negative of this photograph was less than the two-thousandth part of a second. The details have been retouched.
In this position, the horse is entirely clear of the ground, but just about to alight.

**Fig. 3-20**
Eadweard Muybridge
*"Occident" Trotting at a 2:30 Gait*, July 1877, from the series *The Horse in Motion*
Albumen print (cabinet card)
10.2 x 16.5 cm

July of 1877, *"Occident" Trotting at a 2:30 Gait* is not a true photograph, however, but a photographic copy of a collage made to look like an original photograph (fig. 3-20). The original from which it was made is a gouache and watercolor painting with a photograph of the driver's head glued to it (fig. 3-21). Although Muybridge claimed to have succeeded in making photographs clear enough to prove that a galloping horse has all four hooves off the ground at a single point in its stride as early as 1872, the indistinctness that plagued those early experiments evidently persisted. To make his findings public, he arranged to have the photograph on which it is based redrawn by hand.

Manipulations of this sort were common when he began his work. Manual retouching, however extensive, was considered an acceptable way of compensating for the deficiencies of early photographic materials. Ironically Muybridge himself was a major force in changing this attitude. Once scientists began to scrutinize his photographs, many of which were made faster than the naked eye could verify, they began to demand that photographs be made according to strictly objective criteria.

**Fig. 3-21**
John Koch
*"Occident" Trotting*, c. 1876
Watercolor with gouache
45.7 x 58.4 cm

This picture, made by the artist John Koch for Morse's Gallery in San Francisco, is a reproduction of an early Muybridge motion study. It is a collage, combining a drawn copy of a Muybridge photograph with a real photograph of the horse's driver. Once complete, Muybridge re-photographed the composition to create the illusion of a photographic original. The result was published as *Occident Trotting at a 2:30 Gait* (fig. 3-20).

*"Occident" Trotting at a 2:30 Gait* was labeled an "Automatic Electro-Photograph" on the mount. It is difficult to know what to make of this claim. It may be that Muybridge was already experimenting with electric shutters during this period. Alternatively the phrase "electro-photograph" may have been jargon for a photograph made very quickly. The prefix *electro* connoted speed; perhaps it was not meant to be taken literally.

The Center's collection also contains two rare, unpublished photographs of a horse in motion made early in the course of Muybridge's experiments. *"Occident" Trotting Left to Right* and *"Occident" Trotting Right to Left* (see figs. 2-32, 2-33) were made before he began to photograph in sequence, but probably after he produced his collaged image *"Occident" Trotting at a 2:30 Gait*. They are undated but may have been made shortly after his return from a brief self-imposed exile in Central America, after he was acquitted of murdering Larkyns in 1875 (see pp. 258–262). The images reveal an innovative approach to capturing the horse in motion. In each, Muybridge appears to have panned the camera to track the motion of the horse. This caused the foreground and background of the images to appear blurry but enabled Occident's feet to be seen more clearly, as the camera was made to travel in the same plane as the subject. These are the only examples known in which Muybridge used this method to obtain instantaneous results. It is not known how widely they were exhibited, but they could be the hitherto unidentified photographs awarded the prize for instantaneous photography at the San Francisco Twelfth Industrial Exhibition in November of 1877.[28]

In September of 1877 Muybridge wrote to Stanford's assistant, Alfred Poett, suggesting that the work be moved from Sacramento to Palo Alto. "Personally, I would as soon execute the work at Sacramento as at Palo Alto," he wrote, "were I assured that I would not be interfered with by people exercising horses, and others of the public."[29] The letter also helps to

28. Haas 1976, 95.
29. Muybridge to Alfred Poett, September 1877, Jane and Michael Wilson collection, London.

establish that Muybridge was beginning to try to develop an electrical apparatus to trigger his camera shutters. He suggested meeting Poett the coming Saturday at the Electrical Construction House, on Sutter Street in San Francisco. Whether or not electric shutters were ordered on that occasion is not known. In November, according to records in the Jane and Michael Wilson collection, Muybridge paid the San Francisco Telegraph Supply Company $130 for the supply of "Electrical Photo Apparatus."[30] On June 21 of the following year he paid them again, this time $90.75 for the installation of telegraph wire.[31] It is not clear how involved the California Electrical Works was in the project. The only receipt for services provided by the company is dated some six months later, on January 9, 1879.[32] It may be that Muybridge returned to a supplier he had previously discounted, looking for fresh ideas.

These records provide an interesting point of reference for the evaluation of the engineer John D. Isaacs's contribution to the project. Isaacs long maintained that it was he who devised the electrical mechanism used in the Palo Alto experiments. In a letter to Peterson, for example, he answered questions about his role in the affair quite forcefully:

I do not know how long Muybridge had been working for Governor Stanford before Mr. Brown [Arthur Brown, superintendent of bridges and buildings, Southern Pacific Co.] approached me relative to the shutter release. I had never heard of Muybridge before that time, and had no connection with the previous experiments.

I do not think that they had any electrical apparatus prior to that time, because nothing was said to me to that effect when I exhibited to Brown, Montague [S.S. Montague, chief engineer at the Central Pacific Railroad] and others the electrically actuated model to which I referred in my last letter.

So far as I know the first electrical release was made by

30.  Receipt, San Francisco Telegraph Supply Co. to Muybridge, 3 November 1877, Jane and Michael Wilson collection, London.
31.  Receipt, San Francisco Telegraph Supply Co. to Muybridge, 21 July 1878, Jane and Michael Wilson collection, London.
32.  Receipt, California Electrical Works to E. Muybridge, 9 January 1879, Jane and Michael Wilson collection, London.

me. It was proposed to operate the shutters in series by a set of these.[33]

In an earlier letter he described confronting Muybridge about his claim to have invented the mechanism: "I was much surprised to learn from these proceedings that Muybridge had obtained patents in his own name on the various devices originated by me and some time later I met him in San Francisco and accused him, in the presence of others, of having obtained these patents fraudulently by falsely representing himself as the author. He was much perturbed and confused and unable to make an intelligible reply."[34]

As sincere as Isaacs's claim was undoubtedly was, it is difficult to evaluate its merits. The letters Muybridge exchanged with Poett demonstrate that he had been working to find a supplier of electrical components as early as September 1877. At that time there was no mention of Isaacs or his design. In addition, it should be noted that the first shutter was little more than a telegraph key hooked to an elasticized trigger. Circumstantially it is just what one might expect to receive if a telegraph company made the device. Until more evidence is forthcoming, the issue of the design of the electrical shutter used by Muybridge may never be resolved. In any case, it can be demonstrated that at least part of the device was manufactured by a subcontractor, and that this was instigated by Muybridge himself. Who created the design for the device remains an open question.

An innovative shutter was just one of the ingredients Muybridge needed to advance his experiments. In October of 1877 he wrote to Poett again, this time with instructions for the design of benches on which his cameras could be mounted. "I think 45 degrees will be the right angle," he advised. "The ends of the board should run close to the ground. Please let me know when you expect to be ready."[35] Soon an elaborate motion study studio began to take shape on the Palo Alto stock farm (see fig.

33. John D. Isaacs to Harry Peterson, 5 February 1916, Peterson Papers, Department of Special Collections, Stanford University Library.
34. John D. Isaacs to Harry Peterson, 4 December 1915, Peterson Papers, Department of Special Collections, Stanford University Library.
35. E. Muybridge to Alfred Poett, 29 October 1877, Jane and Michael Wilson collection, London.

THE HORSE IN MOTION.

Illustrated by
MUYBRIDGE.

Copyright, 1878, by MUYBRIDGE.                    MORSE'S Gallery, 417 Montgomery St., San Francisco

Patent for apparatus applied for.                                         AUTOMATIC-ELECTRO-PHOTOGRAPH.

"MAHOMET," owned by LELAND STANFORD; ridden by G. DOMM, cantering at an 8 minute gait over the Palo Alto track, 18th June, 1878.
The negatives of these photographs were made at intervals of twenty-one inches of distance, and about the twenty-fifth part of a second of time; they illustrate consecutive positions assumed during a single stride of the horse. The vertical lines were twenty-one inches apart; the horizontal lines represent elevations of four inches each. The negatives were each exposed during the two-thousandth part of a second, and are absolutely "untouched."

13930.

**Fig. 3-22**
Eadweard Muybridge
*"Mahomet" Cantering at an 8 Minute Gait*, 18
    June 1878, from the series *The Horse in
    Motion*
Albumen print (cabinet card)
10.1 x 19.7 cm

1–8). In June of 1878, with the annual spring rains past, Muybridge invited the press to witness the creation of motion picture sequences.

This event marked a turning point in Muybridge's career. Armed with improved equipment, including a battery of Dallmeyer lenses imported from England and a newly minted electrical shutter device, he took several of his first published sequences in full public view. On June 15 the first public sessions were held. On June 22 the *California Rural Press* published its account:

On one side of the track a large screen is placed, and set at an angle of about 20 degrees from the perpendicular, the screen being covered with white cloth and having white lines formed across it 21 inches apart, which show black

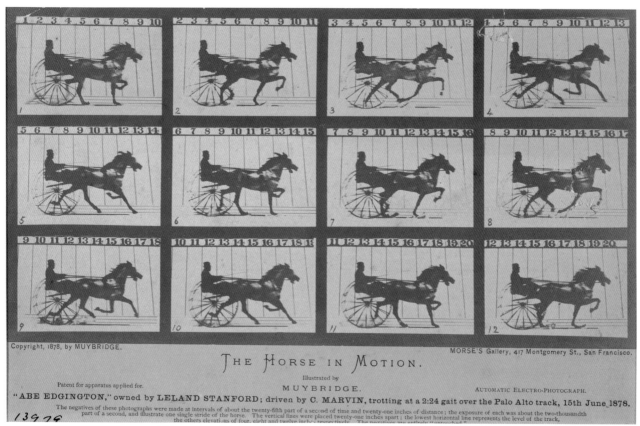

Fig. 3-23
Eadweard Muybridge
*"Abe Edgington" Trotting at a 2:24 Gait*,
15 June 1878, from the series *The Horse
in Motion*
Albumen print (cabinet card)
10.5 x 21 cm

against the white cloth. The spaces between the lines are numbered from one to twenty in conspicuous black figures at the top. . . . On the opposite side of the track from the screen a low shed was erected, open in front, and on a bench or table were placed 12 cameras, numbered in order, so as to take 12 views 21 inches apart. These cameras were constructed with an improved double slide, so that exposure would be cut off instantly, one slide moving each way across the lens. . . . A battery of eight jars was placed in the shed, and each camera had an independent set of wires.[36]

The wires, the paper explained, were attached to each camera and strung across the track, underground. This method was suited only to wheeled carriages. When the carriage passed through the track, the wheels tripped the wires and caused the

36. *California Rural Press*, 22 June 1878; reprinted in Mozley 1972, 69.

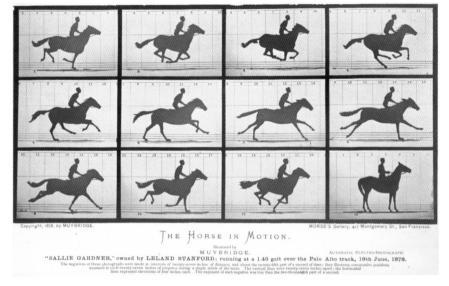

THE HORSE IN MOTION.
Illustrated by
MUYBRIDGE.
AUTOMATIC ELECTRO-PHOTOGRAPH.

Copyright, 1878, by MUYBRIDGE.                    MORSE'S Gallery, 417 Montgomery St., San Francisco.

"SALLIE GARDNER," owned by LELAND STANFORD; running at a 1.40 gait over the Palo Alto track, 19th June, 1878.

The negatives of these photographs were made at intervals of twenty-seven inches of distance, and about the twenty-fifth part of a second of time; they illustrate consecutive positions assumed in each twenty-seven inches of progress during a single stride of the mare. The vertical lines were twenty-seven inches apart; the horizontal lines represent elevations of four inches each. The exposure of each negative was less than the two-thousandth part of a second.

**Fig. 3-24**
Eadweard Muybridge
*"Sallie Gardner" Running at a 1:40 Gait*, June
1878, from the series *The Horse in
Motion*
Albumen print (cabinet card)
10.3 x 20.7 cm

shutters to fire in succession. If a horse without wheels was to be photographed, thin threads would be substituted for the underground wires. The animal would snag them briefly as it proceeded through the course. As it was pulled, each thread would release a different shutter.

The result of this new series of experiments was a series of six cabinet cards (plus the previously printed *"Occident" Trotting at a 2:30 Gait*), which were published under the series title *The Horse in Motion* in 1878. They are among Muybridge's most recognizable works, and the first he made using sequential imagery. Distributed internationally, photographs such as *"Mahomet" Cantering at an 8 Minute Gait* helped solidify Muybridge's burgeoning reputation (figs 3-22–3-24).

The following year, after refining his technique and improving the electric shutter mechanism, Muybridge proceeded to make an extensive series of sequences of animals. This resulted in his first photographically illustrated book, *Attitudes of Animals in Motion*, in 1881. *Attitudes* was handmade and self-published. Few copies were ever produced, but the Stanfords received at least two versions. One was a bound album of matte collodion printing-out paper prints, of which several copies were made (fig. 3-25). The other, apparently unique, was a loose folio of glossy printing-out paper prints (figs. 3-6, 3-17, 3-26). The structure of each was identical. Horses received pride of place, but various farmyard animals and even humans were added to the mix. Later Muybridge would write that it was Jane Stanford who encouraged him to expand his inquiry.[37]

37.  Mozley 1972, 128. In a letter to Stanford dated May 2, 1892, Muybridge wrote that it was "Mrs. Stanford's . . . desire to extend the investigation." Muybridge, who evidently fussed over the content of his letters to Stanford, crossed out this phrase in the draft of his letter. The original is in the Janet Leigh Papers, Bancroft Library, University of California, Berkeley.

**Fig. 3-25 (above)**
Eadweard Muybridge
*The Attitudes of Animals in Motion,* 1881
Bound album of collodion printing-out
    paper prints
17.7 x 24.5 x 3.5 cm

Because it was handmade, fewer
than a dozen copies of this volume
were ever produced. But they remain a
towering achievement of Muybridge's
years in Palo Alto. The book was
designed as a compendium of his
research, ranging from early experi-
ments with galloping horses to the
documentation of other animals and
humans. The exquisite detail and
beautiful tonality of the prints exem-
plify Muybridge's technical mastery.

**Fig. 3-26 (below)**
Eadweard Muybridge
*"Hattie H," Irregular (Flicking Tail),*
    1879, plate 66 from the series *Atti-*
    *tudes of Animals in Motion*
Printing-out paper print
16 x 22.4 cm

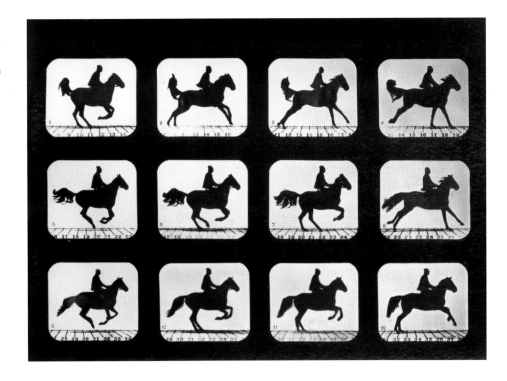

# THE FIRST ZOOPRAXISCOPE DISC: THE FIRST MOTION PICTURE?

THE MUYBRIDGE COLLECTIONS at the Iris & B. Gerald Cantor Center for Visual Arts at Stanford University include a maquette, or preliminary model, of a zoopraxiscope disc (fig. 3-28). The earliest surviving example of a Muybridge projection device, it is making its public debut in *Time Stands Still*.

*Zoopraxiscope* is the name Muybridge gave to his device to reanimate motion photographs (fig. 3-27). Invented in 1879, it is based on a machine invented by the Belgian scientist Joseph Plateau around 1832. Plateau called his device the phenakistoscope. It was similar to the zoopraxiscope, but it used drawings instead of photographs to animate pictures.

Based on the principle of persistence of vision, the zoopraxiscope was used to project a short loop of photographs. Persistence of vision is the phenomenon that makes cinematography possible. Even though films are made out of thousands of individual frames, when these frames are projected in quick succession, they appear animated. The reasons for this are physiological. When people are exposed to a quick flash of an image, they briefly hold it in mind. If another similar image is flashed during this retention period, the brain smoothes the transition from one to the next. If this process is repeated, the result is an optical illusion of continuous movement.

The zoopraxiscope is widely accepted as a precursor of cinematography. Unlike cinema films, however, zoopraxiscope projections repeat after only a few seconds. To make a zoopraxiscope presentation, drawn copies of Muybridge's photographs were arranged in sequence around the edge of a circular piece of clear glass. A metal disc the same size was mounted in front, with slots cut in it corresponding to the frames of the sequence. This metal disc acted as a shutter. Behind the disc arrangement sat a converted magic lantern projector. When operated, the two discs spun in counterrotation. Light flickered through the slots in the shutter disc and briefly illuminated each of the glass frames. The result was a short, repeating projection (figs. 3-29–3-32, 4-11).

Contrary to popular belief, the zoopraxiscope could not be used to project actual photographs. This would be possible only later, with the invention of stroboscopic light sources, such as that used by the German photographer Ottomar Anschütz. Because the zoopraxiscope used spinning discs, the left side of each image was projected at a fractionally different time than the right. As a result, images were distorted and compressed. A zoopraxiscope presentation made with real photographs looks strange. Though animated, subjects appear unnaturally short and squat.

To get around this problem, each frame of photographic imagery was redrawn and elongated by hand. Lengthening was calculated to compensate for the compression of the image

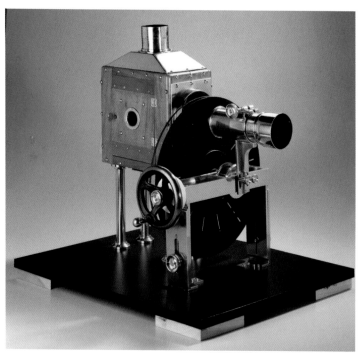

**Fig. 3-27 (above)**
After Eadweard Muybridge
Reconstruction, using components of the
    original, by David Beach
*Zoopraxiscope*, 1881
Working adaptation of the machine of 1881;
    brass and wood with magic lantern
    housing of 1878; built by Stanford pro-
    fessor David Beach in 1972
52.4 x 46.5 x 55 cm

**Fig. 3-28 (below)**
Eadweard Muybridge
*"Nimrod" Pacing*, c. 1879
Maquette for a zoopraxiscope disc made of collodion on
    glass positives
Diam. approx. 30.5 cm; each piece approx. 1.5 x 1.8 cm
    or smaller

This unique maquette, or model, for a zoopraxiscope disc is the earliest known example of a motion picture sequence made by Muybridge. Painstakingly reconstructed, the ring of collodion on glass slides is incomplete but unmistakable. Each frame is bound in the black tape the photographer used to make lantern slides. The arc created by these taped frames forms a ring exactly the right size to fit inside a 12-inch disc. The purpose of this ring is unclear. Zoopraxiscope projections cannot be made successfully from real photographs like these. The zoopraxiscope makes images look unnaturally compressed; to compensate for this, images must be redrawn by hand and artificially elongated. This maquette, therefore, must either have been made before Muybridge recognized the compression effect of his machine, or was meant only to illustrate the principles of the device. In either case, it is one of the first zoopraxiscope discs ever made. With it, the seeds were sown for the invention of cinima.

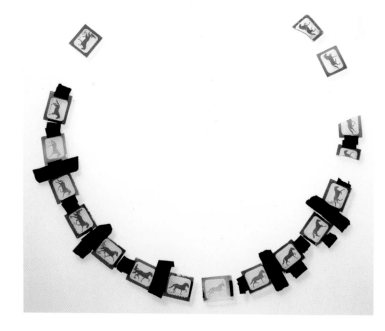

**Fig. 3-29**
Eadweard Muybridge
*Monkeys Grabbing Coconuts,* c. 1893
Zoopraxiscope disc
Diam. 30.5 cm

Not all of Muybridge's zoopraxiscope discs were made from original photographs. Though this charming sequence may have been based loosely on photographs Muybridge made of animals climbing trees, it is extremely unlikely he ever photographed this exact scene.

**Fig. 3-30**

Eadweard Muybridge

*Horses with Riders and Dogs, Running in Two Directions*, c. 1893

Zoopraxiscope disc

Diam. 40.7 cm

As his work matured, Muybridge seems to have become increasingly fascinated with counter-movements; that is, animations that proceed in various directions regardless of the rotation of the spinning disc itself. In sequences like this one, he arranged figures so that they would seem to go in opposite directions. This was something he could not do in still photographs. He undoubtedly felt it added to the interest of his projections.

in projection. This was done by a professional retoucher, probably using a mirror held at an angle to get a consistent correction. At the same time, color was added. This had the double benefit of both enlivening the images and partially obscuring their handmade character.

The Stanford example is made not from redrawn images, but from small wet-plate collodion glass slides arranged in a circular pattern. They were fastened together in a ring using the same kind of black binding tape Muybridge used to finish lantern slides. Over the years the tape has split and perished in places. It has been painstakingly reconstructed for display in *Time Stands Still*. Although only twenty pieces out of the original twenty-four have been preserved, the size of the ring can be determined from the curvature of the intact fragments. The disc would have been twelve inches (30.4 cm) in diameter, which was one of the standard sizes Muybridge used in his zoopraxiscope.

Why original photographs were used in the maquette's construction is unclear. It may represent an early experiment in animating photographs, before Muybridge understood the compression effect of his zoopraxiscope machine. Or it could be that the disc was intended as an early prototype, to demonstrate how a zoopraxiscope might be made. In either case, it clearly dates from early in the development process.

The subject of the maquette is Leland Stanford's horse Nimrod. The horse is shown pac-

ing. This sequence appeared as plate 30 of Mubyridge's book *Attitudes of Animals in Motion* in 1881. According to the preface to the book, the photographs themselves were made in 1879.

Late in 1878 several pundits wrote to suggest that Muybridge try to animate his photographs using a machine called a zoetrope, another early animation device. In October of that year the editor of *Scientific American* suggested that photographs from the series *The Horse in Motion* could cut be cut out and mounted into strips for this purpose. In December the French scientist Etienne-Jules Marey also wrote to Muybridge musing about the "beautiful zoetropes" he might make from his photographs.[1]

Zoetropes, however, are not projecting devices. They are made using opaque paper strips. There is no evidence Muybridge actually tried to make zoetrope strips, but the Hungarian artist Bertalan Székely did. *Time Stands Still* includes two examples of zoetrope strips made from Muybridge photographs (figs. 3-38, 3-39). Szekeley's are the only known examples to have been preserved from this period.

There is a long tradition of naming projection devices with witty compound names based on Greek or Latin roots. Muybridge coined the term *zoopraxiscope* from the Greek words meaning "animal action viewing device." Originally he called it the *zoogyroscope*, or "animal spinning viewing device." Plateau's term

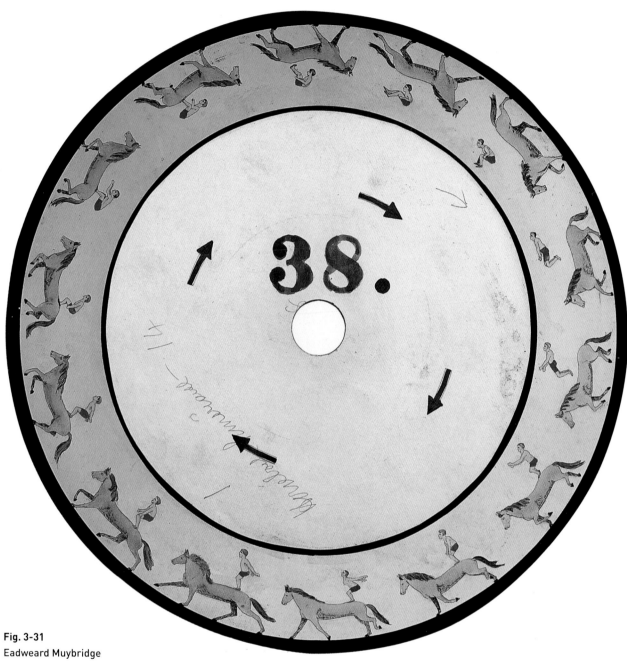

**Fig. 3-31**
Eadweard Muybridge
*Athlete, Somersault on Horseback*, c. 1893
Zoopraxiscope disc
Diam. 30.5 cm

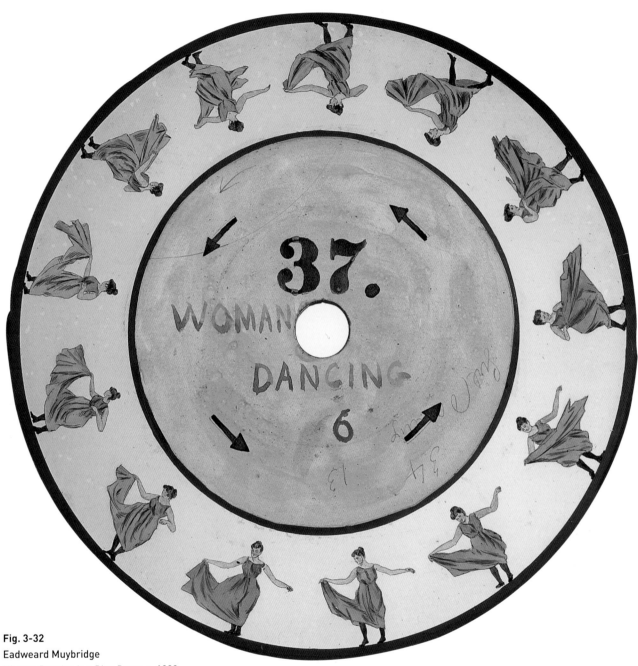

Fig. 3-32
Eadweard Muybridge
*Woman Dancing in a Blue Dress*, c. 1893
Zoopraxiscope disc
Diam. 30.5 cm

*OPPOSITE PAGE*
Fig. 3-33
Henry Heyl
*Phasmatrope with Disc*, 1873
Photographic equipment made of wood, metal, and cardboard; containing a
    projection disc made of sixteen wet-plate collodion on glass positives
45.7 x 30.5 cm

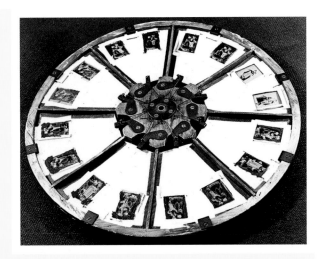

*phenakistoscope* is derived from the words for "deceitful viewing device." There are many other examples, such as Henry Heyl's Phasmatrope ("phantom turner") (fig. 3-33), John Ayrton Paris's Thaumatrope ("magical turner"), Jules Duboscq-Soleil's Bioscope ("life viewing device"), and Anschütz's Tachyscope ("speed viewing device"). Jane and Leland Stanford owned a machine called a Megalethoscope ("big truth viewing device"), which used specially constructed translucent slides to create transient lighting effects. It too is in the collection of the Cantor Arts Center.

The name Muybridge chose for his device is not just quaint; it also reveals his intention for the machine. His "animal action viewing device" was not meant for amusement, although it certainly did entertain audiences. Rather, it was meant to be quasi-scientific in nature. With his photographs of moving horses, Muybridge had succeeded in representing things the eye cannot normally see. As a result, many viewers were suspicious of them because they had no way of confirming their accuracy.

Before Muybridge, instantaneous photographs were often simulated or heavily retouched to look as though they captured action, even when they did not. Some accused Muybridge of similar acts of deception and wanted proof that the phases of motion his camera revealed were reliable. The zoopraxiscope offered an ingenious way to provide this proof. Using it, Muybridge was able to recon-

struct motion from the pictures he made. Skeptics might not have believed in the veracity of his photographs on their own, but when they saw them projected in motion, they saw something they recognized and could mentally verify. During his presentations Muybridge delighted in stopping his projections to reveal the individual frames that made up a sequence. By stopping and starting the machine in this way, he was able to move between the atomized view of the photographic sequence and the reconstituted view of the motion picture projection.

Few in the audience would have appreciated the irony of the situation. Though the zoopraxiscope served to establish the authenticity of the photographs, the discs it projected were actually made from drawn and elongated copies of the originals.

NOTES
1. Haas 1976, 117.

*OPPOSITE PAGE*
**Fig. 3-34**
Francis Galton
*Explanation by Composites of Muybridge's
    Photographs, of the Conventional Repre-
    sentation of a Galloping Horse,* 1882
Montage of cyanotype prints
9.5 x 12 cm

Charles Darwin's cousin Francis Galton is best known as the founder of eugenics, the pseudo-evolutionary theory that people can be bred to accentuate certain desirable genetic characteristics. But he was also an immensely creative scholar, and not all of his ideas were nearly so controversial. In the early 1880s, he devised a method for combining negatives from separate exposures to create archetypes – images that he believed were perfect representations of the common characteristics shared among sitters of a particular type. For example, he combined dozens of photographs of criminals to produce a single 'meta photograph' of a perfect criminal type. He repeated this process with numerous other types, including scientists, military men, artists, and those suffering from certain diseases.

In this example, Galton applied his composite photography technique to Muybridge's motion studies. The idea was to find the centers of gravity and the trends in movement associated with particular behaviors. Thus, Galton joined the ranks of those devoted to analyzing and reinterpreting Muybridge's works.

Ironically, whereas Muybridge worked tirelessly to create separate instantaneous photographs of isolated episodes of time, Galton tried to dissolve the temporal separation between frames. Much as cinema would later do, Galton stitched together the disparate images that instantaneous photography produced.

## Punching the Clock: Instantaneity and Analysis

It is often assumed that the so-called chronophotographers— that is, those photographers who used the instantaneous photography techniques pioneered by Muybridge to study motion— focused on creating new pictures and that each developed his own technique and idiom to create fresh works. This is partially true. A number did create new systems for gathering and processing instantaneous photographic information. There is, however, considerable overlap in the efforts of this small community of researchers. They influenced one another extensively, acting and reacting to experiments performed by their colleagues. Muybridge was among the first to achieve success and remained, in the English-speaking world at least, the most famous practitioner of the new science. Consequently, much of the work of chronophotographers in the early 1880s involved reinterpreting his results.

An excellent example of this is the work of Francis Galton (1822–1911), father of the pseudo-science of eugenics and cousin to Charles Darwin. Galton is not usually described as a chronophotographer, though his aims were similar. Rather than breaking events into increasingly smaller and limited frames of activity as Muybridge did, Galton did the opposite, reconstituting separate images into a new whole. Galton developed a method of composite photography, sandwiching negatives together to create a meta-composition out of constituent parts. He famously applied this technique to persons of carefully defined types, such as those suffering from certain diseases, criminals, doctors, scientists, and politicians. By combining negatives, he hoped to arrive at the common traits that unified each population.

In 1882 Galton also created several composite photographs using Muybridge's horse studies. His *Explanation by Composites of Muybridge's Photographs of the Conventional Representation of a Galloping Horse* (fig. 3-34) would have been used to lecture on the implications of Muybridge's results. Galton used his tech-

Explanation, by Composites of Muybridge's photographs, of the conventional representation of a galloping horse. by Francis Galton F.R.S. June 1882.

Composite of the A group.

A. group occupies two tenths of a second

All the legs bent beneath the body.

Composite of the B group

B. group occupies one tenth of a second

Hind leg on ground, fore legs in air.

Composite of the C group

C. group occupies one and half tenths of a second

Hind and fore legs extended.

Composite of the D group

D group occupies one and half tenths of second

Hind legs in air, fore leg on ground.

| Resemblances in the composites to conventional fig: | | |
|---|---|---|
| Group | Hind legs | Fore legs |
| A | none | none |
| B | none | some |
| C | some | some |
| D | some | none |
| All | Some | Some |

Composite of all the positions

The positions of the hind and fore legs respectively, that are the longest maintained, seem to leave the strongest impression on the bewildered judgement, viz: the hind legs as in C and D, and the fore legs in B and C

The photographs are from Plate XVI of Stanford's 'Horse in motion' (Trübner & Co)

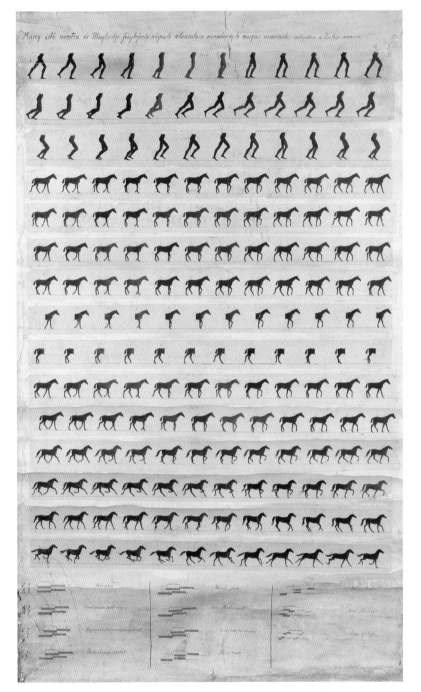

nique to draw conclusions about balance, center of gravity, and the preponderance of movements in the gait of a horse, rather than the specific location of particular elements of the body at any given time. The synthesis he performed is in this sense comparable to Muybridge's zoopraxography, in that it seeks to reintegrate the parts that photography had separated.

Less well known, but equally interesting, is the work of the Hungarian academic artist Bertalan Székely (1835–1910). Székely was an accomplished if conventional painter in Budapest; to this day his works are richly represented in the Hungarian National Gallery. Although he never corresponded with Muybridge directly, he learned of his *Horse in Motion* photographs shortly after their publication in 1878. Székely immediately began to experiment with them, redrawing them in dozens of meticulous new compositions. Among these are a series of extraordinary presentation drawings made for anatomy lectures at the Hungarian Academy of Fine Arts. In them, he combined Muybridge's photographs of horses with his own studies of human motion. His *Human and Equestrian Motion*

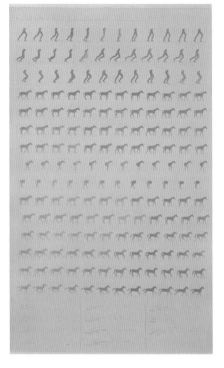

*OPPOSITE PAGE*
**Fig. 3-35**
Bertalan Székely
*Human and Equestrian Motion (after Muy-
bridge and Marey)*, 1879–80
Demonstration drawing, pencil and India
ink on paper, heightened with white,
mounted on canvas
259 x 154 cm

*ABOVE*
**Fig. 3-36**
Bertalan Székely
*Human and Equestrian Motion (after Muy-
bridge and Marey)*, 1879–80
Albumen print, reduction of demonstration
drawing
30.6 x 18.9 cm

*(after Muybridge and Marey)* (figs. 3-35, 3-36), for example, made in 1879–80, combines episodes of motion that he felt would be helpful for his students at the academy to understand.

Székely was omnivorous in his approach, extracting information from dozens of authorities on anatomy and motion. Stillman's book on motion was another of his sources, providing inspiration for a number of intriguing drawings. In *Paces of a Horse (after Muybridge and Stillman)* (fig. 3-37), he made a remarkable innovation, drawing the path of the horses' hooves in three dimensions, not just the two evident in Muybridge's original photographs. Székely also appears to have been one of the first researchers to make Muybridge's photographs into zoetrope strips (figs. 3-38, 3-39). To make them, he painstakingly copied each of Muybridge's original motion studies by hand. The collection of the Hungarian Academy of Sciences now contains dozens of these strips, which were presumably used for educational purposes. Székely may have been aware of the suggestion made by the French photographer Etienne-Jules Marey that Muybridge should adapt his work for animation using the common optical toy. If so, he took this advice to extremes, producing more zoetropes after Muybridge than Muybridge himself probably ever did. Moreover, many of the strips he rendered on graph paper, enabling graphical analysis on a background grid years before Muybridge would adopt a similar method.

Székely was in close contact with Marey, a towering figure in the chronophotography movement. Unlike Muybridge, Marey had been trained as a scientist and maintained an abiding concern for the scientific value of his photographs. He sent Székely some of his first photographic experiments, including the earliest known copy of a photograph made with a photographic gun. Representing gulls in flight, the photographs are currently in the collection of the Hungarian National Academy of Sciences. The photographic gun was a device Marey used to make sequential images. Shaped like a stylized weapon, it was loaded with a

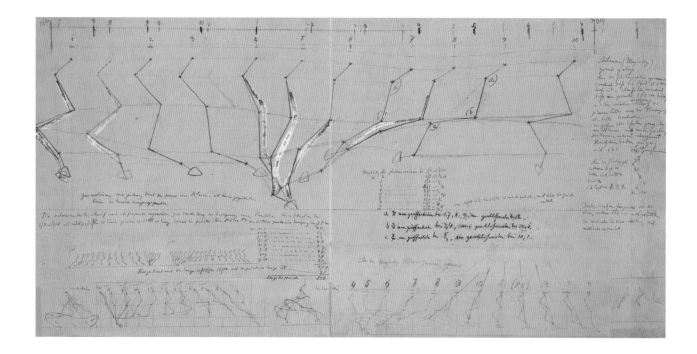

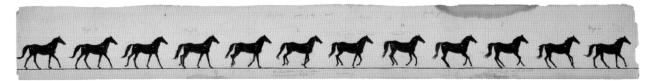

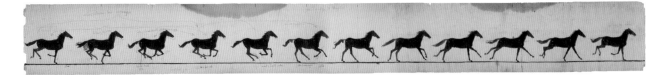

**Fig. 3-37 (top)**
Bertalan Székely
*Paces of a Horse (after Muybridge and Still-
man),* c. 1882
Pencil, ink, and gouache on tracing paper,
mounted on card
30 x 60 cm

**Fig. 3-38 (middle)**
Bertalan Székely
*Grand gallop de Muybridge,* 1879–80
Zoetrope strip: pencil and ink on paper
139.5 x 15.4 cm

Székely may have been the first person
to make Muybridge's photographs into

motion pictures. Even as Muybridge was
planning to animate his photographs using
his new zoopraxiscope machine, the Hun-
garian artist was already making his photo-
graphs into zoetrope strips, each frame
painstakingly copied from a Muybridge
photograph.

Invented by William George Horner in
1834, Zoetropes consist of a series of pic-
tures on a paper strip arranged on the
inside of a revolving drum. The drum has
small slits enabling the viewer to see the
pictures; as the drum spins the frames
seem to run together creating the illusion
of movement.

**Fig. 3-39 (bottom)**
Bertalan Székely
*Petit gallop de Muybridge,* 1879–80
Zoetrope strip: pencil and ink on graph
paper
140 x 15.8 cm

Not content with simply redrawing Muy-
bridge's photographs, Székely applied
them to graph paper to enable him to track
and quantify the differences between
frames. Muybridge himself would eventu-
ally include a grid pattern in his photo-
graphs, but not until 1884, when he moved
to Philadelphia.

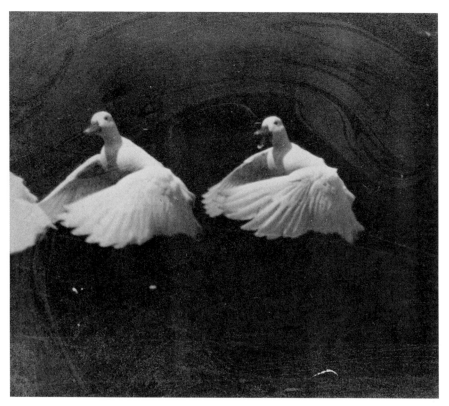

**Fig. 3-40**
Etienne-Jules Marey
*Duck in Flight*, 1887
Albumen print
12.7 x 14.5 cm

photographically sensitive disc that spun as an exposure was made. With each successive exposure, the disc would spin slightly, enabling the operator to record a sequence of events.

Characteristic of Marey was a concern with maintaining a single point of view, which is seldom evident in Muybridge's photographs. Marey produced most of his sequential images on a single plate, as in his photograph *Duck in Flight* (fig. 3-40).

Depending on the speed at which the exposures were made, the resulting images would overlap to varying degrees or could be kept completely separate. The advantage of this approach was that it provided a single perspective from which the subject could be seen. Muybridge used a battery of cameras, each of which was separated from its neighbor by a variable distance, depending on the subject. This resulted in a series of shots roughly perpendicular to the subject. Marey, by contrast, generally conducted his experiments with a single lens. The effect was that of a single eye surveying events. Photographing in this way also meant that images could not easily be added or subtracted from the final composition. Using his individual frames of imagery, Muybridge was free to alter and manipulate his sequences. Marey could not. Consequently, a scientist viewing his photographs could be reassured that the action depicted was portrayed just as it happened. The technique was more limiting but also more trustworthy (figs. 3-41–3-50).

**Fig. 3-41**
Etienne-Jules Marey
*Mr. Schenkel—Running Jump, High Jump,*
   *High Jump,* 18 July 1886
Three albumen prints
10.8 x 29.8, 11.8 x 29.7, and 11.5 x 29.7 cm

A number of other figures worked in the wake of Muybridge's experiments in Palo Alto, testing, reinterpreting, or expanding his results. Albert Londe (figs. 3-51–3-53), Ottomar Anschütz, and Thomas Eakins were among those inspired by the work. Anschütz was particularly sophisticated, using state-of-the-art lenses and chemistry to produce images that surpassed Muybridge's work in sharpness and detail (fig. 3-54). In his *Dog, Three Poses* (fig. 3-55a, b, c), for example, the texture of the animal's fur is rendered with great detail; skin, hair, and muscle structure are shown with more precision than Muybridge would ever achieve. In addition, Anschütz was concerned with capturing behaviors unencumbered by experimental conditions. He tried to avoid artificial settings such as those arranged by Muybridge, favoring instead pictures of animals in their natural habitats. His series of photographs of storks, for example, is an excellent example of this sensibility (fig. 3-56). Two parents are shown interacting with their young, bringing them food and responding to their calls for attention. The idea was to

show not just how the animals function physiologically, as Muybridge did, but also what they would actually do if left to their own devices (figs. 3-56, 3-57).

The artist Thomas Eakins (1844–1916) has a special place in the history of chronophotography, as he is the only photographer known to have worked alongside Muybridge. When Muybridge took up residence at the University of Pennsylvania in 1884, the university assigned Eakins, among others, to mind him. In part, this was for Muybridge's benefit, but it was mainly to provide assurance of the timely progression of the experiments for the university and the project's financial guarantors. Aware of Muybridge's lack of academic training, they may have hoped to keep him honest. As it happens, Eakins lasted in Muybridge's new studio for only a short time. He was an advocate of the single-lens methods espoused by Marey, with which Muybridge never became comfortable. Although Muybridge did experiment with a Marey wheel camera and may even have tried to use a photographic gun, as soon as his battery of cameras was perfected, he switched to that method exclusively. Perhaps as a result of this preference, Eakins appears to have lost interest in the project.

In Eakins's *Jesse Godley, Walking, Coming to a Stop* (fig. 3-60), the use of the Marey wheel technique is evident. Photographs by Eakins are easily distinguished, however, from those of Marey. Eakins, who was trained as an artist, was interested in using the works as artistic studies and consequently seems to have been more concerned with the aesthetic appearance of the final prints than Marey was. Unlike Marey's prints—which are of good, serviceable quality—Eakins's are often sumptuous. In addition to the standard albumen paper Marey used, Eakins printed in deep, Prussian blue cyanotype, as in *Jesse Godley, Walking*, and richly subtle platinum. Later Muybridge would also experiment with cyanotype. It may be that this was suggested by Eakins.

**Fig. 3-42 (left)**
Etienne-Jules Marey
*Mr. Charles Franck—Running at Speed, Running at Speed, Long Jump Preceded by Running*, 18 July 1886
Three albumen prints
11.5 x 29.4, 11.5 x 29.8, and 12.4 x 29.7 cm

**Fig. 3-43 (below)**
Etienne-Jules Marey
*Running Jump*, c. 1882
Albumen print
7.3 x 18.7 cm

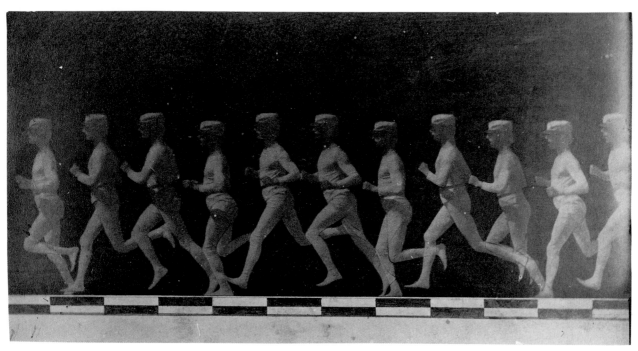

**Fig. 3-44**
Etienne-Jules Marey
*Running*, 1882–86
Albumen print
8.3 x 19.8 cm

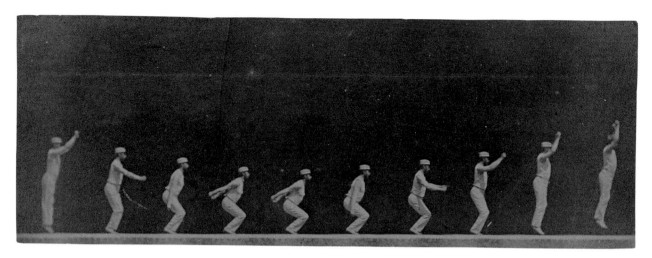

**Fig. 3-45**
Etienne-Jules Marey
*Standing Broad Jump*, 1883
Albumen print
6 x 17.2 cm

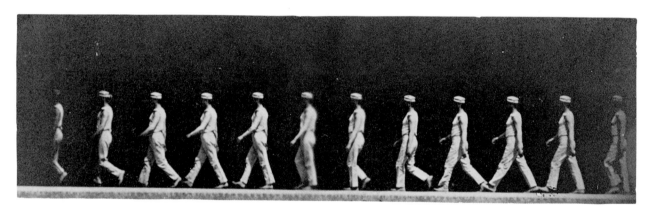

**Fig. 3-46**
Etienne-Jules Marey
Etienne-Jules Marey
*Walking*, 1882–86
Albumen print
4.9 x 16.7 cm

*OPPOSITE PAGE*
**Fig. 3-47**
*Walking Sideways, Steps from the Joinville
    School, Walking on Tiptoe, Walking on
    Heels, Walking with a Weight of 40 Kg,
    Walking with a Weight of 60 Kg, Walking
    Faster with a Weight of 60 Kg*, 1886
Seven albumen prints
27 x 20.9 cm (sheet); each image 3.3 x 11.5
    cm or smaller

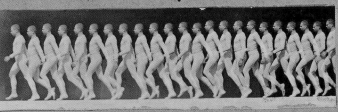

Marche de côté

Pas de l'école de Joinville

Marche sur la pointe des pieds

Marche sur les talons

Marche avec charge de 40 kil

Marche avec charge de 60 kil

id. plus rapide

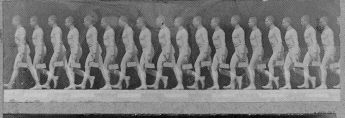

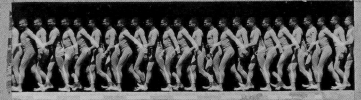

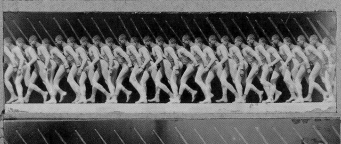

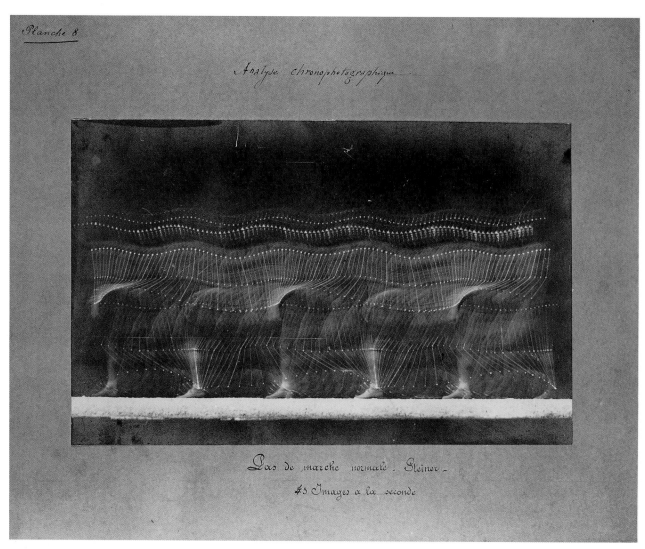

**Fig. 3-48**
Etienne-Jules Marey
*Walking (Geometric)*, 1883
Albumen print
14 x 22.5 cm

**Fig. 3-49**
Etienne-Jules Marey
*Bird in Flight*, 1886–87
Five albumen prints
5.3 x 8.5 cm each or smaller

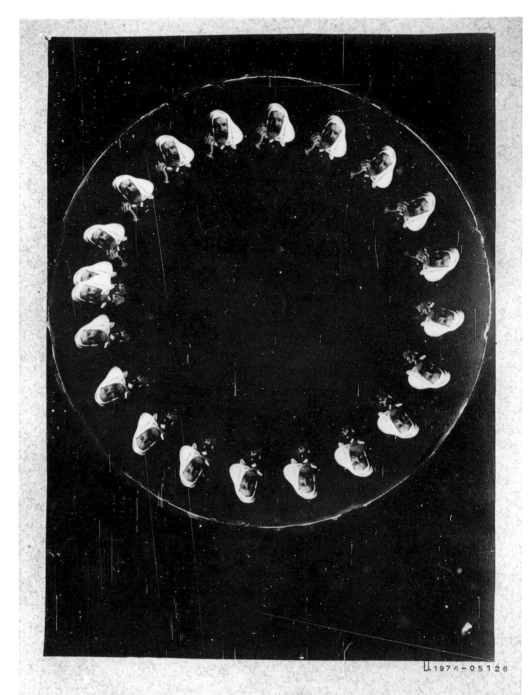

**Fig. 3-50**
Etienne-Jules Marey
*Self-Portrait Wearing a Turban, Made with a Spinning Plate*, c. 1886
Albumen print
16 x 12.7 cm

Epreuve photographique obtenue avec un appareil a plaque tournante

**Fig. 3-51**
Albert Londe
*Dog Leaping at the Hip-*
*podrome*, 1887
Albumen print
10 x 15 cm

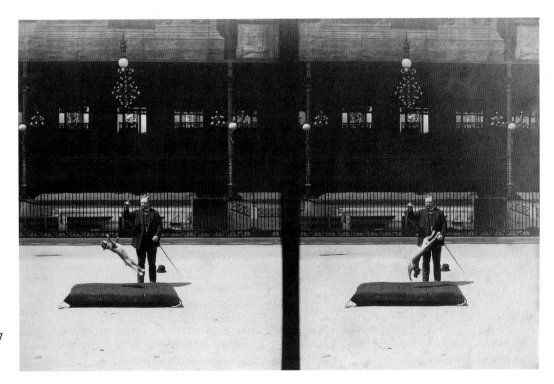

**Fig. 3-52**
Albert Londe
*Dog Leaping at the*
*Hippodrome*, 1887
Albumen print
10 x 15 cm

**Fig. 3-53**
Albert Londe
*Horses Jumping at the
    Hippodrome*, 1887
Platinum prints
37.5 x 28 cm

**Fig. 3-54**
Ottomar Anschütz
*Horse Jumping a Hurdle*, c. 1887
Albumen print
9.5 x 14 cm

**Fig. 3-55 a–c**
Ottomar Anschütz
*Dog, Three Poses*, 1886
Three albumen prints
14 x 15.2 cm each

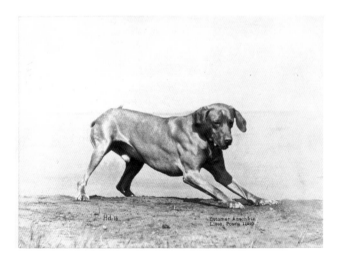

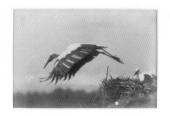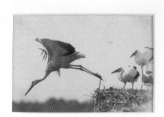

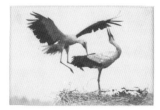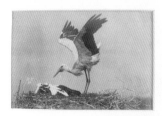

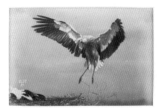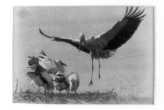

**Fig. 3-56 (left)**
Ottomar Anschütz
*Storks in a Nest*, 1884
Albumen print
9.4 x 13.9 cm

**Fig. 3-57 (below)**
Ottomar Anschütz
*Doves at a Feeder*, 1884
Albumen print
9.3 x 13.8 cm

**Fig. 3-58**
Ottomar Anschütz
*Pack of Hounds Leaping over a Ditch*, c. 1884
Albumen print
7.6 x 18.1 cm (approx.)

**Fig. 3-59**
Thomas Eakins and Ellen Wetherald Ahrens
*Analysis of Horses in Motion (after Muybridge)*, c.1884
Series of four lantern slides
8.3 x 10.2 cm

Thomas Eakins' work as a chronophotographer is well known. However, before he began to make his own motion study photographs he was among those who analyzed and reinterpreted Muybridge's works. Even before Muybridge came to the University of Pennsylvania in 1884, Eakins used illustrations of Muybridge's motion photographs in lectures at the Pennsylvania Academy of Fine Arts. Eakins was interested in the trajectories that could be deduced from Muybridge's motion studies; that is, the changing relationship between critical anatomical points as horse and rider progress. As early as 1879, he had written to Muybridge suggesting that he publish trajectories of horses' hooves traced from his photographs. But Eakins also applied himself to the task, as this series of lantern slides demonstrates. The drawings themselves are believed to have been made by Ellen Ahrens, one of his students at the Academy.

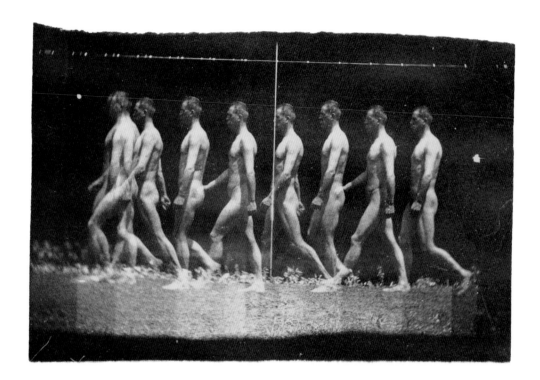

Fig. 3-60
Thomas Eakins
*Jesse Godley, Walking,*
*Coming to a Stop,*
1884
Cyanotype print, mul-
tiple exposures
from a Marey
wheel camera
5.7 x 8.4 cm

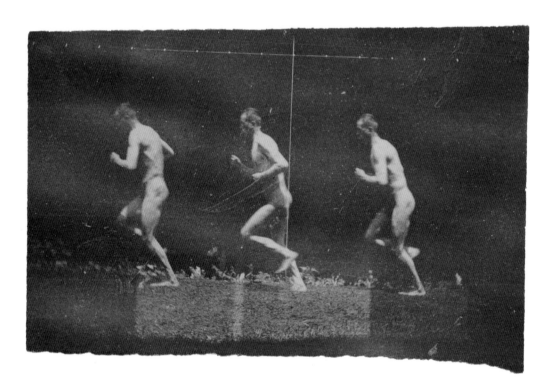

Fig. 3-61
Thomas Eakins
*Jesse Godley,*
*Running*, 1884
Cyanotype print, mul-
tiple exposures
from a Marey
wheel camera
5.7 x 8.5 cm

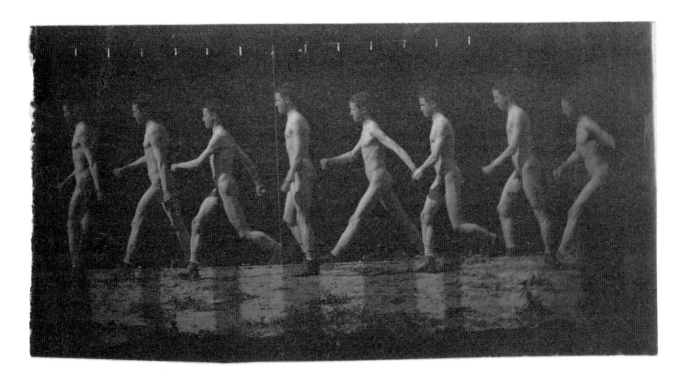

Fig. 3-62
Thomas Eakins
*Man Walking*, 1884
Platinum print, multiple
    exposures from a
    Marey wheel camera
5.4 x 10.4 cm

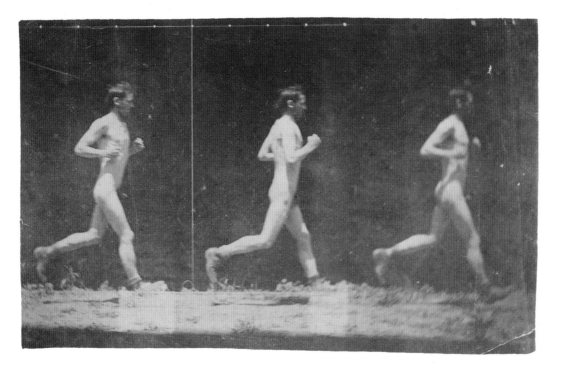

Fig. 3-63
Thomas Eakins
*Man Running, Wearing
    Boots*, 1884
Albumen print, multiple
    exposures from a
    Marey wheel camera
14.3 x 22.8 cm

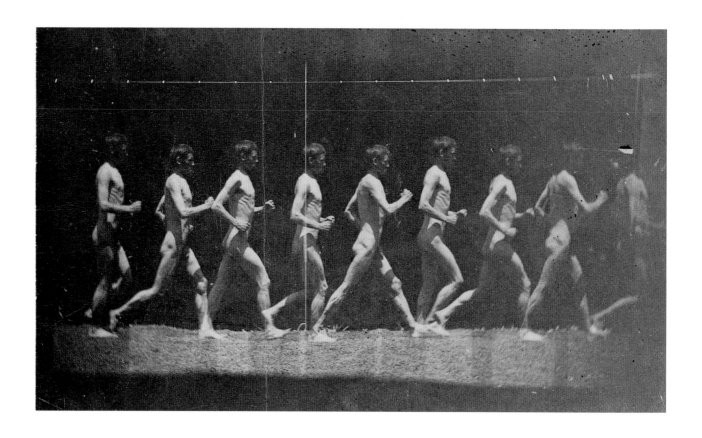

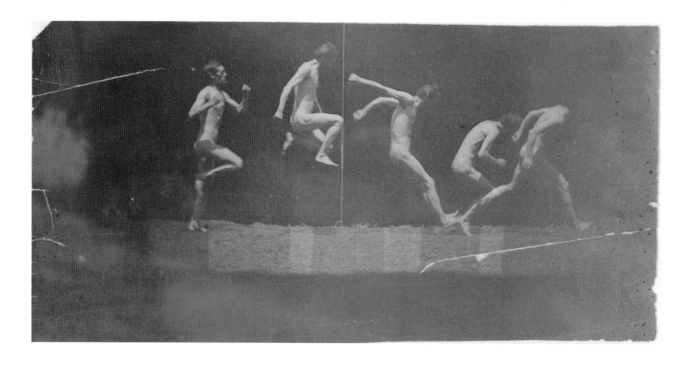

*OPPOSITE PAGE*

**Fig. 3-64 (top)**
Thomas Eakins
*George Reynolds, Walking*, 1884
Albumen print, multiple exposures from a Marey wheel camera
5.9 x 9.9 cm

**Fig. 3-65 (bottom)**
Thomas Eakins
*George Reynolds, Running Long Jump*, 1884
Albumen print, multiple exposures from a Marey wheel camera
5.9 x 10.2 cm

**Fig. 3-66 (below)**
Thomas Eakins
*Man Walking, Wearing Boots*, 1884
Platinum print, multiple exposures from a Marey wheel camera
12.3 x 13.9 cm

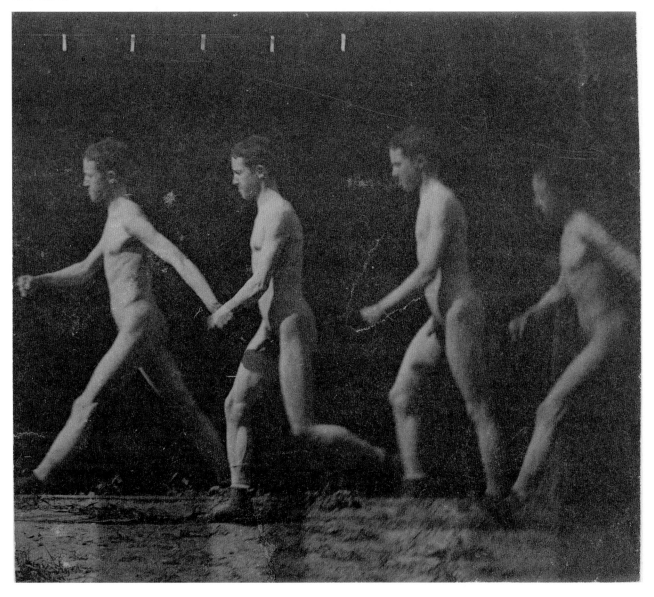

## Animal Locomotion

In 1883, having traveled throughout Europe lecturing about his results in Palo Alto, and having decisively split with Leland Stanford over the handling of the Stillman book, Muybridge petitioned the University of Pennsylvania and other likely institutions to underwrite an extension of his research. According to the prospectus, which was never executed as planned, it was to result in a publication called *The Attitudes of Man, the Horse, and Other Animals in Motion*.[38] The quasi-evolutionary implications of the phrase "man . . . and other animals" may have been too much for would-be buyers; ultimately the title was changed to the more neutral *Animal Locomotion*. Subscribers were offered one hundred "original photographs," printed by the permanent process, selected from photographs made in 1883. In addition, the subscriber could submit his or her own animal for Muybridge to photograph and would be welcome to visit the studio track while the investigations were being made.

At the instigation of the university provost, William Pepper, the University of Pennsylvania agreed to support the work. Details of the supervisory committee, which was to include Eakins, were settled, and financial arrangements were made. Muybridge ordered a new set of lenses, the "largest and most magnificent camera lenses ever made," he would later claim.[39] Soon he was ensconced in the university's veterinary department. He began his work a year later than planned, with instructions to make photographs useful to both medical and veterinary students.

The work in Philadelphia was based on previous efforts in Palo Alto, although the emphasis changed slightly. Muybridge dispensed with the method he had used in California, in which electrically activated trip wires were employed to trigger the shutters. In Palo Alto in 1879 he had begun to use a clockwork mechanism to control exposure for certain animals, especially humans. This was necessary to capture certain kinds of movement. Many human behaviors, for example, are not suited to the

38. Unpublished prospectus, Janet Leigh Papers.
39. Muybridge 1893, 15.

trip-wire method, which works well only if the subject proceeds with constant velocity. Horses were ideal for such treatment, as they were usually recorded proceeding steadily along a straight track. If a subject's course is erratic, however—for example, if he or she reverses, stops, or moves in a way that would not cause a trip wire to be activated—then the method is unsuitable. In Philadelphia, Muybridge planned to make more pictures of this type. To accommodate this, he built a clockwork mechanism to fire his cameras. Time, suddenly, was the absolute currency of a Muybridge picture.

The transformation was significant. When a horse or other animal moves through a series of trip wires, its progress is measured. But the wires activate only when the animal gets to them; the sequence records the position of the animal at two- or three-foot intervals. This arrangement has one basic flaw—it does not pick up changes in the rate of movement. So if a running animal hesitates at some point in its stride, or if it is faster pushing off in a leap than it is coming down from one, the camera does not adjust accordingly. Photographs made by trip wires mark only the passage of an animal. They cannot capture changes in speed.

The *Animal Locomotion* portfolio, however, is not, strictly speaking, made up of actual photographs. The prints themselves are collotypes, made using an ink-based photomechanical process designed to enable photographs to be published in book form. In the late 1860s and early 1870s a number of new processes were developed to allow printing plates to be made from photographic originals. Before this time, if an author wanted to put a photographic illustration in a book, the publisher would have to arrange for copies of the photograph to be printed and inserted by hand. Photographic illustrations were usually glued to the printed pages, or "tipped in." This was a laborious and expensive process, and consequently, few books were photographically illustrated before the advent of photomechanical printing in the 1870s. Using these new

methods, photographs could be printed much as woodcuts and line engravings were and published in books affordably. The plates in *Animal Locomotion* were made using one of these new methods.

Collotype plates do not look like traditional printing plates. Unlike plates used in etching and engraving, which are normally made of copper or zinc, collotype plates are glass. This glass is coated with a light-sensitive gelatin mixture. The gelatin layer holds the ink and serves as the matrix for the print. To transfer an image to the gelatin, the printer places a photographic negative in contact with the glass plate. Light is shone through the negative, which causes the gelatin to reticulate, or fissure, in proportion to the light transmitted. The result is a network of tiny cracks in the surface of the gelatin corresponding to the contact negative. The cracks hold ink in proportion to the amount of reticulation on the surface, making reproduction of the photograph possible. The plate is inked, paper is put in contact with it, and pressure is applied. The finished print resembles a photograph but is made of ink.

The fact that the pictures in *Animal Locomotion* were made using this method accounts for their distinctive, slightly fuzzy texture—under a microscope the lines that form them are made up of millions of tiny cracks. Collotype prints are not as sharp as photographs, but they are much less expensive to produce in large quantities, and they are highly permanent because the inks from which they are made are relatively insensitive to light. This is why *Animal Locomotion* plates are comparatively common in museum and gallery collections today. They were printed in large numbers, and many of them are well preserved.

Collotype printing is complicated enough when transferring a single image to paper, but Muybridge, who worked with sequences of images, faced additional problems. His cameras at the University of Pennsylvania produced thousands of negatives that had to be compiled for publication. These original negatives have been lost, except for one example contained in a film

**Fig. 3-67**

Maker unknown, possibly Scovill Manufacturing Co. (for Eadweard Muybridge)

*Plate holder*, c. 1884

Photographic equipment, black painted wood with fabric roll back, number 8, used in the University of Pennsylvania experiments; with three unexposed original glass plate negatives

14 x 97.3 x 5.2 cm

holder at the Cantor Arts Center. The center owns film back number 8 from Muybridge's Pennsylvania experiments (fig. 3-18). When opened, the holder was found to contain three strips of glass coated with photographic emulsion but apparently never exposed or processed. Each strip could be used to make four 2 1/4-inch (5.7 cm) square images—that is, twelve images for each holder. Though blank, these are the only known examples of original Muybridge negatives from *Animal Locomotion* (fig. 3.67).

The negatives were too small to use directly in publication, so they had to be enlarged. To do so, each was copied using lantern slide materials, producing thousands of enlarged transparencies of the original negatives. These were then arranged in order, cut if necessary, and attached to large glass plates. These plate/slide montages are known as interpositives—positive renditions of the negatives used to produce the final plates but not finished products in themselves. Many of these interpositive plates still exist. A small number are scattered among several collections—including the Cantor Arts Center (figs. 3-68–3-70), George Eastman House, and the Philadelphia Museum of Art—but the majority, 528 in all, are in the collection of the National Museum of American History at the Smithsonian Institution.

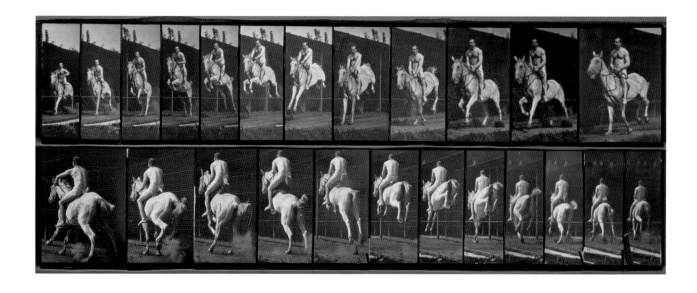

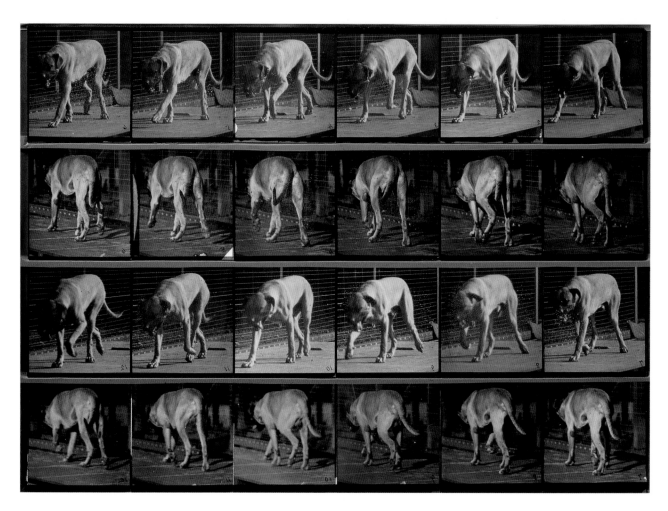

OPPOSITE PAGE

**Fig. 3-68 (top)**
Eadweard Muybridge
*White Horse "Pandora" Leaping over a Hurdle, Rider Nude*, 27
    September 1885, from the series *Animal Locomotion*
Gelatin-silver on glass interpositive plate
18.1 x 49.2 cm

**Fig. 3-69 (bottom)**
Eadweard Muybridge
*Dog Named "Dread," Walking*, 25 October 1885, from the series
    *Animal Locomotion*
Gelatin-silver on glass interpositive plate
29.6 x 41.9 cm

**Fig. 3-70**
Eadweard Muybridge
*Man Riding a Trotting Horse,* September 1885, from the series
    *Animal Locomotion*
Gelatin-silver on glass interpositive plate
29.8 x 42.6 cm

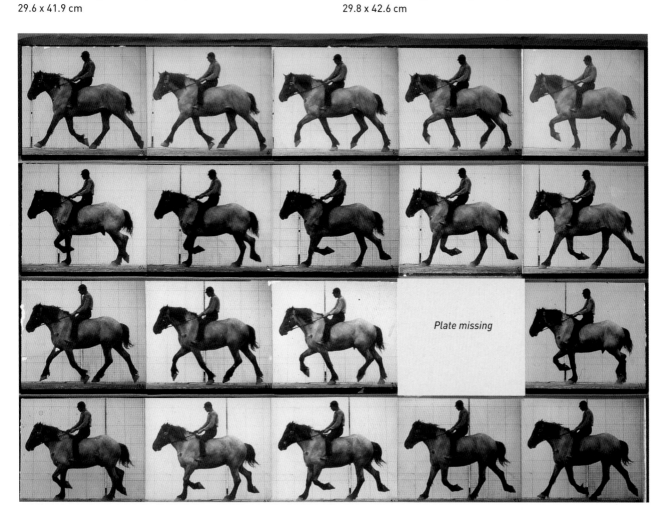

Plate missing

The interpositive plates were made by the New York City firm of J. B. Colt & Co., a specialist manufacturer of lantern projectors, slides, and accessories. Many of them are marked with a stamp reading "Published by J B Colt & Co.," but Colt was not the final publisher of the images. The title page of *Animal Locomotion* lists another company, the Photo-Gravure Company of New York, as the publisher. Few records exist about either firm. One may have been a subsidiary of the other, or they may have been competitors. The fact that the glass plates list Colt as publisher while the collotypes list the Photo-Gravure Company may even mean that Colt was released from the work at some point.

It is not clear why Muybridge would have chosen either firm for the work, or even why he decided to use lantern slides to make his plates in the first place. Cost may have been a factor. The Colt catalogue of 1893 boasted that "slides for the Lantern are now made in such great variety that collections of photographs can be had in this format at less expense than good prints on paper."[40] Conventional lantern slide materials would have been fairly common, but Muybridge used an ultra-thin glass to make them, which had to be specially ordered. (The unusual composition of this glass is one reason many of the interpositives are badly deteriorated today.) Lantern slides may simply have been the materials he knew best, since he had been presenting slide lectures about his work since the early 1880s. His zoopraxiscope too was essentially an adapted lantern slide projector, and it is now known that the earliest prototype of a zoopraxiscope disc was made from small lantern slides (see p. 158; fig. 3-28). In any case, nearly all of Muybridge's later works existed originally in the form of lantern slides before they were made into something else; they were the ingredients from which nearly all late Muybridge imagery grew.

The glass interpositive plates are made of a series of lantern slides mounted on 16-by-23 1/2-inch (40.4 by 59.7 cm) glass plates. The slides themselves were attached, emulsion side up, to the glass and lined with thin strips of masking tape. The glass

40. J. B. Colt & Co., *Catalogue of Optical Lanterns, Lantern Slides, and Accessories* [New York, 1893], 13.

surrounding the slides was also masked using orange tape and bound with a cream-colored tape at the edges. Orange was an effective color for masking. Early photographic materials were slightly more sensitive to shorter wavelengths of light—that is, those on the blue-green end of the spectrum. Longer wavelengths, such as red and orange, were less easily recorded. So orange masking would have been effective because it allowed less light to transmit to the negative. It is even conceivable that Muybridge used special orthochromatic (orange-insensitive) chemistry to copy the plates, which would have made the orange masking especially effective.

Collotypes cannot be made from positives, however. So in order to make the collotype printing plates, Muybridge had to convert them to negatives first. The glass plates were backlit, using a light box or similar device, and rephotographed. A nearly complete set of transitional negatives, or internegatives, made in this way exists in the collections of the Philadelphia Museum of Art. These were the negatives used to make the collotype plates. It is hard to know quite what they looked like when new, as the material of which they are made is now yellowed and extremely brittle. They appear, however, to be thick pieces of transparent gelatin.

The whole process of making a Muybridge collotype required five steps. First, negatives were made in the camera. These were then enlarged and made into thin lantern slides. The lantern slides were arranged on glass plates and rephotographed to make a transitional negative. The negative was then used to make a collotype printing plate. The plate was then inked and transferred to paper.

One consequence of all this copying was a loss in clarity. Each time a photograph is copied, it becomes slightly less sharp than its predecessor, and contrast increases. Blacks and whites become more pronounced, and midtones tend to disappear. To try to correct this, it seems Muybridge slightly reduced the size of the interpositives in printing. The images on the interposi-

tive plates are minutely larger than their related collotypes, and this reduction made the loss in clarity less obvious. In general, however, the collotype plates in *Animal Locomotion* are not as clear as they would have been using another process. There is also considerable variation in print quality between plates in *Animal Locomotion*. The process was very exacting. Muddy pictures could result if the printer was not careful.

Why, then, did Muybridge use a process that was so tricky and that would result in such a loss of sharpness? In California he had been regarded rightly as a virtuoso photographic printer. His mammoth-plate landscapes of the Yosemite Valley, for example, are among the sharpest and most technically accomplished photographic works of the nineteenth century. Moreover, the pictures he published in his first book of motion studies, *Attitudes of Animals in Motion*, are printing-out paper prints; these were made directly by contact from negative to positive. The quality of the printing in *Attitudes* is excellent, although the images are small.

The ability to enlarge may have been one reason Muybridge opted for the more complex collotype process over others. Because of the size of the photographs published in the early *Attitudes* book, minute details are difficult to see. Nearly all of these images are silhouettes, however, so there was not much concern about being able to discern internal structure. By the time Muybridge made *Animal Locomotion*, technology had improved enough so that not just the outline but also the subtle positions of fur, fat, muscle, and sinew in action could be recorded. To see this well, it was necessary to enlarge the images. Enlargement, therefore, involved a compromise. Using collotype did reduce sharpness, but it also enabled things to be shown on a larger scale.

Nevertheless, there are other processes that would have enabled Muybridge to achieve the same effect without so many intermediate stages. The final step, in which the interpositive plate was rephotographed to make a transitional negative, could

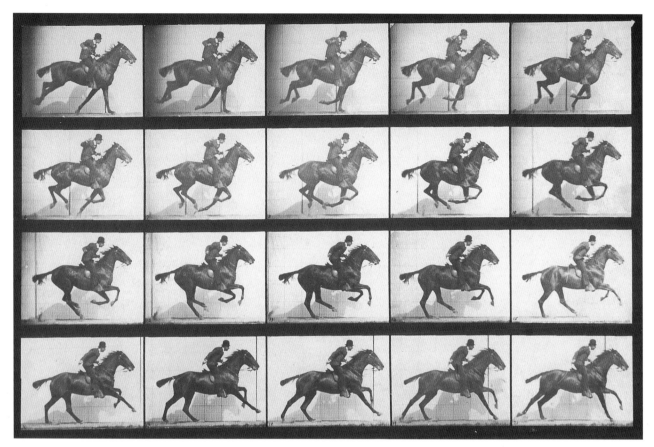

**Fig. 3-71**
Eadweard Muybridge
*Gallop, Bay Horse "Daisy,"* 1884–86, full-
    plate proof of plate 628 from the series
    *Animal Locomotion*
Cyanotype print, mounted on card
31.8 x 48.4 cm

have been avoided had he used a positive-to-positive process. Why, for example, did he not make prints directly from the positive plates he and the Colt company made? There is evidence that he did try to do so.

The collections at the National Museum of American History include seven full-plate cyanotypes that were printed directly from the glass interpositive plates (fig. 3-71). Cyanotypes are photographs made with an iron salt rather than silver. Related to blueprints, they are easily distinguished by their striking blue color. The full-plate cyanotypes at the National Museum of American History are the only known works of their kind. Each is labeled in letterpress in the margin "Copyrighted 1887, by Eadweard Muybridge," suggesting that they were intended not as proofs, but as finished prints.

The use of cyanotypes presents problems, however. Though

the results are potentially beautiful, the process produces high-contrast images. Shadows and highlights register well, but mid-tones tend to be lost. In addition, Muybridge had arranged to have his lantern slides attached to the interpositive plates emulsion side up. This was best for copying using a light box, because the photographer would not be shooting through the glass to which the emulsion is attached, which would result in a loss in clarity. By the same logic, if the interpositives were to be used in contact with the printing paper, then the plates would have to be inverted for printing, so the emulsion would be touching the paper. This would make for the best prints, because there would be no glass intervening between the interpositive image and the paper. Unfortunately the interpositives are correct only when viewed from the emulsion side. When they are turned upside-down, left and right in the photographs is reversed. Worse still, the individual frames had been numbered in the image, so an upside-down contact printing would make all the numbers look backward.

This problem can be seen in the seven full-plate cyanotypes at the National Museum of American History. In some, the left-right orientation is correct, and the numbers read properly. But these look fuzzy because the plates had to be printed from the wrong side. In other words, to get left and right correct in a contact print, the plates had to be put on top of the paper with the emulsion on top, separated by two layers of glass—the glass of the lantern slides, plus the glass of the plate they were stuck to. Not all of the National Museum's cyanotypes were made this way, however. Some were printed emulsion side down. These prints are sharp and crisp, but the orientation is backward. It is not known whether Muybridge realized that this would be a problem when he began his work, or if it emerged only later. The chronology of events leading up to the collotype printing may never be known. It is clear that none of the processes used was perfect, that the printing company changed at some point in the project, and that Muybridge experimented with cyanotype

printing as an alternative to collotype. Without the benefit of correspondence or records from the Colt company, the story behind these full-sized cyanotype prints remains a mystery.

These seven cyanotype prints are just a tiny fraction of the works held in the photographic history collections at the National Museum of American History. It has only recently been discovered that the collections include one of the most extraordinary artifacts in all of Muybridge scholarship—a nearly complete set of proofs for the *Animal Locomotion* series. These proofs provide a key to unlocking many of the mysteries associated with the *Animal Locomotion* plates, enabling scholars to see for the first time how Muybridge went about making his pictures.

### Cyanotype Proofs

For many years, *Animal Locomotion* has been known only through the collotype plates published by the University of Pennsylvania in 1887 and a handful of related materials in museum collections. A number of unpublished materials—such as the glass interpositive plates at Stanford, Philadelphia, and Eastman House—have been known, but these have not provided much information beyond that contained in *Animal Locomotion*.

There are other curiosities, but they have done little to shed new light on Muybridge and his work. For example, the International Museum of Photography at George Eastman House owns a number of album pages handmade on gelatin-silver printing-out paper instead of the published collotype form. Like the full-plate cyanotypes, these may have been made before Muybridge had settled on collotype as the technique he would use to publish the folio. They may also have been prototypes, intended either as a mock-up to present to potential printers or as a presentation set to sign up potential subscribers. Or they may have been made after *Animal Locomotion* was published, either for Muybridge's own enjoyment or as a special set for an important client. A disproportionate number

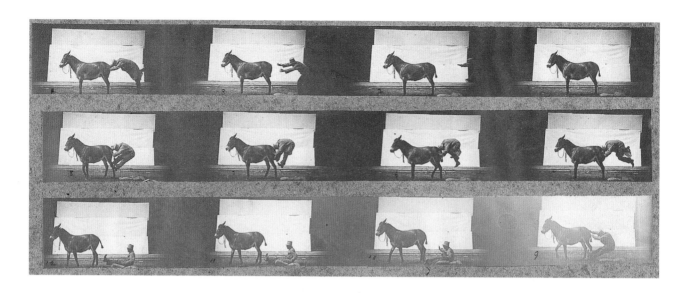

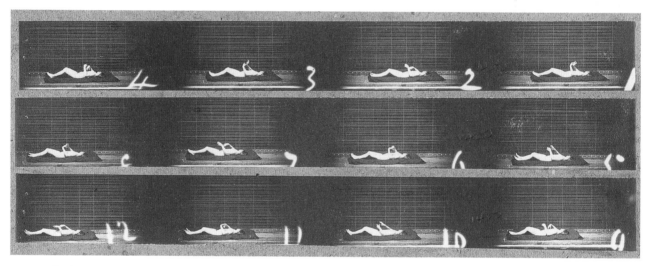

**Fig. 3-72 (top)**
Eadweard Muybridge
*Mule "Denver" Butted by a Man*, 19 June
    1885, proof of plate 663 from the series
    *Animal Locomotion*
Three cyanotype prints, mounted on card
11 x 29.1 cm

**Fig. 3-73 (bottom)**
Eadweard Muybridge
*Artificial Convulsions (Alice Cooper)*, 24 Sep-
    tember 1885, unpublished proof from
    the series *Animal Locomotion*
Three cyanotype prints, mounted on card
10 x 29.3 cm

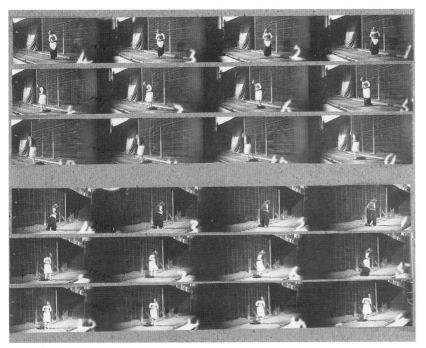

**Fig. 3-74**
Eadweard Muybridge
*Dropping Skirt and Unfastening Corsets
(Blanche Epler)*, 24 September 1885,
unpublished proof from the series *Ani-
mal Locomotion*
Six cyanotype prints, mounted on card;
Muybridge negative number 1405
21.7 x 28.8 cm

of the Eastman House prints are of nude female figures, suggesting that they were produced either for an artist with a particular interest in moving female subjects or for a private collector with an admiration of the female form. In any case, the Eastman examples correspond exactly to the collotype plates. Apart from their beautiful brick red color, they look much the same as the published works.

The collection of cyanotype proofs at the National Museum of American History, however, is completely unique. The museum possesses proofs of nearly all the plates in the *Animal Locomotion* series, together with a number of images that have never been published, such as *Dropping Skirt and Unfastening Corsets (Blanche Epler)* (fig. 3-74). Many of the unpublished plates are variants of published images, discarded in favor of clearer or more complete renditions. Others, such as *Dropping Skirt*, represent ideas explored in the studio but rejected for publication. The cyanotype process was probably chosen to make the proofs because cyanotypes are quick and relatively inexpensive to make. Also, their distinctive color ensured that they would not be confused with final prints once the decision to print the final version in collotype had been made (figs. 3-75, 3-76).

In addition to the visual information they contain, the proofs provide a sort of Rosetta Stone for unraveling Muybridge's laboratory notebooks. The existence of these notebooks, now in the library at George Eastman House, has been known for some time. Much of their content has been indecipherable, however,

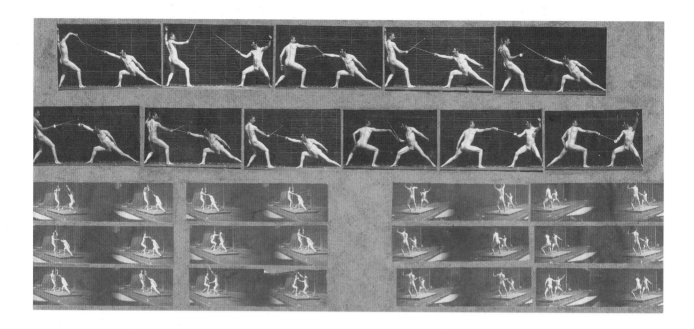

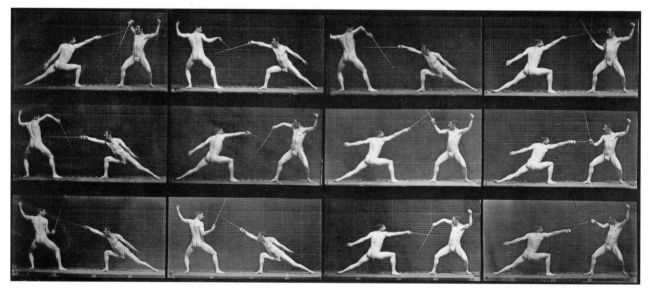

**Fig. 3-75 (top)**

Eadweard Muybridge

*Fencing (Mr. Hutchinson and Mr. Bonifon)*, 11 October 1885, unpub-
    lished proof from the series *Animal Locomotion*

Twenty-three cyanotype prints, mounted on card

23.1 x 54.1 cm

**Fig. 3-76 (bottom)**

Eadweard Muybridge

*Fencing (Mr. Bonifon and Mr. Austin)*, 11 October 1885, plate 349
    from the series *Animal Locomotion*

Collotype

18.1 x 42.2 cm

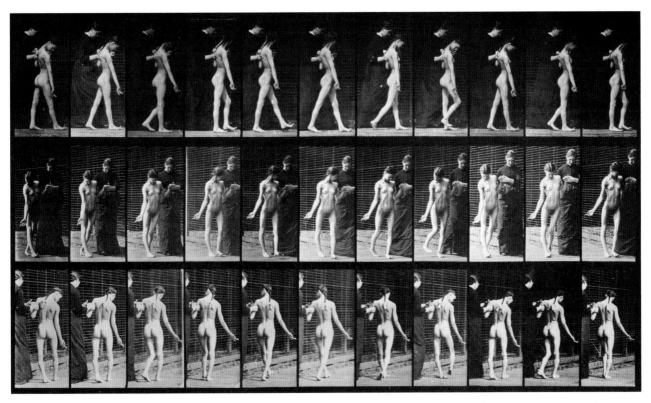

**Fig. 3-77**
Eadweard Muybridge
*Woman with Multiple Sclerosis, Walking*
    *(Anna May Keisler)*, 25 September 1885,
    plate 541 from the series *Animal Loco-*
    *motion*
Collotype
20.8 x 35.8 cm
    Muybridge photographed many different
types of individuals for the *Animal Loco-*
*tion* series, including a number of subjects
with physical disabilities. Sequences like
this one, showing a young woman with mul-
tiple sclerosis walking, were made for med-
ical purposes. It was intended to demon-
strate some of the complex adaptations
involved in compensating for the loss of
ordinary means of movement.

41.  Eadweard Muybridge, Lab
     Book #3, Library, George East-
     man House, Rochester, New
     York, 82:2602:1.

because Muybridge used serial numbers rather than published
plate numbers when compiling his notes. For example, using
Muybridge Lab Book #3, it is possible to determine only that
serial number 1415, photographed on September 25, 1885,
depicts a woman named Anna May Keisler, age twenty-three.
She is described performing the action "Walking (clinical)."[41]
Without additional information, it is difficult to know to which
image this entry should be attached. The proof of serial number
1415 in the American History collection provides not just the
raw negatives associated with this entry, however, but also the
published plate number. From annotations on it, it emerges
that serial number 1415 was published as plate 541 of the series,
with the title *Woman with Multiple Sclerosis, Walking (Anna May
Keisler)* (fig. 3-77). Using the notebooks and proofs together, it
is possible to deduce a wealth of information about when each
sitting occurred; the names, ages, and occupations of many sit-
ters; and whether there were retakes of a particular image.

In the National Museum of American History proofs, published and unpublished alike, it is possible to see nearly the entire Muybridge studio. The stagelike illusion of abstraction is broken, as the mundane details of the surrounding environment intrude on each image. The sometimes flimsy facades erected to stage the photographs, the location of equipment, and the unguarded appearance of sitters photographed when a camera misfired are all visible. Looking at the proofs, it immediately becomes apparent how much editing was required to make the images that appear in *Animal Locomotion*. Nearly all of the images in the published plates are enlarged versions of the original negatives. Few, if any, were printed just as they came from the camera. Instead they were cropped to isolate particular elements of behavior or to mask inconsistencies in the negative.

The published and proof versions of *Movement of the Hand, Lifting a Ball (Mr. Tadd)* (figs. 3-78, 3-79), for example, demonstrates this connection. In the unpublished version the sitter is fully visible, as is the background behind him. Before publication the negatives were cropped substantially, however, leaving only the hand and ball visible. Most *Animal Locomotion* plates were made this way, narrowing the field of view to isolate desired elements.

In Philadelphia, Muybridge used two kinds of cameras. The first, a lateral type, was similar to those commonly used in Palo Alto. A bank of cameras was strung along the track at regular intervals to record the subject as it progressed left to right or right to left, perpendicular to the view. Examples of these cameras are preserved at the National Museum of American History, at the International Museum of Photography at George Eastman House, and at the Philadelphia Museum of Art. Made of cheap poplar, the sort of wood used to make packing crates, they indicate an attention to economy uncharacteristic of Muybridge's work. There may have been other concerns addressed by using poplar too: the weight of the camera apparatus would certainly have been considerable, and using a light wood

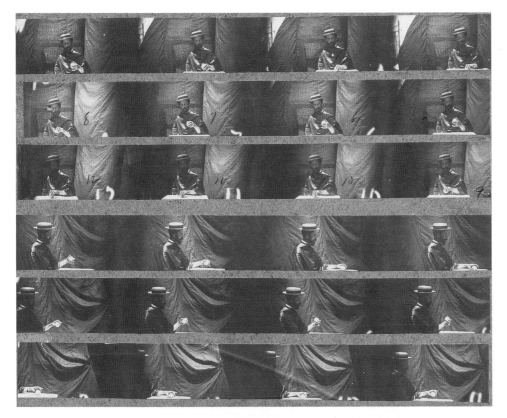

**Fig. 3-78**
Eadweard Muybridge
*Movement of the Hand, Lifting a
    Ball (Mr. Tadd)*, 24 July 1885,
    proof of plate 534 from the
    series *Animal Locomotion*
Six cyanotype prints, mounted on
    card
21.7 x 28.4 cm

**Fig. 3-79**
Eadweard Muybridge
*Movement of the Hand,
    Lifting a Ball (Mr.
    Tadd)*, 24 July
    1885, plate 534
    from the series
    *Animal Locomotion*
Collotype
22.2 x 33.1 cm

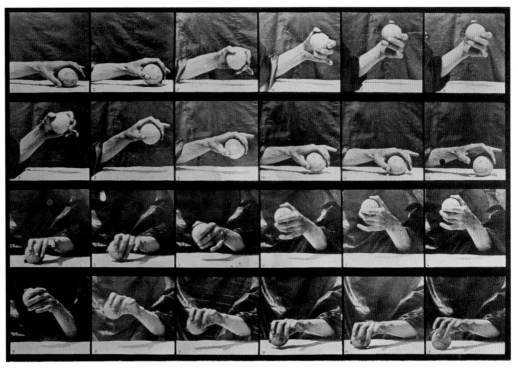

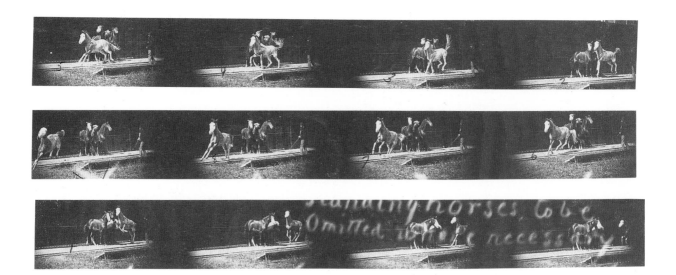

**Fig. 3-80**
Eadweard Muybridge
*Nutmeg Horse "Hornet" Attempting to Jump*
*Three Horses*, 18 June 1885, unpublished
proof from the series *Animal Locomotion*
Three cyanotype prints, mounted on card
11.5 x 28.8 cm

reduced the likelihood of collapse. Moreover, the cameras were meant to be used only temporarily and were probably intended to be disposed of after use. The manufacturer of these cameras is not identified, but the fittings are consistent with those of the Scovill Manufacturing Company of New York. This makes sense, as Muybridge had given his address care of Scovill in the initial prospectus for *Animal Locomotion*.

The second type of camera, used sparingly in Palo Alto but liberally in Philadelphia, was used for foreshortenings. These were single camera units with multiple lenses on the front, designed to make images of subjects coming toward or moving away from the operator. These could be arranged either at a forty-five-degree angle or head-on to the sitter according to the photographer's needs. No intact foreshortening camera is known to have survived. The National Museum of American History does, however, possess several items of Muybridge equipment that may have been part of them. One of them is a standard mammoth plate holder, measuring 18 by 21 inches (45.6 x 53.3 cm), containing two dark slides.[42] This holder may have been used as the back of a foreshortening camera. It would have been approximately the right size, and it was natural to use readily available materials whenever

42. The accession number of the plate holder is 2101.1. The lens boards are 2102.2.

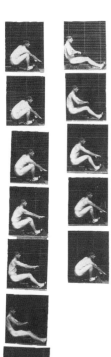
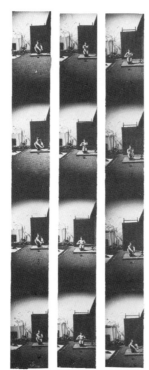
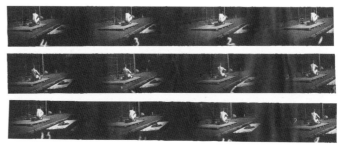

**Fig. 3-81 (top)**
Eadweard Muybridge
*Rowing, Nude (Frank Gummey)*, 24 October
   1885, unpublished proof from the series
   *Animal Locomotion*
Eighteen cyanotype prints, mounted on card
29.7 x 51.2 cm

**Fig. 3-82 (above)**
Eadweard Muybridge
*Somersault*, before 2 May 1885, unpublished proof from the series
   *Animal Locomotion*
Six cyanotype prints, mounted on card
8.3 x 31.7 cm
   Sometimes it was difficult to keep track of the proper
sequence of events in a Muybridge photograph. Occasionally, as in
this example, a frame might be mounted upside-down.

*OPPOSITE PAGE*

**Fig. 3-83**

Eadweard Muybridge

*Cockatiel in Flight*, August 1885, proof of
    plate 758 from the series *Animal Loco-
    motion*

Six cyanotype prints, mounted on card
19.7 x 28.3 cm

These unedited proofs of one of Muy-
bridge's best known sequences of a cock-
atiel in flight shows the considerable
manipulations involved in producing images
of birds in flight. Rather than try to track
birds as they flew, Muybridge simply stood
well back with his camera, ensuring he
would capture them regardless of where
they went. Then he enlarged each frame in
the darkroom, narrowing in on the animals'
bodies to create the illusion that they were
closely tracked.

The markings on the surface of these
proofs are painted chemically on the sur-
face, suggesting that preliminary editing
was done quickly as the proofs were being
printed.

possible. Also in the museum's collection are two items
described as "lens boards," actually long, narrow, brown-
stained oak boards with black-stained trim. The purpose of
the boards is not recorded. The presence of a small lip on the
top of them as if to retain something, the matte black paint-
ing on one side to minimize unwanted reflections, and the
use of expensive but strong and stable oak suggest, however,
they may have been used to support heavy foreshortening
cameras.

The negatives used were 2 1/4 inches square. In many cases
only half of the area was used, however, resulting in an image
approximately 2 1/4 by 1 1/8 inches (5.7 x 2.8 cm). This gave
Muybridge two different formats to work with, a "full size"
and a "half size." Using the negatives full size provided the
greatest resolution and was preferable for printing, but full-
size negatives also provided little margin for error. If the
subject was not centered in the frame when the timer acti-
vated the shutter, it would be cut off or not registered at all.
For rapidly moving subjects, it was more convenient to use
the half-size negative. The lens projected on a smaller por-
tion of the negative, and the image was reduced, providing
greater leeway. The quality of the resulting print would be
compromised, but the subject would at least be fully captured
in the negative. The collection of Muybridge equipment at
Eastman House includes a wooden cone that may have been
used to toggle between full- and half-size negatives. With the
cone on, the lens would have been stepped back a fixed dis-
tance from the negative. A number of such cones could have
enabled Muybridge to quickly change his cameras from one
mode to the other, without having to adjust the bellows of
each individually.

Muybridge never seems to have photographed direct front
and rear foreshortenings simultaneously. If one foreshortening
camera was aimed at a subject head-on, for example, then the
other would be aimed from the rear at forty-five degrees. This

was probably intended to prevent the opposing camera from appearing in the view. By angling each camera precisely, he could ensure that neither would be evident in the other's field of vision. This is an interesting conceit, foreshadowing the use of the shot/countershot technique by filmmakers.[43]

Perhaps the most dramatic revelation contained in the National Museum of American History cyanotype proofs is the way in which birds were photographed. Muybridge photographed these and other animals at the Philadelphia Zoological Gardens. Birds did fly free, but they were tethered so that they could be retrieved easily. Most were released in front of a large gridded screen, which they were meant to fly past. Muybridge did try to arrange his cameras to track the birds as they flew. He stood well back with his camera, however, keeping a wide-angle of view to ensure that each phase of the bird's flight was captured. Each image was then cropped and cleaned up in the darkroom. In the case of the unpublished proof *Cockatiel in Flight* (fig. 3-83), the erratic path of the bird is recorded, as well as the editing marks painted chemically on the surface. As this picture demonstrates, a considerable amount of intervention was sometimes required to make the final plate cohesive (see fig. 1-4).

The proofs also make it possible for scholars to evaluate the integrity of Muybridge's *Animal Locomotion* images. In recent years a number of writers have called the reliability of the work into question, stressing the inherent manipulability of each plate.[44] Using the camera battery method, Muybridge pro-

43. Shot/countershot describes the privileged point of view used in some motion pictures. In the simplest example, two characters are shown facing each other. The camera moves effortlessly from the point of view of one character to that of the other, all the while concealing the camera's presence on the set. By making sure one camera seldom registered the presence of another, Muybridge was able to create a similar illusion of omniscience.

44. Unfortunately I am one of those who erroneously challenged the reliability of Muybridge's *Animal Locomotion* plates (see Prodger 1996).

OPPOSITE PAGE
**Fig. 3-84 (top)**
Eadweard Muybridge
*Curtsey (Mrs. Welsh)*, 21 September 1885,
    plate 198 from the series *Animal Loco-
    motion*
Collotype
19.8 x 38 cm

**Fig. 3-85 (bottom)**
Eadweard Muybridge
*Turning Away and Running Back*, 10 July
    1885, plate 73 from the series *Animal
    Locomotion*
Collotype
24.9 x 31.3 cm

duced series of individual images that could be combined, altered, or substituted at will. Given this potentially easy escape and the inconsistent appearance of some images, it has long been supposed that some *Animal Locomotion* plates are assembled from disparate sources. The proofs, however, provide incontrovertible evidence of the way in which each plate was assembled. Remarkably few show evidence of the long-suspected manipulations; nearly all are faithful renditions of the originals. In some cases, problems arose in particular sequences that required editing. Rear foreshortening shutter five frequently misfired, for example, and there are numerous examples in the proofs of workarounds being devised to correct this. Similarly, there were occasionally problems with the timing of the first or last frame. Usually these were simply excised from the sequence. And in some cases the beginning or end contained frames in which nothing happened, as when an activity meant to take ten frames was completed in eight. But in general there are only minor corrections. Studying the cyanotype proofs, one is struck by how faithful they are to the originals. Muybridge was more honest than might at first be apparent.

Made up of 781 plates and thousands of individual exposures, *Animal Locomotion* depicts a comprehensive range of human and animal behaviors. It is Muybridge's most mature work, containing the fullest vision of instantaneous photography's capabilities that he would realize. Produced in an astonishingly short period of three years, it represents a Herculean effort by Muybridge and his publishers. The images it contains are alternately quirky, beautiful, haunting, and even maddening. And they are meaningful—laden with subtexts such as sexuality, class, race, and gender roles. Often the results are compelling as a result of astute decisions made in the studio. Sometimes they were the consequence of luck or technical necessity. Muybridge succeeded by navigating these competing currents.

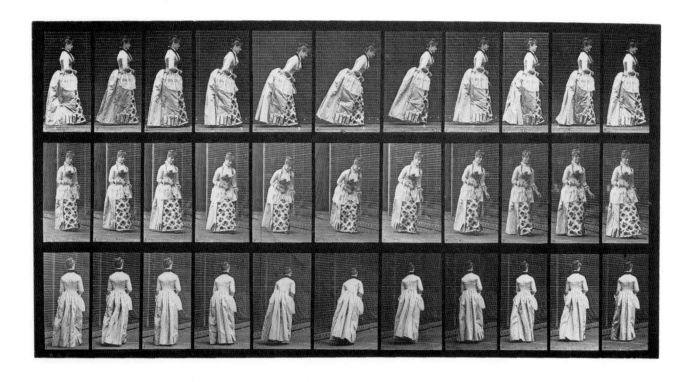

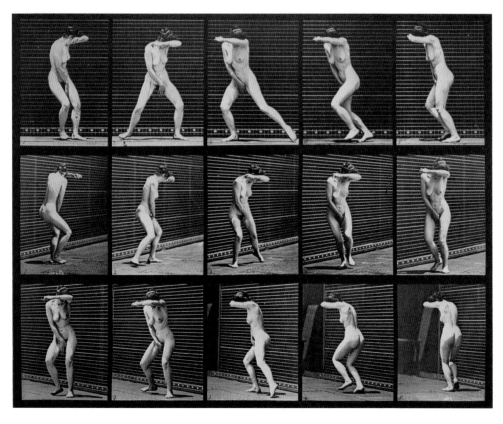

## Muybridge and the Art of Instantaneity

The *Animal Locomotion* proofs reveal for the first time many of the technical forces that governed Muybridge's work. The materials available to him in the 1880s were easier to use than those with which he had started his experiments, but there were still many difficulties to overcome. Although his sponsors at the University of Pennsylvania gave him considerable freedom as well as financial support, Muybridge was still constrained by resources and equipment. His cameras were prone to malfunction; human models and animal specimens had to be found, guided, and sometimes cajoled; and the results had to be painstakingly processed, organized, and prepared for publication. Furthermore, Muybridge undoubtedly felt economic pressures, as the work became more and more ambitious and its publication ever more unprofitable. To make matters worse, the importance of his research, which in Palo Alto had been indisputable, was no longer obvious. Great progress had been made in photographic science since he had begun his work more than ten years earlier; even as he toiled in Philadelphia, photographers around the world were beginning to use new rapid-dry plates, artificial lights, and improved lenses to launch their own instantaneous photography investigations. Yet, in spite of all this, Muybridge succeeded in producing uniquely compelling photographs. In the late 1880s and 1890s, soon after he had ceased producing new work, instantaneous photography became increasingly commonplace. But Muybridge's photographs never lost their distinctiveness.

With his first photographs of the galloping horse in California, Muybridge had pushed photography beyond the threshold of what is visible and made time stand still. As a result, natural and photographic vision had diverged forever. Prior to the perfection of instantaneous photography, camera and eye had been parallel tools. Though photography offered an especially efficient means to gather information, the things one could see in a photograph were the same sorts of things one could see in life.

In Muybridge's photographs, however, the close parallel
between observation and recording was disrupted. Eye and
camera were no longer substitutes for each other but partners,
the eye relegated to contemplating what the camera showed.

Suddenly the question was what to do with this unprece-
dented extension of visual possibilities. Muybridge recognized
the research potential of his techniques and cultivated an air of
scientific authority in articles and lectures. He also knew that
painters, sculptors, and draftspersons would be interested in
this formerly unexplored world, and he touted the value of his
photographs as artists' studies. His interest in these dimen-
sions of the work was undoubtedly sincere, yet it is wise to
remember that his cultivation of different audiences also
enabled him to generate sales. Muybridge was always concerned
with public acceptance of his work. He understood that the
needs of his customers were wide-ranging and tried to indulge
their tastes. In so doing, he devised an extraordinary pictorial
system, synthesizing fresh compositions from volumes of indi-
vidual instantaneous photographs. From his early achievements
in Palo Alto to his later efforts in Philadelphia, Muybridge's
motion studies are easily recognized. Invariably they are made
up of grids, six across and three down, or eight across and two
down, or any number of other similar combinations. He
arranged his pictures in this way not just to make them useful
for analysis and study, but because he thought it made them
look good.

He could have tried to produce larger, more technically pre-
cise images, or more picturesque versions of his experiments.
This was the approach of most of the instantaneous photogra-
phers who preceded him. Those who in the 1840s, 1850s, and
1860s had photographed clowns, animals, waves, clouds, boats,
smoke, and street scenes in motion aspired to make sharper
and clearer instantaneous images than had been made before.
Yet it was the relationship between these images that seems to
have most interested Muybridge. Whereas his predecessors in

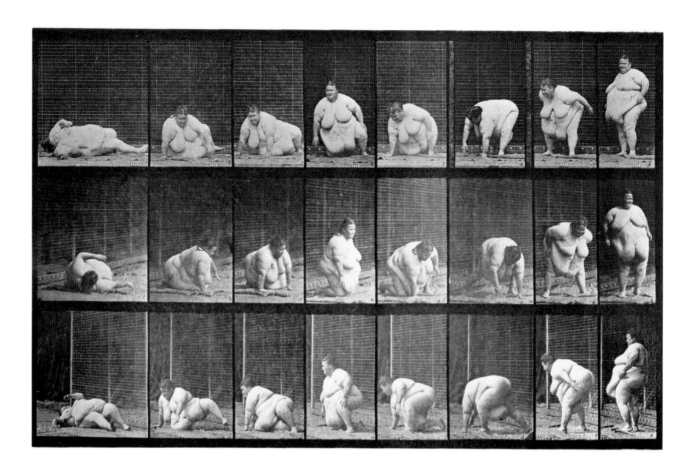

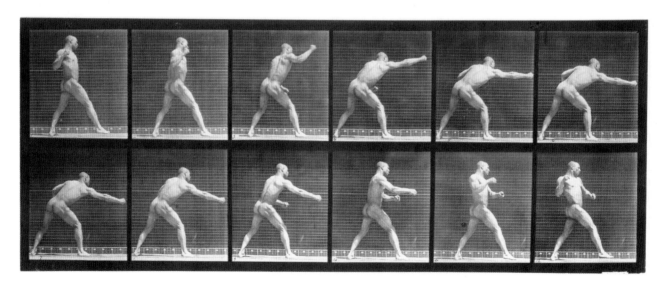

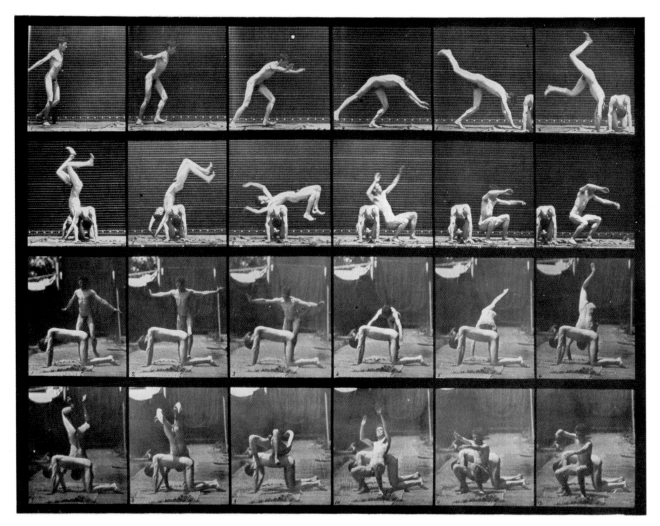

*OPPOSITE PAGE*
**Fig. 3-86 (top)**
Eadweard Muybridge
*Arising from the Ground (Miss Cox)*, 25 September 1885, plate 268 from the series
*Animal Locomotion*
Collotype
21.9 x 34.6 cm

**Fig. 3-87 (bottom)**
Eadweard Muybridge
*Striking a Blow, Right Hand (Ben Bailey)*, 2
May 1885, plate 344 from the series
*Animal Locomotion*
Collotype
17.3 x 44.6 cm

In *Animal Locomotion*, Muybridge
extended his study of human movement to
include individuals of various races. Pictures of this sort were intended for artists
to use as preparatory studies, and for scientists to consider as evidence of the physiological characteristics of different ethnic
groups. Nevertheless, like many of the best
photographs in the series, this composition
stands successfully on its own.

**Fig. 3-88 (above)**
Eadweard Muybridge
*Leap Frog, Flip (Mr. Grier and Mr. Mullen)*, 22
July 1885, plate 364 from the series *Animal Locomotion*
Collotype
23.7 x 31.4 cm

instantaneous photography had been content to produce individual compelling images, he concentrated on the disjunctions created by freezing time. Unlike the instantaneous photographers of the mid-nineteenth-century, Muybridge attempted to record the transitions made in moving from one posture to another. As a result, visibility and invisibility are dominant themes in his work.

It is tempting to imagine that it was the repeated appearance of instantaneous imagery, however modest—seen again and again in books, print sellers' shops, and galleries—that drove his work. Whether or not this is the case, Muybridge may be considered the embodiment of a parade of imagery that arose with the mass production of photographs in the Victorian era. At the very least, his works mark a climax in the instantaneous photography movement. In Muybridge, the achievements of hundreds of instantaneous photographers were distilled. As a result, a new aesthetic based on assembly, repetition, and the mechanical coalesced.

The development of a new standard in instantaneous photography was Muybridge's first major accomplishment. In the 1870s, when his first photographs of horses in motion became known, he was commended as an *instantaneous* photographer. The project Leland Stanford initially hired him to tackle, the question of unsupported transit, was essentially the same one photographers had struggled to address since the invention of the medium. Whether the subject was horses, clouds, waves, street activity, or portraiture, the problem was essentially the same—stretching the limits of photographic technology to accommodate moving subjects. Muybridge's project, however, was qualitatively different from its predecessors. For the first time a photographer managed to record events that were truly rapid—that is, that occurred beyond the threshold of natural human vision. Suddenly the old rules of representation and verification no longer applied, and a new frontier in instantaneous photography had been established.

Once Muybridge had perfected a means for making instantaneous photographs, he devised a system for dissecting activity using sequential images. Although such imagery was not new in art, and had already been used to a limited degree in photography, Muybridge was the first to recognize the potential of combining instantaneity with sequence. Using a battery of cameras, he was able to atomize action, stripping it into easily digested pieces. This enabled the viewer to choose the section of activity that interested him or her and to evaluate transitions from one state to the next. Such an approach proved a boon to scientists and artists alike. As a result, photography was elevated from the status of a means of illustration, similar to drawing or printmaking, to an investigative tool. Chronophotographers began to use the medium as a way to study elusive phenomena. And artists came to trust photography as an authoritative source of visual information. The union of instantaneous photography with sequential imagery, and the consequent invigoration of photography as an analytical medium, was Muybridge's second major accomplishment.

Third, Muybridge created a way to reconstitute his photographs using a projection device. The zoopraxiscope undoubtedly affected the development of cinema and may have hastened its arrival. At first, the machine provided proof that the sequences into which action had been separated were genuine. Audiences watched as still images were transformed into short animated loops of activity and back again; the conversion helped to convince them that what they saw was real. The process helped to legitimize Muybridge's techniques of instantaneous photography and sequential imagery, but the zoopraxiscope soon took on a life of its own. He quickly discovered that projected photographic animations were a powerful form of entertainment. Consequently audiences developed new expectations about how imagery could be presented. The contribution Muybridge made to the history of motion pictures is another of his main accomplishments.

Finally, and perhaps most provocatively, Muybridge was among the first to recognize the aesthetic potential of instantaneous photography. Ultimately he must be remembered not just as an inventor or technician but as an artist also. As his work progressed, he delved increasingly into the visual possibilities of the world he revealed. Works such as *Fencing (Mr. Bonifon and Mr. Austin)* (see fig. 3-76) and *Walking Elephant* (fig. 3-89), for example, are characteristic of this exploration. Though they depict behaviors mechanically abstracted, sliced into temporal parts, and decontextualized, collectively they manage to form a pleasing and balanced composition. More than mere documents, Muybridge's best images are visceral and emotive.

One important element of Muybridge's artistic success is the use of compositional strategies to make appealing pictures. In *Fencing* and *Walking Elephant*, frames of imagery often play from one to the next, seemingly pointing from one to another, thereby linking fractured space. The subtle differences evident between the frames in *Walking Elephant*, for example, are echoed in the balanced regularity of the grid and amplified by tight cropping around the animal. Each elephant inhabits a small box barely sufficient to contain its enormous frame. The effect is not of a single animal moving, but of a herd of elephants arranged in an incredible formation, each seemingly extending its trunk to touch the hind leg of the one before it.

Choice of subject matter is another important element of Muybridge's artistic expression. *Animal Locomotion* in particular is a remarkable feat of the imagination, its images ranging from simple pictures of clothed men and women walking to numerous esoteric situations. People appear in various states of undress, revealing the particularities of sex, race, disabilities, and body type. Nudity is a recurring theme. Consequently, there is an erotic aspect to much of Muybridge's work, but it is never prurient. Instead, the mechanical facts of people are laid bare. Within the abstract confines of the artificial space Muybridge created, a certain pathos manifests itself. Many of the figures

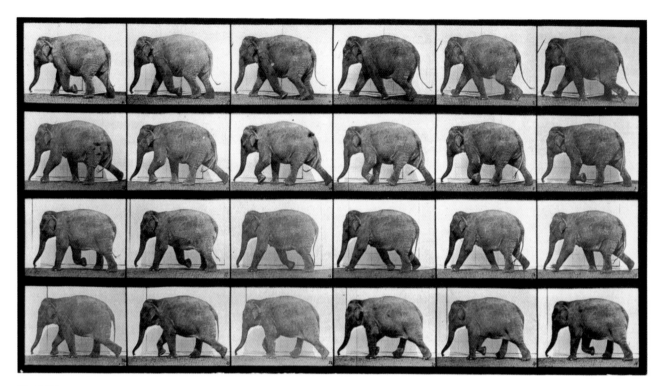

**Fig. 3-89**
Eadweard Muybridge
*Walking Elephant*, August 1885, plate 733
    from the series *Animal Locomotion*
Collotype
20.5 x 37.8 cm

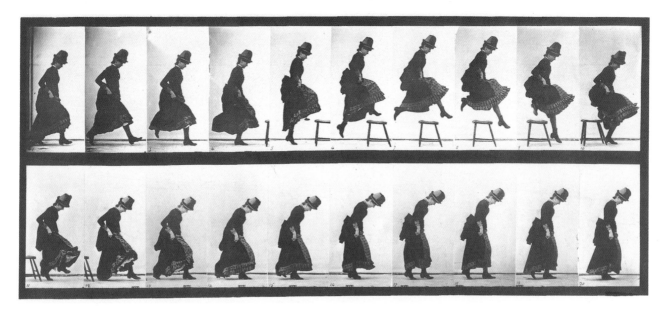

**Fig. 3-90**
Eadweard Muybridge
*Jumping over a Chair (Mrs. Coleman)*, 19
     September 1885, plate 156 from the
     series *Animal Locomotion*
Collotype
18.7 x 43 cm

45. Chickens scared by a torpedo
     appear in plate 781. The latter
     is the last plate published in
     the series, suggesting that,
     having turned his attention to
     the reactions of poultry to pro-
     jectiles, Muybridge had at last
     exhausted his prodigious list of
     motion study experiments.

seem lonely, their behaviors disjointed, and their actions futile.
Unlike his instantaneous photography forebears, Muybridge
used his techniques to explore the unglamorous side of exis-
tence. Through his lens the simple facts of behavior are made
plain, stripped of motivation, emotion, and context. And the
occasional craziness of life is allowed to assert itself. How else to
explain a primly attired woman leaping gamely over a chair (fig.
3-90), or a flock of chickens being scared by a torpedo?[45]

The artistic use of instantaneous photography constitutes a
curious tautology. One of the principal arguments in support of
instantaneous photographs as objective documents is that they
may be executed without the direct control of the photographer.
Mechanically executed, they are immune to the whims of a
human operator. Moreover, because they record events tran-
spiring beyond the limits of human perception, instantaneous
photographs frequently look strange, even random. Muybridge
created a carefully controlled set of circumstances that pro-
duced unpredictable imagery. Like all instantaneous photogra-
phers, he did not know precisely what would happen when he
activated his cameras. Yet he took the results and made them
into a coherent whole. This remains one of his most significant

and alluring achievements.

It is probably just as well that Harry Peterson's script was never made into a motion picture. His heart was in the right place; he hoped to provide an educational picture that would both inspire and challenge audiences. Yet "From Cave Man to Edison" is full of inaccuracies, faulty deductions, and half-truths. Most importantly, it overlooked one of his greatest achievements—the creation of a new form of art based not on what the eye can ordinarily see, but on what the camera can tell us. It is an art made up of the elusive, probing the unlikely intersection between the mechanical and the imaginary. And so, in spite of the inadequacies of Peterson's script, the end of the film as he envisaged it would surely make a fitting addition to any future movie made about Muybridge. A fade to black, then:

> Muybridge in his little cottage in England.
> Goes out, sits on a box.
> Dozes.
> Children pass by, paying no attention to him.
> Is ignored by everyone.
> Drops asleep.
> Dreams.[46]

46. Peterson, "Synopsis," 2.

# Never Seen This Picture Before

## Muybridge in Multiplicity

*Tom Gunning*

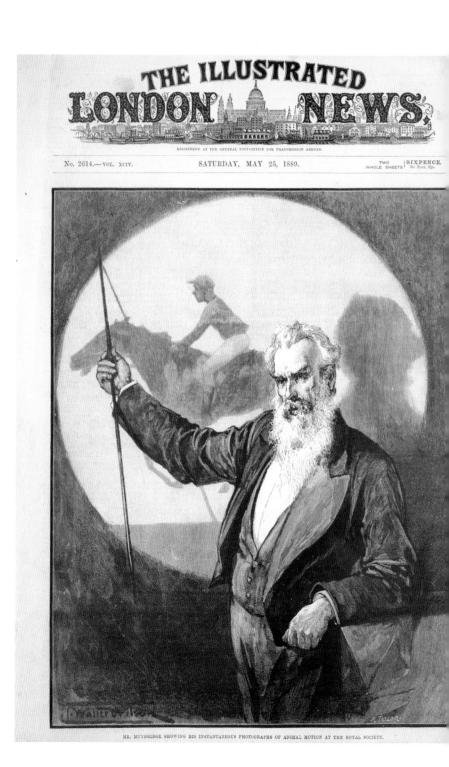

THE ILLUSTRATED LONDON NEWS.

REGISTERED AT THE GENERAL POST-OFFICE FOR TRANSMISSION ABROAD.

No. 2614.—VOL. XCIV.     SATURDAY, MAY 25, 1889.     TWO WHOLE SHEETS | SIXPENCE By Post, 6½d.

MR. MUYBRIDGE SHOWING HIS INSTANTANEOUS PHOTOGRAPHS OF ANIMAL MOTION AT THE ROYAL SOCIETY.

OPPOSITE PAGE
Fig. 4-1
J. Walter Wilson
*Mr. Muybridge Shows His Instantaneous Photographs of Animal Motion at the Royal Society*, 1889
Engraving on broadside, from the *Illustrated London News*, 25 May 1889
30.4 x 23.5 cm

1. The creation of Muybridge's reputation as the father or inventor of motion pictures is traced in Haas 1976, 187–203, with the first such claims appearing in 1910 through Muybridge's friend and advocate Benjamin Carter. The earliest use of the term *father* Haas cites comes from F. A. Talbot's 1914 book *Moving Pictures*. It has a long career after that, culminating in Hendricks 1975.

2. See Muybridge's letter to the British *Journal of the Camera Club*, printed in the November 9, 1897, issue, quoted in Haas 1976, 185. Muybridge reiterated these claims in the prefaces to his last publications, *Animals in Motion* (1899) and *The Human Figure in Motion* (1901). In spite of his printed claims of priority in motion picture devices, Carter admitted that "he looked upon the invention of the motion pictures as a mere incident in his work of investigation of animal movements for the purposes of science and art" (Haas 1976, 189).

Shortly after his death Eadweard Muybridge received the title "father of the motion picture."[1] Although Muybridge himself, a few years before he died, made the connection between his photographic records of human beings and animals in motion and newly appearing devices such as the Kinetoscope, Vitascope, and Cinématographe, there is little doubt that he would have been surprised by the suggestion that these inventions were the culmination of his work.[2] Nor should an exploration of Muybridge in relation to the history of cinema take such a narrow view, regarding his work as significant only insofar as it serves as harbinger of the work of Thomas Edison and the Lumière brothers, let alone that of Orson Welles, Stan Brakhage, or Steven Spielberg.

## A Case of Disputed Paternity

As if questionable paternity were fated to pursue Muybridge both literally and figuratively in life and beyond the grave, the epithet "father" must be deemed problematic from almost every point of view. The term drags with it a biological teleology that recent approaches to history strive to avoid, not to mention more than a hint of patriarchalism. Further, what is meant by "motion pictures" stands in need of explication, a task that reveals a great deal about the ambivalent nature of Muybridge's innovations and pictures, which evoke or represent motion in a number of different manners. One might claim that to see Muybridge as the father of the film industry constricts the nature of his work rather than expands it, given that his photography relates more strongly to late nineteenth-century painting and sculpture, the science of physiology, the technical development of still photography, not to mention social ideas about gender and the body, than it does to the future development of Hollywood. But rather than dismissing Muybridge's position in relation to the origins of motion pictures, the task becomes one of redefinition, examining the ambiguities of the myths of origin in order to discover a broader understanding of motion pictures.

Rather than a bearded patriarch, a certified point of paternity, Muybridge appears as a sort of crazy uncle, the site of many intersections between photography, science, art, and new forms of mass entertainment. The image of Eadweard Muybridge haunts us, beckoning to us from the space between things, the interstices and gaps that appear, unexpectedly, within actions and between instants.

It was Muybridge, more than any other figure, who introduced what Walter Benjamin, decades later, termed "the optical unconscious," revealing that much of everyday life takes place beneath the threshold of our conscious awareness:

> Even if one has a general knowledge of the way people walk, one knows nothing of a person's posture during the fractional second of a stride. The act of reaching for a lighter or a spoon is a familiar routine, yet we hardly know what really goes on between hand and metal, not to mention how this fluctuates with our moods. Here the camera intervenes with the resources of its lowerings and liftings, its interruptions and isolations, its extensions and accelerations, its enlargements and reductions. The camera introduces us to unconscious optics as does psychoanalysis to unconscious impulses.[3]

Benjamin wrote in the 1930s, aware that the camera had first filtered such unconscious behavior through the lens of instantaneous photography, demonstrating for all to see what really happens while our bodies walk and our minds are elsewhere.

By the late nineteenth century the optical devices of modern science that first appeared in the seventeenth century had already explored both the infinitesimal and the extraterrestrial through the optics of enlargement, but these discoveries of the previously unseen were spatially removed into realms outside human experience, due either to vast distance or microscopic size. Muybridge, in contrast, conquered time, rather than span-

3. Walter Benjamin, "The Work of Art in the Age of Mechanical Reproduction" in *Illuminations*, ed. Hannah Arendt, trans. Harry Zohn (New York: Schocken Books, 1969), 237.

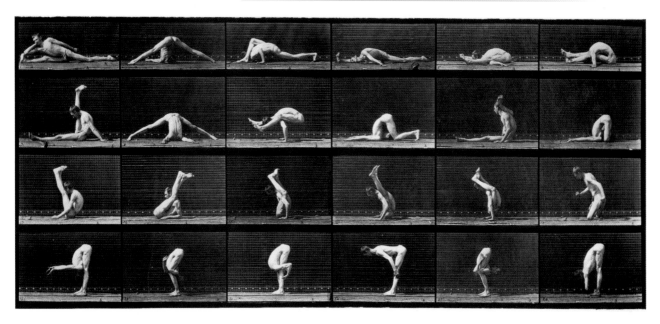

**Fig. 4-2**
Eadweard Muybridge
*Contortionist (Mr. Bennett)*, 18 July 1885,
    plate 510 from the series *Animal Loco-
    motion*
Collotype
18.5 x 42.1 cm

ning or penetrating space, as he exposed the tiniest intervals of
motion. His discoveries rely upon a modern rational and scien-
tific mastery of space and time in which each has been calcu-
lated and charted in relation to the other. This modern concep-
tion of a unified, standardized, and measurable space and time
formed the basis not only for pure scientific research but also
for claims of private property and calculation of industrial effi-
ciency. Muybridge's photography also makes visible a drama
that would otherwise remain invisible: the physical body navi-
gating this modern space of calculation. His images of the nude
human body framed within a geometrically regular grid capture
the transformations of modern life brought on by technological
change and the new space/time they inaugurated, as naked flesh
moves within a hard-edged, rational framework (fig. 4-2).

Hollis Frampton has described the extraordinary abstraction
of the space of Muybridge's later photographs: "a uniform grid
of Cartesian coordinates, a kind of universal 'frame of refer-
ence,' ostensibly intended as an aid in reconciling the succes-
sive images with chronometry, that also destroys all sense of
scale (the figures could be pagan constellations in the sky), and
utterly obliterates the tactile particularity that is one of photog-

raphy's paramount traits, thereby annihilating any possible feeling of place."[4] If this all-too-visible contrast of flesh and abstraction seems too melodramatic, let us recall again the essentially interstitial nature of Muybridge's work. He remains a figure poised between paradigms, operating in the ambiguous interval that separates (or possibly joins) different discourses.

First of all, Muybridge was an accomplished artist working in a new medium whose technical demands served as arguments both for and against its truly being an art form. As a photographer and artist he is best known for his work that had scientific aspirations. In an era in which art and science appeared to flirt with each other before finalizing what seemed like an ultimate divorce, Muybridge's straddling of artistic and scientific practice may provide an object lesson. In this respect, his difference from a trained scientist like Etienne-Jules Marey, so clearly pointed out by Marta Braun, does not make him any less fascinating and may in fact be essential in defining his uniquely ambiguous fascination.[5]

Secondly, Muybridge's work as both artist and scientist addresses peculiarly modern issues of visibility. From the scientific point of view, he offered his photographs as visible evidence. But photography here intersects with an issue that had haunted scientific representation ever since the microscope and telescope. If the human serves as the model of the visual, how does this term apply to images that the human eye cannot see without mediation? The claim (always disputed, even if widely accepted) that photography offered a record of human vision reaches one of several crises with Muybridge's work and with instantaneous photography generally. What sort of image was a photograph that showed something the eye could not verify? This and related questions opened a complex theoretical issue, which Muybridge's own practices served to make even more complex. What in a photograph makes it evidence, and in what way is this evidence visual? While these issues remain vexed even today, Muybridge had to confront them in a manner that called into question the assumed meanings of these terms.

4. Hollis Frampton, "Eadweard Muybridge: Fragments of a Tesseract," in Frampton 1983, 77.

5. Braun 1992, esp. 232–56. In case it is not obvious, I want to acknowledge how much Braun's work inspired this essay.

Thus the ambiguities of visual evidence reach back in many ways to his contested position between the artistic and the scientific.

Thirdly, let us return to our starting point, the claim that Muybridge was the "father of motion pictures." If this claim is to have any meaning beyond the wrangling of lawyers in early twentieth-century patent suits, it must confront the interaction between stillness and movement in Muybridge's work. How significant is the actual projection of motion pictures by his zoopraxiscope, and where does that significance lie? If Muybridge is to be seen as inspiring Edison, does this offer another figure with whom he can be compared: the inventor and entrepreneur? Artist, scientist, showman—Muybridge was none of these exclusively but worked in relation to all of them. Likewise, his "motion pictures" must be approached through their interstitial nature. They existed both as still images and, in certain conditions, as illusions of motion, but always as *pictures* that had been animated, images whose trick of taking on life was demonstrated to the audience, never taken for granted.

Finally, as the harbinger of the optical unconscious, Muybridge simultaneously analyzed motion into its components, like a good scientist, and then reendowed it mechanically with motion, which fools our eyes. His art employs almost contradictory energies, seizing and parsing out motion into still images, then accumulating these individual images at such a rate of speed that they seem once more to move. There is something obsessive about this circular fascination, something that almost recalls Penelope weaving and unweaving her tapestry. This final antinomy, the exploration of the zone between stillness and motion, may supply us with a key to Muybridge's fascination for the contemporary viewer. For surely he is what we make of him, and what has been made of him varies from generation to generation and context to context. I believe that for recent generations of American artists Muybridge served as a model of a way to move beyond art as self-expression toward an art that, flirting again with science, seeks to demonstrate its essential condi-

*OPPOSITE PAGE*
**Fig. 4-3**
Sir Edward Coley Burne-Jones (England,
    1833–98)
*The Golden Stairs*, 1880
Oil on canvas
269.2 x 116.8 cm
Tate Gallery, London
Photo: Tate Gallery/Art Resources, NY

6. For accounts of Muybridge's interaction with European artists, see Haas 1976, 127–34; Hendricks 1975, 136–41. For a penetrating discussion of the effect of Muybridge on the portrayal of horses in painting, see Prodger 1996, 44–59. Françoise Forster-Hahn's pioneering essay "Marey, Muybridge, and Meissonier: The Study of Movement in Science and Art" in Mozley 1972, 85–109, remains one of the best treatments of this topic. A complete bibliography of the literature on Muybridge in relation to the visual arts is beyond the scope of this essay.

7. With the phrase "mechanical objectivity" I reference the key work of Daston and Galison 1992.

8. This analysis of the works of Burne-Jones and Khnopff in relation to motion analysis also forms part of my unpublished essay "Bodies in Motion," which explores more broadly the relation between the representation of the body in instantaneous photography and chronophotography at the turn of the century and its relation to Symbolist art.

tions. If this seems to arc back to an image of Muybridge as scientist, however, that may be an illusion. It may be what the photograph does not show, what cannot be seen, that truly constitutes the optical unconscious.

**Muybridge among the Artists: Symbolizing an Arc of Motion**
A full discussion of Muybridge's relation to the late nineteenth-century art world is far beyond the scope of this essay but needs to be written. Admittedly, the effect of his motion photographs on painting and sculpture has always been central to all accounts of his work. Muybridge's encounter with Ernest Meissonier and their debate about the nature of equestrian painting; his feting by the London and Parisian art world, which included encounters with Lawrence Alma-Tadema and Auguste Rodin; his collaboration with Thomas Eakins—all of these have been described in the standard biographical studies of Muybridge, and a few aspects have been thoroughly explored.[6] But the relation between Muybridge's images and nineteenth-century painting and sculpture can be expanded beyond this well-researched discussion of direct influences.

Muybridge's motion studies are usually viewed in relation to realism and naturalism in late nineteenth-century painting and sculpture. Although these terms are terribly imprecise and embrace styles as different (to draw on painters who have been said to have to have been influenced by Muybridge's motion study photographs) as the academic Meissonier, the Impressionist Degas, and the naturalist Eakins, they do share a concern with paying attention to the visible appearance of things, with "getting it right." During the late nineteenth century the concept of truthful visible appearance underwent a crisis, exemplified by the fact that visible reality could be described in terms of either the mechanical objectivity of the scientific observer or the subjective impressions of the artist.[7]

But Muybridge's images can move beyond the issue of accurate models. I want to place Muybridge in a different context,

relating him to a contemporaneous move-
ment in art that placed great emphasis on the
portrayal of movement as rhythmic succes-
sion yet opposed itself to the scientific
observation of the world: Symbolism, a
movement whose borders are almost as
imprecise as those of realism or naturalism,
but whose practitioners defined themselves
through a new relation to the visible world,
one liberated from a slavish copying. I am
not so much claiming a direct influence as
arguing for the value of placing Muybridge's
work within a broader spectrum of visual art.
Let me provide a vivid visual example,
Edward Burne-Jones's 1880 painting *The
Golden Stairs* (fig. 4-3). Burne-Jones's pur-
poses as a painter stood at antipodes to the
scientific researches we would associate with
Muybridge's motion studies. One of the
widely dispersed group of fin de siècle
painters who reacted against the dominant
materialism and scientific worldview of their
era through a search for a new spirituality,
Burne-Jones turned to visions of the ideal,
invoking a realm of myth and legend. And
yet, it seems to me, anyone familiar with
Muybridge's images would immediately stop
before Burne-Jones's canvas and make other
associations.[8]

Although this image represents a full
troupe of individual female musicians
descending a stair, the interaction of their
respective bodily positions creates such a
harmonized effect that it is hard not to see
them as successive stages of a single action.

Reportedly Burne-Jones used several models for the faces (although the physiognomy of all of Burne-Jones's women looks the same to me), but a single model in successive poses was used for the body, which explains what Russell Ash has described as "the chorus line equality of their proportions."[9] This pattern of rhythmic repetition gives this deliberately archaic image a modern effect. Although the individual bodies are sharply defined, the downward sweep of the procession, from step to step and posture to posture, creates an impression of the stages of metamorphosis of a single moving body, especially if we follow the succession of the line of limbs in a steady rhythm of flexation, subordinating individual bodies to an overwhelming rhythm or movement and repetition. The flow of the pleats of the women's dresses further stresses this rhythmic unity of action, even though the studies Burne-Jones made of his model descending the staircase, were, like Muybridge's motion studies, done from the nude.

The double helix of women's faces, though drawn from different models, also seems to capture separate stages of a single motion, particularly in sets of three, as heads pivot and gazes make a circuit of the space, until at the point of exit, to quote Belgian Symbolist Fernand Khnopff's description of this painting, "the last of the maidens stops and turning her head once more sheds a smile of farewell."[10] The rhythm moves from head to toe, with the succession of feet and toes causing Burne-Jones to complain, "I have drawn so many toes lately that when I shut my eyes I see a perfect shower of them."[11]

Clearly Burne-Jones operated within a long tradition of rhythmic portrayals of groups that dates from at least Tintoretto and that ultimately drew inspiration from Greek friezes. The date of the painting's completion, 1880, just precedes Muybridge's trip to Europe but comes shortly after the publication of his series of motion studies of horses in the United States and Europe. The painting also predates Muybridge's University of Pennsylvania work, in which women first paraded before his camera. Therefore,

9. Russell Ash, *Sir Edward Burne-Jones* (New York: Harry N. Abrams, 1993), pl. 19.

10. Fernand Khnopff, "Memories of Burne-Jones," in Dorra 1994, 34.

11. Quoted in Ash, *Burne-Jones*, pl. 19.

Burne-Jones most likely created his painting without the direct influence of Muybridge; indeed, I suspect the influence ultimately runs the other way, with Burne-Jones's ladies, or similar compositions, affecting the look of Muybridge's Philadelphia photographs.

The purported scientific purposes of the chronophotographer and this late Romantic painter contrast sharply. Rather than attempting to chart the flow of physical bodies with a modern precision technology, Burne-Jones sought to resurrect a distant era and convey an archaic spirituality. But the visual convergence of this artistic and spiritual project at the end of the nineteenth century with a scientific project from about the same time involves more than formal coincidence. This is even clearer if we look at a painting by Burne-Jones's Belgian admirer Khnopff, *Memories* of 1889 (fig. 4-4). Here again we find a succession of female figures whose repetitive physical similarities, strongly posed positions, and manipulation of a single object, a badminton racquet, creates a chronophotography-like image, as if delineating separate stages of a single motion. The rhythm of staggered motion and repetition begins with the three figures on the left, stacked in superimposition, which evoke a pivoting of the head, which, in turn, cues a circular transit around the figure, as if the viewpoint were in motion, as much as the figure itself (recalling Muybridge's serial images employing a semicircular battery of cameras to create a 180-degree view). The later date of Khnopff's *Memories* makes a direct influence from Muybridge (or possibly even Marey) more possible. (*Animal Locomotion*, which included these semicircular views, was published in 1887, Marey's experiments with chronophotography of human figures began in 1882, and Ottomar Anschütz had published chronophotographs by 1886.)[12]

But if the influence from chronophotography is more direct, it is also defamiliarized. No less than those of Burne-Jones, Khnopff's purposes and effects deviate strongly away from scientific observation toward envisioning an ideal. As Emile Verhaeven said in his essay on Khnopff, "In symbolism fact and world

12. On Anschütz's rather neglected work in chronophotography, see Rossell 1998, 41–47.

**Fig. 4-4**
Ferdinand Khnopff (Belgium, 1858–1921)
*Memories*, 1889
Pastel on paper
127 x 200 cm
Brussels, Koninklijke Musea voor Schone
    Kunsten van België
Photo: Art Resources, NY

become mere pretext for ideas; they are handled as appearances, ceaselessly variable and ultimately manifest themselves only as the dreams of our brains."[13] The title of the painting, *Memories*, psychologizes this physical repetition, as if the successive images might be Proustian specters of the self multiplied in recall.

Paintings of the Symbolist school at the turn of the century nearly swarm with similar modular compositions that present variations of figures so similar that one gets the impression of the rhythmic articulation of a single action. The paintings of Swiss Symbolist Ferdinand Hodler from the 1890s include many such groups, in which similarity of drapery and the symmetry of posture and gesture create a rhythmic flow from repetitive figure to repetitive figure. Once again, a host of sources for these images can be cited without referring to Muybridge, but a visual echo certainly sounds for anyone aware of both. The Symbolists strove to portray a world suffused by a common rhythm that travels through diverse bodies and through nature itself. Starting from opposed intentions, the images of Muybridge's motion studies and the portrayal of rhythm by Symbolist painters converge in similar visual schema.

If initially all I am claiming is that familiarity with Muybridge's work transforms the way we see Symbolist paintings, my next claim would be that, on returning to Muybridge's images, they too look different due to this encounter. If, as Braun has quite convincingly claimed, Muybridge sometimes rearranged the order of his series of images, sacrificing the precision of scientific recording (exemplified by Marey's work) for what she describes as "pictorial" values, I believe that these values bring us closer to the compositions of the Symbolists than to those of realists such as Eakins.[14] Symmetry, completeness of a pattern, the values that Braun sees as distorting the scientific mission of Muybridge's work, are not only traditional pictorial values but also the specific effects that the Symbolists wished to convey through their portrayal of motion—values we could also describe in terms of rhythm, order, and harmony.

13. Emile Verhaeven, "Un peintre symboliste," in Dorra 1994, 62.
14. Braun 1992, 247–53.

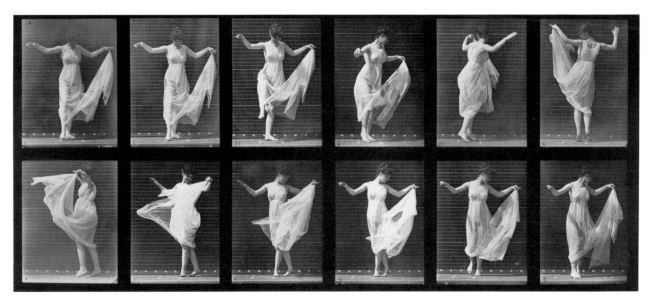

**Fig. 4-5**
Eadweard Muybridge
*Fancy Dancing (Miss Larrigan)*, 28 July 1885,
    plate 187 from the series *Animal Loco-
    motion*
Collotype
18.9 x 42.8 cm

15.  On Löie Fuller, the Symbolists,
    and cinema, see my essay,
    "Löie Fuller and the Art of
    Motion: Body, Light, Electric-
    ity, and the Origins of Cin-
    ema," in *Film/Art/Modernism:
    Essays in Honor of Annette
    Michelson*, ed. Richard Allen
    and Malcolm Turvey (Amster-
    dam: University of Amsterdam
    Press, 2002).

Further, the drapery around women models, which, Braun complains, often obscures precisely those parts of the body that would interest a physiologist, recalls not only classical models and academic painting but also the flow of drapery found in the works of Symbolists or proto-Symbolists such as Burne-Jones, Dante Gabriel Rossetti, Pierre Puvis de Chavannes, and Jean Delville. While the drapery in all these cases seems intended to offer a (possibly hypocritical, certainly flimsy) sublimation of female nudity, the fascination Muybridge shows with the actual ripples and flowing forms of the veils, scarves, and shawls these women flourish, caught in all of their metamorphoses, seems to antici-pate the serpentine dance of that paradigm of Symbolist aesthet-ics, Löie Fuller.[15] Muybridge's images of ephemeral motion, while recalling Marey's photographs of liquids or smoke, do not share his analytical methods or his ultimate purposes in photo-graphing these subjects (recording aspects of the physics of liq-uids or of aerodynamics). Like Fuller's dance (which premiered in Paris and gained worldwide fame in 1893), Muybridge's flut-tering fabrics offer the delight in the forms of motion, bereft of obvious practical or scientific application (fig 4-5).

Rather than a linear causality, my placing of Muybridge in relation to the Symbolists shows a circular logic. His pictorial sense was shaped by these aesthetic expectations as much as by

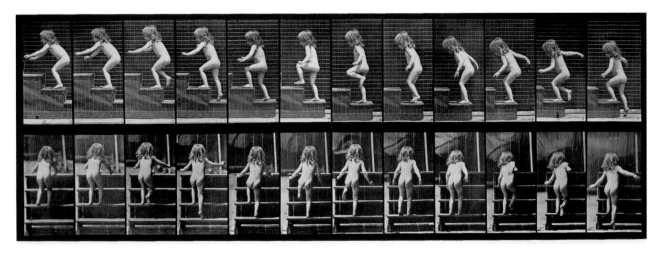

**Fig. 4-6**
Eadweard Muybridge
*Child Ascending a Stair (Edith Tadd)*, 29 July
 1885, plate 473 from the series *Animal
 Locomotion*
Collotype
15.9 x 46.3 cm

those of the realists who seized on his images as sources that could verify the "objectivity" of their paintings. But by the 1890s (and more than a decade before the modernist paintings by Frantisek Kupka and Marcel Duchamp, which seem more derivative of Marey's semitransparent, superimposed specters than of Muybridge's solid and opaque figures[16]), paintings by the Symbolists reflect an obsession with rhythm through images of bodily motion conveyed by repetitive figures. This concern with the body as a carrier of rhythm may also serve as a bridge between Muybridge's earlier and later work. It has always struck me as curious that a photographer who initially scorned the more lucrative and technically easier path of professional photography, that of studio portraiture, in favor of landscape and location photography would end up shooting the human figure within an abstract space. But Muybridge's motion studies differ from traditional portrait photography as much as his earlier landscape did, in spite of their focus on the human body. Rather than capturing individualizing details of face or figure, Muybridge's chronophotographs document a common human rhythm, flowing through bodies whose differences seem mitigated by their consistency of framing and the omnipresent grid. While he may not have had any interest in Symbolist metaphysics, his images too capture a universal rhythm coursing through rather abstracted human figures (fig. 4-6).

Muybridge clearly designed his work with contemporaneous

16. On Marey's influence on modernist painting, see the masterful treatment in Braun 1992, 264–319.

17. Jean-Dominique Lajoux, "Muybridge, Marey et les femmes," in Delimata 1996, 90–119.

18. Linda Williams, "Film Body: An Implantation of Perversions," in *Narrative, Apparatus, Ideology*, ed. Philip Rosen (New York: Columbia University Press, 1986), 507–34; Braun 1992, 249. Jayne Hathor Morgan—in her wonderfully researched and argued essay "Muybridge, Mitchell, and the Aesthetics of Neurasthenia," *History of Photography* 23 (autumn 1999): 218–24—relates the portrayal of both male and female in Muybridge's photography to the different conceptions of treatment for neurasthenia (the rest cure for women, outdoor physical activity for men) by Dr. Silas Weir Mitchell, who was at the University of Pennsylvania at the time of Muybridge's work and was an associate of Muybridge's (who photographed Mitchell's horse). One might add here that Muybridge himself was advised by Dr. William Gull to undertake outdoor physical activity as treatment for the mental and nervous effects of his stagecoach accident. Hendricks (1975, 13) sees this as a possible reason why Muybridge took up landscape photography. That Dr. Gull, consulting physician to Queen Victoria, has recently been identified as a likely suspect in the Jack the Ripper murders is something I will avoid commenting on.

images in painting in mind. This explains another key difference between Muybridge and Marey, which anthropologist Jean-Dominique Lajoux has pointed out: the almost complete absence of women in Marey's work and their importance in Muybridge's major work at the University of Pennsylvania.[17] Marey's physiological studies were directed primarily toward the male body, with the goal of improving the French soldier and the French industrial worker (fig. 4-7). As Linda Williams has shown, when men are given props in Muybridge's photographs, they tend to be of either a military or professional sort (rifles and blacksmith tools, for example), while women are given props related to domesticity (and, as Braun perceptively added, erotic fantasy): flowers, piles of hay, cigarettes, and baths of water.[18] While the role of Muybridge's *Animal Locomotion* as disguised pornography needs further probing, his display of the difference of gender in his work, compared with its relative repression in Marey, must not be lost sight of, however conventional Muybridge's portrayal may be argued to be. Marey's repression of the female body has its roots in the scientific attitude that the male body was the proper scientific object, from which the female body was a deviation.[19] Thus, Marey could effectively ignore female physiology. (Interestingly, it reenters with the anthropological chronophotographs of Africans that Félix-Louis Regnault took in 1895 and which Marey presented in 1896 to the Académie des Sciences—the ethnic other somehow demanding the portrayal of both sexes.)[20] Once again Muybridge falls on the side of artistic practice. In both Symbolist and academic painting of the era, the body, which expresses rhythmic motion, is primarily female, and Muybridge's veiled and naked ladies no longer seem anomalous in this context.

It is hard to believe that Pictorialist photographer F. Holland Day's sequential (and scandalous) *The Last Seven Words of Christ* from 1898, which shows a series of seven close-cropped images of Day's agonized face made up as that of Christ, would have

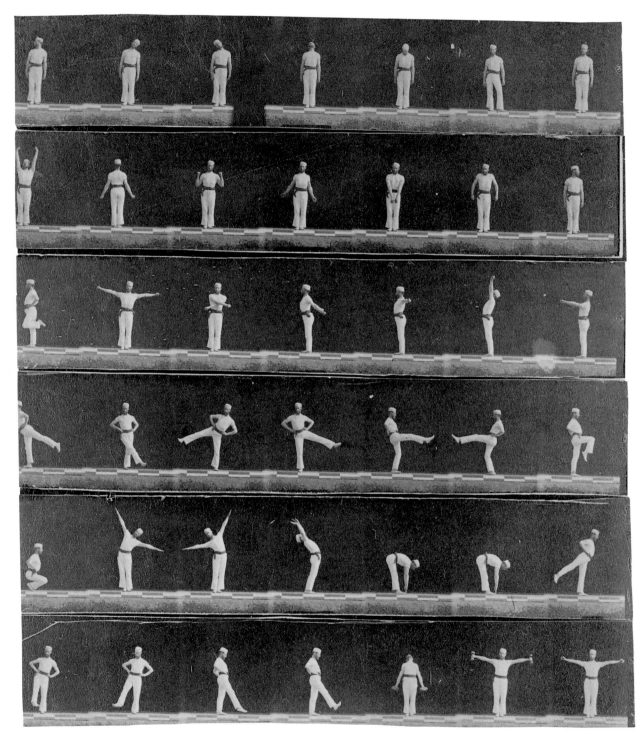

**Fig. 4-7**
Etienne-Jules Marey
*Gymnastic Poses*, 1883
Albumen print
19.4 x 17.5 cm

19. This is evident in classical anatomy, as noted by Daston and Galison 1992: "For Albinus [the eighteenth-century anatomist] it went without saying that a perfect skeleton was perforce male" (90). Lajoux's more practical explanation that Marey drew on the army for his models may, however, be correct ("Muybridge, Marey et les femmes," 115–16). Clearly this is a subject for further research. One might find the complement of Marey's almost exclusively male chronophotographs in the predominately female subjects of the photographic record of hysteria produced by Jean-Martin Charcot at Salpêtrière; see Georges Didi-Huberman, *Invention de l'hystérie: Charcot e l'iconographie photographique de la Salpêtrière* (Paris: Macula, 1982), passim.

20. See Fatimah Tobing Rony, *The Third Eye: Race, Cinema, and Ethnographic Spectacle* (Durham, N.C.: Duke University Press, 1996), 48–61.

21. F. Holland Day, *Suffering the Ideal* (Santa Fe: Twin Palms Press, 1995), pls. 23, 26, 27.

22. Haas (1976, 158) lists a number of American and European artists who were original subscribers to *Animal Locomotion* (1887), including Augustus Saint-Gaudens, Louis Tiffany, Puvis de Chavannes, and Rodin, as well as more academic painters such as Meissonier, Alma-Tadema, and

been conceived without the example of Muybridge's motion photography.[21] The succession of expressions stands at antipodes to a physiological analysis. The varied positions of the face, while possibly intended to convey a violent death throe, hardly chart a likely continuity of motion. The temporal intervals so crucial to Marey (and which, Braun has demonstrated, Muybridge sometimes fudged) are irrelevant here. Clearly Day's photographs were separately posed and shot, but he derived from Muybridge the form of a series of closely related images evoking an arc of physical motion yet forming an idealized image of time and the sublime agony of the body.

Muybridge's wobble between the appearance of scientific methods and patently artificial practices comes into focus when we recall that a major purpose behind the publication of his magnum opus *Animal Locomotion* was to provide an atlas of figure studies for artists. While it may be dubious whether Muybridge's photographic compendium ever contributed to scientific knowledge, there is no question that it was purchased by artists and used by them in their work.[22] Artists approaching the work from this perspective did not expect to use Muybridge as a template. Rather, as an anonymous reviewer for the *Nation*, quoted by Haas, stressed: "The use of these records of transient phases of motion is to show how the body passes from an earlier to a later phase, through what changes it passes from rest up to the culminating moment of action and back again to rest: and the artist's true method of study is to master the whole movement, and then to select for representation the one or two phases that most nearly convey the sense of this movement as a whole."[23]

This specifically artistic conception of "movement as a whole," reflects, I believe, a motivation for Muybridge's rearrangements and other deviations from scientific practice. Further, the idea that movement could convey an arc, from rest through action to reestablished rest, reflected the representation of motion in Symbolist art, directly in contrast to the frozen

William Bouguereau. It should be emphasized that Marey also lectured on the relevance of chronophotographs to artistic representation and that his assistant Demenÿ prepared in 1893 *Du mouvement de l'homme*, of which Braun says, "This large format portfolio was conceived as an artist's handbook, providing models to assist in the artist's representation of human locomotion." She concludes, however, that it was inspired by Muybridge's book (Braun 1992, 268). Charcot and Regnault also drew on comparison with artistic representation in their work, and Charcot's colleagues Albert Londe and Paul Richer brought out *Atlas d'anatomie artistique* and *Physiologie artistique de l'homme* in 1895. Clearly this was an era of interpenetration of scientific and artistic practice.

23. *Nation*, 19 January 1888; cited in Haas 1976, 156.
24. André Bazin, "Ontology of the Photographic Image," in *What Is Cinema?* trans. Hugh Gray (Berkeley: University of California Press, 1967), vol. 1, 11.
25. Lajoux, "Muybridge, Marey et les femmes," 116.
26. Daston and Galison 1992.

paroxysms, which in the words of André Bazin, created "the tortured immobility" by which Baroque painting conveyed bodily motion.[24] Muybridge's images, whether taken as a complete series or as separate instants, could supply painters with either type of image of motion. This purpose also explains the need for images of women in the later Muybridge work. As Lajoux said, these images were "created to illustrate academic poses on the subject or theme of movement."[25] The absence of female models would have been a severe handicap to an artist's handbook. Even the flutter of a scarf could play a role in this context.

**Muybridge among the Scientists:**
**The Atlases of "Mechanical Objectivity"**

The reviewer for the *Nation* not only highlighted a fissure between the representation of motion by artists and its scientific recording but also reflected a debate within scientific practice in relation to which Muybridge's practices, as revealed and critiqued by Braun, seem less aberrant than anachronistic (albeit inconsistently so). In the representation of scientific objects, what is the relation between the particular and the typical? While this relation was also debated heatedly in artistic circles at the end of the nineteenth century, scientific discourse about representation had tilted strongly toward the "objective" recording of individual particulars, reacting against earlier practices that had sought out the typical or ideal type. Lorraine Daston and Peter Galison have traced this debate through the development of scientific atlases.[26]

What sort of book is Muybridge's *Animal Locomotion* of 1887? Clearly it falls into the category of the "atlas" as described by Daston and Galison in their seminal essay "The Image of Objectivity." Originally applied to maps, then to large folio-size illustrated supplements to scientific works, by the late nineteenth century the term *atlas* referred to large-format pictorial scientific books (and, we should add, to the atlases of anatomy used by artists). In the latter half of the nineteenth century, "atlases

proliferated in number and kind, purveying images of every-thing from spectra to embryos, and . . . became manifestos for the new brand of scientific objectivity." Atlases are primarily visual texts in which "illustrations command center stage."[27] The atlas was designed to train the scientific eye through a compendium of visual examples.

Atlases possess a longer history, and their transformation may shed some light on Muybridge's practices. Daston and Galison delineate three stages in the scientific atlas's attitude toward representation. During the eighteenth century makers of atlases sought to portray the ideal. Visualizing not the particular but the "pure" exemplar, such atlases presented images that improved on actual models in order to capture the archetype behind countless individual phenomena. A modification of the pursuit of the ideal appeared as atlases moved toward a practice Daston and Galison term the "characteristic," which "locates the typical in the individual" through a process of summation of many individual instances.[28] Both these approaches predate the use of photography and therefore not only relied on the skills of an artist-depicter but also considered the aesthetic process as a means of arriving at the essentially typical.

According to Daston and Galison, the introduction of photography did not in itself create a completely new sort of atlas in the later nineteenth century. Growing doubts about the element of subjectivity that the scientist and artist-depicter necessarily brought to illustration preceded technological innovation. Photography provided a means to achieve a newly defined preference for objectivity over typicality. Photography contributed to this pursuit less through increased accuracy (in terms of color, for instance, photography could never match a careful colorist) than by supplying an impersonal mechanical process, which could deliver scientific illustration from the hand and eye of human subjectivity. While Muybridge and his photographer contemporaries in the middle decades of the nineteenth century had sought by various pictorial means to endow their

27. Ibid., 124 n. 3, 81, 85.
28. Ibid., 88.

mechanical images with the devices and appearance of traditional art, it was photography's automatic nature, its perceived *lack* of "artistic means," that guaranteed it a primary place in the new atlases of the late nineteenth century dedicated to the mechanical reproduction of many individual particulars.

This adoption of photography by scientists should not be read as a naive assertion of photographic truth. As Daston and Galison have noted, "The photograph . . . did not end the debate over objectivity; it entered the debate."[29] Since the pursuit of objectivity involved discipline on the part of the scientist, rigorously avoiding the subjective aspects of interpretation or aesthetics, photography too had to be practiced in this disciplined manner. Retouching was taboo, providing information on angle of view and other aspects of the photographic process de rigueur (hence Muybridge's detailing of angle and exposure for each of his plates).[30] But, in its automatic and mechanical aspects, the photograph offered an emblem of escape from subjectivity—provided it was used in the spirit of nonintervention that the discourse of "objectivity" called for. As Daston and Galison put it, "What the photograph (along with tracings, smoked glass, camera lucida, and other mechanical devices) offered was a path to truthful depiction of a different sort, one that led not by precision but by automation—by the exclusion of the scientist's will from the field of discourse."[31]

Muybridge fits uncomfortably within this schema. While *Animal Locomotion* certainly gives the appearance of belonging to these later nineteenth-century atlases devoted to visual images of particulars attained through mechanical objectivity, the denunciation of the aesthetic seems foreign to Muybridge. His outrage about the limited credit he was given in Leland Stanford's 1882 publication *The Horse in Motion* (where the authorial credit is given to J. D. B. Stillman, with Muybridge credited only in passing) shows some discomfort with the protocols of mechanical objectivity. Stanford, quite creditably, saw himself as the originator of Muybridge's photography of horses at Palo

29. Ibid., 112.
30. Prodger (1996, 56) lists a number of other questions a scientist would want Muybridge to answer in order to satisfy the conditions of scientific evidence.
31. Ibid., 117.

32. Quoted in Haas 1976, 139. For a treatment of the controversy, see 135–44, and also Hendricks 1975, 141–46.

33. Review from the San Francisco paper the *Daily Morning Call*, 17 February 1868; cited in Hendricks 1974, 18.

34. A frequently quoted statement from the *Alta California* for April 7, 1872; cited in Mozley 1972, 45.

35. For examples of composite prints by Muybridge, see Hendricks 1975, 26; Haas 1976, 101. Muybridge also patented a "sky shade" that allowed photographers to capture sky effects more directly by creating different exposure for different parts of the negative; described in Mozley 1972, 110–11.

36. One such recipe is given in Mozley 1972, 113. Stillman makes the claim of Muybridge's technical backwardness in a letter to Stanford's lawyer quoted in Haas 1976, 136. His claim seems exaggerated, although it does seem Muybridge was not aware of the dry plate process until his trip to Europe, but this would indicate a delay of only months.

Alto and considered (or so he later claimed in court) Muybridge an expert photographer parallel to the "expert engineers, electricians, mechanics assistants and laborers" employed by him to realize the project.[32] Whatever the ethical status of his disregard of Muybridge's contribution, Stanford's attitude follows the discourse of mechanical objectivity, while Muybridge's claim of creative authorship rests as much on traditional aesthetic claims of a picture maker as on his account of his larger technical role. It would be interesting to know if similar tensions ever arose over any other photographic atlases of the era.

Although the aesthetic status of photography was still debated at the end of the nineteenth century, there is no question that Muybridge's earlier work as a landscape photographer aspired to the status of art. Thus his Yosemite photographs were praised for "combining as they do, the absolute correctness of a good sun picture after nature, with the judicious selection of time, atmosphere, conditions and fortunate points of view."[33] The famous accounts of Muybridge cutting down "trees by the score that interfered with the cameras from the best point of sight,"[34] hardly indicates a practice of nonintervention, while his "judicious selections" define his artistry (fig. 4-8). Like most landscape photographers, he was adept at composite prints, which would allow sky effects of clouds or moonlight to be superimposed over a landscape.[35] Likewise, he always credited his achievements in instantaneous photography to his unique formulas for collodion and developers and "the closest attention to the details of the process," showing the pride of a handicraft worker, if not an artist (this may explain his slightly delayed adoption of commercial dry plates in spite of their superiority in taking instantaneous photographs).[36]

Muybridge would be an unlikely candidate for the saintly regimen of self-renunciation and monastic discipline, suspicious of any subjective intervention, which Daston and Galison describe as the ideal for the late nineteenth-century scientist. Muybridge across his career performed as an artist, however

**Fig. 4-8**
Eadweard Muybridge
*Yosemite Valley from Sandy Run*, 1872
Albumen print
43 x 57 cm
Iris & B. Gerald Cantor Center for Visual
    Arts at Stanford University, Museum
    Purchase Fund, 1972.199

complex defining that term becomes in an age of technology. According to Galison, late nineteenth-century scientists identified their ideal of mechanical objectivity with the technology of the camera and contrasted it to the freedom of subjective interpretation an artist could employ: "The artist's autonomy and interpretive moves were powerful threats to the representational endeavor, threats the camera alone could quell."[37] But we might doubt that Muybridge ever saw his camera this way. Phillip Prodger has shown that in Muybridge's recording of the phases of a solar eclipse in January of 1880 (fig. 4-9), "several of the plates were not actually produced photographically. Instead they were painted, perhaps to replace damaged or incomplete negatives, or possibly to supply perspectives which were lacking in the original." As Prodger comments, "It was probably not Muybridge's intention to deceive his audience, so much as to present a clear and visually appealing digest of the eclipse as it was known to have occurred."[38]

Muybridge's eclipse sequence includes the same sort of rearrangements and montages of images that Braun found in *Animal Locomotion*. Such practices reveal Muybridge less as a bad scientist than as an artist who interpreted his role to be that of a visual presenter. Such an understanding may also explain the mysterious lack of photographic evidence of Muybridge's purported first photographs of the horse in motion in 1872 and 1873, and the collaged painting he apparently photographed and published as *Occident Trotting at a 2:30 Gait* in 1877 (see fig. 3-20). That the purported photographs of 1872 and 1873 were never published, but served rather as the basis of prints published by Currier and Ives, and that Muybridge's 1877 offering is not a photograph but a painting, reflect, as Robert Bartlett Haas has claimed, less a hoax perpetrated on a gullible public than a different attitude toward the means of making photographs public, particularly in an era when mass reproduction of photographs through the halftone process of printing was not yet available.[39] As Haas has written, "Once the equine image was

37. Peter Galison, "Judgment against Objectivity," in *Picturing Science, Producing Art*, ed. Caroline A. Jones and Peter Galison (New York: Routledge, 1998), 345.

38. Prodger 1996, 55.

39. Neil Harris, "Iconography and Intellectual History: The Halftone Effect," in *Cultural Excursions: Marketing Appetites and Cultural Tastes in Modern America* (Chicago: University of Chicago Press, 1990), 304–17. Through the 1880s even photographic journals had photographs redrawn and engraved rather than employing the more expensive process of "tipping in" actual photographic prints.

**Fig. 4-9**
Eadweard Muybridge
*Phases of the Eclipse of the
    Sun*, 11 January 1880
Albumen print
13.3 x 10.2 cm
Iris & B. Gerald Cantor
    Center for Visual Arts
    at Stanford University,
    Stanford Family Collec-
    tion, 13920

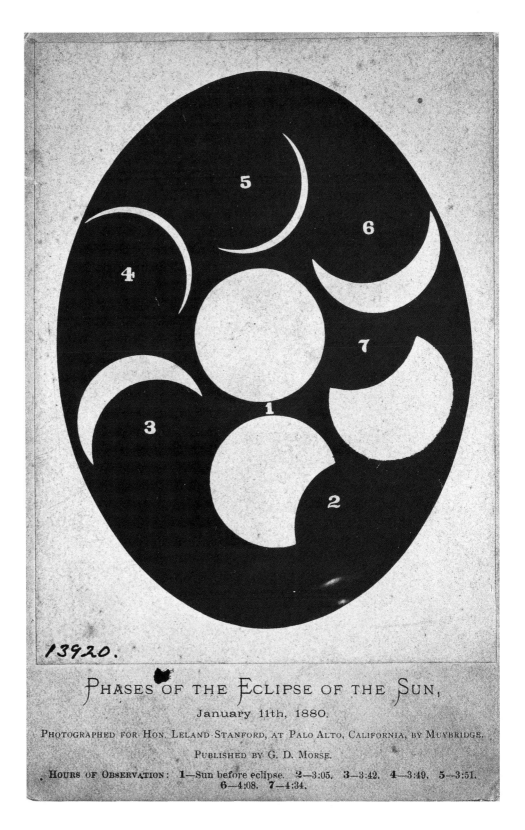

arrested by instantaneous photography, the proof was in. Presentation of the data was entrusted to the more familiar graphic media—the drawing, the lithograph, the woodcut or the painting—as being more capable than the print of an instantaneous photograph of rendering details." Indeed, as late as 1909, even within the "mechanical objectivity" context of late nineteenth-century scientific atlas, photographs were often transcribed (although more meticulously than Currier and Ives did, of course) as drawings or lithographs.[40]

Thus we could characterize Muybridge's practices as designed to present visual records, conceived with the taste and pictorial sense of an artist, and technically produced with the skill of a master craftsman. His images of exotic locations such as Alaska, Guatemala, or even Yosemite before roads made it tourist-accessible; his images of the battles of the Modoc Indian War, often restaged, but on the authentic location; even his 360-degree panoramas of San Francisco—all endeavored to present a vivid visual record of something most viewers of the photographs would have difficulty seeing for themselves. The fixing of the intervals of motion through instantaneous photography would seem to provide a similar visual record of something difficult for the human eye to see.

Or would it? If Muybridge's aestheticizing practices seem to relate him to the idealizing images of the scientific atlases prepared before the regime of mechanical objectivity, the contradictory nature of the instantaneous image makes this relation somewhat difficult to define. As Prodger put it: "All of this changed with the development of truly instantaneous photography. Muybridge claimed to be able to take images as fast as 1/1000 of a second. At that rate the camera may record actions too rapid to be seen with the naked eye. As a result, the generally accepted standard of truth in photography, the plausibility of appearance, no longer applied."[41] As Joel Snyder has insistently argued, photographs do not simply show us what we see. Through most of its nineteenth-century existence, however, the

40. Haas 1976, 19; Daston and Galison 1992, 101.
41. Prodger 1996, 55–56.

discourse surrounding photography served to "align . . . photographic vision with human vision." If a simple identification of the two could not be made, early photographs were nonetheless seen as confirming what we see, even as they exceeded human ability to depict such sights by manual means such as drawing or painting. But instantaneous photography crossed a line. As Snyder put it: "With photography, however, we were supposed to be able to represent what we see and only what we see. But we cannot see just about everything shown in a chronophotograph of a man running. There is a challenge here to the primacy of vision, to its adequacy."[42]

For Marey, as a scientist who first approached the analysis of movement through the graphic method (that is, through charts inscribed by instruments directly measuring movement, rather than by photographs), this contradiction of a visible document that exceeded the possibilities of human sight caused little problem. Marey as a scientist wished to exceed the human senses, to correct them by detouring around them, thus eliminating human intervention, observation, and error. His chronophotographic images short-circuited human perception, producing not a simulacrum or confirmation of vision, but rather a mechanical product, exemplifying (or, according to Snyder, even exceeding) mechanical objectivity. Marey's deep distrust, not only of human subjectivity but also of the human senses as a means of recording data, determined his devices, both graphic and photographic, which "simultaneously chart what they register."[43] Human intervention (or even mediation) no longer appears, since the machine directly detects and records its data.

In contrast to the total abstraction evident in Marey's charts produced by the purely graphic method, however, the chronophotograph does present us with a visual image, not just traces to be graphed. Marey recognized that there were things within his photographic work that had to be *seen*, not simply marked. Here lies part of the "wobble" between "what one sees

42. Joel Snyder, "Visualization and Visibility," in Jones and Galison, *Picturing Science*, 392, 393.
43. Ibid., 381.

**Fig. 4-10**
Etienne-Jules Marey
*Vibrations of an Elastic Rod*, c. 1886
Albumen print
6.5 x 16.3 cm

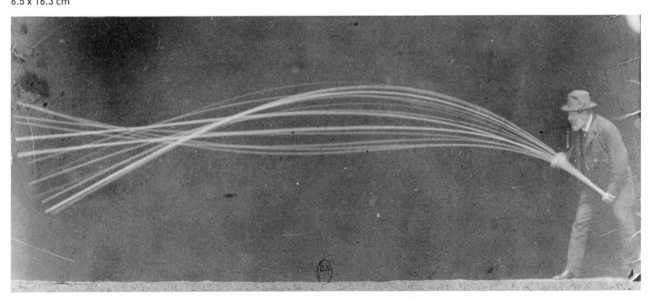

and what really exists," which Snyder discusses in his essay. These pictures do show us something we cannot otherwise see, but we *do* see them, in a sense we even recognize them, and they do affect the way we see things afterward. If Marey, the objective scientist, began to wobble in his description of these images, how much more did Muybridge, the technician/artist? Muybridge, I would claim, hoped to bring his motion studies back into alignment with human vision. His aestheticizing practices are, I think, gestures toward this realignment. If the individual images appeared strange in their frozen motion, the entire arc of movement as rhythmically portrayed in the series as a whole could provide aesthetic familiarity and satisfaction.

As did Marey after him, however, Muybridge realized that the only way to complete this realignment was to produce not simply pictures of motion, but motion pictures. For both Muybridge and Marey the production of actual motion pictures from the individual images of their analysis of motion would provide the guarantee of their process. As Snyder has said of Marey, "In attesting directly to the eye, motion pictures dispense with any need of interpretation; for him, their testimony is self-evident."[44] Yet Marey's attitude toward the motion picture remained ambivalent. After the projections of the Lumière brothers, he commented: "In the final analysis they [i.e., actual motion pictures as opposed to chronophotographs] show what the eye sees directly; they add nothing to the power of our sight, remove none of its illusions. But the true character of a scientific method is to supplement the weaknesses of our senses or to correct their errors."[45] Marey's break with colleague and disciple Georges Demenÿ came over Demenÿ's commercial exploitation of the motion pictures that Marey's devices had made possible. The realm of commercial entertainment repulsed the physiologist.[46] But for more than a decade Muybridge had embraced the role of a showman, presenting his zoopraxiscope projections of animals and humans in motion. As a showman, he united in a peculiarly modern synthesis his roles as popular scientist, technician, and artist.

44. Ibid., 396.
45. Etienne-Jules Marey, preface to *La photographie animée*, by Éugene Trutat (Paris, 1899), quoted in Jacques Deslandes, *Histoire comparée du cinéma*, 2 vols. (Paris: Casterman, 1966), vol. 1, 144 (translation by the author).
46. Laurent Mannoni, *Georges Demenÿ, pionnier du cinéma* (Douai: Pagine, 1997), 53–61.

**Muybridge among the Showmen: Motion as an Attraction**

If we approach the claim that Muybridge was the "father of the motion picture" literally, it must rest on his projection of moving images through the zoopraxiscope (see inset, chapter 3). As I stated earlier, the basis of this claim carries many uncertainties. Muybridge's actual projection device, though baptized by him with a unique name, was not truly a unique invention; his lack of any attempt to patent it undoubtedly reflects his awareness of his basic retooling of projecting versions of the phenakistoscope introduced by Austrian Franz von Uchatius and patented in the United States in 1869 by A. B. Brown.[47] Further, Muybridge's device makes use of nonphotographic materials, in this case colored translucent drawings (based on, but not photographically reproducing, his original chronophotographs). Thus Muybridge did not actually project moving photographic images, but rather animated drawings, not unlike the drawings prepared from his photographic series for use in nonprojecting devices of moving illusion such as the zoetrope or phenakistoscope.[48]

Reconstituting the motion analyzed by Muybridge's photographs seems implicit in the photographic project itself, at least from the point in 1877 when the original project of *photographing* a horse in motion was transformed into *photographing several phases* of a horse in motion, a feat requiring setting up a battery of cameras. Anita Mozley theorized decades ago that Stanford and Muybridge's initial choice of a battery of twelve cameras may have been determined by the fact that zoetrope strips generally included twelve images, and thus the idea of observing the photographs within a motion picture device may have been embedded in the multiple-camera plan.[49] Once Muybridge's series of horse images was published in 1878, suggestions of observing them within a zoetrope device came from many sources, including Eakins and Marey.[50] Zoetrope strips with drawings based on Muybridge's photographs were almost immediately offered commercially by several international

47. Haas 1976, 117–18. For detailed and carefully researched descriptions of projection systems based, like Muybridge's zoopraxiscope, on the phenakistoscope, see Mannoni 2000, 223–47.

48. Examination of the surviving Muybridge picture discs for the zoopraxiscope found that only one contains photographs—images of the horse skeleton, which was most obviously not one of Muybridge's motion photographs (Rossell 1998, 39; see fig. 4-11).

49. Mozley 1972, 71.

50. Haas 1976, 117.

sources. Photographing the phases of motion entailed a complex photographic and engineering feat, calling on the talents not only of Muybridge but of a group of electrical and mechanical engineers who helped lay out the track and realize the shutter devices. But once that was achieved, endowing these images with motion was literally child's play (in fact, Muybridge's first viewing device for the photographs was based on a model he found in J. H. Pepper's *Boy's Playbook of Science*).[51]

The purpose behind animating Muybridge's images was initially a scientific demonstration of their accuracy. As Muybridge phrased it, he constructed the zoopraxiscope "for synthetically demonstrating movements analytically photographed from life."[52] The demonstration was designed, therefore, to validate the often counterintuitive and visually strange positions of the horses' limbs presented by the still images, which led to accusations by many early critics that the images had been posed or faked. Visual proof came from actually seeing these clumsy positions transformed into familiar-seeming motion once animated, the self-evident testimony that Marey also sought from his projection devices. As Muybridge put it in one of his demonstration lectures, "you will readily understand that if any of the positions were incorrect, it would upset the experiment altogether."[53] From this point of view, synthesis of motion serves simply as a scientific cross-check of the accuracy of the analysis of motion that remains the true purpose of chronophotography.

But Muybridge's demonstrations did not occur simply in the laboratory or before scientific conferences; he sought out a broader public, a step Marey resisted: the actual embracing of the role of showman. Muybridge's early public appearances followed the nineteenth-century mode of magic lantern lecturers, illustrating his discussions of his photographic studies of animal locomotion with projected lantern slides. Apparently he interspersed these occasionally with lantern slides of his other photographic work, such as his views of Alaska or Guatemala,

51. Haas 1976, 117. Haas is referencing John Henry Pepper, *The Boy's Playbook of Science* (London and New York: Routledge, Warne, and Routledge, 1860), with many subsequent editions.
52. Muybridge 1899, 12.
53. Muybridge, lecture given to the Royal Society of Arts, 4 April 1882; reprinted in Hendricks 1975, 236.

following here the well-established entertainment mode of travel lecturers such as John Stoddard.[54] Muybridge eventually (like Stoddard's protégé Burton Holmes some years later) supplemented his program of still slides with motion picture devices. As Charles Musser has claimed, Muybridge's relation to the prehistory of the cinema comes not only from his experiments in representing motion but also from his role as a lanternist lecturer, part of the broader "history of screen practice" of which cinema forms one aspect. Descriptions by audience members or projection assistants indicate that Muybridge was an effective lecturer, one who obviously relished being in the spotlight. As Musser has shown, Muybridge's lectures followed protocols set up long before within the practices of screen entertainments.[55]

But whatever Muybridge's own taste for show business may have been, audience fascination with the actual propelling of still images into motion endowed this scientific demonstration with the thrill of a new form of visual entertainment. This fascination removes Muybridge's practice from the regimens of self-denial that Daston and Galison describe as the essence of late nineteenth-century science and propels it into the pursuit of visual pleasure that marks late nineteenth-century mass entertainment. Popular science presentations in the nineteenth century, such as the spectacular shows presented at London's Royal Polytechnic Institution, with its battery of complex magic lanterns with their various trick effects, rivaled other visual genres of popular entertainment such as panoramas, dioramas, sensational melodramas, and theaters of magical illusion.[56]

If one of the marks of these hypervisual spectacles was an immersion in sensual effects that seems distant from the refined scientific lecture that Muybridge presented, one should not make the separation too strong. The invitation to Muybridge to open a zoopraxographical hall along the Midway of the World's Columbian Exposition in Chicago in 1893 envisioned a form of entertainment that could compete with other popular

54. For a discussion of nineteenth-century lantern lecturers, see Musser 1990, 38–41.
55. Musser 1990, 15–54.
56. On the Royal Polytechnic Institution and other visual entertainments of the nineteenth century, see Mannoni 2000, 264–66, and passim, and Richard D. Altick, *The Shows of London* (Cambridge: Harvard University Press, 1978), 382–89. Barbara Stafford, in *Artful Science* (Cambridge: MIT Press, 1994), details the relation between science and visual education during the Enlightenment.

attractions (the Midway being—unlike the White City, where educational and government exhibits were gathered—the area for popular commercial attractions). While the official announcement from the Fine Arts Commission described the educational value of the presentations taking place in the hall, it also stressed that it would provide entertainment for "popular and juvenile audiences."[57] Muybridge's attraction was not particularly successful, but its placement among commercial amusements does not seem to be a major category mistake, simply a miscalculation of audience taste in this particular context.

Early responses to Muybridge's projections of moving images provide some of the earliest examples I have found of what Bazin would later call "the myth of total cinema." Elsewhere I have claimed that this desire for a total illusion involving several senses invoked less a timeless, idealist desire for transparent representation than a sensational hyperrealism specific to the late nineteenth century.[58] Thus the journalist for *The Call* reported after Muybridge's zoopraxiscopic presentation before the San Francisco Art Association on May 4, 1880, "Nothing was wanting but the clatter of hoofs upon the turf and an occasional breath of steam to make the spectator believe he had before him the flesh and blood steeds."[59] While this smacks of journalistic rhetoric, the desire for sound to complete the illusion seems to me quite significant in realizing the true appeal of Muybridge's presentation. It contrasts sharply with the aural accompaniment that Fairman Rogers announced for his presentation of Muybridge's images as redrawn for the zoetrope by Thomas Eakins: "An addition to the zootrope [*sic*] is now being made by which, at the moment at which each foot appears to the eye to strike the ground, a sharp tap of a small hammer will be made by the instrument, and the cadence of the step will be made manifest to the ear, and will aid materially in the study of the motion."[60] Rogers's address to the ear aids the analytical and scientific purpose of Muybridge's project. But the desire for the clatter of

57. Announcement by Newton Carpenter, secretary of the Art Institute of Chicago, cited in Haas 1976, 174.

58. Bazin, *What Is Cinema?* vol. 1, 17; Tom Gunning, "Animated Pictures: Tales of Cinema's Forgotten Future after One Hundred Years of Film," in *Reinventing Film Studies*, ed. Christine Gledhill and Linda Williams (London: Arnold, 2000), 316–31.

59. Cited in Haas 1976, 120.

60. Fairman Rogers, "The Zoetrope," *Art Interchange*, 9 July 1879; reprinted in Mozley 1972, 119.

hoofs moves in another direction, toward a multisensual form of illusionistic entertainment—dare we say it—toward the movies.

The fateful encounter in 1888 between Muybridge and Thomas Edison led, along with the latter's subsequent encounter with Marey, directly to Edison's development of the Kinetoscope and therefore the origins of modern cinema (and thus provides an essential link in Muybridge's rather mediated paternity). This meeting focused, according to Muybridge, on the combination of his photographic experiments with Edison's innovation of the phonograph. While Gordon Hendricks has rightly claimed that such a combination would not have been particularly feasible, the equation of the phonograph's ability to capture a temporally continuously unfolding record of sound with Muybridge's zoopraxiscope's unfolding of a visual process in time remains prescient.[61] The idea of uniting the two, however impracticable it might have been in 1888, certainly triggered Edison's thinking about a motion picture machine, which he described, in his first caveat to the United States Patent Office, as a machine that would "do for the eye what the phonograph does for the ear."[62] Edison took the interrelation so literally that his first viewing device employed a cylinder based on those used for his phonograph records, with microscopic images spiraling around this base.

This encounter between Edison and Muybridge pushed the development of chronophotography toward the production of synthesis rather than analysis and, consequently, toward the realm of mass entertainment rather than objective scientific research. While Edison's meeting with Marey in France in August 1889 at the Universal Exposition supplied the final essential technical solution of replacing the cylinder with a long band of film of the type Marey had been using for his most recent experiments, Marey's strong opposition to the use of his inventions as commercial entertainment shows the essential difference in orientation between the American inventor-entrepreneur and the French physiologist.[63] No such gulf

61. Accounts of the meeting can be found in Hendricks 1975, 175, and Musser 1990, 62; Muybridge's own account is in Muybridge 1899, 15. Hendricks also treats the meeting in his *Edison: Motion Picture Myth* (Berkeley and Los Angeles: University of California Press, 1961), 12. I discuss the relation between the phonograph and the early motion picture devices in Gunning 2001.

62. See Neil Baldwin, *Edison: Inventing the Century* (New York: Hyperion, 1995), 274.

63. Braun 1992, 189–90.

existed between Edison and Muybridge, who, in his capacity as a photographer and a travel and popular science lecturer, already participated in the world of entertainment, albeit in its more elite forms. Edison's move into the realm of entertainment (although prepared for undoubtedly by his love for, and mastery of, publicity) had been initially unplanned and even reluctant, as he slowly realized that the phonograph, which he had designed for commercial business use (recording office memos), was impracticable for that purpose and that its real commercial value lay in recording instrumental music, songs, and comic monologues. Although some would claim that Edison never fully accepted his role as entertainment entrepreneur, he designed the improved phonograph, which he announced in 1888 and placed on the commercial market in the early 1890s (largely to forestall competition from other devices, such as Bell's graphophone), as an entertainment machine. Edison always approached his motion picture device, the Kinetoscope (whose development and manufacture immediately followed the launch of the perfected phonograph), as an amusement device.

What was the entertainment offered by Muybridge's zoopraxiscope? If there was a surplus value over its demonstration of the accuracy of the individual still frames, something less intellectual and more visual—able to entertain even "popular and juvenile" audiences—how would we describe it? Here we have to enter into the realm of wonder and astonishment, a tradition of optical transformation that Muybridge may or may not have consciously participated in, but that his audiences certainly did. Muybridge never presented either still or moving images exclusively (at least after the introduction of the zoopraxiscope) but always displayed both and, in fact, alternated them.[64] If the projections invoked the ideal of total illusion for some viewers, what undoubtedly fascinated most of them was precisely the *transformation* of still images into an illusion of continuous motion. This crossing of a perceptual threshold undoubtedly

64. See the description by Ernest Weber, the projectionist for Muybridge's 1889 British lectures, reprinted in Hendricks 1975, 213–14.

sent a thrill through the audience, as it did a few years later in the first Lumière projection, which, like many early motion picture projections, began with a freeze-frame.[65]

We sense the actual process of transformation, as still images collapsed into an illusion of motion, in early accounts of Muybridge's "demonstrations." A report in the *American Register* of the "magnificent entertainment" given by Meissonier in Paris in 1881, in which Muybridge presented his zoopraxiscope in France for the first time, describes this transformation: "With the aid of an instrument called the zoopraxiscope many of the subjects were exhibited in actual motion, and the shadows traversed the screen, apparently to the eye as if the living animal itself were moving, and the various positions of the horse and the dog, many of which, when viewed singly, are singular in the extreme, were at once resolved into the graceful, undulating movement we are accustomed to associate with the action of those animals."[66] A British reviewer similarly described the effect of transformation a year later: "By the aid of an astonishing apparatus called the 'Zoopraxiscope,' which the lecturer described as an improvement on the old Zoetrope, but which may be briefly defined as a Magic Lantern Run Mad (with method in its madness), the ugly animals suddenly became mobile and beautiful, and walked, cantered, ambled, galloped and leaped over hurdles, in the field of vision in a perfectly natural manner."[67] Transformation into motion supplied the scientific demonstration that both Muybridge and Marey recognized their often absurd-appearing still images might demand from skeptical observers. As a British reviewer of the Meissonier projections affirmed, "their truthfulness was demonstrated most successfully."[68] Yet these descriptions testify to something more—a surplus value, an act of magical transformation, as well as scientific demonstration. It was this transformation from still image to movement—from unfamiliar and often ungainly poses to satisfying, graceful, and natural movement—that constituted the *cloue* of Muybridge's spectacles, their main event and attraction.

65. I discuss both the Lumière practice and the phenomenology of this transformation in "New Thresholds of Vision: Instantaneous Photography and the Early Cinema of the Lumière Company," in *Impossible Presence: Surface and Screen in the Photogenic Era*, ed. Terry Smith (Sidney, Australia: Powers Institute, 2001), 71–100.

66. "Mr. Muybridge's Photographs of Animals in Motion," *American Register* 3 (December 1881); cited in Forster-Hahn, "Marey, Muybridge, and Meissonier," 85.

67. George A. Sala, *Illustrated London News*, 18 March 1882; cited in Mozley 1972, 131.

68. *Standard* (London), 28 November 1881; cited in Mozley 1972, 131.

**Fig. 4-11**
Eadweard Muybridge
*Skeleton of a Horse, Running,* c. 1893
Zoopraxiscope disc
Diam. 40.7 cm

# THE LARKYNS AFFAIR

AT TWILIGHT ON OCTOBER 17, 1874, a crazed but determined Eadweard Muybridge arrived in the town of Calistoga, in the northern Napa Valley. He had been traveling the better part of the day. A ferry had taken him from San Francisco to Vallejo; from there he hopped the train north. At 7:30 he arrived in town, hired a wagon and team, and headed for the Yellow Jacket Mine.

Muybridge had come to see Major Harry Larkyns, an itinerant Briton with a murky past. Larkyns claimed to be the son of Scottish nobility, to have fought alongside the Italian patriot Giuseppe Garibaldi, and to have repulsed the Germans in the Franco-Prussian War. Supposedly made a rajah in Central Asia, he bragged of a life of importance and opulence. But, he said, he had grown tired of such indulgences and returned to Europe to dabble in the London theatrical world and hobnob on the Continent. According to Larkyns, it was a thirst for new challenges and a taste for adventure that brought him to California. Eulogizing him in 1874, the *San Francisco Examiner* described his seemingly superhuman charm:

> He was every inch a Bohemian and a debonair man of the world. He spoke divers tongues, all equally well as he did English. He had been everywhere and seen everything. He had roamed the world and been a solider of fortune,

writer, poet, musician. . . . He could box like Jem Mace, and fence like Agramonte. . . . He could hit more bottle necks with a pistol at twenty paces than anyone else, and he never sent his right or left fist into a bully's face but that the bully was carried away. . . . [He] was a scientist, chemist, metallurgist. . . . No one could mention anything he could not do better than anybody else, and when it came to cooking a delicacy in a chafing dish, Delmonico was simply not up to it. . . . Larkyns was over six feet tall, straight as a lance, and had the gift of spreading a ripple of sunshine wherever he went.[1]

In reality, it is doubtful if any of Larkyns's stories were true. At the very least, he was a convicted swindler and a notorious womanizer, one of the legions of dubious characters drawn to the frontier in the early days of European settlement. In the partial anarchy of the "Wild West," people like Larkyns could find willing dupes for their fabulous tales, while at the same time escaping the long arm of the law. The only verifiable fact of his life prior to his encounter with Muybridge was an incident of fraud reported in Salt Lake City in 1871. After a brief escape to Hawaii, he returned to San Francisco and was jailed for writing bad checks. Released only after the victim failed to show up in court, he took a series of odd jobs,

eventually landing a position as critic for the *San Francisco Post*. Suddenly he was back in business.

With hindsight, it is obvious that Larkyns was up to no good. But Muybridge's wife, Flora, was blind to it. Flora and Eadweard Muybridge were an odd couple to begin with. It is thought that they met in the studio of Arthur and Christian Nahl, with whom Muybridge became affiliated in April of 1869. Accounts differ regarding Flora's position there. It seems, however, that she was either a retoucher or receptionist for the firm. When Eadweard met her, she was already married to a San Francisco saddler named Lucius Stone, but the two divorced in December 1870. Shortly thereafter (or perhaps even before) Eadweard and Flora began a love affair. At the time of her divorce Flora was nineteen. Eadweard was forty-one. They married two years later, in 1872.

Just what caused their marriage to disintegrate remains a matter of speculation. Shortly after they wed, Muybridge began his work for Leland Stanford in Sacramento. He put in long hours at work and was away from home for considerable stretches of time. Larkyns, whom Muybridge had befriended, offered to entertain Flora, and at first Muybridge welcomed the idea. Gradually Flora became infatuated with Larkyns, and the two met secretly and often.

In fall of 1873 Muybridge learned that Flora was pregnant. He had no reason to doubt that the child was his own, and when he was born, on April 13, 1874, he was named Floredo Helios Muybridge, taking his first name from his mother and his middle name from Muybridge's photographic pseudonym. Before long, however, Muybridge came to suspect that Flora and Larkyns had been having an affair. One day he discovered them in each other's arms, and Muybridge forbade Larkyns ever to visit again. Once he saw Larkyns passing notes to Flora's nurse. Later he intercepted a letter. It read: "Why doesn't the old man get out of town and leave us alone? At the place on Montgomery Street they think you are my wife."[2]

Muybridge was deeply perturbed, and this time he upped his warnings. He went to see Larkyns in the offices of the newspaper where he worked and demanded that he never communicate with Flora again. If he did, Muybridge warned, he would kill him. Larkyns seems to have taken the threat seriously. He found a job as manager of a circus outside town, where he worked for a time. Eventually he was hired as a surveyor at the Yellow Jacket Mine in Calistoga, out of harm's way. Flora and the baby Floredo were sent to Oregon.

In the fall of 1874 Muybridge discovered that Flora and Larkyns were continuing to write to each other. By coincidence Susan Smith, the nurse, sued Muybridge for back pay. He maintained that he had given the money to pay her to Flora, but it seems that she never gave it to her. After a brief legal

wrangle, it emerged that Smith had a number of recent letters between Flora and Larkyns. Muybridge demanded to see them. On October 14 she relented. After reading them, he is said to have cried out and collapsed on the floor.

Muybridge never had reason to doubt the paternity of his son. But three days later it became clear that he was probably not the boy's real father. On October 17 Muybridge went to see Smith again, hoping to probe her for more information. This time, ironically, she had left a photograph of Floredo on a table. The historian Robert Bartlett Haas has described the scene, as reconstructed from court testimony. Muybridge saw the photograph:

"Who is it?" he said with a start.

"He is your baby," answered Mrs. Smith.

"I have never seen this picture before. Where did you get it and where was it taken?"

"Your wife sent it to me from Oregon. It was taken at Rulofson's."

Muybridge turned the picture over and began to tremble. "My God," he cried, "what is this on the back of this picture in my wife's handwriting—'Little Harry'?"[3]

Enraged, Muybridge extracted the details from Mrs. Smith. Flora and Larkyns had considered the baby theirs all along. The idea that he was

Muybridge's child was a sham, designed to keep up appearances.

Muybridge could stand no more. By nightfall he was in a carriage heading for the Yellow Jacket Mine. According to the driver, he shot a test round on the way to the mine. On arrival, he knocked on the door of the mine superintendent. Benjamin Prickett, the foreman, answered the door. There was a small gathering inside. Larkyns was later said to have been playing cribbage. Muybridge asked for him. When he came to the door, Muybridge simply said, "Good evening, Major. My name is Muybridge. Here is the answer to the message you sent my wife."[4] With that, he shot him once, near the heart. According to the doctor who attended the wound, he must have died almost instantly.

Muybridge gave himself up peacefully and soon found himself in the Napa Jail. A grand jury indicted him for "feloniously, wilfully, unlawfully, and of his malice aforethought" murdering Harry Larkyns.[5] Two promising young California lawyers, Cameron King and Wirt Pendegast, were brought in to defend him. It has been suggested that Leland Stanford arranged for Muybridge's defense, but the extent of his involvement is not clear. Interviewed in the 1920s, William Rulofson's son, A. C. Rulofson, claimed that his father paid about $3,000 for Muybridge's representation.[6] But, according to oral tradition in the Pendegast family, Pendegast provided his services for free.

The trial was short, but it was a national sensation. The papers were full of it. There was some talk of using an insanity defense, but Muybridge refused to suffer the indignity. Instead, his lawyers argued that he had committed justifiable homicide. Pendegast's concluding remarks were considered decisive. In what was then considered one of the great oratorical performances in legal history, he pleaded his case:

> Muybridge was not only avenging the wrongs done him when he shot the man dead, but was protecting Mrs. Muybridge against him in the future.
>
> Larkyns, after being forbidden the home, had he entered the premises and wrenched a shingle from the roof, Muybridge would have been justified in shooting him dead. But when he entered the front door as his trusted friend, and stole from him his rarest jewel, the love and good name of his wife, and writes "prostitute" across her brow, and dishonors and ruins the home of her husband, that husband is to ask the law to protect him against a repetition of such conduct if it could be repeated.
>
> The debaucher holds the woman in his arms, kisses her lips on the night of the birth of her child, calls her "his baby," intrudes himself into the sacred precincts of the birth chamber, and afterwards exchanges ribald jokes at the expense of the older man whom they have wronged.
>
> You, gentlemen of the jury, you who have wives whom you love, daughters whom you cherish, and mothers whom you reverance, will not say "insanity."
>
> I cannot ask you to send this man back to a happy home—he hasn't any—the destroyer has been there and has written all over it, from foundation stone to roof tree, "Desolation! Desolation!" His wife's name has been smirched, his child bastardized, and his earthly happiness so utterly destroyed that no hope exists for its reconstruction. But let him go forth again among the wild and grand beauties of Nature in his present beloved profession, where he may, perhaps, pick up again a few of the broken threads of his life and obtain such compensation as may be attained by one so cruelly stricken through the very excess of his love. Or send him to the gallows. Ye are the judges![7]

The speech was met with thunderous applause. The jury deliberated overnight but returned the desired verdict. Larkyns's murder was justifiable homicide.

Muybridge was released, but he was never the same man again. Once freed, it was thought advisable for him to travel to Central America, where he been planning a photographic expedition. The motion studies were suspended. He

sailed on the *Montana* in February of 1875, returning early the following year.

In December of 1874 Flora had filed for divorce. The following April, as Muybridge toured the Isthmus of Panama, she died, at age twenty-four. The papers reported that she suffered from paralysis. Floredo was sent to the Protestant Orphan Asylum in San Francisco. Muybridge paid for his care, at least initially. But he effectively disowned him and seems never to have participated directly in the child's upbringing after his acquittal.

It will never be known just how deeply the Larkyns experience haunted Muybridge. It was certainly a turning point in his life, if not his career. At least one of his contemporaries, George S. Covey, a horse trainer who worked with Muybridge in Palo Alto after the murder, felt he could see the change:

Most of the time he wore a slouch hat with the brim down over his eyes. He would even do this in the house until it would be brought to his attention in some way that it was in poor taste to wear a hat in the house. He had a very peculiar habit that insomuch as when he was talking to a person he would never look them in the eyes. His eyes were always wandering off either to the right or the left. He never said much, and when he did speak he spoke very quickly. He never talked to the men working with him. He smoked cigarettes a great deal using the old ready made style. Part of the time he worked with his coat off with his sleeves rolled up, but once in a while he would have his coat on. He was not careful in his dress but decidedly slouchy. In his younger days, however, he had been a very handsome man and a very fine dresser. He gave the idea of having passed through a great deal of trouble with a careless disregard of the future.[8]

NOTES

1. *San Francisco Examiner,* 19 October 1874; cited in Haas 1976, 63.
2. Haas 1976, 65.
3. Haas 1976, 67.
4. Haas 1976, 68.
5. Haas 1976, 71.
6. George S. Covey, interview with Harry Peterson, Jane and Michael Wilson collection, London, 13.
7. Unpublished transcript of the Muybridge trial, Janet Leigh Papers, Bancroft Library, University of California, Berkeley.
8. Ibid.

**Muybridge, My Contemporary:**
**Tracking the Laws of Art in the 1970s**

In the 1970s, during my years as a graduate student in the
Department of Cinema Studies at New York University, I expe-
rienced directly the upsurge of interest in Muybridge's work
and its influence on contemporary artists and filmmakers as
well as scholars. Prompted first by the reissuing of selections of
Muybridge's photographs in an inexpensive edition by Dover
Publications in 1969, then by the flurry of articles that were
launched by the centennial of his first work with Stanford, the
appearance of biographies by Haas and Hendricks in the middle
of the decade fueled a rediscovery that can now be taken for
granted: the recognition of one of the great photographic prac-
titioners of the nineteenth century. Exhibitions of Muybridge's
work proliferated, reproductions of his photographs appeared
on covers of journals of contemporary art, citations in paintings
and sculpture abounded; Muybridge was among the key refer-
ences for New York City art world in the 1970s and early 1980s.
In 1974 Thom Anderson's extraordinary documentary film *Ead-*
*weard Muybridge: Zoopraxographer* opened at the New York Film
Festival, allowing contemporary audiences to experience that
thrill of the transformation into motion, as Muybridge's actual
photographs (as opposed to drawings based on them) were ani-
mated for the first time.

If history is not simply a process of transmission but pos-
sesses its own techniques of transformation, a somewhat new
Muybridge appeared in the mid-1970s. The tradition of Muy-
bridge's photographs inspiring portrayals of the human body
had continued with the work of Francis Bacon in the 1950s and
1960s. But artists in the 1970s responded less to the individual
images of bodily postures than to the serial images, which res-
onated with visual schemata Pop artists such as Andy Warhol
had been exploring, making Muybridge's repetitive figures
seem startlingly modern. I will not attempt to discuss Muy-
bridge's enormous effect on contemporary American art here,

but I will sketch something of the context that welcomed his rediscovery, especially in the realm of experimental film.

Far from seeming like a resurrection of archaic material, Muybridge's use of mechanical reproduction; his objectified approach to the human figure; his abstracted, gridded space; and his distanced, unemotional portrayal of human gesture (as opposed to Bacon's expressionistic appropriation of awkward poses)—all appeared extraordinarily contemporary in the 1970s and early 1980s. This was the era of structural film and Minimalism in painting and music, in which the individualized gestures of Abstract Expressionism (already shaken by the carnivalesque moment of Pop Art, which prepared the way for a new impersonality in art and fascination with mechanical reproduction) had given way to works that displayed the systematic parameters that determined their form. Rather than the chance-determined processes that had characterized much of the 1960s' appropriation of Surrealism, predictable and ordered procedures now shaped the final form of paintings, musical compositions, and films by artists such as Frank Stella, Stephen Reich, and Ernie Gehr. Such works seemed to aspire to the condition of scientific demonstration, and Muybridge's photographs provided a resurrected model for the union of scientific abstractions with the particularities of photography.

The scientific ambitions of these works were chiefly a matter of reference and method, however, rather than final purpose. While impersonal schemata delivered artists from what Hollis Frampton called the "thumbprint" conception of art making as personal expression, these artists' appropriation of scientific terminology and rationalized procedures were at least as deviant from actual scientific methods as Muybridge's practices had been. Nothing captures the fusing of admiration and irony in appropriations of Muybridge as well as Frampton's own photographic series *Sixteen Studies from Vegetable Locomotion*, undertaken in 1975 in collaboration with Marion Faller (figs. 4-12a, b). In this series of photographs Frampton arranged a variety of

vegetables against a Muybridge-like grid, giving them a mise-en-scène and ironic Muybridge-like titles, such as number 519, *Tomatoes Descending a Ramp*. Rather than analyzing a real phenomenon, however, the series blatantly creates one; the locomotion of vegetables exists only as a product of the procedure the artist has arranged. In fact, the human hands that propel the vegetable action appear in the images, like the hands of puppeteers unwittingly exposed (and even occasionally whole bodies, as when we see Marion Faller shucking ears of corn in the coyly titled number 601, *Sweet Corn Disrobing*). The pathos of vegetable migration across an imaginary space and time exists only as optical parody, as in number 782 (one more number than Muybridge's *Animal Locomotion*!), entitled *Apple Advancing*, in which a progressively more closely framed apple seems to swagger toward the camera.[69]

The group of filmmakers who flourished in New York City in the late 1960s and 1970s—including Canadian Michael Snow, Ernie Gehr, Ken Jacobs, and Frampton, all of whom lived within blocks of one another in lower Manhattan and interacted in theoretical discussions and actual filmmaking—did not embrace systematic patterns or scientific schema as a capitulation to modern rationality. In spite of their deliberate differentiation from the personal filmmakers who directly preceded them, these filmmakers remained individual researchers of the sort Arthur Rimbaud had called for a century earlier, each willing to "search his soul, inspect it, test it, learn it."[70] They responded to Rimbaud's call for artists to become "the supreme *Savant*" with films designed to explore, not the individual psyches, but the conditions of filmmaking and the relation between films and their viewers. Gehr described the purposes behind his film *Serene Velocity* in an interview with Jonas Mekas in 1971: "A desire less to express myself and more of making something out of the film material itself relevant to film for spiritual purposes . . . What I mean by 'spiritual' is sensitizing the mind to its own consciousness by allowing the mind to simply observe and

69. The series is reproduced in Bruce Jenkins and Susan Krane, *Hollis Frampton: Recollections, Reconstructions* (Cambridge: MIT Press, 1984), 77–85.

70. Arthur Rimbaud to Paul Demenÿ, 15 May 1871, in *Rimbaud: Complete Works, Selected Letters*, ed. Wallace Fowlie (Chicago: University of Chicago Press, 1966), 307. I have addressed the extraordinary coincidence that this manifesto-like letter was addressed to the brother of Georges Demenÿ, Marey's assistant and inventor of the Phonoscope, which was one of the first commercial motion picture devices (Gunning 2001).

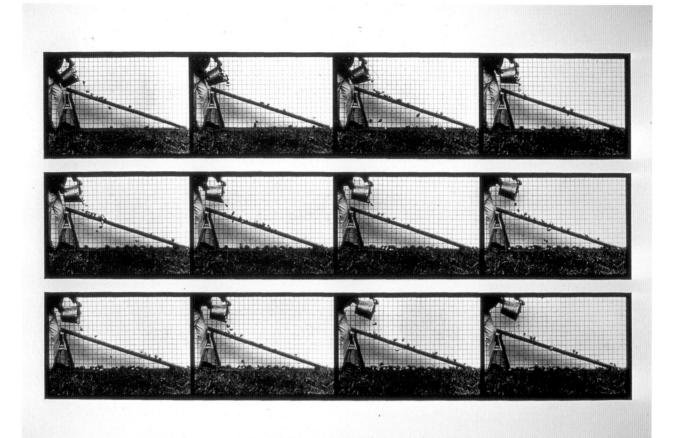

**Fig. 4-12 a, b**
Hollis Frampton (United States, 1936–1984)
    and Marion Faller (b. 1941)
*519. Tomatoes Descending a Ramp*, 1975
    (left), and *601. Sweet Corn Disrobing*,
    1975 (right), from the series *Sixteen
    Studies from Vegetable Locomotion*
Gelatin-silver prints
27.9 x 35.6 cm
Photo: Estate of the Artist

71. "Ernie Gehr Interviewed by
    Jonas Mekas, March 24, 1971,"
    *Film Culture*, nos. 53–55
    (spring 1972): 26–27.
72. Hollis Frampton, "A Lecture,"
    in Frampton 1983, 198.

digest the material film phenomena presented, rather than manipulating it to evoke moods and sentiments."[71] Frampton echoed this substitution of exploration of a personal self or psychology for works that explore the interaction between mind and medium. Referring to himself in the (impersonal) third person, he declared:

If we dared ask, he would probably reply that self-expression interests him very little.

He is more interested in recovering the fundamental conditions and limits of his art.[72]

While such a mission may have been far from Muybridge's announced purposes in undertaking his life's work in photography, his role as pioneer in a new technological medium,

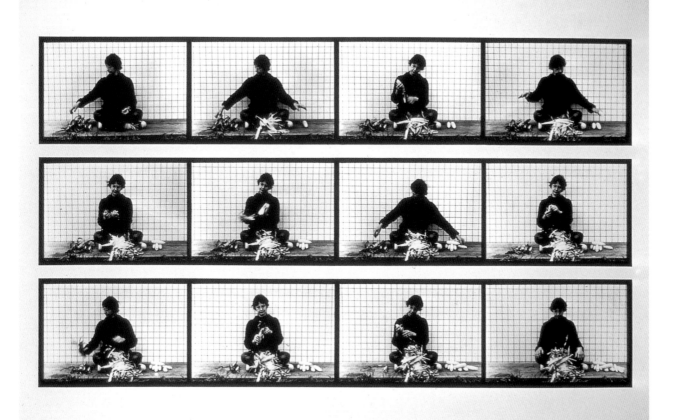

exploring its precarious existence at the intersection of art and science, necessitated a similar labor of definition, seeking out the nature of photography by constantly expanding it limits. One might well describe confronting the still image with its extension into an illusion of motion as discovering "the fundamental conditions and limits of his art."

Frampton, in his essay on Muybridge originally published in the journal *October* in 1981, located a central theme for Muybridge's work that has little to do with the physiological investigations usually cited as the motivation for it. Muybridge, Frampton claimed, "fastened upon time as his grand subject," time as a fundamental category of both experience and photography. But the temporality Frampton located in Muybridge's work is not limited to the rational coordinates of measurement

fundamental to modern observational science. As Braun and others have pointed out, Muybridge was distressingly imprecise, and even occasionally misleading, in indicating the measurable time his images actually represented (while Marey's later chronophotographs inscribe precise temporal markings by including a chronometer in the image). Time in Frampton's experience of Muybridge appears rather in his repetitive schemata and the dialectic between the still image and the course of motion the series of still images implies. Muybridge's repetitive images recall for Frampton, "an incessant reiteration that is one of the most familiar and intolerable features of our dreams."[73]

Beyond the repetition that constitutes each individual series, Frampton also finds a repetition compulsion at the core of the very encyclopedic nature of Muybridge's project, asking: "Quite simply, what occasioned Muybridge's obsession? What need drove him beyond a reasonable limit of dozens or even hundreds of sequences, to make them by thousands?"[74] I will hold off for the moment giving Frampton's answer to this question (he did have one), simply to point out the way this reception of Muybridge in the late twentieth century may recall the reception of his images I am claiming occurred at the end of nineteenth century among the Symbolists. Rather than supplying an exhaustive scientific atlas, or even a copybook for artists, Muybridge's mechanical reproduction takes on a "spiritual" dimension, providing a space for meditation on the nature of order, temporality, and repetition in an art form.

Muybridge also served as the subject of a theatrical production, *The Photographer*, with music by Minimalist composer Philip Glass, at the Brooklyn Academy of Music in 1983. I remember being personally disappointed by this production when I first saw it, finding the relation between Glass's repetitive scoring and Muybridge's serial images a bit too obvious. Listening to the recording of its music over the years, however, I have found it more interesting, especially as a gloss on Framp-

73. Frampton, "Fragments of a Tesseract," 77.
74. Ibid., 79.

ton's essay and his answer to his question about the source of Muybridge's repetition compulsion.

I must confess that I was also initially disappointed by Frampton's diagnosis of Muybridge's obsession with photographing the processes of motion and stilling them over and over again. Drawing on the scandal of Muybridge's life—that in 1874 (after the first photographs of the horse in motion but before the series of multiple images) Muybridge shot and killed his wife's lover, Harry Larkyns, after learning (or believing he had learned) that Floredo, the child his wife bore him, was the issue of her long-term affair with the adventurer (see inset, chapter 4).[75] Muybridge killed Larkyns with a single shot, declaring, "My name is Muybridge. Here is the answer to the message you sent my wife." The message apparently went straight to Larkyns's heart. Frampton sees this central traumatic incident of Muybridge's life as a moment when time would have stood still for him: "Time seems, sometimes, to stop, to be suspended in tableaux disjunct from change and flux. Most human beings experience, at one time or another, moments of intense passion during which perception seems vividly arrested: erotic rapture or extremes of rage or terror come to mind. Eadweard Muybridge may be certified as having experienced at least one such moment of extraordinary passion. I refer, of course, to the act of committing a murder."[76] Frampton's strong interpretation of the dialectic of stillness and motion within Muybridge's work in terms of a phenomenology of human consciousness encountering its limits seemed to me compelling. But his specific solution to the mystery of repetition seemed, as Orson Welles once described the Rosebud revelation of *Citizen Kane*, rather "dollar book Freud."

As I recall (perhaps unjustly after two decades), *The Photographer* used this central incident in a more ham-fisted manner, alternately cynical and coy. The vocal version of the first act of Glass's musical piece "A Gentleman's Honor," however, bereft of the drama and provided only with minimal lyrics, opens up a

75. The incident is fully documented in both Haas (1976, 63–78) and Hendricks (1975, 65–77).
76. Frampton 1983, 79.

more complex relation to Muybridge's act of rage and its original complex motivation. The lyrics run:

All that white hair
A Gentleman's honor
And a long white beard
Burns up in fever
And this artificial moonlight
An artificial sky
Horses in the air, feet on the ground
Never seen this picture before
Never seen this picture before
And his artificial moonlight, an artificial sky
Horses in the air . . .
"Whose baby is this?"
Never seen, never seen this picture before
Horses in the air, feet on the ground
Never seen, never seen this picture before
Horses in the air, feet on the ground
Never seen, never seen this picture before
Never seen, never seen this picture before[77]

The elliptical yet repetitive logic of these lines, recalling the stuttering gait of a Muybridge sequence, satisfies as an image of Muybridge's life much more than I recall the accompanying drama doing. The image of Muybridge's physiognomy is introduced, as well as his plaintive question about the paternity of his son; the artfully, if artificially, achieved skies of his composite photographs are evoked. And then comes his most famous image: horses that seem suspended in midair in one image, then strike the ground with their hooves in the next. The repeated refrain, "Never seen this picture before" would seem to refer to the absolutely unheralded nature of Muybridge's images, their novel strangeness, never before seen by the eye of man. Its insistent repetition, however, references a different moment in his life.

77. Philip Glass, "A Gentleman's Honor," from *The Photographer* (New York: Dunvagen Music Publishers, 1983).

A photograph triggered Muybridge's murderous rage and doubt about the paternity of his child. He had first discovered the adulterous pair in an embrace and insisted that they never see each other again. He found, however, that they were exchanging letters through an intermediary, Mrs. Susan Smith, who had been nursing his wife after the birth of her child. Muybridge discovered these letters and again confronted Larkyns, telling him that if he communicated with his wife again, he would kill him. Later, due to an unpaid bill, Mrs. Smith contacted Muybridge and revealed that additional letters that had passed between the pair and that she had copies. Muybridge read these, greatly upset. He returned to Smith's apartment the next day. According to her testimony:

> His attention was immediately drawn to a photograph of Floredo on the center table. "Who is it?" he said with start.
> "He is your baby," answered Mrs. Smith.
> "I have never seen this picture before. . . ."
> Muybridge turned the picture over and began to tremble. "My God," he cried, "what is this on the back of this picture in my wife's handwriting— Little Harry?"

The inscription led Mrs. Smith to confess that Flora had indicated to her that Floredo was really Larkyns's child. Muybridge fell on the floor in a fit. After he recovered, he left to search out Larkyns and killed him.[78]

The trauma that Muybridge underwent, strong enough to trigger one of the fits he had suffered from ever since a stagecoach accident left him with severe head injuries a decade earlier, was mediated by his own medium, photography. The shock of an unfamiliar picture with a devastating inscription on its back impelled Muybridge into syncope, despair, and an act of murder. A world of pain can be contained within a picture, never before seen, provoking, perhaps, not only a repetitive obsession with still moments but also a need to release it, to

78. Haas 1976, 66. I have quoted Haas's summary of Smith's testimony.

deliver the image from its eternal stillness into the relief of motion. . . . If invoking this incident to gain a purchase on the discovery of a new representation of temporality that Muybridge's images made possible still smacks too much of the melodramatic and—worse—of psychological biography (as if the artist's work were simply a matter of self-expression), I would like to plead guilty here to an act of appropriation, but of the sort that I think has been continual in the reception of Muybridge's work.

It is the multiplicity, the polyvalence of this work that makes it so uniquely valuable in modern art. Less than the trace of a single psychology, it remains interstitial. Its position in history lodges among differing and even contradictory discourses: the technological development and evolving practices of a new medium; the discourse of adopting this new medium as a form or artistic representation; the often quite opposite discourses wishing to adapt this medium as a means and even a model for scientific objectivity; the excitement of a sudden magical transformation into motion, whether as scientific demonstration, pure spectacle, or both simultaneously; and, perhaps most enduringly, the possibility of using this medium to portray the rhythms of life, the order and harmony that suffuse the human and animal body, providing either a material demonstration or a symbol of an encounter that might be termed spiritual. Muybridge's work shouldered the nineteenth century's burden of making things visible in all its contradiction. His reception in the twentieth century recognized not only this visibility but also all the things it refers to that were never seen (before), never seen (again).

# CHECKLIST OF THE EXHIBITION

Note: Because of their extreme sensitivity to light, not all of photographs can be displayed at both venues.

**Ottomar Anschütz (Germany, 1846–1907)**

*Doves at a Feeder*, 1884
Five albumen prints
9.3 x 13.8 cm each (approx.)
Museum Ludwig, Agfa Foto-Historama, Cologne,
   FH3115-3119
Figure 3-57

*Pack of Hounds Leaping over a Ditch*, c. 1884
Seventeen albumen prints
7.6 x 18.1 cm each (approx.)
Museum Ludwig, Agfa Foto-Historama, Cologne,
   FH00267-74 and FH3106-14
Figure 3-58

*Storks in a Nest*, 1884
Nine albumen prints
9.4 x 13.9 cm each (approx.)
Museum Ludwig, Agfa Foto-Historama, Cologne,
   FH2618-22 and 2625-28
Figure 3-56

*Dog, Three Poses*, 1886
Three albumen prints
14 x 15.2 cm each
Iris & B. Gerald Cantor Center for Visual Arts at
   Stanford University, Membership Art Acquisition
   Fund, 1999.197–99
Figure 3-55a, b, c

*Horse Jumping a Hurdle*, c. 1887
Albumen print
9.5 x 14 cm
Bibliothèque nationale de France, Paris, EO289B
   (petit folio)
Figure 3-54, Cliché Bibliothèque nationale de
   France, Paris

**Edward Anthony (United States, 1819–88)**

*Broadway—Burst of Sunlight after a Shower*, c. 1859
Stereo albumen print
7.4 x 15.4 cm
Collection of Ken and Jenny Jacobson
Figure 2-54

*Broadway from Barnum's Museum, Looking North*, c.
   1860
Stereo albumen print
7.5 x 15.1 cm
Collection of Ken and Jenny Jacobson
Figure 2-27

*Ice-Skating, Central Park*, 1866
Stereo albumen print
7.6 x 15.1 cm
Collection of Ken and Jenny Jacobson
Figure 2-11

**Edmond Bacot (France, active 1850s)**

*View of the Sea, Boulogne-sur-Mer*, May 1850
Albumen print
13.7 x 18.6 cm
Société Française de Photographie, Paris, 19-10
Figure 2-41, Photo: Collection of Société Française
   de Photographie

**Balch's Art Views (Bermuda, active 1860s)**

*Devil's Hole, Fish Swimming (Instantaneous)*, c. 1868,
   no. 79 from the series *Bermuda Illustrated*

Stereo albumen print

8.2 x 15.9 cm

Private collection

Figure 2-7

**David Beach. See "After Eadweard Muybridge"**

**Auguste-Adolphe Bertsch (France, d. 1871)**

*La barrière blanche*, 1855

Two salt prints

22.2 x 19 cm each

Société Française de Photographie, Paris, 34-3 and
   34-4

Figure 2-50a, b, Photo: Collection of Société
   Française de Photographie

**Geoffrey Bevington (England, active c. 1860–70)**

*Glove Leather Dyers*, 1863

Albumen print

37 x 42 cm

Victoria and Albert Museum, London, AP.14-1863

Figure 2-56, Photo © V&A Picture Library

**Valentine Blanchard (England, 1831–1901)**

*The National Gallery and St. Martin's Church, London,
   from Pall Mall*, before 1862

Stereo albumen print, published by C. E. Elliott

7.7 x 15.6 cm

Collection of Ken and Jenny Jacobson

Figure 2-52

**W. G. Campbell (Britain, active 1850s)**

*The Lesson*, c. 1856, from the *Photographic Album* for
   the year 1857

Albumen print

14.8 x 17.6 cm

The Royal Photographic Society Collection, National
   Museum of Photography, Film and Television,
   Bradford

Figure 2-9, Photo courtesy of Royal Photographic
   Society

**Eugène Colliau (France, active 1850s–1860s)**

*Boat under Full Sail*, c. 1861

Albumen print

17.2 x 24.2 cm

Bibliothèque nationale de France, Paris, EO25,
   N.8598

Figure 2-20, Cliché Bibliothèque nationale de
   France, Paris

*The Coast*, c. 1861

Albumen print

17.2 x 24.2 cm

Bibliothèque nationale de France, Paris, EO25,
   N.8595

Figure 2-19, Cliché Bibliothèque nationale de
   France, Paris

**Léon Crémière (France, before 1850–after 1882)**

*Savage Expressions of a Dog and a She-Wolf*, October
   1867

Woodburytype print, from *Journal le centaur*

12.7 x 17.5 cm

Bibliothèque nationale de France, Paris, EO43B

Figure 2-57, Cliché Bibliothèque nationale de
   France, Paris

**Charles Darwin (England, 1809–82)**

*The Expression of the Emotions in Man and Animals:*
*Plate 1, Expressions of Suffering*, 1872
Heliotype plate, from bound book containing seven
heliotype plates
Octavo
Iris & B. Gerald Cantor Center for Visual Arts at Stan-
ford University, Museum Purchase Fund, 1973.102
Figure 2-37

**Louis-Jean Delton (France, before 1820–after 1899)**

*The Clowns Georges and Sarinel*, 21 August 1863
Albumen print
19.4 x 15.4 cm
Bibliothèque nationale de France, Paris, EO42, N.7460
Figure 2-63, Cliché Bibliothèque nationale de
France, Paris

*The Clowns Georges and Sarinel (Violin)*, 21 August 1863
Albumen print
19.4 x 15.4 cm
Bibliothèque nationale de France, Paris, EO42, N.7459
Figure 2-64, Cliché Bibliothèque nationale de
France, Paris

*Bicycle, Acrobatic Maneuvers*, c. 1868
Albumen print
18.1 x 13.5 cm
Bibliothèque nationale de France, Paris, EO42, N.2347
Figure 2-60, Cliché Bibliothèque nationale de
France, Paris

*Riders in the Bois de Boulogne*, 1882, from the series *Le
Tour de Bois*
Albumen prints
27 x 35.5 cm
Bibliothèque nationale de France, Paris, Delton,
"Bois de Boulogne Folio," 4th series, plate 1
Figure 2-58, Cliché Bibliothèque nationale de
France, Paris

*Longchamp, Grand Prix de Paris, Paradox First,
Reluisant Second*, 14 June 1885
Albumen print
9.5 x 18.8 cm
Bibliothèque nationale de France, Paris, EO42,
N.396
Figure 2-59, Cliché Bibliothèque nationale de
France, Paris

**André-Adolphe-Eugène Disdéri (France, 1819–90)**

*Digo Djanetto with Dog*, c. 1854
Salt print
15.2 x 12.2 cm
Bibliothèque nationale de France, Paris, EO19B
DL1854, no. 4
Figure 2-74, Cliché Bibliothèque nationale de
France, Paris

*A Lesson*, c. 1854
Salt print
11.4 x 16.8 cm
Bibliothèque nationale de France, Paris, EO19B
DL1854, no. 90
Figure 2-73, Cliché Bibliothèque nationale de
France, Paris

*The Juggler Manoel*, 1861
Albumen print from a glass negative
20 x 23.5 cm
Gilman Paper Company Collection
Figure 2-72

**Louis-Pierre-Théophile Dubois de Nehaut (Belgium,
active 1854–60s)**

*Another Impossible Task ("Miss Betsy," the Elephant)*,
1854
Salt print from a glass negative
16.3 x 21.2 cm
Gilman Paper Company Collection
Figure 2-12

**Guillaume-Benjamin Duchenne de Boulogne (France, 1806–75) with Adrien Tournachon (France, 1825–93)**

*Horror (Profile)*, c. 1856, fig. 57 from *Mécanisme de la physionomie humaine* (1862)
Albumen print
11.6 x 8.8 cm
The J. Paul Getty Museum, Los Angeles, 84.XP.720.83
Figure 2-17, © The J. Paul Getty Museum

*Synoptic Plate*, c. 1856, plate 6 from *Mécanisme de la physionomie humaine* (1862)
Albumen print
13.3 x 13.3 cm
Iris & B. Gerald Cantor Center for Visual Arts at Stanford University, Committee for Art Acquisitions Fund, 1998.127
Figure 2-16

**Thomas Eakins (United States, 1844–1916)**

*George Reynolds, Running Long Jump*, 1884
Albumen print, multiple exposures from a Marey wheel camera
5.9 x 10.2 cm
Hirshhorn Museum and Sculpture Garden, Smithsonian Institution, Transferred from Hirshhorn Museum and Sculpture Garden Archives, 1983. NMSG 83.46
Figure 3-65, Photo: Lee Stalsworth

*George Reynolds, Walking*, 1884
Albumen print, multiple exposures from a Marey wheel camera
5.9 x 9.9 cm
Hirshhorn Museum and Sculpture Garden, Smithsonian Institution, Transferred from Hirshhorn Museum and Sculpture Garden Archives, 1983. NMSG 83.45
Figure 3-64, Photo: Lee Stalsworth

*Jesse Godley, Running*, 1884
Cyanotype print, multiple exposures from a Marey wheel camera
5.7 x 8.5 cm
Hirshhorn Museum and Sculpture Garden, Smithsonian Institution, Transferred from Hirshhorn Museum and Sculpture Garden Archives, 1983. NMSG 83.52
Figure 3-61, Photo: Lee Stalsworth

*Jesse Godley, Walking, Coming to a Stop*, 1884
Cyanotype print, multiple exposures from a Marey wheel camera
5.7 x 8.4 cm
Hirshhorn Museum and Sculpture Garden, Smithsonian Institution, Transferred from Hirshhorn Museum and Sculpture Garden Archives, 1983. NMSG 83.50
Figure 3-60, Photo: Lee Stalsworth

*Man Running, Wearing Boots*, 1884
Albumen print, multiple exposures from a Marey wheel camera
14.3 x 22.8 cm
Hirshhorn Museum and Sculpture Garden, Smithsonian Institution, Transferred from Hirshhorn Museum and Sculpture Garden Archives, 1983. NMSG 83.49
Figure 3-63, Photo: Lee Stalsworth

*Man Walking*, 1884
Platinum print, multiple exposures from a Marey wheel camera
5.4 x 10.4 cm
Hirshhorn Museum and Sculpture Garden, Smithsonian Institution, Transferred from Hirshhorn Museum and Sculpture Garden Archives, 1983. NMSG 83.56
Figure 3-62, Photo: Lee Stalsworth

*Man Walking, Wearing Boots*, 1884
Platinum print, multiple exposures from a Marey
 wheel camera
12.3 x 13.9 cm
Hirshhorn Museum and Sculpture Garden, Smith-
 sonian Institution, Transferred from Hirshhorn
 Museum and Sculpture Garden Archives, 1983.
 NMSG 83.54
Figure 3-66, Photo: Lee Stalsworth

**Thomas Eakins and Ellen Wetherald Ahrens (United
States, 1844–1916)**
*Analysis of Horses in Motion (after Muybridge)*, c. 1884
Series of four lantern slides
The Franklin Institute, Philadelphia, Eakins
 IA.1-3, 5
Figure 3-59, Photo: Charles Penniman, The Histori-
 cal and Interpretive Collection of The Franklin
 Institute, Philadelphia, PA

**William England (Scotland, 1815–80)**
*Rue de Rivoli, prise de l'Hotel du Louvre à Paris: Vue
 instantanée*, 1861
Stereo albumen print
7.1 x 14.6 cm
Collection of Ken and Jenny Jacobson
Figure 2-49

**Roger Fenton (England, 1819–69)**
*September Clouds*, 1859
Albumen print
20.6 x 28.7 cm
The Royal Photographic Society Collection, National
 Museum of Photography, Film and Television,
 Bradford, RPS 3144/2
Figure 2-29, Photo courtesy of Royal Photographic
 Society

**Jean-Baptiste Frénet (France, 1814–89)**
*Family Group with Yawning Child*, c. 1855
Salt print from a collodion transfer negative
23.2 x 16.6 cm
Iris & B. Gerald Cantor Center for Visual Arts at
 Stanford University, Elizabeth K. Raymond Fund,
 2001.23
Figure 2-1

**Charles Furne and Henri Tournier (France, active
1857–61)**
*Pumping Water*, c. 1861, from the series *Épreuve à
 mouvement*
Stereo albumen print
7.6 x 13.5 cm
Collection of Ken and Jenny Jacobson
Figure 2-24

**Francis Galton (England, 1822–1911)**
*Explanation by Composites of Muybridge's Photographs
 of the Conventional Representation of a Galloping
 Horse*, 1882
Montage of cyanotype prints
University College Library, London; Galton Papers,
 no. 166
Figure 3-34

**C. A. D. Halford (England, active 1860s)**
*Beach and Pier at Ventnor, Isle of Wight*, 1864
Stereo albumen print
8 x 15.5 cm
Collection of Ken and Jenny Jacobson
Figure 2-4

**Attributed to Lady Clementina Eliphinstone Hawarden (Scotland, 1822–65)**

*A Kiss*, c. 1860
Albumen print
19.1 x 11.4 cm
Harry Ransom Humanities Research Center, The University of Texas at Austin, Gernsheim Collection, 964:016:027
Figure 2-23

**Henry Heyl (United States)**

*Phasmatrope with Disc*, 1873
Photographic equipment made of wood, metal, and cardboard, containing a projection disc made of sixteen wet-plate collodion on glass positives
The Franklin Institute, Philadelphia, 1278
Figure 3-33, Photo: Charles Penniman, The Historical and Interpretive Collection of The Franklin Institute, Philadelphia, PA

**David Octavius Hill (Scotland, 1802–70) and Robert Adamson (Scotland, 1821–48)**

*Fishergate, St. Andrews*, 1846
Calotype print
14.9 x 19.7 cm
Collection Jane and Michael Wilson, 89:3840
Figure 2-68

**Attributed to David E. James & Co. (United States, active 1850s)**

*Two Women, Looking Down from a Window in Boston(?)*, c. 1855
Daguerreotype
1/9 plate; 5.4 x 4.1 cm (unopened)
Collection of Ken and Jenny Jacobson
Figure 2-13

**Kerbs & Speiss Co. (for Eadweard Muybridge)**

*Nine objective lens board*, c. 1879
Photographic equipment
8 x 17.5 x 19.6 cm
Iris & B. Gerald Cantor Center for Visual Arts at Stanford University, Museum Purchase Fund, 1972.20.8
Figure 1-9

**John Koch**

*"Occident" Trotting*, c. 1876
Watercolor with gouache
45.7 x 58.4 cm
Iris & B. Gerald Cantor Center for Visual Arts at Stanford University, Stanford Family Collections, 1983.48
Figure 3-21

**Ernest Lamy (France, b. 1828, active to 1878)**

*Porte and Boulevard St. Denis, Paris, in the Snow*, c. 1863, from the series *Paris instantanée*
Stereo albumen print
8.1 x 14.8 cm
Collection of Ken and Jenny Jacobson
Figure 2-31

**Gustave Laverdet (France, active 1860s)**

*Porte St. Martin*, 1862
Two albumen prints
10 x 7 cm each
Bibliothèque nationale de France, Paris, EO439B.7808 and EO439B.7809
Figure 2-25a, b, Cliché Bibliothèque nationale de France, Paris

**Gustave Le Gray (France, 1820–84)**

*Sea and Sky*, c. 1856
Albumen print
31.6 x 40 cm
Iris & B. Gerald Cantor Center for Visual Arts at
    Stanford University, Museum purchase, with
    funds realized through the deaccession and sale of
    gifts from the Alinder Collection, 1994.28
Figure 2-42

*The Broken Wave, Sète (La grande vague, brisée, Sète)*, c.
    1857
Albumen print
41.4 x 33.5 cm
The J. Paul Getty Museum, Los Angeles, 84.XM.347.11
Figure 2-2, © The J. Paul Getty Museum

**John Dillwyn Llewelyn (Wales, 1810–82)**

*Two Birds at a Rustic Cottage*, 1852
Calotype print
17 x 22.9 cm
The Royal Photographic Society Collection, National
    Museum of Photography, Film and Television,
    Bradford, Llewelyn, pt. 1, sec. 2, no. 4164
Figure 2-70, Photo courtesy of Royal Photographic
    Society

**Albert Londe (France, 1858–1917)**

*Dog Leaping at the Hippodrome*, 1887
Albumen print
10 x 15 cm
Société Française de Photographie, Paris, ASOAL191
Figure 3-51, Photo: Collection of Société Française
    de Photographie

*Dog Leaping at the Hippodrome*, 1887
Albumen print
10 x 15 cm
Société Française de Photographie, Paris, ASOAL192
Figure 3-52, Photo: Collection of Société Française
    de Photographie

*Horses Jumping at the Hippodrome*, 1887
Platinum prints
37.5 x 28 cm
Société Française de Photographie, Paris, ASOAL317
Figure 3-53, Photo: Collection of Société Française
    de Photographie

**Etienne-Jules Marey (France, 1830–1904)**

*Running Jump*, c. 1882
Albumen print
7.3 x 18.7 cm
Bibliothèque nationale de France, Paris, EO91B
    Marey (petit folio) D.1976-05111
Figure 3-43, Cliché Bibliothèque nationale de
    France, Paris

*Running*, 1882–86
Albumen print
8.3 x 19.8 cm
National Technical Museum, Prague, 36451
Figure 3-44

*Walking*, 1882–86
Albumen print
4.9 x 16.7 cm
National Technical Museum, Prague, 26080
Figure 3-46

*Gull in Flight*, c. 1883
Albumen print
5.8 x 16.6 cm
Bibliothèque nationale de France, Paris, EO91B
    Marey (petit folio) D.1976-05161
Figure 1-5, Cliché Bibliothèque nationale de France,
    Paris

*Gymnastic Poses*, 1883
Albumen print
19.4 x 17.5 cm
National Technical Museum, Prague, 49586
Figure 4-7

*Standing Broad Jump*, 1883
Albumen print
6 x 17.2 cm
National Technical Museum, Prague; 49584
Figure 3-45

*Walking (Geometric)*, 1883
Albumen print
14 x 22.5 cm
National Technical Museum, Prague, 36454
Figure 3-48

*Mr. Charles Franck—Running at Speed, Running at
Speed, Long Jump Preceded by Running*, 18 July 1886
Three albumen prints
11.5 x 29.4, 11.5 x 29.8, and 12.4 x 29.7 cm
National Technical Museum, Prague, unnumbered
Figure 3-42

*Mr. Schenkel—Running Jump, High Jump, High Jump*, 18
July 1886
Three albumen prints
10.8 x 29.8, 11.8 x 29.7, and 11.5 x 29.7 cm
National Technical Museum, Prague, unnumbered
Figure 3-41

*Self-Portrait Wearing a Turban, Made with a Spinning
Plate*, c. 1886
Albumen print
16 x 12.7 cm
Bibliothèque nationale de France, Paris; EO91B
Marey (petit folio) D.1976-05126
Figure 3-50, Cliché Bibliothèque nationale de
France, Paris

*Vibrations of an Elastic Rod*, c. 1886
Albumen print
6.5 x 16.3 cm
Bibliothèque nationale de France, Paris, EO91B
Marey (petit folio) D.1976-05112
Figure 4-10, Cliché Bibliothèque nationale de
France, Paris

*Walking Sideways, Steps from the Joinville School, Walk-
ing on Tiptoe, Walking on Heels, Walking with a
Weight of 40 Kg, Walking with a Weight of 60 Kg,
Walking Faster with a Weight of 60 Kg*, 1886
Seven albumen prints
27 x 20.9 cm (sheet), each image 3.3 x 11.5 cm or
smaller
National Technical Museum, Prague, 49563 a–g
Figure 3-47

*Bird in Flight*, 1886–87
Five albumen prints
5.3 x 8.5 cm each or smaller
National Technical Museum, Prague, 49582
Figure 3-49

*Duck in Flight*, 1887
Albumen print
12.7 x 14.5 cm
National Technical Museum, Prague, 49581
Figure 3-40

**Ernest Meissonier (France, 1815–91)**
*Portrait of Leland Stanford with Muybridge's Book "Atti-
tudes of Animals in Motion,"* 1881
Oil on canvas
41.9 x 31.7 cm
Iris & B. Gerald Cantor Center for Visual Arts at
Stanford University, Stanford Family Collections,
12038
Figure 1-6

**Count de Montizon (Britain, active 1853–55)**

*Hippopotamus at the Zoological Gardens, Regent's Park, London*, 1855, from the *Photographic Album* for the year 1855
Salt print
11.2 x 12.1 cm
The Royal Photographic Society Collection, National Museum of Photography, Film and Television, Bradford
Figure 2-69, Photo courtesy of Royal Photographic Society

**Eadweard Muybridge (England, United States, 1830–1904)**

*Horse Studies, Drawings of Reindeer, and Views of Sacramento*, 1872–73
Albumen prints, page from the Brandenburg Album
33 x 26.3 cm
Iris & B. Gerald Cantor Center for Visual Arts at Stanford University, Museum Purchase Fund, 1972.9.45
Figure 1-7

*"Occident" Trotting at a 2:30 Gait*, July 1877, from the series *The Horse in Motion*
Albumen print (cabinet card)
10.2 x 16.5 cm
Iris & B. Gerald Cantor Center for Visual Arts at Stanford University, Stanford Family Collections, 13927
Figure 3-20

*"Occident" Trotting, Left to Right*, c. 1877
Albumen print (cabinet card)
8.8 x 12.7 cm
Iris & B. Gerald Cantor Center for Visual Arts at Stanford University, Stanford Family Collections, 13924
Figure 2-32

*"Occident" Trotting, Right to Left*, c. 1877
Albumen print (cabinet card)
8.8 x 12.7 cm
Iris & B. Gerald Cantor Center for Visual Arts at Stanford University, Stanford Family Collections, 13922
Figure 2-33

*"Mahomet" Cantering at an 8 Minute Gait*, 18 June 1878, from the series *The Horse in Motion*
Albumen print (cabinet card)
10.1 x 19.7 cm
Iris & B. Gerald Cantor Center for Visual Arts at Stanford University, Stanford Family Collections, 13930
Figure 3-22

*"Mahomet" (Phases 1, 3, 4, 5, and 6)*, 1878
Series of five lantern slides; glass collodion positives
5.4 x 7.6 cm each
Iris & B. Gerald Cantor Center for Visual Arts at Stanford University, Stanford Family Collections, 13875–9
Figure 3-4

*"Occident" Trotting at a 2:20 Gait*, 20 June 1878, from the series *The Horse in Motion*
Albumen print (cabinet card)
10.2 x 20.9 cm
Iris & B. Gerald Cantor Center for Visual Arts at Stanford University, Stanford Family Collections, 13928
Figure 1-3

*"Abe Edgington" Trotting at a 2:24 Gait*, 15 June 1878, from the series *The Horse in Motion*
Albumen print (cabinet card)
10.5 x 21 cm
Iris & B. Gerald Cantor Center for Visual Arts at Stanford University, Stanford Family Collections, 13929
Figure 3-23

*"Sallie Gardner" Galloping (Phases 1, 2, 5, 6, 7, 8, 10, and 11)*, 1878
Series of eight lantern slides; glass collodion positives
5.4 x 7.6 cm each
Iris & B. Gerald Cantor Center for Visual Arts at Stanford University, Stanford Family Collections, 13867–74
Figure 3-3

*"Sallie Gardner" Running at a 1:40 Gait*, June 1878, from the series *The Horse in Motion*
Albumen print (cabinet card)
10.3 x 20.7 cm
Iris & B. Gerald Cantor Center for Visual Arts at Stanford University, Stanford Family Collections, 13926.4
Figure 3-24

*Athlete, Backwards Somersault*, 1879, plate 104 from the series *Attitudes of Animals in Motion*
Printing-out paper print, published by Eadweard Muybridge in 1881
16 x 22.4 cm
Special Collections, Stanford University Libraries, RBC.TR140.M93.f.104
Figure 3-15

*Athlete Running*, 1879, plate 95 from the series *Attitudes of Animals in Motion*
Printing-out paper print, published by Eadweard Muybridge in 1881
16 x 22.4 cm
Special Collections, Stanford University Libraries, RBC.TR140.M93.f.95
Figure 3-13

*Athletes Boxing*, 1879, plate 111 from the series *Attitudes of Animals in Motion*
Printing-out paper print, published by Eadweard Muybridge in 1881
16 x 22.4 cm
Special Collections, Stanford University Libraries, RBC.TR140.M93.f.111
Figure 3-16

*Athlete, Standing Leaps*, 1879, plate 100 from the series *Attitudes of Animals in Motion*
Printing-out paper print, published by Eadweard Muybridge in 1881
16 x 22.4 cm
Special Collections, Stanford University Libraries, RBC.TR140.M93.f.100
Figure 3-14

*Dog Running*, 1879, plate 74 from the series *Attitudes of Animals in Motion*
Printing-out paper print, published by Eadweard Muybridge in 1881
16 x 22.4 cm
Special Collections, Stanford University Libraries, RBC.TR140.M93.f.74
Figure 3-10

*Goat Running, Chased by Man Wielding Stick*, 1879, plate 88 from the series *Attitudes of Animals in Motion*
Printing-out paper print, published by Eadweard Muybridge in 1881
16 x 22.4 cm
Special Collections, Stanford University Libraries, RBC.TR140.M93.f.88
Figure 3-12

*Greyhounds Running*, 1879, plate 77 from the series *Attitudes of Animals in Motion*
Printing-out paper print, published by Eadweard Muybridge in 1881
16 x 22.4 cm
Special Collections, Stanford University Libraries, RBC.TR140.M93.f.77
Figure 3-11

*"Hattie H.," Irregular (Flicking Tail)*, 1879, plate 66 from the series *Attitudes of Animals in Motion*
Printing-out paper print, published by Eadweard Muybridge in 1881
16 x 22.4 cm
Special Collections, Stanford University Libraries, RBC.TR140.M93.f.66
Figure 3-26

*Leland Stanford Jr. on His Pony "Gypsy"—Phases of a Stride by a Pony While Cantering*, May 1879
Series of eight lantern slides; glass collodion positives
5.4 x 7.6 cm each
Iris & B. Gerald Cantor Center for Visual Arts at Stanford University, Stanford Family Collections, 13859–66
Figs. 3-1, 3-2

*"Mohawk," Irregular (Bridled)*, 1879, plate 62 from the series *Attitudes of Animals in Motion*
Printing-out paper print, published by Eadweard Muybridge in 1881
16 x 22.4 cm
Special Collections, Stanford University Libraries, RBC.TR140.M93.f.62
Figure 3-9

*"Nimrod" Pacing*, c. 1879
Maquette for a zoopraxiscope disc made of collodion on glass positives; unpublished variant of plate 20, *Attitudes of Animals in Motion* (1881)
Diam. approx. 30.5 cm; each piece approx. 1.5 x 1.8 cm or smaller
Iris & B. Gerald Cantor Center for Visual Arts at Stanford University, Stanford Family Collections, 1994.46.1, 2, 4-8, 9a-b, 10-12, 13a-c, 14-18 (20 pieces)
Figure 3-28

*"Phryne L" Leaping*, 1879, pls. 173–74 from the series *Attitudes of Animals in Motion*
Printing-out paper print, published by Eadweard Muybridge in 1881
16 x 22.4 cm
Special Collections, Stanford University Libraries, RBC.TR140.M93.f.173–4
Figure 3-6

*"Phryne L" Leaping a 3'6" Hurdle*, 1879, plate 46 from the series *Attitudes of Animals in Motion*
Printing-out paper print, published by Eadweard Muybridge in 1881
16 x 22.4 cm
Special Collections, Stanford University Libraries, RBC.TR140.M93.f.46
Figure 3-7

*"Phryne L" Pacing, Change to Running*, 1879, plate 59 from the series *Attitudes of Animals in Motion*
Printing-out paper print, published by Eadweard Muybridge in 1881
16 x 22.4 cm
Special Collections, Stanford University Libraries, RBC.TR140.M93.f.59
Figure 3-8

*Posturing*, 1879, plate 115 from the series *Attitudes of Animals in Motion*
Printing-out paper print, published by Eadweard Muybridge in 1881
16 x 22.4 cm
Special Collections, Stanford University Libraries, RBC.TR140.M93.f.115
Figure 1-1

*Skeleton of a Horse, Leaping, Leaving the Ground*, 1879, plate 201 from the series *Attitudes of Animals in Motion*
Printing-out paper print, published by Eadweard Muybridge in 1881
16 x 22.4 cm
Special Collections, Stanford University Libraries, RBC.TR140.M93.f.201
Figure 3-17

*The Attitudes of Animals in Motion*, 1881
Bound album of collodion printing-out paper prints, published by Eadweard Muybridge, with photographs made 1878–79
17.7 x 24.5 x 3.5 cm
Iris & B. Gerald Cantor Center for Visual Arts at Stanford University, Stanford Family Collections, 13932
Figure 3-25

*Gallop, Bay Horse "Daisy,"* 1884–86, full-plate proof of plate 628 from the series *Animal Locomotion*
Cyanotype print, mounted on card, printed c. 1887; Muybridge negative number 9.1340
31.8 x 48.4 cm
Photographic History Collection, National Museum of American History, Smithsonian Institution, 3856.0760
Figure 3-71; cover

*American Eagle, Flying*, August 1885, unpublished proof from the series *Animal Locomotion*
Six cyanotype prints, mounted on card, Muybridge negative number 1109
29 x 41.8 cm
Photographic History Collection, National Museum of American History, Smithsonian Institution, 3856.0653
Figure 2-30

*Arising from the Ground (Miss Cox)*, 25 September 1885, plate 268 from the series *Animal Locomotion*
Collotype, printed by the Photo-Gravure Company, New York, for the University of Pennsylvania, 1887
21.9 x 34.6 cm
Iris & B. Gerald Cantor Center for Visual Arts at Stanford University, Stanford Family Collections, 1941.1018.129
Figure 3-86

*Artificial Convulsions (Alice Cooper)*, 24 September 1885, unpublished proof from the series *Animal Locomotion*
Three cyanotype prints, mounted on card; Muybridge negative number 1400
10 x 29.3 cm
Photographic History Collection, National Museum of American History, Smithsonian Institution, 3856.0730
Figure 3-73

*Child Ascending a Stair (Edith Tadd)*, 29 July 1885, plate 473 from the series *Animal Locomotion*
Collotype, printed by the Photo-Gravure Company, New York, for the University of Pennsylvania, 1887
15.9 x 46.3 cm
Iris & B. Gerald Cantor Center for Visual Arts at Stanford University, Stanford Family Collections, 1941.1018.172
Figure 4-6

*Cockatiel in Flight*, August 1885, plate 760 from the series *Animal Locomotion*
Collotype, printed by the Photo-Gravure Company, New York, for the University of Pennsylvania, 1887
22 x 31.9 cm
Photographic History Collection, National Museum of American History, Smithsonian Institution, 65115.3077
Figure 1-4

*Cockatiel in Flight*, August 1885, proof of plate 758 from the series *Animal Locomotion*
Six cyanotype prints, mounted on card; Muybridge negative number 1181
19.7 x 28.3 cm
Photographic History Collection, National Museum of American History, Smithsonian Institution, 3856.0554
Figure 3-83

*Contortionist (Mr. Bennett)*, 18 July 1885, plate 510 from the series *Animal Locomotion*
Collotype, printed by the Photo-Gravure Company, New York, for the University of Pennsylvania, 1887
18.5 x 42.1 cm
Iris & B. Gerald Cantor Center for Visual Arts at Stanford University, Stanford Family Collections, 1941.1018.184
Figure 4-2

*Curtsey (Mrs. Welsh)*, 21 September 1885, plate 198 from the series *Animal Locomotion*
Collotype, printed by the Photo-Gravure Company, New York, for the University of Pennsylvania, 1887
19.8 x 38 cm
Iris & B. Gerald Cantor Center for Visual Arts at Stanford University, Stanford Family Collections, 1941.1018.79
Figure 3-84

*Dog Named "Dread," Walking*, 25 October 1885, from the series *Animal Locomotion*
Gelatin-silver on glass interpositive plate, manufactured by J. B. Holt Company
29.6 x 41.9 cm
Iris & B. Gerald Cantor Center for Visual Arts at Stanford University, Stanford Museum Collections, 2002.10
Figure 3-69

*Dropping Skirt and Unfastening Corsets (Blanche Epler)*, 24 September 1885, unpublished proof from the series *Animal Locomotion*
Six cyanotype prints, mounted on card; Muybridge negative number 1405
21.7 x 28.8 cm
Photographic History Collection, National Museum of American History, Smithsonian Institution, 3856.0731
Figure 3-74

*Fancy Dancing (Miss Larrigan)*, 28 July 1885, plate 187 from the series *Animal Locomotion*
Collotype, printed by the Photo-Gravure Company, New York, for the University of Pennsylvania, 1887
18.9 x 42.8 cm
Iris & B. Gerald Cantor Center for Visual Arts at Stanford University, Stanford Family Collections, 1941.1018.70
Figure 4-5

*Fencing (Mr. Bonifon and Mr. Austin)*, 11 October 1885, plate 349 from the series *Animal Locomotion*
Collotype, printed by the Photo-Gravure Company, New York, for the University of Pennsylvania, 1887
18.1 x 42.2 cm
Iris & B. Gerald Cantor Center for Visual Arts at Stanford University, Stanford Family Collections, 1941.1018.123
Figure 3-76

*Fencing (Mr. Hutchinson and Mr. Bonifon)*, 11 October 1885, unpublished proof from the series *Animal Locomotion*
Twenty-three cyanotype prints, mounted on card; Muybridge negative number 1497 (written 1479 on mount)
23.1 x 54.1 cm
Photographic History Collection, National Museum of American History, Smithsonian Institution, 3856.0741
Figure 3-75

*Jumping over a Chair (Mrs. Coleman)*, 19 September 1885, plate 156 from the series *Animal Locomotion*
Collotype, printed by the Photo-Gravure Company, New York, for the University of Pennsylvania, 1887
18.7 x 43 cm
Photographic History Collection, National Museum of American History, Smithsonian Institution, 65115.2565
Figure 3-90

*Leap Frog, Flip (Mr. Grier and Mr. Mullen)*, 22 July 1885, plate 364 from the series *Animal Locomotion*
Collotype, printed by the Photo-Gravure Company, New York, for the University of Pennsylvania, 1887
23.7 x 31.4 cm
Iris & B. Gerald Cantor Center for Visual Arts at Stanford University, Stanford Family Collections, 1941.1018.127
Figure 3-88

*Man Riding a Trotting Horse*, September 1885, from the series *Animal Locomotion*
Gelatin-silver on glass interpositive plate, manufactured by J. B. Holt Company
29.8 x 42.6 cm
Iris & B. Gerald Cantor Center for Visual Arts at Stanford University, Stanford Museum Collections, 2002.9
Figure 3-70

*Movement of the Hand, Lifting a Ball (Mr. Tadd)*, 24 July 1885, plate 534 from the series *Animal Locomotion*
Collotype, printed by the Photo-Gravure Company, New York, for the University of Pennsylvania, 1887
22.2 x 33.1 cm
Iris & B. Gerald Cantor Center for Visual Arts at Stanford University, Stanford Family Collections, 1941.1018.189
Figure 3-79

*Movement of the Hand, Lifting a Ball (Mr. Tadd)*, 24 July 1885, proof of plate 534 from the series *Animal Locomotion*
Six cyanotype prints, mounted on card; Muybridge negative number 986
21.7 x 28.4 cm
Photographic History Collection, National Museum of American History, Smithsonian Institution, 3856.0404
Figure 3-78

*Mule "Denver" Butted by a Man*, 19 June 1885, proof of
plate 663 from the series *Animal Locomotion*
Three cyanotype prints, mounted on card;
Muybridge negative number 663 [*sic*]
11 x 29.1 cm
Photographic History Collection, Nat'l Museum of
American Hist., Smithsonian Inst., 3856.0612
Figure 3-72

*Nutmeg Horse "Hornet" Attempting to Jump Three Horses*,
18 June 1885, unpublished proof from the series
*Animal Locomotion*
Three cyanotype prints, mounted on card;
Muybridge negative number 641
11.5 x 28.8 cm
Photographic History Collection, National Museum
of American History, Smithsonian Institution,
3856.0603
Figure 3-80

*Rowing, Nude (Frank Gummey)*, 24 October 1885,
unpublished proof from the series *Animal
Locomotion*
Eighteen cyanotype prints, mounted on card;
Muybridge negative number 1511
29.7 x 51.2 cm
Photographic History Collection, National Museum
of American History, Smithsonian Institution,
3856.0747
Figure 3-81

*Somersault*, before 2 May 1885, unpublished proof
from the series *Animal Locomotion*
Six cyanotype prints, mounted on card; Muybridge
negative number 138
8.3 x 31.7 cm
Photographic History Collection, National Museum
of American History, Smithsonian Institution,
3856.0570
Figure 3-82

*Striking a Blow, Right Hand (Ben Bailey)*, 2 May 1885,
plate 344 from the series *Animal Locomotion*
Collotype, printed by the Photo-Gravure Company,
New York, for the University of Pennsylvania, 1887
17.3 x 44.6 cm
Iris & B. Gerald Cantor Center for Visual Arts at
Stanford University, Stanford Family Collections,
1941.1018.121
Figure 3-87

*Turning Away and Running Back*, 10 July 1885, plate 73
from the series *Animal Locomotion*
Collotype, printed by the Photo-Gravure Company,
New York, for the University of Pennsylvania, 1887
24.9 x 31.3 cm
Iris & B. Gerald Cantor Center for Visual Arts at
Stanford University, Stanford Family Collections,
1941.1018.30
Figure 3-85

*Walking Elephant*, August 1885, plate 733 from the
series *Animal Locomotion*
Collotype, printed by the Photo-Gravure Company,
New York, for the University of Pennsylvania, 1887
20.5 x 37.8 cm
Iris & B. Gerald Cantor Center for Visual Arts at
Stanford University, Stanford Family Collections,
1941.1018.217
Figure 3-89

*White Horse "Pandora" Leaping over a Hurdle, Rider
Nude*, 27 September 1885, from the series *Animal
Locomotion*
Gelatin-silver on glass interpositive plate, manufac-
tured by J. B. Holt Company
18.1 x 49.2 cm
Iris & B. Gerald Cantor Center for Visual Arts at
Stanford University, Stanford Museum
Collections, 1998.128
Figure 3-68

*Woman with Multiple Sclerosis, Walking (Anna May
Keisler)*, 25 September 1885, plate 541 from the
series *Animal Locomotion*
Collotype, printed by the Photo-Gravure Company,
New York, for the University of Pennsylvania,
1887
20.8 x 35.8 in
Iris & B. Gerald Cantor Center for Visual Arts at
Stanford University, Stanford Family Collections,
1941.1018.192
Figure 3-77

*Athlete, Somersault on Horseback*, c. 1893
Zoopraxiscope disc
Diam. 30.5 cm
Kingston Museum and Heritage Service, 1955.82.38
Figure 3-31

*Horses with Riders and Dogs, Running in Two Directions*,
c. 1893
Zoopraxiscope disc
Diam. 40.7 cm
Kingston Museum and Heritage Service, marked
"D35" and "18.20" in center
Figure 3-30

*Monkeys Grabbing Coconuts*, c. 1893
Zoopraxiscope disc
Diam. 30.5 cm
Kingston Museum and Heritage Service, 1955.82.22
Figure 3-29

*Skeleton of a Horse, Running*, c. 1893
Zoopraxiscope disc
Diam. 40.7 cm
Kingston Museum and Heritage Service, marked "11"
and "31" in center
Figure 4-11

*Woman Dancing in a Blue Dress*, c. 1893
Zoopraxiscope disc
Diam. 30.5 cm
Kingston Museum and Heritage Service, 1955.82.37
Figure 3-32

**After Eadweard Muybridge (England, active United
States, 1830–1904)**
Reconstruction, using components of the original, by
David Beach
*Zoopraxiscope*, 1881
Working adaptation of the machine of 1881; brass and
wood with magic lantern housing of 1878; built by
Stanford professor David Beach in 1972
52.4 x 46.5 x 55 cm
Iris & B. Gerald Cantor Center for Visual Arts at
Stanford University, Museum Purchase Fund,
1972.237
Figure 3-27

**Circle of Eadweard Muybridge (England, active
United States 1830–1904)**
*Jane Stanford, Leland Stanford Jr., Mrs. Parker, and
Eadweard Muybridge at the Palo Alto Motion Studio*,
c. 1878
Albumen print on cabinet card
5.7 x 9.1 cm
Lent by Eldon and Susan Grupp
Frontispiece

*The Palo Alto Motion Studio*, 1879
Patent model
30.7 x 30.7 x 30 cm
National Museum of American History, Smithsonian
Institution, 48866.754
Not illustrated

*Timing mechanism* used to make the series *Animal Locomotion*, 1884–85
39 x 30.6 x 22.6 cm
National Museum of American History, Smithsonian Institution, 65115.2099
Not illustrated

**Nadar (Gaspard-Félix Tournachon) (France, 1820–1910)**

*Series Self-Portrait*, c. 1864
Albumen print
14.5 x 13.3 cm
Bibliothèque nationale de France, Paris; Eo 15 (petit folio), tome 1
Figure 2-55, Cliché Bibliothèque nationale de France, Paris

**Charles Nègre (France, 1820–80)**

*Fall or Death of a Horse, Quai Bourbon*, and *Works on Pont Louis Philippe, Quai Bourbon*, 1855–60
Two uncut and untrimmed stereo albumen prints mounted together
18.3 x 20.1 cm
Collection of Ken and Jenny Jacobson
Figure 2-18

*The Kitchen at Vincennes Imperial Asylum*, 1858–59
Two albumen prints
16.8 x 17.2 cm
Collection Jane and Michael Wilson, 87:3057
Figure 2-8

**Oscar Gustave Rejlander (Sweden, active England, c. 1813–75)**

*Juggler*, c. 1860
Platinum print, printed later from the original negative
14.5 x 19.5 cm
The Royal Photographic Society Collection, National Museum of Photography, Film and Television, Bradford, RPS 1959
Figure 2-71, Photo courtesy of Royal Photographic Society

*Ginx's Baby*, 1871–72
Carte-de-visite albumen print, copy after a drawn enlargement
7.9 x 5.5 cm
Private collection
Figure 2-36

*Ginx's Baby*, 1871–72
Original carte-de-visite albumen print
9.1 x 5.7 cm
Private collection
Figure 2-35

*Ginx's Baby*, 1871–72
Polychrome drawing; enlargement of the original photograph
54 x 43.9 cm
The Royal Photographic Society Collection, National Museum of Photography, Film and Television, Bradford, PF15-2764
Figure 2-34, Photo courtesy of Royal Photographic Society

**Henry Peach Robinson (England, 1830–1901) and Nelson King Cherrill (England, active 1860s–80s)**

*The Beached Margent of the Sea*, 31 May 1870
Albumen print
28.5 x 37.8 cm
The Royal Photographic Society Collection, National Museum of Photography, Film and Television, Bradford, 8149
Figure 2-6, Photo courtesy of Royal Photographic Society

**Henry Sampson (England, active 1858–70)**

*Landing from a Pleasure Trip, Southport*, c. 1860
Stereo albumen print
7.2 x 13.8 cm
Collection of Ken and Jenny Jacobson
Figure 2-39

**Charles Piazzi Smyth (Britain, 1812–1900)**

*Unconscious Lookers-on, Novgorod*, c. 1857
Collodion on glass negative
17 x 8.5 cm
Royal Observatory, Edinburgh, Smyth box 14, item 4
Figure 2-51

**Giorgio Sommer (Germany, active Italy, 1834–1914)**

*Via Toledo, Naples*, 1865–67
Stereo albumen print
7.3 x 14.1 cm
Collection of Ken and Jenny Jacobson
Figure 2-28

**Jacob Davis Babcock Stillman (United States, 1819–1888)**

*The Horse in Motion, as Shown by Instantaneous Photography with a Study on Animal Mechanics, Founded on Anatomy and the Revelations of the Camera, in Which Is Demonstrated the Theory of Quadrupedal Locomotion*, 1882
Bound book, containing five heliotype photographs and ninety-one photolithographs of drawings made after photographs by Eadweard Muybridge; published by James R. Osgood & Co., Boston
Quarto: 31 x 24 x 5.3 cm
Special Collections, Stanford University Libraries
Figure 3-5

**Bertalan Székely (Hungary, 1835–1910)**

*Grand gallop de Muybridge*, 1879–80
Zoetrope strip: pencil and ink on paper
139.5 x 15.4 cm
Department of Manuscripts and Rare Books of the Library of the Hungarian Academy of Sciences, Budapest, safe no. 116/31
Figure 3-38

*Human and Equestrian Motion (after Muybridge and Marey)*, 1879–80
Albumen print, reduction of demonstration drawing
30.6 x 18.9 cm
Hungarian Academy of Fine Arts, Budapest, lt.2580 R.130
Figure 3-36

*Human and Equestrian Motion (after Muybridge and Marey)*, 1879–80
Demonstration drawing, pencil and India ink on paper, heightened with white, mounted on canvas
259 x 154 cm
Hungarian Academy of Fine Arts, Budapest, Lt.2580
Figure 3-35

*Petit gallop de Muybridge*, 1879–80
Zoetrope strip: pencil and ink on graph paper
140 x 15.8 cm
Department of Manuscripts and Rare Books of the
Library of the Hungarian Academy of Sciences,
Budapest, safe no. 116/5
Figure 3-39

*Paces of a Horse (after Muybridge and Stillman)*, c. 1882
Pencil, ink, and gouache on tracing paper, mounted
on card
30 x 60 cm
Hungarian Academy of Fine Arts, Budapest; unnumbered
Figure 3-37

**A. Taupin (France, active 1860–1870s)**
*Milking a Cow (from Nature)*, c. 1860
Albumen print
16.7 x 21.2 cm
Iris & B. Gerald Cantor Center for Visual Arts at Stanford University, Alice Meyer Buck Fund, 1982.19
Figure 2-15

**Adrien Tournachon (France, 1825–1903)**
*Meeting Interrupted by an Ape*, 1861
Albumen print
7.4 x 9.9 cm
Bibliothèque nationale de France, Paris, EO99B,
DL.1861.8723
Figure 2-61, Cliché Bibliothèque nationale de
France, Paris

*Tug of War*, 1861
Albumen print
7.4 x 9.9 cm
Bibliothèque nationale de France, Paris, EO99B,
DL.1861.8723
Figure 2-62, Cliché Bibliothèque nationale de
France, Paris

**Twyman Brothers (England, active 1860s–70s)**
*Beach and Pier at Margate*, c. 1865
Stereo albumen print
7.8 x 13.5 cm
Collection of Ken and Jenny Jacobson
Figure 2-38

**Thomas Kirby Van Zandt (United States, active 1844–60)**
*"Abe Edgington" with Sulky and Driver, Budd Doble*, 16
September 1876
Crayon and ink wash underdrawing on canvas
53.4 x 81.3 cm
Iris & B. Gerald Cantor Center for Visual Arts at
Stanford University, Stanford Family Collections,
1963.107
Figure 3-18

*"Abe Edgington" with Sulky and Driver, Budd Doble*,
February 1877
Oil on canvas
53.5 x 81.2 cm
Iris & B. Gerald Cantor Center for Visual Arts at
Stanford University, Stanford Family Collections,
1963.106
Figure 3-19

**Frédéric Viret (France, active 1857–88)**
*Bathers, Sologne*, 1857–64
Stereo albumen print
7.2 x 13.4 cm
Collection of Ken and Jenny Jacobson
Figure 2-14

**Jean Victor Warnod (born Macaire) (France, 1812–c. 1886)**

*Ships at Le Havre*
Albumen print
21.5 x 16.9 cm
The J. Paul Getty Museum, Los Angeles, 84.XP.720.83
Figure 2-47, © The J. Paul Getty Museum

**Carleton Watkins (United States, 1829–1926)**

*Montgomery from Market Street*, 4 July 1864
Stereo albumen print
7.8 x 15.3 cm
Collection of Ken and Jenny Jacobson
Figure 2-26

**George Washington Wilson (Scotland, 1823–93)**

*H.M.S. Cambridge in Hamoaze, a Broadside*, 1857
Stereo albumen print
7.6 x 15.4 cm
Iris & B. Gerald Cantor Center for Visual Arts at
    Stanford University, Elizabeth K. Raymond Fund,
    2001.48
Figure 2-44

*H.M.S. Cambridge in Hamoaze, Great Gun Practice*, 1857
Stereo albumen print
7.6 x 15.4 cm
Iris & B. Gerald Cantor Center for Visual Arts at
    Stanford University, Elizabeth K. Raymond Fund,
    2001.47
Figure 2-43

*Loch of Park, Aberdeenshire—Sunset (Instantaneous)*,
    1859
Stereo albumen print
7.8 x 14.5 cm
Collection of Ken and Jenny Jacobson
Figure 2-48

*Princes Street, Edinburgh, Looking West*, 1860 or
    1863–64
Stereo albumen print
7.6 x 13.5 cm
Collection of Ken and Jenny Jacobson
Figure 2-53

*View from Ryde Pier, Isle of Wight, Evening (Instanta-
    neous)*, c. 1860
Stereo albumen print
7.5 x 14.3 cm
Private collection
Figure 2-45

**J. Walter Wilson (Britain)**

*Mr. Muybridge Shows His Instantaneous Photographs of
    Animal Motion at the Royal Society*, 1889
Engraving on broadside, from the *Illustrated London
    News*, 25 May 1889, engraved by R. Taylor
30.4 x 23.5 cm
Private collection
Figure 4–1

**Colonel Stuart Wortley (Britain, 1832–90)**

*Rolling Clouds*, c. 1863
Albumen print
26.5 x 35.2 cm
The J. Paul Getty Museum, Los Angeles,
    84.XO.868.5.19
Figure 2-5, © The J. Paul Getty Museum

*A Wave Rolling In*, 1863–65
Albumen print
23.2 x 27.9 cm
The J. Paul Getty Museum, Los Angeles, 86.XM.670
Figure 1-2, © The J. Paul Getty Museum

**Maker unknown**

*The Horse in Motion—Automatic Electro Photograph by Muybridge*, 27 July 1878
Page from the *San Francisco Illustrated Wasp*
37.4 x 26 cm
Iris & B. Gerald Cantor Center for Visual Arts at Stanford University, Museum Purchase Fund, 1974.190.1
Figure 1-10

**Maker unknown (Britain?)**

*Breaking Wave, with Boat Passing at the Shore*, c. 1855
Stereo albumen print, published by P. E. Chappuis, London
6.7 x 13.6 cm
Private collection
Figure 2-3

**Maker unknown, possibly John D. Isaacs (for Eadweard Muybridge)**

*Piece of an electric shutter mechanism*, c. 1878
Photographic equipment
20 x 9 x 9 cm
Iris & B. Gerald Cantor Center for Visual Arts at Stanford University, Museum Purchase Fund, 1972.20.9
Figure 1-9

*Trigger mechanism*, c. 1878
Photographic equipment, brass
10.5 x 7 x 3.8 cm
Iris & B. Gerald Cantor Center for Visual Arts at Stanford University, Museum Purchase Fund, 1972.20.21
Figure 1-9

**Maker unknown, possibly Achille Quinet (France, active 1851–71)**

*Ice-Skaters on the Seine*, c. 1855
Lightly albumenized salt print
20.5 x 27.8 cm
Private collection
Figure 2-10

**Maker unknown, possibly Scovill Manufacturing Co. (for Eadweard Muybridge)**

*Plate holder*, c. 1884
Photographic equipment, black painted wood with fabric roll back, number 8, used in the University of Pennsylvania experiments; with three unexposed original glass plate negatives
14 x 97.3 x 5.2 cm
Iris & B. Gerald Cantor Center for Visual Arts at Stanford University, Museum Purchase Fund, 1972.20.18
Figure 3-67

# SELECTED BIBLIOGRAPHY

Abney 1895
Abney, William de Wiveleslie. *Instantaneous
Photography*. New York: Scovill and Adams, 1895.

Aubenas 1895
Aubenas, Sylvie. *Gustave Le Gray, 1820–1884*. Los Ange-
les: Getty Trust Publications, 2002.

Aubenas and Gunthert 1996
Aubenas, Sylvie, and André Gunthert. *La révolution de la
photographie instantanée, 1880–1900*. Paris: Biblio-
thèque nationale de France and Société Française de
Photographie, 1996.

Barnes 1998
Barnes, John. *The Beginnings of the Cinema in England,
1894–1901*. Exeter: University of Exeter Press, 1998.

Barnouw 1981
Barnouw, Erik. *The Magician and the Cinema*. Oxford:
Oxford University Press, 1981.

Blanchard 1862
[Blanchard, Valentine]. "Stereographs: Instantaneous
Views of London Photographed by Valentine Blan-
chard." *British Journal of Photography* 9 (15 October
1862): 381–82.

Blanchard 1863
Blanchard, Valentine. "On Instantaneous Photography."
*British Journal of Photography* 10 (1 January 1863):
5–6.

Blanchard 1891
Blanchard, Valentine. "Instantaneous Photography
Thirty Years Ago." *Photographic Quarterly* 2, no. 6
(1891): 147–57.

Blanchere 1865
Blanchere, Henri de la. "Instantaneous Photography."
*British Journal of Photography* 12 (26 May 1865): 275–76.

Braun 1992
Braun, Marta. *Picturing Time: The Work of Etienne-Jules
Marey*. Chicago: University of Chicago Press, 1992.

Ceram 1965
Ceram, C. W. *Archaeology of the Cinema*. New York: Har-
court, Brace and World, 1965.

Chanan 1995
Chanan, Michael. *The Dream That Kicks: The Prehistory
and Early Years of the Cinema in Britain.* London:
Routledge, 1995.

Clark 1931
Clark, George T. *Leland Stanford: War Governor of Califor-
nia, Railroad Builder, and Founder of Stanford Univer-
sity*. Stanford: Stanford University Press, 1931.

Claudet 1868
[Claudet, Antoine]. "Instantaneous Photography a
Quarter of a Century Ago." *Photographic News* 12 (22
May 1868): 249.

Coe 1992
Coe, Brian. *Muybridge and the Chronophotographers*. Lon-
don: Museum of the Moving Image, 1992.

Crompton 1997
Crompton, Dennis, Richard Franklin, and Stephen
Herbert, eds. *Servants of Light: The Book of the Lantern*.
Leicester: Magic Lantern Society, 1997.

Curving Plates 1871
"On Curving Plates for Instantaneous Views." *British Journal of Photography* 18 (10 March 1871): 107.

Dagognet 1992
Dagognet, François. *Etienne-Jules Marey: A Passion for the Trace.* Translated by Galeta Robert and Jeanine Herman. Cambridge: MIT Press, 1992.

Dallmeyer 1926
J. H. Dallmeyer Ltd. *The Early History of the House of Dallmeyer: Giving an Outline of the Progress Made in Photographic Optics by J. H. Dallmeyer and His Successors.* London: J. H. Dallmeyer, 1926.

Daston and Galison 1992
Daston, Lorraine, and Peter Galison. "The Image of Objectivity." *Representations* 40 (fall 1992): 81–128.

Davis and Nilan 1989
Davis, Margo, and Roxanne Nilan. *The Stanford Album: A Photographic History, 1885–1945.* Stanford: Stanford University Press, 1989.

Dawson 1862
Dawson, George. "Notes on Instantaneous Shutters." *British Journal of Photography* 9 (1 December 1862): 445–46.

Dawson 1863
Dawson, George. "On Instantaneous Photography." *British Journal of Photography* 10 (1 April 1863): 138–39.

Delimata 1996
Delimata, Joyce, ed. *Marey/Muybridge: Pionniers du cinéma, rencontre Beaune/Stanford.* Beaune: Conseil régional de Bourgogne, 1996.

Despratz 1861
Despratz, l'Abbé. "On Instantaneous Photography." *British Journal of Photography* 9 (15 November 1861): 404.

Diamond 1863
Diamond, Hugh Welch. In *Reports by the Juries on the Subjects in the Thirty-six Classes into Which the Exhibition Was Divided.* Edited by Peter Le Neve Foster and John Frederick Iselin the Elder. London: Society for the Encouragement of Arts, Manufactures, and Commerce, 1863: 12–14.

Dorra 1994
Dorra, Henri, ed. *Symbolist Art Theories: A Critical Anthology.* Berkeley and Los Angeles: University of California Press, 1994.

Dupeux and Leuba 1991
Dupeux, Cécile, Marion Leuba et al. *La passion du mouvement au XIXe siècle: Hommage à E. J. Marey.* Exhibition catalogue. Beaune: Musée Marey, 1991.

Eder 1888
Eder, Josef Maria. *La photographie instantanée: Son application aux arts et aux sciences.* Paris: Villars et Fils, 1888.

Ewing 1863
Ewing, James. "On the Manipulation, Developing, and Intensifying of Negatives." *British Journal of Photography* 10 (16 February 1863): 71–73.

Fell 1983
Fell, John L., ed. *Film before Griffith.* Berkeley and Los Angeles: University of California Press, 1983.

Fescourt 1932
Fescourt, Henri. *Le cinéma, dès origines à nos jours.* Paris: Éditions du Cygne, 1932.

Fielding 1967
Fielding, Raymond, ed. *A Technological History of Motion Pictures and Television*. Berkeley and Los Angeles: University of California Press, 1967.

Frampton 1983
Frampton, Hollis. *Circles of Confusion: Film, Photography, Video, Texts, 1968–1980*. Rochester, N.Y.: Visual Studies Workshop Press, 1983

Frizot 1977
Frizot, Michel, ed. *E. J. Marey, 1830/1904: La photographie du mouvement*. Exhibition catalogue. Paris: Centre Georges Pompidou; Musée National d'Art Moderne, 1977.

Frizot 1984
Frizot, Michel. *La chronophotographie, avant le cinématographe: Temps, photographie et mouvement autour de E.–J. Marey*. Beaune: Association des amis de Marey, 1984.

Fry 1861
Fry, Samuel. "Instantaneous Photography." *Photographic News* 5 (25 October 1861): 496–97.

Gernsheim 1988
Gernsheim, Helmut. "Instantaneous Photography." In *The Rise of Photography, 1850–1880: The Age of Collodion*. London: Thames and Hudson, 1988.

Grubb 1871
Grubb, Howard. "Instantaneous Pocket Cameras." *British Journal of Photography* 18 (3 March 1871): 99.

Gunning 1995
Gunning, Tom. "An Aesthetic of Astonishment: Early Film and the [In]Credulous Spectator." In *Viewing Positions*. Edited by Linda Williams. New Brunswick, N.J.: Rutgers University Press, 1995: 114–33.

Gunning 2001
Gunning, Tom. "Doing for the Eye, What the Phonograph Does for the Ear." In *The Sounds of Early Cinema*. Edited by Richard Abel and Rick Altman. Bloomington: Indiana University Press, 2001: 13–31.

Gunthert 1999
Gunthert, André. "La conquête de l'instantané: Archéologie de l'imaginaire photographique en France (1841–1895)." Ph.D. diss., École des Hautes Études en Sciences Sociales, Paris, 1999.

Haas 1976
Haas, Robert Bartlett. *Muybridge: Man in Motion*. Berkeley and Los Angeles: University of California Press, 1976.

Haes 1892
Haes, Frank. "The Early Days of Animal Photography." *Photographic News* 36 (15 January 1892): 38–39.

Harding 1996
Harding, Colin, and Simon Popple, eds. *In the Kingdom of Shadows: A Companion to Early Cinema*. London: Cygnus Arts, 1996.

Harris 1993
Harris, David. *Eadweard Muybridge and the Photographic Panorama of San Francisco, 1850–1880*. Exhibition catalogue. Montreal: Canadian Center for Architecture, 1993.

Hendricks 1975
Hendricks, Gordon. *Eadweard Muybridge: The Father of the Motion Picture*. London: Secker and Warburg, 1975.

Herbert 2000a
Herbert, Stephen, ed. *A History of Early Film*. 3 vols. London: Routledge, 2000.

Herbert 2000b
Herbert, Stephen, ed. *A History of Pre-Cinema*. 3 vols. London: Routledge, 2000.

Herschel 1860
Herschel, Sir John F. W. "Instantaneous Photography." *Photographic News* 4 (May 1860): 1.

Highley 1861
Highley, Samuel. "Instantaneous Shutters." *British Journal of Photography* 8 (15 March 1861): 104–5, 128–30.

Hockin 1863
Hockin, J. B. "On Instantaneous Pictures by the Use of Formic Acid in the Developer." *British Journal of Photography* 10 (16 March 1863): 116.

Homer 1962
Homer, W. I. "Concerning Muybridge, Marey, and Seurat." *Burlington Magazine* 104 (September 1962): 391–92.

Honour 1979
Honour, Hugh. *Romanticism*. New York: Harper and Row, 1979.

Howlett 1858
Howlett, Robert. "On Taking Instantaneous Pictures." *Photographic Notes* 3 (1 January 1858): 11–12.

Hoyt 1967
Hoyt, Edwin P. *Leland Stanford: A Biography of the Governor of California Who Built a Controversial Railroad and Founded a Great University*. New York: Abelard-Schuman, 1967.

Instantaneous Exposures 1866
"On Instantaneous Exposures, and Improved Means for Effecting Them." *British Journal of Photography* 13 (12 January 1866): 13–14.

Jacobson 2001
Jacobson, Ken. *The Lovely Sea-View: A Study of the Marine Photographs Published by Gustave Le Gray, 1856–58*. Petches Bridge, England: Ken and Jenny Jacobson, 2001.

Janis 1987
Janis, Eugenia Parry. *The Photography of Gustave Le Gray*. Chicago: University of Chicago Press, 1987.

Keene 1862
Keene, Alfred. "A New Rapid Dry Process." *British Journal of Photography* 9 (1 December 1862): 446–47.

Kibble 1862
Kibble, John. "On Instantaneous Photography." *British Journal of Photography* 9 (15 October 1862): 379–80.

Londe 1886
Londe, Albert. *La photographie instantanée: Théorie et pratique*. Paris: Gauthier-Villars, 1886.

Lothrop 1973
Lothrop, Eaton S. *A Century of Cameras from the Collection of the International Museum of Photography at George Eastman House*. Dobbs Ferry, N.Y.: Morgan and Morgan, 1973.

Low 1997
Low, Rachael. *The History of British Film*. London: Routledge, 1997.

MacDonald 1979
MacDonald, Gus. *Camera: A Victorian Eyewitness*. London: B. T. Batsford, 1979.

MacDonnell 1972
MacDonnell, Kevin. *Eadweard Muybridge: The Man Who Invented the Moving Picture*. London: Weidenfeld and Nicolson, 1972.

Mann 1862
Mann, A. "Description of an Instantaneous Shutter."
*British Journal of Photography* 9 (1 July 1862):
243–45.

Mannoni 1999
Mannoni, Laurent. *Etienne-Jules Marey: La mémoire de
l'oeil*. Paris: Cinémathèque française, 1999.

Mannoni 2000
Mannoni, Laurent. *The Great Art of Light and Shadow:
Archaeology of the Cinema*. Translated and edited by
Richard Crangle. Exeter: University of Exeter Press,
2000.

Marbot 1981
Marbot, Bernard. *After Daguerre: Masterworks of French
Photography (1848–1900) from the Bibliothèque
Nationale de France*. Exhibition catalogue. New York:
Metropolitan Museum of Art, 1981.

Marks, Harrison, and Dercum [1888] 1973
Marks, W. D., Allen Harrison, and Francis Dercum. *Ani-
mal Locomotion: The Muybridge Work at the University of
Pennsylvania: The Method and the Result*. Philadelphia:
J. B. Lippincott, 1888. Reprint, New York: Arno,
1973.

Milty 1976
Mitry, Jean, ed. "Le cinéma dès origines: Les
précurseurs, les inventeurs, les pionniers, cinéma
d'aujourd'hui." *Cahiers bimestriels*, no. 9 (1976):
47–59.

Morgan-Brown 1903
Morgan-Brown, W., for Eadweard Muybridge. "Appara-
tus for Taking Instantaneous Photographs of Animals
in Motion." *Abridgements of Patent Specifications*, 1903
(1878), no. 2746.

Morris 1980
Morris, Richard. *John Dillwyn Llewelyn, 1810–1882: The
First Photographer in Wales*. Cardiff: Welsh Arts
Council, 1980.

Mozley 1972
Mozley, Anita Ventura, ed. *Eadweard Muybridge: The
Stanford Years*. Exhibition catalogue. Stanford, Calif.:
Museum of Art, Stanford University, 1972.

Musser 1990
Musser, Charles. *The Emergence of Cinema: The American
Screen to 1907*. New York: Scribner, 1990.

Muybridge 1881a
Muybridge, Eadweard. *Attitudes of Animals in Motion: A
Series of Photographs Illustrating the Consecutive Posi-
tions Assumed by Animals Performing Various Move-
ments; Executed at Palo Alto, California, in 1878 and
1879*. San Francisco, 1881.

Muybridge 1881b
Muybridge, Eadweard. "Leland Stanford's Gift to Art
and to Science, Mr. Muybridge's Inventions of
Instant Photography and the Marvelous Zoögryro-
scope." *San Francisco Examiner*, 6 February 1881.

Muybridge 1887
Muybridge, Eadweard. *Animal Locomotion: An Electro-
photographic Investigation of Consecutive Phases of Ani-
mal Movement*. Philadelphia: University of Pennsyl-
vania, 1887.

Muybridge [1887] 1979
Muybridge, Eadweard. "*Muybridge's Complete Human
and Animal Locomotion: All 781 Plates from the 1887
Animal Locomotion*, 3 vols. Introduction by Anita
Ventura Mozley. New York: Dover Publications, 1979.

Muybridge 1893
Muybridge, Eadweard. *Descriptive Zoöpraxography; or, The Science of Animal Locomotion*. Chicago: R. R. Donnelley and Sons, 1893.

Muybridge 1899
Muybridge, Eadweard. *Animals in Motion: An Electro-photographic Investigation of Consecutive Phases of Muscular Actions*. London: Chapman and Hall, 1899.

Muybridge [1899] 1957
Muybridge, Eadweard. *Animals in Motion*. Reprint, New York: Dover Publications, 1957.

Muybridge 1901
Muybridge, Eadweard. *The Human Figure in Motion: An Electro-photographic Investigation of Consecutive Phases of Muscular Actions*. London: Chapman and Hall, 1901.

Muybridge [1901] 1955
Muybridge, Eadweard. *The Human Figure in Motion*. Reprint, New York: Dover Publications, 1955.

Newhall 1949
Newhall, Beaumont. *The History of Photography: From 1839 to the Present*. New York: Museum of Modern Art, 1949. Revised edition, New York: Little, Brown & Co., 1982.

Newhall 1950
Newhall, Beaumont. "The George E. Nitzsche Collection of Muybridge Relics." *Medical Radiography and Photography* 26, no. 1 (1950): 24–26.

Petschler 1891
Petschler, H. "Instantaneous Shutter." *British Journal of Photography* 9 (1 September 1861): 330.

Photographs by Moonlight 1870
"Photographs by Moonlight, and Sunlight Effects." *Photographic News* 14 (19 August 1870): 385–86.

Prize for Dry Collodion 1862
"Prize for an Instantaneous Dry Collodion." *British Journal of Photography* 9 (15 March 1862): 109–10.

Prodger 1996
Prodger, Phillip. "The Romance and Reality of the Horse in Motion." In Delimata 1996, 44–71.

Prodger 1999
Prodger, Phillip. "Darwin, Rejlander, and the Evolution of Ginx's Baby." *History of Photography* 23 (autumn 1999): 260–68.

Prodger 2000
Prodger, Phillip. "How Did Muybridge Do It?" *Aperture*, no. 158 (spring 2000): 12–16.

Ramsaye 1926
Terry Ramsaye. *A Million and One Nights: A History of the Motion Picture*. 2 vols. New York: Simon and Schuster, 1926.

Rapid Sea Views 1870
"Rapid Sea Views and Moonlight Pictures." *Photographic News* 14 (2 September 1870): 418.

Retouching the Negative 1870
"Retouching the Negative." *British Journal of Photography* 17 (24 June 1870): 293.

Robinson 1864
Robinson, Henry Peach. "The Changes in Photography during the Last Few Years." *British Journal of Photography* 11 (1 February 1864): 39.

Robinson and King 1870
Robinson, Henry Peach, and Cherrill Nelson King. "Photographs by Moonlight." *Photographic News* 14 (26 August 1870): 407.

Rossell 1997
Rossell, Deac. *Ottomar Anschütz and His Electrical Wonder*. Hastings: Projection Box, 1997.

Rossell 1998
Rossell, Deac. *Living Pictures: The Origins of the Movies*. Albany: State University of New York Press, 1998.

Sheldon and Reynolds 1991
Sheldon, James L., and Jock Reynolds. *Motion and Document, Sequence and Time: Eadweard Muybridge and Contemporary American Photography*. Exhibition catalogue. Andover, Mass.: Addison Gallery of American Art, Phillips Academy, 1991.

Snell 1883
Snell, George. "The Galloping Horse in Art." *Century* 26 (June 1883): 315–17.

Sobieszek 1985
Sobieszek, Robert. *Masterpieces of Photography from the George Eastman House Collections*. New York: Abbeville, 1985.

Solnit 2003
Solnit, Rebecca. *River of Shadows: Eadweard Muybridge and the Technological Wild West*. New York: Viking, 2003.

Stillman 1881
Stillman, Jacob Davis Babcock. *The Horse in Motion as Shown by Instantaneous Photography: With a Study on Animal Mechanics Founded on Anatomy and the Revelations of the Camera, in Which Is Demonstrated the Theory of Quadrupedal Locomotion*. Boston: James R. Osgood and Co., 1881.

Sturgis 2000
Sturgis, Alexander. *Telling Time*. Exhibition catalogue. London: National Gallery, 2000.

Sutton 1871
Sutton, Thomas. "A New Wet Collodion Process." *British Journal of Photography* 18 (10 March 1871): 109.

Szöke 1992
Szöke , Annamária, et al. *Székely Bertalan: Mozgástanulmányai*. Budapest: Magyar Képzömüvészeti Föiskola, 1992.

Talk in the Studio 1870
"Talk in the Studio: Photography and Moonlight." *Photographic News* 14 (25 February 1870): 95.

Taylor 1981
Taylor, Roger. *George Washington Wilson: Artist and Photographer, 1823–93*. Aberdeen: University of Aberdeen Press, 1981.

Thomas 1997
Thomas, Ann, ed. *Beauty of Another Order: Photography in Science*. Exhibition catalogue. New Haven: Yale University Press, in association with the National Gallery of Canada, Ottawa, 1997.

Thompson 1871
Thompson, Stephen. "Instantaneity." *Photographic News* 15 (3 March 1871): 102–3.

Tissot's Instantaneous Shutter 1863
"Monsieur Tissot's Instantaneous Shutter." *British Journal of Photography* 10 (1 January 1863): 449.

Tutorow 1971
Tutorow, Norman E. *Leland Stanford: Man of Many Careers*. Menlo Park, Calif.: Pacific Coast Publishers, 1971.

Waring 1882
Waring, George E., Jr. "The Horse in Motion." *Century* 24 (July 1882): 381–88.

Weaver 1989
Weaver, Mike. *British Photography in the Nineteenth Century: The Fine Art Tradition*. Cambridge: Cambridge University Press, 1989.

Williams 1887
Williams, Talcott. "Animal Locomotion in the Muybridge Photographs." *Century* 34 (July 1887): 356–68.

Williams 1989
Williams, Linda. *Hard Core: Power, Pleasure, and the "Frenzy of the Visible."* Berkeley and Los Angeles: University of California Press, 1989.

# INDEX